blower
SNOWBOARDING INSIDE OUT

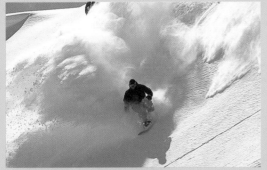 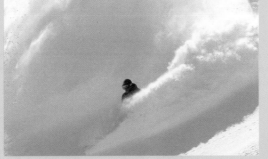 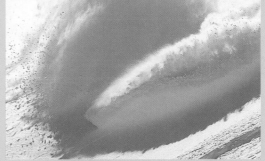

blow·er, *noun* 1: one that blows 2: a device for producing a current of air or gas 3: a loud arrogant boaster 4: a British telephone 5: *Slang,* term used to describe the actions of, and/or the conditions surrounding, the act of snowboarding. *The riding was epic, I was making BLOWER powder turns all day*

FIRST PUBLISHED IN 2001 BY
BOOTH-CLIBBORN EDITIONS LIMITED
12 PERCY STREET
LONDON W1T 1DW
UK
WWW.BOOTH-CLIBBORN.COM

AUTHORED AND COMPILED BY JEFF CURTES, JARED EBERHARDT, ERIC KOTCH
PHOTOGRAPHY BY JEFF CURTES
ART DIRECTED AND DESIGNED BY JARED EBERHARDT
DIRECTOR OF PHOTOGRAPHY AND PROJECT COORDINATED BY ERIC KOTCH
ADDITIONAL PHOTOGRAPHY BY JON FOSTER, MARK GALLUP, TREVOR GRAVES, DEAN BLOTTO GRAY,
SCOTT NEEDHAM, VINCENT SKOGLUND, VIANNEY TISSEAU, HIRO YAMADA, KEVIN ZACHER
ADDITIONAL DESIGN BY MALCOLM BUICK, AARON JAMES DRAPLIN, RUBY LEE
PORTFOLIO PHOTOGRAPHY BY GEOFF FOSBROOK, ALEX WILLIAMS
WRITTEN BY JARED EBERHARDT, EVAN ROSE, KEVIN WILKINS
DVD COMPILED AND EDITED BY JON BOYER
EDITED BY LIZ FARRELLY
CREATIVE CONSULTING AND INITIATION BY JIM ANFUSO

WITH THANKS TO

MERRY BAKER, BRIGHTON, JAKE CARPENTER, CRAIG ABEL CHAMPION, DAVID COVELL, DON AND
VIRGINIA CURTES, JOE CURTES, GREG AND ANNE MARIE DACYSHYN, DJ, KATE DODGE, DAVE
DOWNING, BARRY DUGAN, ENEMY, ESTAB, JULIA FRÖMEL, HIROSHI FUJIWARA, H3, RENE HANSEN,
SLOAN HARRIS, TREVOR RAY HART, MIKE HATCHETT, SUSANNA HOWE, INTERNATE, MICHAEL JAGER,
JENN, VINCE LAVECCHIA, SUSAN LEE, LIMP, SCREAMING LORD, ARI MARCOPOULOS, MATT, BRUNO
MUSSO, NICK, SCHRIBER, STRUGGLE INC., DAVE SYPNIEWSKI, T, LANCE VIOLETTE, ANTHONY VITALE,
CANDICE WILHELMSEN, ANDY WRIGHT

A CATALOGUING-IN-PUBLICATION RECORD FOR THIS BOOK IS AVAILABLE FROM THE PUBLISHER.

ISBN 1-86154-219-4

PRINTED AND BOUND IN HONG KONG

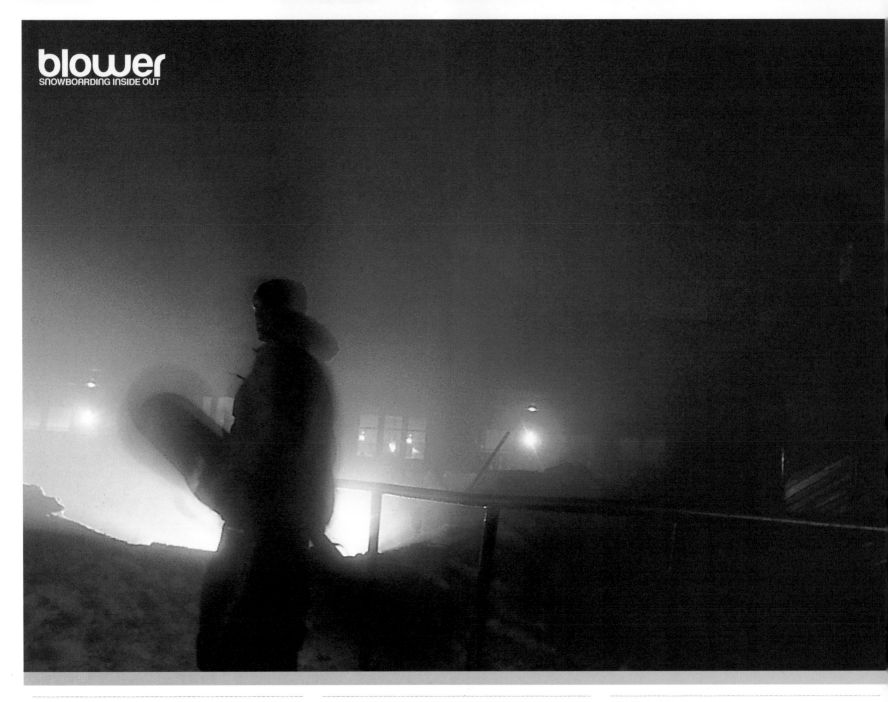

blower
SNOWBOARDING INSIDE OUT

CHAPTER_1:[9-26]_NATURE_&_ENVIRONMENT

GROUND ZERO, REGARDLESS OF YOUR STANCE ANGLE, FASHION SENSE, PREFERRED PROFESSION OR WHEN (OR IF) YOU CHOSE TO GET OFF THE EVOLUTIONARY BUS, WE ARE ALL AT THE MERCY OF MOTHER NATURE. AS SNOWBOARDERS, THE WEATHER IS OUR COMMON DENOMINATOR. THERE IS NO SUBSTITUTE FOR THE EXCITEMENT OF AN IMPENDING STORM, AND THERE IS NOTHING LIKE THE FEELING OF HELPLESSNESS WHEN YOU ARE IN THE MIDDLE OF A DRY SPELL. WHEN IT SNOWS THE WORLD IS RIGHT AGAIN. MODERN SNOWBOARDING MAY BE TESTING THE NEED FOR SNOWSTORMS AND IT MAY BE PROPER ETIQUETTE TO SHOVEL THE SNOW OFF THE STEPS OF THE HANDRAIL, BUT IT STILL TAKES A THIN LAYER OF SNOW TO REMIND US WHAT SPORT THIS REALLY IS.
DESIGN:MALCOLM BUICK TEXT:KEVIN WILKINS

CHAPTER_2:[27-112]_PROFESSIONAL_SNOWBOARDING

IT MAY BE A FUN JOB, BUT IT'S STILL WORK. IMAGINE YOUR COMMUTE TO WORK WAS 36 HOURS, YOUR DAY AT THE OFFICE WAS OVER A WEEK LONG AND YOUR EARLY RETIREMENT (WITHOUT PENSION) WAS LOOMING ON THE LANDING OF EVERY JUMP. IN ADDITION, IMAGINE HAVING TO ANSWER TO THE MARKETING DEMANDS OF TEAM MANAGERS, FILMERS, PHOTOGRAPHERS AND DESIGNERS. WHAT GOOD IS HAVING FUN IF IT DOESN'T HELP EARN YOUR PAY? TO TOP IT ALL OFF, THE ODDS ARE AGAINST YOU HAVING ANYTHING TO SHOW FOR YOUR WEEK' S EFFORTS. AT BEST, YOU MAY BE REWARDED WITH ONE OR TWO THREE TO FOUR SECOND 16MM CLIPS AND A COUPLE OF 35MM SEQUENCES. THE DAY AT THE OFFICE LASTS A WEEK BUT YOU STILL ONLY HAVE A YEAR (THAT' S IF YOU CAN AFFORD TO SWITCH HEMISPHERES HALFWAY THROUGH) TO GET YOUR THREE MINUTES OF FOOTAGE FOR THE VIDEO. EVERY MINUTE IN TRANSIT, WAITING FOR THE WEATHER, OR HEALING FROM INJURY IS TIME BORROWED AGAINST YOUR ALREADY SHORT YEAR (AND CAREER). BEFORE YOU EVEN REALISE IT YOU HAVE A NEW PAIR OF BOOTS TO BREAK-IN, YOUR NEW GRAPHICS TO GET SHOTS OF AND IT' S TIME TO START OVER AGAIN. DESIGN:RUBY LEE TEXT:KEVIN WILKINS

CHAPTER_3:[113-156]_PEOPLE

SOMEWHERE IN ITS EVOLUTION SNOWBOARDING BECAME A LIFESTYLE. AS THE CAST OF CHARACTERS BEGAN TO EMERGE, MAGAZINES BECAME MORE THAN COLLECTIONS OF TRAVEL STORIES AND ACTION PHOTOGRAPHY. PEOPLE WERE HUNGRY FOR IMAGES OF THEIR HEROES LIVING THE DREAM ON AND OFF THE HILL. SNOWBOARD PHOTOGRAPHY TURNED A CORNER, BLURRING THE LINES BETWEEN FASHION, DOCUMENTARY AND ACTION PHOTOGRAPHY.

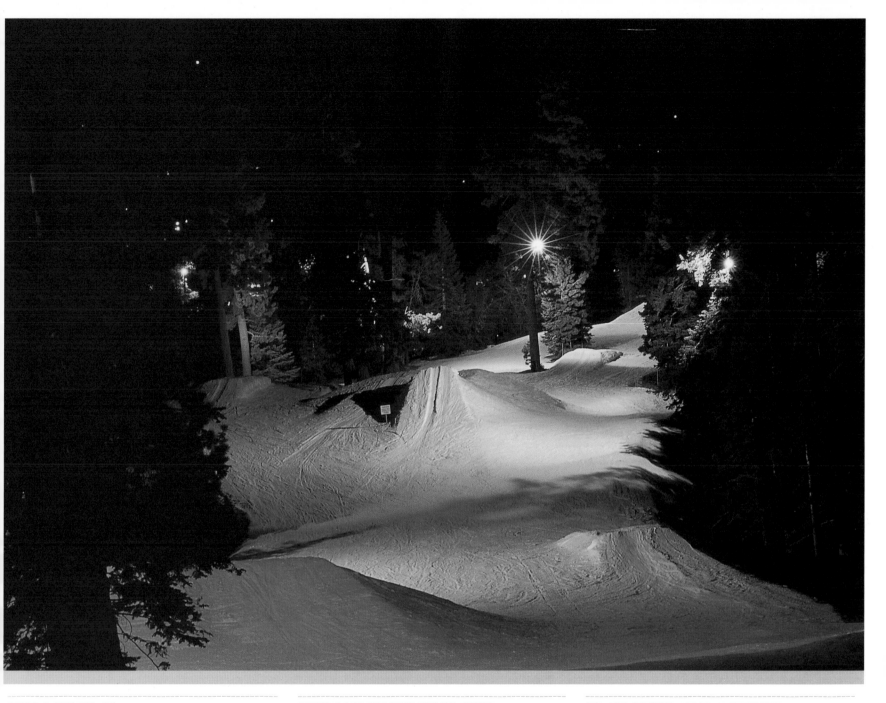

CHAPTER_4:[157-188]_ART

JUST AS NATURE PROVIDES THE CANVAS FOR THE SELF-EXPRESSION OF RIDING, THE SNOWBOARD ITSELF PROVIDES A MEDIUM OF SELF-EXPRESSION ON AND OFF THE HILL. A SNOWBOARD IS MUCH MORE THAN THE SUM OF ITS PARTS. THERE IS AN EMOTIONAL ATTACHMENT TO THE BOARD, WHICH GOES DEEPER THAN P-TEX AND A WOODEN CORE. SNOWBOARD GRAPHICS ARE MORE THAN A RANDOM PLACEMENT OF ARTWORK AND STICKERS; IT'S A COLLABORATION BETWEEN ARTISTS, DESIGNERS AND PRO-RIDERS. THIS IS A COLLECTION OF PERSONAL WORK FROM SOME OF THE ARTISTS WHO HAVE PROVIDED THE RAW MATERIAL FOR COUNTLESS UNBELIEVABLE SNOWBOARD GRAPHICS.

CHAPTER_5:[189-220]_BURTON/JDK,THE_PROCESS

THIS IS A GRAPHIC HISTORY OF ONE OF THE LONGEST RUNNING RELATIONSHIPS IN DESIGN. THE RELATIONSHIP WAS FORGED AND FLOURISHED BY BLURRING THE TRADITIONAL CLIENT/CREATOR BARRIERS. BURTON'S CORPORATE CULTURE EMBRACES THE OPPORTUNITY FOR DESIGNERS TO NOT ONLY BE INFORMED BUT TO HELP PLAN STRATEGY AND DECIDE ON POLICY. IT ALL BEGAN IN 1990 WHEN MICHAEL AND GIOVANNA JAGER WERE ASKED TO PRESENT A SELECTION OF SNOWBOARD GRAPHICS AT BURTON SNOWBOARD'S OWNER/FOUNDER JAKE BURTON'S ANNUAL FALL BASH. THE REST IS HISTORY. THE EARLY DAYS WERE VERY EXCITING, AS THE WORD NO WASN'T PART OF ANYONE'S VOCABULARY, (UNLESS IT WAS A RESPONSE TO THE QUESTIONS, "ARE YOU GOING TO GO HOME TONIGHT?" OR "DID YOU KNOW IT'S CHRISTMAS TOMORROW?"). BUSINESS GREW EXPONENTIALLY EVERY YEAR FOR BOTH COMPANIES AND PRINTING BUDGETS WERE SIMPLY MADE TO BE BROKEN. THIS, COMBINED WITH A PASSION FOR DESIGN, FUELLED A DEDICATED CREW OF JDK DESIGNERS AND BURTON MARKETERS TO PUSH SNOWBOARD DESIGN AND MARKETING, WHICH PIONEERED MUCH OF WHAT IS BEING RECYCLED IN THE INDUSTRY TODAY. COMMENTARY BY DAVID COVELL

[221-229]:SHAVEMART (UNPAID ADVERTISEMENT)

SHAVEMART (UNPAID ADVERTISEMENT) WITH SNOWBOARDING'S INCREASING ACCEPTANCE AMONG THE MASSES VARIOUS CORPORATIONS HAVE SOUGHT TO GRAB ON TO SNOWBOARDING'S MOMENTUM AND INFLUENCE WITH YOUTHFUL CULTURES SO AS TO HELP SELL THEIR WARES. SHAVEMART IS ONE SUCH COMPANY, OFFERING "EVERYTHING ON SNOW AT LOWEST PRICES". DO YOURSELF A FAVOUR AND RIP THIS OUT RIGHT NOW AND THROW IT AWAY WITH THE REST OF THE JUNK MAIL.

INDEX:[230-234]

AN INDEX OFFERING THE STANDARD SORT OF INFORMATION YOU WOULD EXPECT FROM AN INDEX WITH BONUS COMMENTARY FROM THE AUTHORS ON IMAGES IN THIS BOOK.

CHAPTER_6:[235-256]-UNTITLED.

UNTITLED. A COLLECTION OF THE AUTHORS' FAVOURITE AND MOST COMPELLING PHOTOGRAPHY, SO DRAW YOUR OWN CONCLUSIONS.

I'VE BEEN EDITING PHOTOS OF TALENTED SNOWBOARDERS, INTERESTING PEOPLE, AND A MIX OF EVERYTHING IN-BETWEEN FOR BURTON SNOWBOARDS FOR ALMOST TEN YEARS. OVER THAT PERIOD I'VE SEEN A LOT OF GREAT PHOTOS, SHOT BY A VARIETY OF TALENTED PHOTOGRAPHERS; SO MANY PHOTOS I COULD NEVER COUNT, BUT STRANGELY ENOUGH I CAN RECALL THEM ALL.

AS THE PAST DECADE MOVED ON AND THE BURTON MARKETING PROCESS CONTINUED, (ADS, CATALOGUES, ETC.) THERE WAS AN INCREASING AMOUNT OF PHOTOGRAPHY LEFT UNUSED OR USED INAPPROPRIATELY (COVERED WITH COPY, REPRODUCED TOO SMALL, ETC). FOR YEARS I'VE BEEN THINKING OF A WAY TO USE THESE PHOTOS AND SHOW THEM IN THE FORMAT THEY DESERVE. BLOWER IS THAT OPPORTUNITY.

A SIMPLE IDEA. TO DISPLAY GREAT PHOTOS SHOT BY JEFF CURTES AND A GROUP OF OUR FRIENDS. WELL...NOT THAT SIMPLE.

OUR INITIAL GOAL WAS TO DO A WELL-ROUNDED PHOTOGRAPHIC ESSAY ABOUT THE SPORT OF SNOWBOARDING AND THE LIVES THAT SURROUND IT. NOTHING HISTORICAL, NOTHING POLITICAL. JUST SOME GOOD SOLID ACTION SHOTS, AND A MIX OF THOSE BEHIND THE SCENE SHOTS THAT SHOW THE MADNESS OF OUR DAILY LIVES. WE,VE KEPT IN LINE WITH THIS GOAL PRETTY WELL, ASIDE FROM ONE THING; IT IS NOT WELL ROUNDED. HOW COULD IT BE? IT'S MADE BY THREE PEOPLE WHO HAVE SPENT MUCH OF THEIR LIVES WORKING WITH, AND FOR, BURTON. WE STARTED OFF TRYING NOT TO MAKE A "BURTON BOOK", BUT THAT'S KIND OF WHAT WE ENDED UP WITH. LOOKING BACK THOUGH, I REALISE, HOW COULD IT HAVE BEEN ANYTHING BUT A BURTON-DOMINATED BOOK. I GUESS IT WAS INEVITABLE. AS JARED ONCE WROTE; "BLOWER IS BORN OF ITS CONTRIBUTORS AND WILL TAKE ON THEIR FORM". BURTON IS SNOWBOARDING FOR ME, AND I'M HAPPY AND PROUD TO SHOW THAT.

THERE ARE MANY PEOPLE WHO ARE EXTREMELY PASSIONATE ABOUT SNOWBOARDING. I AMONE OF THOSE PEOPLE. THERE ARE MANY DIFFERING OPINIONS OUT THERE REGARDING SNOWBOARDING. I HAVE MY OPINIONS, JEFF HAS HIS, AND JARED HAS HIS, AND THAT'S JUST WHAT THEY ARE, THEY ARE OUR OPINIONS. BLOWER IS NOT INTENTIONALLY A COMMENTARY ON THE SNOWBOARDING INDUSTRY, AND BY NO MEANS IS IT A COMPLETE LOOK AT SNOWBOARDING. WE'RE NOT TRYING TO MAKE A STATEMENT HERE, WE'RE JUST THREE FRIENDS HAVING FUN, MAKING A BOOK.

ERIC KOTCH

From: Jared
<jared@snowboardinginsideout.com>
Date: Thu, 26 Apr 2001 13:50:10 -0400
Subject: Nothing is ever true to an expert.

Imagine for a moment you were going to make a book based on your experience with snowboarding. Now imagine the first ten or so most important things that would be in that book. Now before you forget, would you mind typing them out and sending them to me (even one or two would be fine) This is going to be content for the intro of the book, under the "things we forgot to put in this book" section.

Thanks for your help
--Jared

www.snowboardinginsideout.com

From: Jake Burton
Date: Wed, 9 May 2001 11:41:22 -0400<
Subject: Re: nothing is ever true to an expert
To: Jared, Jeff Curtes, Eric Kotch

Hi you guys. Here is a selection of real loose initial ideas. I tried to come at it from a variety of different angles with the emphasis being on keeping it short and unique. As you can see, the concepts are pretty diverse. If you're not into it, I can start all over again and come up with some new ideas. It's up to you. Regardless of your feedback, my feelings won't be hurt in any way, I'll just keep working.

Thanks. I look forward to hearing from you,

Jake

#1.The only thing that's more fun than making snowboards is riding them.

#2.Looking at snowboarding shots of the best riders in the world is kind of like looking at porn. You know you want to be right there, but you probably never will. But there's no harm having a little fantasy in our lives.

#3.The last time I went surfing in Costa Rica, this local, who had never seen snow asked what snowboarding was like. I made absolutely no headway until I showed the guy some photos.

#4.(Conversation with an Alien)
ALIEN: What are you?
JAKE: I'm a snowboarder.
ALIEN: What's that?
JAKE: For a third of the year parts of our planet are covered with snow. I cruise around the world all winter searching for freshly fallen snow, and riding it with people who understand what having fun is all about.
ALIEN: Tell me more.

#5.I've probably made millions of turns on a snowboard and very few of them sucked. It's always been fun.

#6.If it's everything people say it is, then I'm convinced that heaven is one big powderfield.

#7.The more I experience and think about snow, the less I understand it. Why does it have to possess the ability to kill you? Why is it that the best powder runs in my life also presented the highest level of fear? Why have we all lost some of our best friends to snow's temper. The best explanation I can come up with is that nature has to be in charge. If it isn't, you might as well be home playin' Playstation.

#8.My kids are growing up thinking that a day job consists of snowboarding 100 days a year, hanging out with the funnest people in the world, and participating in the development of the world's best equipment. Fuck yeah!

#9. As much as I would like to come back to earth in 100 years and ride virtual powder in my living room, I'm happy this isn't going to happen in my lifetime. The places I've seen and the people I've met pretty much define my life.

#10.(From catalogue intro) The best thing about this sport is that all of us decided independently to get into it. Snowboarding is not a sport your parents or some coach shoved down your throat. It was a decision you made yourself. This is a common bond that all snowboarders share, making us all potential friends and deserving of each other's respect. We all understand very clearly that it's all simply about having fun.

From: Jared
<jared@snowboardinginsideout.com>
Date: Fri, 04 May 2001 01:47:29 -0400
To: jared@snowboardinginsideout.com
Subject: Re: nothing is ever true to an expert

I usually hate personal stories, there's usually good reason to keep them personal, but it seemed like everyone here had so many things in common that it felt more like a group therapy session. Please excuse me while I babble about on of my favourite subjects, me.

Through the process of creating this book, I've been sort of the fly in the ointment. My snowboarding history with Burton only goes back four years, so it's been difficult to exclude my prior personal history. There is so much that I would put in here that doesn't really fit the scope of this book, or the limit of 256 pages. I think Eric explains it best in his intro; "We're not trying to make a statement here, we're just three friends having fun making a book".

I grew up in Salt Lake, home of "Ski Utah". Yet I have never skied once. I was too cheap to ski, I was a skateboarder. I had a job at a skate shop that paid me in store credit. During the winter my skating slowed down, as did my need for skate stuff and my credit would build up. I sort of got pressured into taking one of two Wintersticks that weren't selling as one of my paychecks, at $2 an hour it represented about 150 hours of work. I used it maybe a half dozen times. Snowboarding was a cheap alternative to skiing, but my denim outwear made it a miserable experience. During the hike up I'd sweat buckets and it would freeze solid and nearly make me hypothermic during the bus ride home. I remember looking back at my tracks and seeing a long string of powder cursive m's and thinking that I should really learn how to turn backside. I may have snowboarded back in 1986 but I sucked and I hated every minute of it. There was nothing radical about snowboarding back then, hats off to the pioneers that made it what it is today.

Around 1990 my best friends left Salt Lake for the winter to live and work at a skatepark in Arizona. I was in college and just couldn't up-root, so I was left behind. There were no indoor ramps at the time and without my crew it was really hard to motivate and burn the ice off the ramp, and even when I did the ice was gone but I still had to skate alone. It was time for new friends.

My new crew introduced me to clipping tickets, hitch-hiking up the canyon and pro-form equipment. Snowboarding became affordable. We rode almost every day during prime "clipping" times, usually after noon to last lift. I was having the time of my life and not even realising it. At the time it seemed like it was just something we did, totally taken for granted. I was hooked and I didn't even know it. The summer came and for the first time I actually missed winter.

After a couple of these cycles members of my crew began to get sponsored. I was secretly jealous. I'd like to say that I never became a pro because I wasn't willing to bow down to the man and I didn't really care about snowboarding, but really, I just sucked.

My friends were leaving me again, spending summers at Hood and winters at contests and photo-shoots. An ever-widening gap became so big that I had to choose a side, or I should say it was chosen for me. Needless to say, I ended up on the not-pro-snowboarder side of the gap. This is when I first realised that I was having an unrequited love affair with snowboarding. I had to remain attached.

Like most industry people, I found a way to stay inside, or maybe it found me. I displaced my passion for snowboarding with a love for design. It has taken me in deeper than my mediocre snowboarding ever could have. In short, I have become a lurker with a purpose.

We all think of snowboarding through our own set of blinders, here's my unfiltered brainwash (in cronological order):

1. Screaming Lord and Whimpey leaving me in Salt Lake back in 1990.

2. Andy Wright and everyone else from the O.G. Brighton Posse, (especially the ones who were there when we all fit in one car.)

3. Jamie Lynn's Methods.

4. Stan Sanders Priced Rite Trophy, for delivering me from the University of Utah's engineering programme and also allowing me to take in freelance design work from scumbag snowboard companies.

5. Medium magazine.

6. Michael Jager who is the unsung hero of snowboard design. Nobody in the world cares about design as much as him. Nobody.

From: BRUSH
Sent: Thursday, May 03, 2001 8:33 PM
To: ekotch
Subject: Re: nothing is ever true to an expert

I don't know how you guys are doing this. Every time I sit down to work on this list I just get lost reminiscing. And the fact that there might be in your book makes me want my stories or thoughts to be bigger than life. But to be honest that's what snowboarding has been for me. A life unimaginable by most. A life where every moment is worth its mention in your book. Of course there are the obvious standouts such as Ingmars air or the importance of Jake Burton to

I DON'T KNOW? YOU WOULD THINK THAT IT WOULD START WITH ALL THE OLD SCHOOL SHIT ABOUT WHERE SNOWBOARDING CAME FROM & THE PEOPLE THAT STARTED IT...BUT THEN AGAIN, THAT'S BEEN DONE IN LOT'S OF OTHER BOOKS! SO THAT'S A TOUGH CALL.

JEFF

From: scott lenhardt
Date: Fri, 04 May 2001 20:06:45
To: jared
Subject: Re: nothing is ever true to an expert

i can only come up with two experiences that should be of legitness for this project. there are millions of stories, but a few special ones.

i got my purple Craig Kelly stolen from Bromley mtn in 92. that board was fucking brand new-gone. i borrowed someone elses board the next day cause we got dumped on (like 8in). i was walking up to the first chair of the day and saw him buckling in. there was Jake all alone up there for the goods – and besides the drunk liftie, there was not a soul around. i was super nervous, but played it off and buckled in as well. then he turns to me and goes, "single?". holy shit. we rode up the lift and talked about the history of the mountain and how it was the shit. i glanced over as much as possible but trying not to look too much. we got fresh tracks down the face. i doubt he remembers, but i'll never forget that.

the other story is when Vin got all smoked up with Jake and Terje at this year's fall bash. but i wasn't there, so you should ask Vin about that one.

scott

From: shem roose
Sent: Friday, May 04, 2001 3:24 AM
To: ekotch
Subject: Re: nothing is ever true to an expert

ek,

i just checked my e-mail...hopefully you can use this.

going to the burton factory showroom for the first time and buying an elite 150...seeing Jake Burton Carpenter in person as well as team riders...

staring at a portrait of tara eberhard in the back of the burton catalogue for hours...

wanting to talk and ride like brushie...seeing one track mind, snow rules and chill...as well as scream of consciousness...

buying a copy of the first transworld for five bucks from a kid at my school who didn't even snowboard...scouring it for every bit of info and style in every photo...

randy gaetano introducing me to mike lavecchia, vin lavecchia, scott lenhardt and jesse loomis, and the rest of glebelands....

my first chairlift ride at Magic Mountain...not being able to even get up off my ass when buckled on my board...

learning about jamie lynn (through videos and mags) and observing his style...wanting to ride like him especially his methods...

riding a board with fully adjustable stance width...wider than 16 or 17 inches...

going to the u.s. open for the first time (my dad took me) and seeing craig kelly ride the pipe...as well as todd richards, rob morrow, jimmy halopoff, noah brandon, chris roach, terje, etc...(i think this was the first time i saw a half pipe too...1989?)

the changes in snowboarding...clothing, videos, boots, bindings, jibbing...

having my first photo published in transworld snowboarding...

jamie lynn is still my favorite snowboarder.

shem

From: Brad Scheuffele
Date: Fri, 04 May 2001 01:58:59 -0600
To: Jared
Subject: Re: nothing is ever true to an expert

the sport. Everyone could come up with a list like this, but most would leave out the truly important things. For it is not the actual "moments" that are so important in snowboarding. It is the journey or path we have taken between them that should be mentioned. Like when someone mentions Ingmars air I think of myself stepping off a plane in Kiruna, Sweden, (the closest city to Riksgranssen) where I run into at least 7 people all telling me the biggest "you should have been here yesterday" story; and not the fact it graced the cover of at least 4 international snowboard magazines. Or when Jake's name is mentioned I remember a product development meeting I went to at Burton. It was the product managers, Jake and myself all discussing the feasibility of putting some sort of lining in the seat of a pair of pants, as they were very thin and cold when you sat on the chair lift. The product managers response to Jake was that it could not be done. And Jake replied, "if we can put a man on the moon than surely we can put some fleece in the seat of these pants". It is the hundreds of stories like these that would make up my list of the most important things in snowboarding.

After reading this I realised that I just went off on a little tangent. If anyone knows that it is impossible to list the 10 greatest things in snowboarding it would be you. So to you, for having put up with my whatever above, I give you a list. Take it for whatever and it is in no particular order.

Roan Rodgers fakie 720 in HHH.
Guy Mariano in the Blind video for showing how to land with your knees square.
Craig Kelly.
Brushie back side crail at the us open.
Koch "who the fuck do you think you are" and "nice fucking shirt Scheuffele".
Peter Line.
Medium magazine.
Parkwest with Jeremy Gardner.
Blunt.
Jamie Lynn.
Terje at the Parillo park at Wolf Mt..
Brighton.
Forum.
JP Walker.
Watching Whitey lose it.
Trying to follow "Duckboys" carving trail on my Sims Terry Kidwell.
Chris English putting deep heat on his sun burnt face cause Shannon Smith thought it was special after sun cream from her doctor.
Andy and Jared for making bad snowboard companies look good.
Powder.
High speed quads.
Mack Dawg.
Riding with Kami.
The FC.
Andy Brewer.
Milosport.
Saltypeaks.
Anyone who has ever ridden a snowboard.

From: Jon Boyer
Date: Fri, 04 May 2001 08:41:06 -0700
To: Jared Eberhardt
Subject: Re: nothing is ever true to an expert

i started snowboarding because ski racing was not cutting it anymore. i think it was something about the plastic gates smashing my face in 30 below weather in the canadian winters that wasn't working for me. i saw a guy named Niel Daffern riding a snowboard he had made with "SLAYER" written across the bottom ripping around the mountain and i knew i wanted to try it. i saw an ad in an old Thrasher magazine that was for Burton snowboards and i knew i had to have one. no money and parents, who thought it would be just another fad that i had to try, and wouldn't buy me one. so i bought my own board in woodshop. my teacher failed me on that project; little did i know that at that moment i would be pavingthe way for my future life more than the books the teachers were making me study from were. soon afterwards i recieved a gift from my mom and dad. it was a SIMS 1500 FE with metal fins. i guess they figured i wasn't giving up on this. i remember hiking early season to try and get some runs in snow that wasn't deep enough to cover the tall grass in the mountains. it was perfect. i remember driving cross country in my friend's Volkswagen van to the US open in Vermont only to be shut down and not allowed to enter because we were late. things were much simpler then. not much longer after that season i got my first sponsorship and continued my journey down this road of my snowboarding life. i never felt comfortable being a pro. it always felt like a struggle to out do someone else at that time. i felt like there was something else for me to do within this lifestyle. since then i have turned my passions towards capturing the motion of snowboarding on celluliod at a rate of 24 frames per second. i see things in motion now; sometimes slow motion. for me to capture the action of a snowboarder in one single frame seems difficult; i have to capture the whole moment in real time. i then like to put that image to music, hoping to enhance the image and bring it to

life, because after all, don't we all hear music in our heads when we ride?
From: Hubert Schaller
Date: Thu, 26 Apr 2001 10:14:31 -0400
To: Jared
Subject: RE: nothing is ever true to an expert

* tolerance
* respect for everybody who is riding, no matter if he has the most stylish equipment. what is important is that he does it for fun and not to show off.
* riding when it's no longer cool.
* experiencing the mountain and nature.
* not being regimented.
* sharing the fun with others.
* there ARE friends on a powder day.
* the reason to love winters and intense low pressure moving in.

Hubert

From: Dave Cory
Date: Thu, 26 Apr 2001 09:19:54 -0400
To: Jared
Subject: RE: nothing is ever true to an expert

whats crackin'?!
here is my sad assed attempt...

solitude,
landings,
friends,
music/md walkman,
transitions/natural then man made,
personal,
weed,
stretching,
more weed,
water,
contours/natural,
videos,
even more weed,
untracked terrain.

From: gigi
Date: Thu, 26 Apr 2001 14:32:18 +0200 (MEST)
To: Jared
Subject: Re: nothing is ever true to an expert

>i'm not an expert so listen. fill this with all that total icy fucking bullshit.

everyone got his own little story to tell but i would have a photo which should be in there if you want a piece of my story... can i send it to you?

gigi

From: eisenhut
Date: Thu, 26 Apr 2001 09:52:41 +0200
To: Jared
Subject: Re: nothing is ever true to an expert

Most important things about snowboarding...

Well really it's just snow, the board, and a hill. But I suppose you already have enough of that.

Here's some random other stuff.

Damian Sanders in neon colors on the Windlip in Blackcomb.

Perfect Japanese Campers @ Mt. Hood.

Reto Lamm frontflip wearing red checkered pants.

The nucle-air.

The mashed potato by George Pappas.

Jason Ford riding 25% Degree Cants.

Craig Kelly, Double-Handed Rocket.

ISM – International Snowboard magazine.

All the opportunistic wheelers and dealers in the sport: Camp Organisers, Board Manufacturers, Event Organisers, "Action Sport" Publishers.

Jamie Lynn art – both on paper and in the air...

Hmm. Wait. Gotta get some Burton in there:

Size Still Matters ad.

The Madonna ad.

Rippey's first part in video (what was that video again?)

Young Terje on an Austrian glacier.

The Jeff Brushie Cruzin' 53 Board design.

Shaun White winning the Arctic Challenge.

I could go on and on and on...

Johne

From: jess gibson
Date: Wed, 25 Apr 2001 21:30:18 -0600
To: jared
Subject: Re: nothing is ever true to an expert

1. powder.

2. Terje.

3. videos – a picture is worth a thousand words – well a whole bunch of pictures is worth a whole bunch more words.

4. sequences – doesn't leave much to the imagination, but shows how it really went down.

5. backside 180.

6. friends I've made in snowboarding.

7. snowmobiles.

8. freedom.

9. Jussi Oksanen.

10. style.

11. Dave Seone.

Well I don't know if this helps much and these are in no particular order, just rolled out of my head. Can't wait to see the book.

Jess

From: JP Walker
Date: Thu, 26 Apr 2001 02:28:38
To: jared
Subject: Re: nothing is ever true to an expert

yo man check it

1 realising that snowboarding is what i want to do
2 the first time i saw snowboarding
3 seeing a pro in real life for the first time
4 mud
5 selling everything i own to buy boards and lift tickets
6 the first time you stomp a big trick and when you ride you feel pro

i don't know dude. i don't even know if i'm writting about the right things.

From: KScarlett
Date: Thu, 26 Apr 2001 11:12:40 +0900
To: jared
Subject: RE: nothing is ever true to an expert

Jared,

I don't know how I can write but there are some thoughts regarding snowboarding that I would tell people when I talk about snowboarding.

How lucky I am...
– to be surrounded by great people through snowboarding. They are so spiritual and know how to enjoy their life with riding.
– to be able to work for Burton Snowboards. Some say there is no coincidence in this world. Everything has a meaning and it was meant to happen.
– to put myself in a snow environment and make myself have a great time. If there wasn't the sport of snowboarding, I wouldn't have gone out on snow so much.
– to have realised by snowboarding that challenging is good, so as to push myself forward in many ways.
– to have met snowboard. This isn't a sport to me, it's something that I have to have in my life; it's my friends, educations, fun, respect and love. And it will continue to teach me many more things.

Thanks,
Kumi

From: Jill Viggiani
Date: Wed, 25 Apr 2001 17:45:02 -0400
To: Jared
Subject: RE: nothing is ever true to an expert

hmmm,
I need to think 'bout this one. swamp'd right now
can I get back to you by tomorrow?? stoked! very stoked!

thx
– Jill

From: Andy Wright
Date: Sun, 29 Apr 2001 21:53:45 -0800
To: Jared
Subject: Re: nothing is ever true to an expert

These are a little raw, but you should get the idea.

Most Important Things About Snowboarding:

1. Makes snowy, cold, basically miserable weather something to look forward to and cherish, instead of loath and avoid like the rest of the world does.

2. Gives you an opportunity to meet and share time with people whom you might not ever get the chance to because, although you may have totally different interests and backgrounds, you share the common thread of snowboarding.

3. The best way in the world to physically act out many of your skateboarding dreams that you were too big of a pussy to ever attempt on an actual skateboard. Sure you're strapped in and it's snow, but the feeling of McTwist is something I've thought about since the first sequence I ever saw of McGill doing one.

4. Riding powder, to this day, is still the most euphoric sensation I have ever experienced.

5. It's taken me places and shown me things that I would have only seen in postcards.

– andy

From: John Patrick Bowles
Date: Wed, 25 Apr 2001 16:32:49 -0400
To: Jared
Subject: Re: nothing is ever true to an expert

Evan Rose

Pat Bridges (and, of course, the "Patgun")

Original Sin back in the day – Rose, Big Herb, Dan Sullivan, Jay King

First POW!der day at Stowe

"Johnny Rescue" incident w/Rose & Gaetano

Being lucky enough to fall in love with snowboarding in Burlington, which is basically Ground Zero, as opposed to, say, Fucksville, New Jersey. I never would have gotten such an inside view of everything otherwise and never would have met all the cool people (and fucking jerkoffs) that I did.

US Open 99 & US Open 01

Being able to drink everyone under the table

Not being a skater

From: Evan Rose
Date: Wed, 25 Apr 2001 12:39:48 -0700
To: Jared
Subject: Re: nothing is ever true to an expert

I had trouble figuring out what you wanted, but here is my interpretation. I figure you have all the basic crap, so I just picked the first few thoughts that came to my brain and hopefully, well, maybe it'll help you out.

Without getting too gay or fluffy, I could write a thesis on this one: How truly important it means to be a snowboarder. Additionally, how it boils down to our classification in any current year (if it's cool/trendy/or passé) and why we're called snowboarders as opposed to snowboard players. See, we do not play a game, hence, there is no such thing as a basketballer. This is not a team sport. It is an individual thing. And, what makes a snowboarder? Who's to say you're a snowboarder? Just because you visit the hill or take a few trips out west, does not label you a snowboarder. A snowboarder, mind you, is someone that can't live without it. For example, whenever I have the pleasure of "hanging out" with a group of people that "do not snowboard", well, I know it, and sense that something is "different". Not better or worse, just different. Maybe they're the evilest fuck alive, but I inherently realise that they definitely "don't snowboard". I identify with a group, and unfortunately, they do not. Sorry, no big deal. Maybe they think it's a shitbag, hey, that's how it goes. No matter what I do in life, I will most closely identify with being a snowboarder, and fuck, it feels good. No one can take that away. Even when all the snow melts, someone will build indoor resorts. If one becomes a paraplegic, well, that's about as close as someone can come to taking it away. But, I would probably die from the agony of defeat, that I can't snowboard, either than the ultimate pain. That, is some true shit. See, I surf, and, I probably surf more than the "average" surfer. However, I am not a surfer. Nor, do I want to be. I am a snowboarder, and I could write for days and days about this...

The death and naivety of the ski hill as it related to snowboarding's increase. Too many resorts ultimately failed. Too bad. Seemed horrible for such an "up and coming" sport. The resorts were more concerned with real estate deals then accepting and educating themselves with a new, fresh activity. Mountains become as cookie cutter as our society, again, ruling out any form of advancement and individuality. Mooks were at the control. Eventually, the power of snowboarding's influence could not be escaped and reversely effected other mountain sports, making "millions" for undeserving fuckers.

Weed smoking Olympic athletes. How this one factor determined so many things. The effect of the media with a tribute to the "too many" that risk it all for a fucking video part or magazine shot. Kids getting real stoked. Literally. With constant, legitimate advancement things never get old. Snowboarding has proved this better than any other sport. We are blessed with such a variety or conditions, personalities and experiences. We are not limited to a court, field, or alley. And fortunately, just look at some of the photos and videos we take for granted because we have seemingly "seen it all". No we haven't. There's that saying; just when you've seen it all...

E Rose

From: Mark Bock Date: Wed, 25 Apr 2001 14:32:14 -0400
To: jared
Subject: Re: nothing is ever true to an expert

Egads! I take it you're looking for the "alpine perspective"?

Given what little I know about the book (most of which is from this email), if I were one of the authors/editors I'd be interested in taking a look at how some of the more underground subcultures of snowboarding – particularly alpine – have evolved over the years. As you know, ten to fifteen years ago alpine was a bigger thing than it is now, most European snowboarders were hardbooters. Even Damian Sanders rode hardboots – and in the pipe, no less!

Thirteen or so years ago there was a revolution in race board technology – stiff, cambered, asymmetrical boards, that eventually trickled down to freestyle/freeride boards (the early 1990s saw the introduction of the Burton Asym Air; Nitro made an asym freeride board, and I remember that around 1994 or 1995 someone – might have been Nitro – was making a twintip-shaped board that had asymmetrical sidecut, deeper on the heelside edge to account for not being able to get the board as steeply on edge on heelside turns as on toeside. The trickle-down effect of alpine technology influencing freestyle boards continues to this day, but in more subtle ways. The mid-90s saw a move away from asym boards, in part because manufacturers didn't want to be saddled with making regular- and goofy-foot versions of boards and retailers didn't want to sell them, but mainly because North American racers, led by Kildy, Fawcett, etc. (think Cross M), developed a more aggressive technique that called for steeper stance angles, upper body squared with the board and no more "sitting on the toilet". This technique worked best with a symmetrical board with a narrow waist. Burton produced a limited line of symmetrical race boards for the 1994 season (the Stats), then went into it full-bore with the introduction of the Factory Primes in 1995. By 1998, I think, Burton had phased out asyms completely, because even the Euros were by then mostly riding higher stance angles. For a while there was a dichotomy – while the Euros liked symmetrical boards fine, they wanted wider ones, while most North American racers were riding really skinny boards (generally under 180mm waist – Kildy rode a board with a 160mm waist). In the last couple of years, race boards have started to get a little wider again. I haven't quite figured out why; most serious North American racers, such as Mark Fawcett and Jasey Jay Anderson, still ride skinny boards, but of course they're customs. But many racers have moved to waist widths between 180mm and 200mm for added stability in softer/variable snow, and the few producers of race equipment (Burton, Prior, assorted Euro manufacturers and Sims to a lesser extent) have widened their production boards, presumably to put more versatile boards under the feet of non-pro racers who can't afford customs. (Personally, I find the wider boards very sluggish edge-to-edge on East Coast hardpack.)

At any rate, the advances in race board construction over the past decade (dampening, different glass patterns for torsional stiffness, etc.), have trickled down to the freestyle world as well. You can see it in the significantly stiffer freestyle designs – Customs, Balances, etc., are examples. Also that one line that came out a few years back, a specialised stiff pipe board, had the cool pencil drawing graphics, I don't remember the name...By the same token, a lot of freeride boards have gotten considerably stabler at speed (although I still say my 1994 Kelly Slopestyle is the best freeride board ever made).

Another trend that's cropped up recently; for several years now major manufacturers of alpine equipment (i.e., Burton) have seen their alpine sales slack off, not due to a decreasing alpine market but because alpine riders as a whole have gotten increasingly picky about their gear and have been turning to companies like Prior and Coiler. Prior makes excellent production boards, but what they're really known for is their custom boards. Chris Prior will build a board to the exact specs of anyone that can pay for it (custom boards go for around $800). Coiler offers a number of different board designs, all of which are

individually customised to the rider's weight and aggressiveness – for the price of a Factory Prime, you can get a typical line of production freestyle boards. At any rate, the point of all this is that Prior and Donek recently entered the custom board market too, after years of making a typical line of production freestyle boards. At any rate, the point of all this is that Prior and Donek have seen a large increase in orders for custom freestyle/freeride boards as well. (Coiler remains, as far as I know, an alpine-only company, and yes, they are making money.) And the buzz in the alpine community is that Burton might possibly be considering opening a custom shop of their own, especially now that Fawcett is riding for Burton. But you would know better than I whether this is true.

Also consider the influence that carving has had on snowboarding as a whole. Ten or fifteen years ago, most pro snowboarders competed in both freestyle and race events. If you watch videos of the pros of that period freeriding, you'll notice that they tend to have fluid, carvey riding styles (examples – Craig Kelly, Keith Wallace, Mike Jacoby – who later specialised in racing). This carried over into the 90s thanks to Terje and many others. And that new-school thing died a well-deserved death when people realised that low-back bindings aren't very functional and you look like an idiot if you sideslip down to the snowboard park. And look what's become popular the last few years; boardercross. While personally I think slopestyle is cooler, in either case you're looking for speed in addition to flexibility, which is breeding a new type of board combining the best of both worlds. A number of manufacturers now are making boards that combine the stiffness and sidecut of an alpine board with the shape of a freestyle board (more or less), for example, the Burton Fusion.

Finally, another thing you might want to touch on is this: in the 80s, snowboarding was an underground sport. If you saw another snowboarder on the mountain, you were pretty much instant friends and at any rate you nearly always said hi and felt a certain kinship. Nowadays it's still like that in the world of alpine snowboarding. There's a strong underground of alpine snowboarders who pretty much just ignore the freestyle snowboarding behemoth and just do their own thing, communicate with each other via internet newsgroups and bulletin boards, plan their own events (Pure Carve Expression Session, for example, held every year at the various Aspen resorts, and this year, for the first time, there was an East Coast Expression Session), etc.

Anyway, I hope you find this useful. Let me know if you need any future encyclopedias. :)

mark bock
Jager Di Paola Kemp Design

From: Robert Paglia
Date: Wed, 25 Apr 2001 14:25:27 -0400
To: Jared
Subject: RE: nothing is ever true to an expert

Hey there,

If it were my book i'd start the intro at the very basic beginnings and roots because nobody can bitch about that.

1) Got to incorporate the "wicklund" story and some footage on your disc; that shit is soooo old that it just puts the whole Jake vs. Sims etc. at rest and starts where snowboarding really originated. Those guys just refined it a bunch.

2) Should definitely be some sort of Jake-esque copy referring to the days of the backhill and even before. How everyone was just making from scrap and finding hills around the house to "ride" on. all about the fun...prior to tricks and style etc...

3) That would blend nicely into the start of the tech revolution and the birth of the binding etc. (throughout all of it should be an exitement value, how everyone was sooo amped about the sport but boards etc. couldn't keep up.) From here you would have set up a sort of respect for snowboarding tone and could start to get into the names and places of it all. The Tony Hawk book did a good job of this type of thing.

4) Would be cool to incorporate how skateboarding has influenced every aspect of snowboarding, (forgive the skater for stating as such)

5) Could start getting into some of the bigger names who really influenced the sport...Like Heingartner and Bauer(sp?) etc. How people started pushing tougher terrain.

6) Get into the battle of getting resorts to allow all of us in on our new kook machine.

7) Start bringing in Old heroes and first contests and such inklings of where we are today with it all.

8) Bring us on up to the Opens and popularity expansion of the sport over the years and the Olympics etc.

9) Early to mid-nineties biggies. Focusing on

variations of the sport being born. (BX etc...)

10) Modern day stuff, newest tech, names, maybe some world records. Where ya feel it will go in the future...a little snowdeck plug?

There's ten .Some good, some bad. And I wasn't involved in snowboarding for most of these and my sequence might reflect that, but hey I'm catching up to everyone.

I could be way off and the BOOK could be more of a style/art book in which these ideas would be pretty stale.

Always an expert and everything's false.

Look forward to checking this out as well. Glad to help if I did.

later
Rob

From: Kevin Wilkins
Date: Wed, 25 Apr 2001 13:09:12 -0500
To: Jared
Subject: Re: nothing is ever true to an expert

10. Friends
9. Companions
8. Pals
7. Chums
6. Buddies
5. Amigos
4. Comrades
3. Colleagues
2. Partners
1. Snow

From: Dean Blotto Gray
Date: Wed, 25 Apr 2001 13:32:00 -0400
To: Jared
Subject: RE: nothing is ever true to an expert

riding through the trees/forest/back country with your bros

witnessing ground breaking snowboarding

youth

foreign lands

From: Herb George
Date: Wed, 25 Apr 2001 09:08:40 -0800
To: Jared
Subject: RE: nothing is ever true to an expert

most important shit for the book...keeping Burton in mind...

Jeff Brushie

tweaked stalefish on the frontside wall and his video footage from ? sliding that rail coming off the lift (i think one of the first rails slid on film)...truly inspirational for me being from the east coast and learning to snowboard in VT. oh yeah...add to that the flourescent orange fish base graphic.

my first board.. the burton air 6...a lovely teal with black clouds (or at least that's what i thought they were supposed to be) and i even think my air bindings had pink on them... imagine?

a shot of jake smokin' a fat ass joint at the top of stowe (the chin) after hiking up for fresh pow on a crystal clear cold ass sunny VT morning.

as a grom Brushies graphics were the best.

that's it from me.
i hope it helps.

word.
finish that shit already.
hg

From: Nick LaVecchia
Date: Wed, 25 Apr 2001 12:20:42 -0400
To: jared
Subject: Re: nothing is ever true to an expert

1. Creating "One Track's Mine"
2. When I started skiing because Stratton required metal edges on boards.
No more Backhill.
3. Getting certified for the Upper Mountain at Magic Mtn.
4. Riding/filming the Stratton Pipe in May with Jason Ford and his brother.
5. Bouncing on the trampoline outside Burton in Manchester with Craig Kelly
6. Glebelands ruling the scene at Magic Mtn.
7. Putting "rip grip" on my Air 6 for better Tia Pan's.
8. Realising after 2 years of riding the Backhill that I was goofy foot.
9. Riding Hardboots on an Asym Air for a year because they were the shit. Koflach's cause Damian Sander's wore them.
10. Seeing how many people modelled their riding styles after Peter Bauer and Jean Nerva. Alpiners!

Hope this works for you.

From: Jib Hunt

started thinking of the ten things about the sport that were important to me, and realised it would not be universal enough. With a book like this everyone will complain, that should have not been in there, or I can't believe you left that shot out. At the end of the day I was a naive kid who lived in a trailer park at North Narrabeen beach in Australia, I wanted to learn to snowboard and ended up in Breckenridge at the amazing time of 1989. Living in a house with five guys from Michigan who snowboarded, smoked drugs, ate mushies, did acid and nitrous hits. I was so far from home and my comfort zone. I along with the world watched in amazement as some Euro kid called Haakon blew up in the pipe along with some Swiss chick on a wild duck called Nicollette. I saw Palmer in an Uncle Sam suit, Kelly doing the snowboard bumps comp. I worked 70 hours a week in a rental shop fitting ski boots to bus loads of fat smelly Texans, without a green card, earning $2.40 an hour. Spent the first half of the season kidding myself that I had to learn to ski well before snowboarding. When I skied out of control and broke the collarbone of an elderly lady, I realised that I would be better on a board. SO then it started riding Six Chair with my mates at lunch and A-Basin on the weekends in spring with BBQ's and beers. Getting busted for cutting a line at Loveland Pass the week after an avalanche. In the years since then I have come to know as friends so many in snowboarding, and inevitably find out that they too were at Breck in 1989.

It seems such a corny thing to say but back then it was NEW, and that was what made it all the more exciting to me. For others the same things happened but at different times, so what is universal, what is timeless?

Sorry they are not your classic points but hey, those, I am sure, are already in the book.

Here are a few of the moments of the sport that are at the core of my attraction to snowboarding.

The excitement and anticipation I feel riding up a chair-lift, due to the un-touched snow that lies below. It rests upon a three dimensional surface that I am free to traverse and explore. Gravity's pull decides the ultimate limitations of where I can go, but still anything below that line is there for me.

My senses heighten as I roll off the chair and begin to buckle my back foot in. At this point the board becomes an actual part of my body, there is no sensation of separation. Like a shoe for a runner I guess.

At this very moment when you stand upright, and steady yourself, the sounds of the snow compressing under your board are in sync with the sensations of movement you are feeling through your feet, this is a great chance to take a relaxed deep breath, look at the world around you, and as the crisp clean air goes down your throat, your whole being becomes totally immersed in the here and now, whilst humming in the background is the excitement of what lies just ahead.

Protective clothing snug and warm around my body, highlighting the stark contrast of the cold environment that I feel on my face and in my lungs. This uniform of sorts, makes me feel somehow safe.

I clap my hands to clear the snow from my gloves and as some sort of acknowledgement of being totally ready for the task ahead. I don't know if it is purely a guy thing, but the preparation, the equipment, and the fact that you are at the top of a mountain feels akin to what I imagine of a soldier or an explorer.

Gradually I begin to trade position on the mountain for speed; gathering up the exact amount of speed necessary. Moving across this pristine meadow of snow, I am free to at any moment, trade my stockpile of speed, in part or in whole, for any creative purpose I desire, a slight turn, a huge turn, to traverse up-hill, or to launch off a part of the surface and into the air, for a time, until landing back onto the snow. This freedom and exploration continues until gliding to a stop at the bottom of the slope. Laying on your stomach still buckled in looking up at your line and laughing, much else of life is forgotten.

When you consider all this can be done alone, or alongside close friends experiencing the same, it is possible to understand in part what the attraction is to those who snowboard.

A classic shot that captured the anticipation, was used in an ad a few years ago where they were buckling in, early morning at the top of a hill.

From: Will
Sent: Wednesday, May 02, 2001 9:14 PM
To: ekotch
Subject: RE: nothing is ever true to an expert

Here ya go, hope it helps.

Poaching closed runs for 6" of east coast powder.

Endless skier education (is that hard?)

Getting certified to ride

Getting harassed by ski patrol (the man)

Constantly evolving

Stoked on the new trick learned or the feeling from a new move

This is big for me – dreaming about pulling a trick before I actually did it

Getting chicks

Riding with friends and getting stoked watching them

Tune out and drop in

Freedom

Being on the cutting edge of something big

Hope this helps. What's up? Give a call.

Willie

From: DJ
Sent: Thursday, May 03, 2001 6:51 AM
To: Eric Kotch
Subject: RE: nothing is ever true to an expert

computers, and technology overload
gearing up in the morning
talking shit with friends
the stupidity of the whole industry "scene"
the rise of "rock-star" mentalities
waiting...waiting...and waiting
bad weather...really fucking bad weather
watching the Weather Channel
NOAA weather radios
getting yelled at in foreign languages
swamp-ass on Japanese trains
eating curry until your ass burns
trade-show stupidity
deep, cold, clean snow
one turn...only one turn
crowd avoidance
the hike vs. the lift (fuck, I'm lazy)
Olympic lawsuits and the Nazis in Park City
evolution of gear and technology
mass individualism – the building of trends and sports
youth
why do we ride?
what does it mean?
it's all about the turn.......
ride everything, ride anything
too much gear can ruin your day...minimalism
people are weird, snowboarders are weird
too much coffee
too much alcohol
too much sex
too much of everything
people all want to be rich and famous
lifestyle...this sport has created one
from grunge to wealth-aspiration (the evolution of rider style)

Just random babbling....

DJ

From: David Sypniewski
Sent: Thursday, May 03, 2001 8:10 AM
To: Eric Kotch
Subject: RE: nothing is ever true to an expert

1. Farmer
2. Todd Van Belcome (sp?)
3. The music. From Pennywise to Joe Satriani.
4. Regis Roland
5. Roan Rogers
6. John Cardiel
7. Cross-over races with motocross, skate, surf, etc.
8. Jerry Lopez
9. Carter Turk
10. Summer camp at Hood.

From: Jeff Galbraith
Sent: Thursday, May 03, 2001 8:34 AM
To: ekotch
Subject: RE: nothing is ever true to an expert

I don't know if it's too late, but here's a few chaters for my second book...

Police State: Behind The IOC

China: Charlie Don't Shred

Media: AOL, Motor Trend, TB27: Dudes Riding AK, McDWG31: Mad Heads Sliding Wutah, and The Gravity Games: Proud as a Peacock!

Russell Winfield: The Best, Ever?

Hope this helps...

Regards, jg

From: Kevin Zacher
Sent: Thursday, May 03, 2001 9:37 AM
To: ekotch
Subject: RE: nothing is ever true to an expert

I don't take snowboarding that seriously and I wouldn't want to pass any judgement or make

any claims. I have a passion for photography and I enjoy shooting snowboarding pictures. That's it. That's all.
From: Joe D'Orazio
Sent: Wednesday, May 02, 2001 7:57 AM
To: Gus Buckner
Subject: RE: nothing is ever true to an expert

Mountains
Powder
Friends
Explore
Heli
Trees
Cats
Hiking
Bluebird
Elements
Boarding

From: Greg Dacyshyn
Date: Mon, 30 Apr 2001 09:25:33 -0400
To: Jared
Subject: RE: nothing is ever true to an expert

Yo Jared,

I will do it tonight. Promise. Just want to be in the correct frame o'mind, and not in cube land.

Hope that works for ya.

GD

From: Chris Copley
Sent: Wednesday, May 02, 2001 9:27 AM
To: Eric Kotch
Subject: RE: nothing is ever true to an expert

Euro trash alpine PJ Oxbow – Chimsee style – just for the historical perspective. Island Lake Lodge – pimp style experience. Hunter Mountain boiler plate ice moguls – that is most kids' reality. Instructors at any mountain teaching 30 kids per class – this is how the sport grew. Smoking weed on the chair lift ride up. Crashing your car on the way to the hill. Surf-style powder slashes, what we all wish we could do in water. Michael Chuck double back flip – the sickest power aggro attitude. Punk groms that rule. Watching snow vids until all hours of the evening.

Cope.

From: Albert J Massenberg
Date: Wed, 25 Apr 2001 18:02:58 +0200
To: Jared
Subject: AW: nothing is ever true to an expert

okidokey matey,

how the hell are you doin' by the way?

– the smell of still wet stinky socks and stale beer in the morning.
– the drive to the mountain, with your favourite music on.
– the total disorientation after an early morning crash.
– beating German skiers up in the row for the chairlift. But I would also do that when I was skiing too.
– warm spring winds rushing through green trees, while you are riding the slushy season.
– building a kicker for hours and finding out that it won't work after all.
– when you did build a good kicker, never ever return there the next day!!!!
– looking sideways through the trees, while riding powder, and seeing your friends charging.
– shouting Yes! to your friend, when you know it's a definite NO!
– piss your pants laughing when he is getting the snow out of his crack.
– basically making sure that your friends are in pain most of the day, without getting any yourself.
– rolling a joint in the chairlift with heavy winds.
– smoking weed.
– the rush before you go off a cliff.
– doing your best not to claim that you sticked it, (never hands in the air).
– thinking about your other friends who are in school.
– walking to the hotel, totally beat, wet and aching. stopping for just one teeny weeny drinky on the way home and then finding yourself in a bar fight at 5am; glad to still have your softboots on, or with a girl at 3am, sorry that you still have your softboots on.

this sort of wraps up what snowboarding meant to me; damn, I am a sad fuck.

Cheers, Jared,
looking forward to seeing the book.
say hi to sue
Albert

From: Sherryllynn
Sent: Tuesday, May 01, 2001 5:44 PM
To: ekotch
Subject: RE: nothing is ever true to an expert

ok, off the top of my head.
– the fact that now that i live at the beach, i have amazing recurring dreams of riding powder. significant to the book in that once

snowboarding is a part of you it will always be with you, plus the dreams are incredible.
– the torture and abuse of the first day of snowboarding
– the motivating factor for trying snowboarding
– the beauty of watching someone ride really well from the chairlift
– the intense camaraderie of the sport
– a great day of riding with your favourite people to ride with
– riding long lovely groomers with you
– riding with absolutely nothing to prove, and no-one to impress

is that what you want? call or e-mail if you want more, i am off tomorrow, and could think about snowboarding all day. where are you?
love, sher

From: randy gaetano
Sent: Wednesday, May 02, 2001 6:46 AM
To: Eric Kotch
Subject: RE: nothing is ever true to an expert

hey eric

i've been feeling kind of nostalgic these days about riding so these might be sentimental but i'll just go off the top of my head and see what happens...
– a small container of mountain fresh air (almost any mountain)
– the sunny side and the shadowy side of a mountain at the end of a long day of riding
– the moment just before you drop into the pipe at the US Open when you can't hear or feel anything
– one full speed pow turn
– one perfect cliff
– glebelands (all of your friends)
– a latte from the daily grind with jamil before a powder day at vail
– travelling so much that you wake up not knowing where you are for a second
– the feeling of full speed sideways motion
– all the people and support along the way

peace, randy

From: Dave Schmidt
Sent: Wednesday, May 02, 2001 5:38 AM
To: Eric Kotch
Subject: RE: nothing is ever true to an expert

Craig Kelly
the early world champs – dog, MC, etc.
Terje
Palmer
Jake – Demetri – Tom – Chuck
Stratton
the Switchblade
the Videos
Shaun White
a backyard and a Winterstick
007 on a board

From: Emmet Manning
Sent: Wednesday, May 02, 2001 5:13 AM
To: Eric Kotch
Subject: RE: nothing is ever true to an expert

Random thoughts

1st US Open attended. Stratton, hiking Underhill Snowbowl and riding UVM Hospital hill (before parking garage). Getting a job in the industry. Watching the development of two geographic snowboarding scenes; Stratton/Zippy Stowe/Burly. Realisation that snowboarding is mainstream. My first board and first Burton t-shirt. Soul. Why? What? Still? How? Personalities that have come and gone.

EM

From: Steve Francisco
Sent: Wednesday, May 02, 2001 4:35 AM
To: ekotch
Subject: RE: nothing is ever true to an expert

– The first Fruitpunch Ride Day at Stowe.
– Abe with a tarp tied to his ankles and wrists, trying to fly like a squirrel. Mt. Hood, Fall 1999.
– Franny printing the Burton Newsletter on a 'ditto' machine.
– Hands turning black at the US Open from those spring gloves.

that's all I can think of this morning. I'll send more later if I think of any.

thanks, franny

From: Hansi
Sent: Wednesday, May 02, 2001 12:51 AM
To: ekotch
Subject: RE: nothing is ever true to an expert

cold
snow in your face
decadence
happiness
terje
hurting knees
earlybird
way too heavy photobag
nothing like a bluebird pow day

sorry, all i could think of so early in the morning...
how are you doing? living in ibk already?
if so you can come over and we can have

beers.....
cheers
hansi

From: Noah Brandon
Sent: Tuesday, May 01, 2001 10:47 PM
To: ekotch
Subject: RE: nothing is ever true to an expert

snowboarding was racing on the nastar course at the end of the day to see who could beat mark (heingartner) or chris's best time that day. riding until the lift closed with you still on it. getting product from burton for 30% off. getting a skidometer from jake (burton carpenter) as a christmas gift and breaking it going off a jump the first time i used it but not before it showed i had gone 40mph. it was going 60+ mph through the speed trap at the u.s. open before it was the u.s. open (it was simply called the nationals i think?). wanting to ride every minute of every day. learning a method air. seeing terry kidwell spin a 360 off a knoll with an armful of jackets at the nationals in 87-88 before i could even do a 360. seeing damion ride. seeing palmer ride. watching rob morrow in the pipe at the 88 u.s. open only take 4 hits in the pipe where everyone else was getting 8 and he was wearing a wetsuit, the same one he wore as a speed suit in the downhill the day before. knowing every snowboarder in the united states. being able to name a rider as he came down the hill by his style alone.

thanks for making me think about this stuff, i miss it.

noah

From: jon foster
Sent: Tuesday, May 01, 2001 5:59 PM
To: ekotch
Subject: RE: nothing is ever true to an expert

learning to turn
board, boot, binding evolution
first (and every powder turn)
speed
the first snowboarders that pushed forward
the feeling of finding something "new" in the 80s
the feeling of a small world...knowing everyone...close group adventure

pretty much the same list for what I miss

see you, Jon

From: Rene Hansen
Sent: Tuesday, May 01, 2001 5:33 PM
To: Eric Kotch
Subject: RE: nothing is ever true to an expert

Hey Eric,

Greetings from Hemsedal from Rene, Drew and Espen on night shift. We've seen the mail and give you this reply.

Travel, friends, the life experiences that you get from them and how those things have influence on all other parts of your life.

Respect. For the power and beauty of nature. For ability, yours, your friends, from the professional to the weekend warrior.

Passion, as in the hug Roger gave me at the Air and Style.

Progression, style and aggressiveness, as in Romains, Trevor and Gigis riding.

Travel – the good and the bad.

Frustrations?

True love and passion for what we are doing, regardless of the circumstances and time (as we are doing now).

Passion, style, progression, enjoyment of the moment and love for snow.

The sharing aspect of watching somebody or each other's success and progression in a session. You are as stoked watching a friend throw down something gnarly or something they haven't done before, as they are for you. The brotherhood.

No condition of snow, no state of a kicker, no weather, no trick, turn, line or attempt will ever be the same. It is not a spectator sport, you have to be there.
It takes you out of your lounge room seat, away from your telephone to another place. It is an instant in time, never to be repeated and ultimately missed unless you are there.

The feeling of being as family is the shit.

How many times have you been travelling and wanted to go home more than anything in the world, but only two days later, you are dying to get fucking out there again, to the same crew you wanted to kill only a couple of days ago. It is like a drug, hard to get yourself off.

The pictures in this book are highly inadequate for the actual feeling the person is feeling. If

the photo itself doesn't do justice, then words are pathetic. It is impossible to describe how the snow felt, the nuances of gravity, speed and motion. Although these images may give some reflection as to what it is we are trying to describe, these feelings are as easy to define as explaining yellow to a blind man.

Take care Eric. Fuck off and send us the book.

Rene
Burton

From: FSDWOODY
Sent: Tuesday, May 01, 2001 5:33 PM
To: ekotch
Subject: RE: nothing is ever true to an expert

1. Snowboarding is all about the riders.
2. Snowboarding as a business makes no sense.
3. Snow does hurt when you fall in it.

Travis Wood
Sims Snowboards

From: Scott Whimpey
Date: Sat, 05 May 2001 00:01:00 -0600
To: Jared
Subject: RE: nothing is ever true to an expert

OK, here it goes. Sorry about the slow response. I am a little sleepy, so, I might sound gay.

– The feeling of riding/floating on 3 feet of powder.

– Putting my first snowboard on lay-a-way. The excitement of making weekly payments. Knowing, once my board was paid for, that I would be able to hike all day, up Flagstaff, and only have time for 1 run. Being so stoked (is stoked still good to use?) on that 1 run, that I couldn't wait to do it over the next Saturday.

– Having fun attempting to incorporate skateboarding with snowboarding, and looking stupid doing so

– The appreciation of summer when an unseasonable Arctic cold front would come down to Salt Lake, making it too cold to want anything to do with snowboarding

– Nothing tastes better, after snowboarding, than a burrito from Taco Bell

– Night snowboarding is better with a belly full of Jagermeister

– Catching an edge on hard pack, will put hair on your chest. I'm a man!

Let me know if you had something else in mind.

scott

From: Susan Lee
Date: Wed, 02 May 2001 13:50:05 -0400
To: Jared
Subject: Re: nothing is ever true to an expert

snowboarding has been more than just a sport in my life. it has defined who i know, who i trust, all the bad elements that have come into my life, all the great elements that have come into my life. simply, I would not be who I am if it wasn't for snowboarding.

i thought i'd never sound like my parents, but lately i have been saying things like, i miss the good old days. i miss what snowboarding was. i'm scared of where snowboarding is going. i'm scared because what was, was so good – too good. i remember the tight community that snowboarding created, how we all set our school schedules so we could go riding four days a week, and once we did get up on the hill, anyone and everyone on a snowboard was your friend or a friend of a friend. given, that was about 35 people, max, but a nice community none the less. this small group of people made mountains into a social pool. want to know what your friends are up to, what new bands are surfacing, all the idle gossip about any pros you ran into?

so, if i had to write a book, what would be in it? the following:
– snowboard rock. how many sports have their own category of music.
– historical hubs of snowboarding: VT, Summit County, So Cal, SLC.
– age of light to darkness, fashion in snowboarding; fluorescents to black death.
– shape of things to come; twin to shaved down boards to longer boards to directional, and back.

that's it for now. i'll try to write more later, but i have to run to the schriber mtg.

From: Bruce Beach
Sent: Tuesday, May 01, 2001 5:47 PM
To: ekotch
Subject: RE: nothing is ever true to an expert

What the ?&*#$

"Vision is key"

1) Make sure you purchase or acquire at least two pairs of sweet-ass snow goggles. Preferably a pair of Electrics. Don't forget extra lenses (yellow, rose, amber chrome) for the ever changing light conditions. Always have one pair in your bag that you keep your gear in (boards, boots, outerwear, etc.). Always keep another pair stashed in your favourite all-purpose riding jacket. Nothing sucks more than having a shitty pair of goggles fog when you are trying to pick your line down the mountain. If you forget your goggles drop straight into the mountain pro shop and kick down retail for a reputable brand with a dual lens. You will be pissed at yourself if you have to bail after one run and you spend the rest of the day looking for your bros.

2) Get yourself a pair of sunglasses that fit your face structure and don't give you a migraine because the temples are digging into the side of your skull. Preferably a pair of Electrics. This is important for after your long morning of bombing runs from top to bottom and the snow goggles that have been your lifeblood now have smelly sweat dripping from the face foam. It is now time to slip on some guch shades that the chicks or dudes, depending on gender or sexual preference, will dig while you're hanging out at the base lodge drinking your favourite alcohol and bullshitting to your friends or anyone who will listen what an epic day you just had.

Bird

From: Jay Twitty
Sent: Tuesday, May 01, 2001 5:14 PM
To: ekotch
Subject: RE: nothing is ever true to an expert

1. a written description of the first time that i rode. how bad i was but how funny it was.
2. my drawings of burton logos in my notebooks at school during class. drawing guys doing airs.
3. the excitement i felt when i moved to vail. got there the first day and the mountain was open. didn't have any snow pants so i rode in khakis for a week until i could buy some pants.
4. learning how to ollie for the first time.
5. the excitement that i felt when i'd look through new mags in the check out line at safeway to see what new trick i wanted to learn the next day. trying to do tricks with style (no ones in particular, tried to take stuff from jamie, brush, haakon and j brown at the time).
6. riding pow for the first time and tumbling because i hadn't done it before. that should probably be higher on the list. some of this is out of order.
7. getting hired at the shop so i could buy stuff cheaper than retail.
8. getting free boards from burton. so stoked when i was handed the catalogue and could pick anything in there.
9. meeting bob mcknight and signing with quiksilver.
10. going on my first photo shoot.
11. going on my first heli trip.
12. learning anything for the first time.

ek. i'm still so hyped on progression. i've learned so much this year riding-wise. not so many airs, lots of rails. it's all still so fun.

twitty.

From: Eric Blehm
Sent: Tuesday, May 01, 2001 4:57 PM
To: ekotch
Subject: RE: nothing is ever true to an expert

My first chairlift ride (after hiking for my turns before that cause resorts didn't allow it). My first linked turns. The zone snowboarding takes me to...My yoga...My ticket to the world. The catalyst for so many friends. My career writing as a snowboarding journalist. First heli trip. Powder. First trick (Burton Curl, backscratcher air, suitcase air, method – whatever, it put me on top of the world). Seeing Craig Kelly ride in person in powder.

From: Tim Swart
Sent: Tuesday, May 01, 2001 5:00 PM
To: ekotch
Subject: RE: nothing is ever true to an expert

EK,
Here you go:
I love being in the out-of-doors
dancing on the snow
a good total body workout
getting radical
jumping
the need for speed
because all the cool kids are doing it
Coolio does it ("dang! what it look like")
my skis don't work so good
Generation X, Y and Jed
turtlenecks
spring break
camel toes
injuries

I hope that's okay. I can explain if you want.

TS

From: J Curtes
Date: Wed, 2 May 2001 09:30:52 EDT
To: Jared
Subject: Re: nothing is ever true to an expert

Jared – here is what i came up with. It's kinda weird though, because if i think something should be in there, there is usually a picture of it and it IS in there! You know what i mean? Maybe i'm not a good one to ask since i've kinda showed what i think is cool by making this damn book...jc

Curtes list of things that need to be in BLOWER:

– original Wisconsin transplanted to Breck crew of jibbers, Jake Blattner, Nate Cole, Dale Rehberg Roan Rodgers
– Joe
– Victoria Jealouse in Alaska
– a phone transcription of a conversation between Mike and Dave Hatchett
– Leleau (sp?) Angelrath
– "SICKEST SEQUENCE EVER!"
– Anfuso and Seaone teaching three Japanese beach girls how to snowboard at Oze Tokura
– S.A.W.S.S.
– Tyrol Basin, WI
– 2 tongue boots

From: Froeydis
Date: Thu, 27 Apr 2017 10:17:44 -0700
To: Jared
Subject: Re: nothing is ever true to an expert.

team managers designers photographers

From: Trevor Andrew
Date: Tue, 01 May 2001 03:18:07 -0400
To: Jared
Subject: Re: nothing is ever true to an expert

Yo J-dogg what's up kid? To answer your question. I think the first thing in the book should be a dedication to all the great snowboarders and good friends we've lost. Jamil, John Michalack, Vince Georgancin, Neil Edgeworth, Jimmy Corvies, just to name a few. I think that would be cool.

peace, trev

From: shannon dunn-downing
Date: Thu, 26 Apr 2001 11:47:22 -0700
To: Jared
Subject: Re: nothing is ever true to an expert.

1) history.

2) evolution of product; tricks, the inventors of tricks, how they evolved from skateboarding; style, like the big pants movement, girls in pink in 1994, no highbacks, huge stances.

3) the non-competitive vibe. how the olympics has/hasn't changed this. use quotes from back in the day about, do you think snowboarding will be in the olympics. i think tws asked that in an issue years ago.

4) getting personal...heroes, who are the heroes in the sport and why?

5) why is racing dumb – ha!

6) women in snowboarding; pro models, women's specific apparel/snowboard companies; why women made a conscious movement to be a bigger part of the industry.

7) how cool it is that you don't have to compete to be a pro rider. you can do anything you want as long as you make snowboarding look good.

8) ski areas that don't allow it!

9) snowboarding as a job, behind the scenes.

10) snowboarding as fun.

shan

From: Vince LaVecchia
Date: Wed, 25 Apr 2001 11:48:55 -0400
To: Jared
Subject: RE: nothing is ever true to an expert

– Early snowboard videos and magazines; classics of our culture, this shaped much of who we are.
– Pioneers; Kidwell, Burt, Jake, Coghlan, Brush, Kelly, Joe Bogdanski, Sanders.
– Progression; product and riding; how we got here.
– East vs West vs Europe riding styles; how we got here.
– Dumb things in snowboarding; baseless, neon, two tongue boots, bonking, gigantic pants (I know you ran them too).
– The unsung heroes of snowboarding; you, mikey, chris mask, john gerndt, steve matthews etc...
– Worthless road trips; the long ones we all took to get to the ski area that allowed riding, only to be shut down by weather, the mountain, etc...
– Certification stories; when we had to get a license to snowboard.

– Snowboard art. I am sure this is in there.
– Where this sport COULD be headed; the nightmares we all have about Burton and corporate activity killing the sport; futuristic nightmares.
– Women; we love them. Kids; youth continues to fuel this sport, the younger the better.
– Japan; needs to be covered and given credit for keeping snowboarding super cool!

Thanks J, good luck.
VL

From: Chuck White
Date: Tue, 1 May 2001 23:10:41 -0400
To: Jared
Subject: RE: nothing is ever true to an expert

Hey
Sorry about the wait on this, things are nuts right now...

If I wrote about the first thing that came to my mind, it would be to somehow define the feeling of:

Dragging yourself out of bed before it's light out because you know it's dumping. Spending the entire day in the trees with snow past your knees, riding with your friends all day before you realise you never ate lunch.

The second thing I thought of was one day I was at Perg's house. He mentioned some obscure reference to some video and one single turn shown in it, and how it effected him and he used to watch it over and over. Without much more description and before he told me what it was, I mentioned that it must be Craig Kelly's almost last pow turn in "Scream of Consciousness" when the Soup Dragons are playing and the credits were rolling. This probably has nothing to do with the book, but we were both freaked out pretty huge when we realised we were both thinking of the same 1.5-second video clip from about eight years ago, and how it effected both of us.

Otherwise, here's some stuff off the top of my head, but I'm pretty tired right now. Most of these are thinking way back, I guess the last few years are a blur because I work too much:

1. Brushie trout board.
2. The old jib ad with the cigarette.
3. Jamil's funeral and the people there.
4. Cutting people's tips off when I worked at a shop and adding t-nuts for stupidly wide stances.
5. The first time I saw Haakon ride in person at the Open.
6. The not quite right feeling of watching snowboarding in the Olympics the first time and feeling that (for lack of a better term) snowboarding as I knew it was over.
7. The frequent questions on the chairlift; do those things release? is that hard to learn? did you make that thing? etc.
8. Checking the list of mountains that allow before choosing one to go ride.
9. Saying hi to every rider on the hill because you could count them on one hand.
10. I'm tapped. If I think of anything else worthwhile, I'll send it. If I had the Burton 20th anniversary ad in front of me, I'd probably have a lot more ideas...

Chuck

From: trevor
Date: Tue, 1 May 2001 09:12:48 -0700
To: Jared
Subject: Re: nothing is ever true to an expert

10 or so important moments in snowboarding. As I free think here I would imagine that the following hit the top 10 list.

1. The 2nd Nationals where Andy Couglan made the blue high back binding after seeing the carving ability of the west coast Sims team. The overall inception of the high back binding. Period.

2. Jeff Brushie and the freestyle movement. Burton switch from traditional racing roots to freestyle with Jeff and Craig.

3. St. Moritz, 1990ish. Terje copies Craig Kelly's winning run at the Worlds to place 4th at the ripe ole age of 15.

4. Tom Hseih and International Snowboard magazine. Let the hype begin.

5. Terry Kidwell and the introduction of skate style to snowboarding. It would really have to be Alan Armbruster as the style master, as he ended up in jail before the whole heyday of the sport.

6. Breck. 1988 Worlds. The community as we know it begins to blossom.

7. Mystery Air. Not only did it bring the ideals of the modern "pro snowboarder", but it also led the way to modern board construction, i.e. camber, sidewalls, steel edges, twin tips, etc.

8. The JIB. Perata and Farmer named the action and the mid-west jibbers of Dale Rehberg, Roan Roger and Jake Blattner made it famous. Snowboarding needs something to

break boards and keep the consumer buying.

9. Ingamar's air. The timing was everything. Just when you thought a 10-feet air was all there was...guess again. The one-up syndrome hasn't stopped.

10. "Chill" or "Riders on the Storm" as the documentary style of the modern snowboard films that drive our industry to progress.

tg

From: Matt Richardson
Date: Mon, 30 Apr 2001 15:24:46 -0400
To: Jared
Subject: RE: nothing is ever true to an expert

Here's some shit from a guy in the IS dept.

old picture of terje doing a one footed method all tweaked out, you know the one I'm talking about

pics of the crowd at the open halfpipe, specifically during the snowball throwing session

the whiskey series of videos, steak and lobster, milk, faktor

sunset rooster tails, doesn't matter who did em quite possibly my fav snowboard pic of all time

gotta have some neon dayglow represent

jussi doing a 7 over the gap at the x-games

450 to boardslide to 270 out sequence

johan or j. jones straightlining a 50 deg slope

a whole section on the method, make sure to throw in my man jamie lynn, and the terje one on the red poster

rodeo, mid-invert

adam petraska throwing a huge japan up at hood (the pic from the red ad)

the next generation: paglia boardsliding over steps on da junkyard

From: JAC864
Date: Mon, 30 Apr 2001 11:24:19 EDT
To: Jared
Subject: Re: nothing is ever true to an expert

jared...what up?
hope things are good.
you still motoin? i haven't ridden yet too much.
anyway...here are some thoughts...

1. Terry Kidwell

2. Craig Kelly

3. Burton videos back in the day...those were the shit when I started riding.

4. The time when Craig Kelly left Sims to ride for Burton...WOW...

5. The days when jibbing became of age. Jake Blattner, Nate Cole, Dale Rayberg, Tarquin Robins.

6. Tarquin...the leader of the no highbacks revolution.

hope all is great

joe

From: David Downing
Date: Fri, 27 Apr 2001 14:54:56 -0700
To: Jared
Subject: Re: nothing is ever true to an expert

Hey Jared,

good to hear from you.
I actually just got back from my best experience. Alaska with Hatchet. Pretty stoked right now on snowboarding.

The snowboarding experience to me is mainly the lifestyle that comes with it. Being in the mountains riding my magic carpet around with friends is very special. The industry tries to see who the coolest person is and what the sickest trick is, but to me snowboarding is more of the whole experience.
Watching the Weather Channel; cold air on your face; waxing a new board; hiking in the mountains; watching your bros while jibbing some ski resort; and of course, flying through the air and landing in powdery snow.

From: 7MiNUSone
Date: Thu, 26 Apr 2001 22:54:09 -0700
To: Jared
Subject: Re: nothing is ever true to an expert

Craig Kelly coverage, something that reviles him more than past media. He's truly an amazing individual and I think people should know him better.

Jeff Brushie photos and quotes. Style King, no

doubt, and clever on the Mic too. Use that. Everyone should know how good Jeff is.

To somehow convey the feeling of "session" would be an amazing feat. Whether it be at a Burton photo shoot, practice before the finals of the Open, or just a backyard rail session, it's my favourite part of snowboarding and is a feeling I cannot live without.

Good Luck.

From: Aaron Hawkins
Date: Wed, 25 Apr 2001 12:24:08 -0500
To: Jared
Subject: still a loser

10 MOST IMPORTANT THINGS TO ME ABOUT SNOWBOARDING:

1. Looking over at your friends at the top of a mountain and smiling right before you drop into some nice ass line without even a second guess.
2. Sunny pipe days with your friends learning tricks that you always WANTED to do on your skateboard but never were able to.
3. Going to places that you are sure none of your family will EVER get to see, and being able to tell them the stories about how amazing it was.
4. Freeriding early season at Brighton in 1995 with Noah Brandon and Todd Richards going like 100 miles an hour, with them doing everything Switch and me just trying to keep up.
5. Rolling up to some pipe at some new mountain and watching Collin Lentz just fucking WRECK SHOP on every motherfucker there and then leave without even thinking he did any of the tricks he wanted to do.
6. Hiking kickers and barbecuing at Grizzly with Timmie Ostler, Jeremy Jones, JF Pelchat, Klunker and all of the Salt Lake crew in June of 1996.
7. Knowing full well that Baye, Kramer, Collin, and I used to roll the east coast hip-hop steez to all of the events WAY before the Burton and Forum teams decided that they were "dope" enough to market it. Don't think Trevor Andrew didn't used to rock the Hawaiian shirts/surfernerd look. And don't think that BJ Leines used to listen to hip-hop either. Don't think Kier Dillon didn't break his ankle Rollerblading...think twice before you make fun of motherfuckers when they are doing their own thing way before you catch up to it and label it cool...
8. Having the snowboard world as a creative outlet.
9. Pulling out the standard Method air on a good-sized backside quarterpipe with a smooth, steep landing.
10. 45 degrees and sunny at home in Virginia with all of the locals riding and learning new transfer tricks at the Massanutten park.

There you go Jared.

From: tonino copene
To: Jared
Subject: Big Dick
Date: 27 Apr 2001 21:53:44 -0800

My only memories that stick out are of my friends, all your different libs and miller frontsides. Andy always glancing in the reflection of himself. Brandon's first iguana on the back flip jump. The west valley crew with Wester and Brandon Molton.

I think the reason why these things stick out is because of the fluidity that these people had on their snowboards. Each person had different ways of moving their bodies, even if they generally sucked, everyone could do something smooth. Even if it was only turning. They still looked good doing that. I think that is the hard part of photography, capturing the persona of a rider; it's hard to get in one day of shooting. Unless you shoot one of Jamie Lynn's methods, that says who he is in one pop.

–.Tonino *please bury me face down so you all can kiss my ass* Copene

From: Greg Dacyshyn
Date: Tue, 1 May 2001 20:46:30 -0400
To: Jared
Subject: RE: nothing is ever true to an expert

1. Before you sell the dream, you better learn to live it.
2. Never trust a person that won't have a drink.
3. Always take full insurance from your rental car agency.
4. Broken limbs are best attended to within the first 10 days.
5. Never drink a gallon of milk prior to departing on a transcontinental flight.
6. As much as they can be a pain in the ass, team riders are some of the most amazing people and athletes in the world.
7. After Marlboro cigarettes and Coca Cola, weed is the most consistent item found around the globe...Thank God...
8. Japan is an amazing place to visit.
9. It's not about the destination. It's all about the journey.

From: Michael Jager
Date: Wed, 16 May 2001 18:36:11 -0400
To: jared
Subject: Re: nothing is ever true to an expert
Charles Manson ad, where is it? Letter Jake got from family and reply.

Craig Kelly video, Japan tour. The Rover rolled over with 10 Japanese kids inside totin, autograph cards and screaming.

Brushie Fanta soda Chile ad, the soul truth.

Muscle car ad, ASR. Comin, at ya Bullet style.

J2 pubic hair tee shirt 13. Original pubic art by MJ, gift from DJ.

Ari M. lying that he could ski in Zermatt to get the shoot, then milkin, snowboarding for all he could.

Guch, brown pond crosser sequence. Come on, where is it?

Meat man ridin, mechanical bull. Rubbin, meat on that manly mass o, hair at Big Sky Slush Puppy.

Slam Master huckin, chunks in a Tokyo parking lot after a day of 3.5 feet of pow with DJ and two chicken curries with rice (stick with mickey dees).

Craig Kelly/Satan, U.S. Open, 1992. Craig comes in from Czech Republic head shaved, full Satan goatee. Way ahead of the curve. David Roby portrait a classic.

Jake/Day One Chile shoot , 1992. Science Book dealer catalogue. MJ and Aaron Warkov scheming, dreaming up top-down view of steep-ass chute. Drop in. Jake stacks heelside second run, out of control. Head first into high-altitude Andes rock pile. Busted collarbone. Stood up and hiked out. Thought I was going to see the main melon splatter. Bloody scary but we got the shot. Aaron burned motor drive core shooter style. And you know what? You guessed it, there were 13 frames. No shit! Jake got heli-ed out by the Chilean army.

Jeff goin, off in Manchester on JDK Design fucking postage stamp size seps. DJ thanks for the trust.

Jared and MJ Wood Morning thoughts on cold morning 3 a.m. in Munich.

Blue Pilgrim/Pink Injun undercover antics and stripper fest in Portland. Trevor, we love you, man.

Jimmy in the Big Foot suit Jersey-style in Tigne. Respect the fun.

Pornographic packaging flows north to south Vermont Transit style. Robert Mapplethorpe leisure suit rocker somehow survived the trip.

Andy Laats cornfield antics in Austria. Damn lucky he got the outta jail free card.

Chile 2. Burning down the house. Well, $500 picnic table at least and not nailing one single, decent fucking shot as riders went off. Baz, thanks for cleaning up the mess.

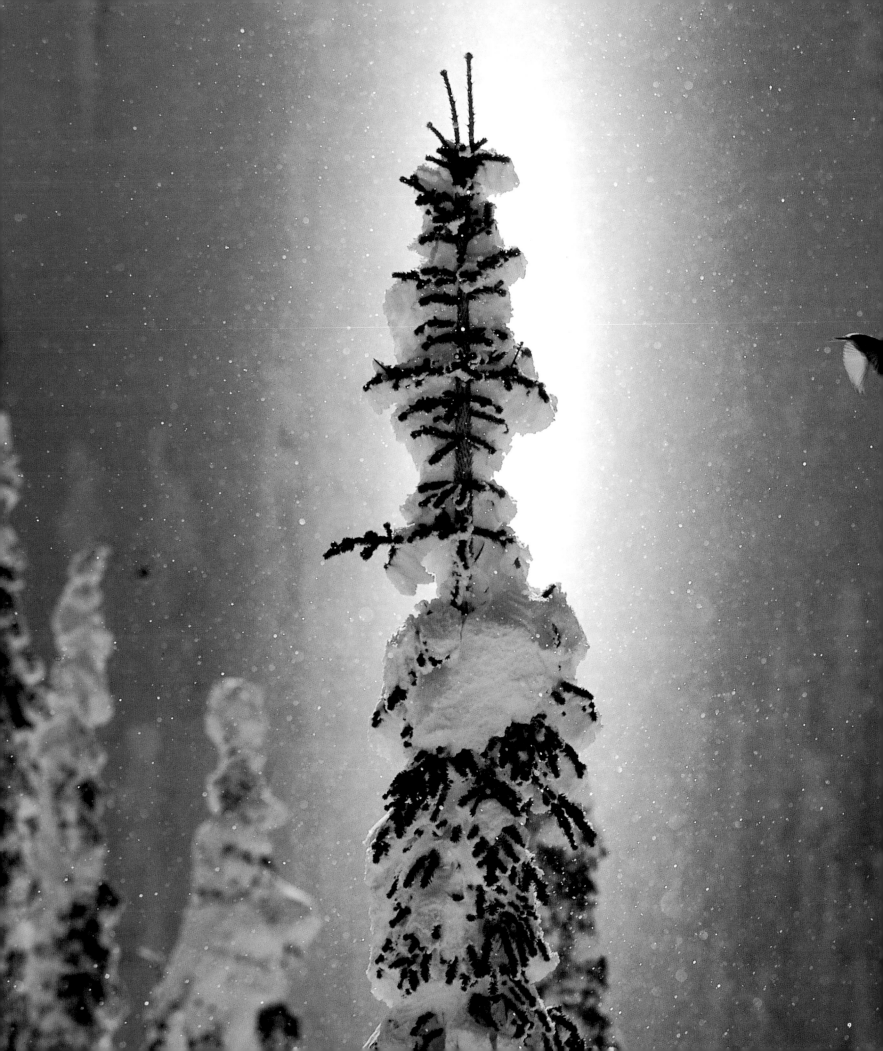

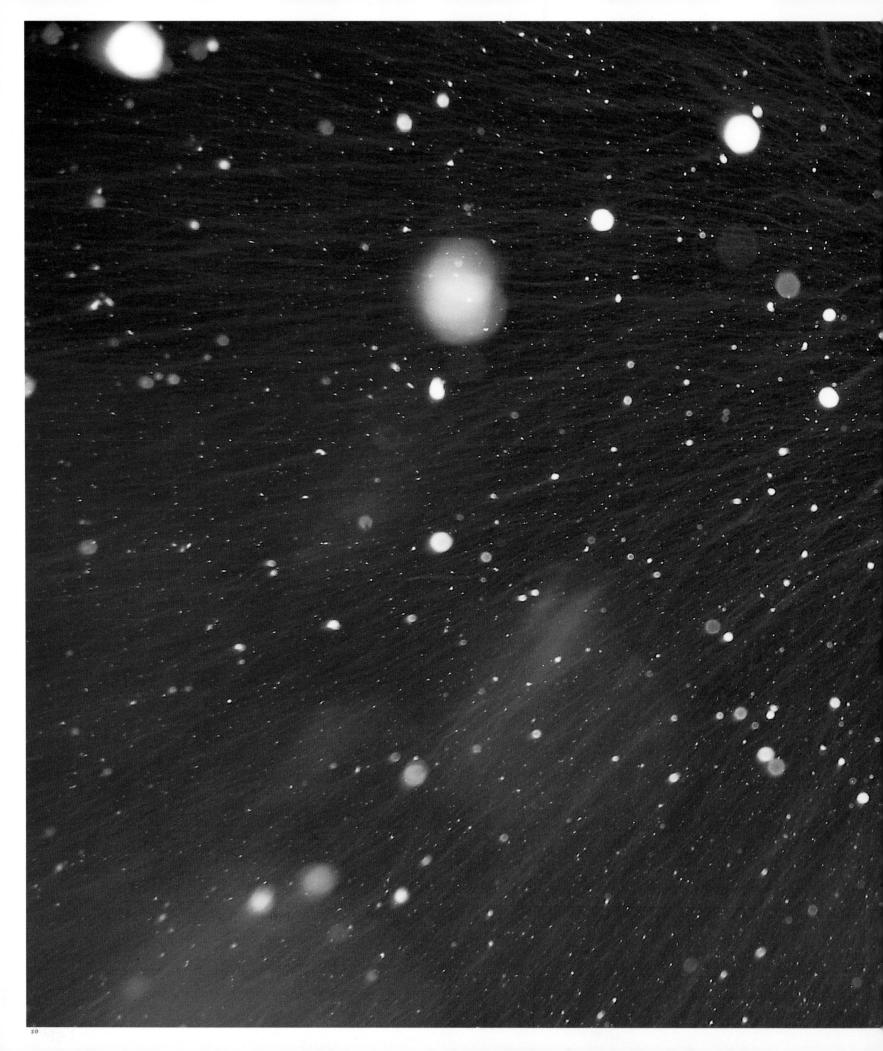

WE ARE AN INERT BUT WELL-MEANING CONGLOMERATE OF SIDEWAYS LOBBYISTS PROPOSING THAT WIDESPREAD INITIATIVES BE PASSED IN FAVOUR OF THE TYPE OF NATURE, AND CONTROL OVER NATURE, THAT WE ARE IN NEED OF MOST, THE FLAKY WHITE STUFF. BOXES UPON TRUCKLOADS UPON STADIA, FULL OF MAGIC CRYSTALLINE GOODNESS.

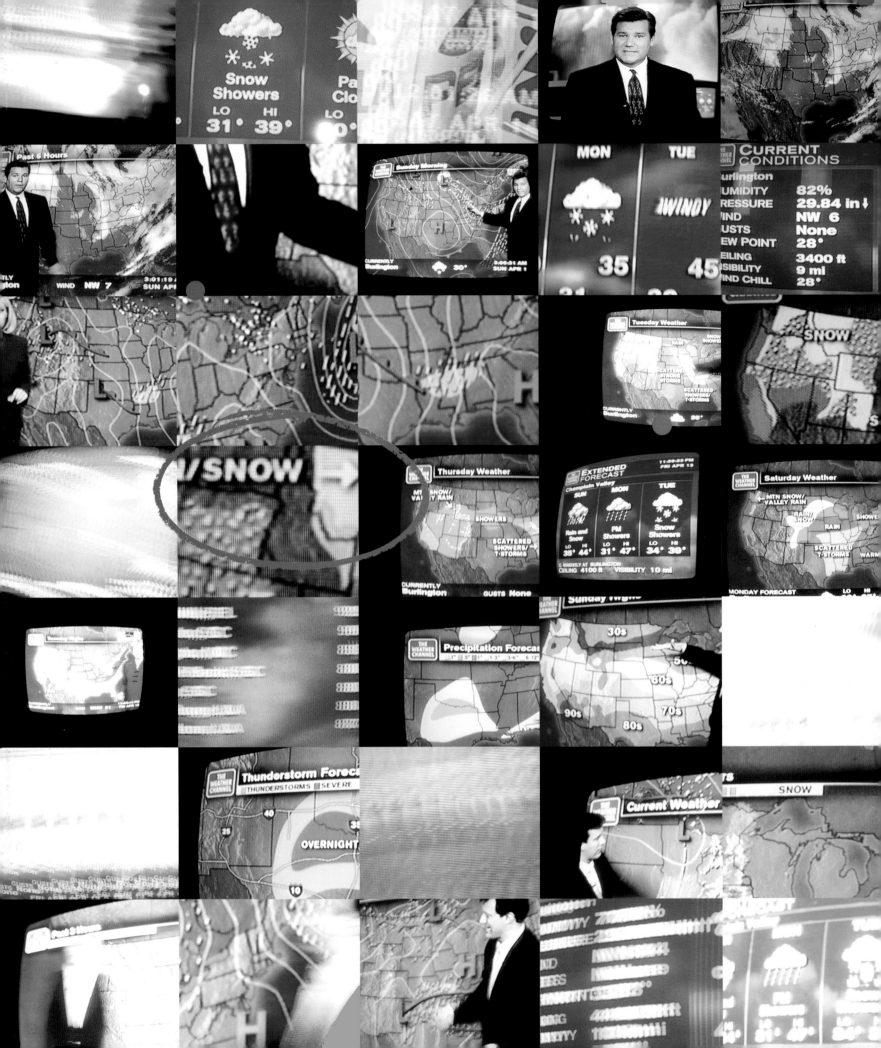

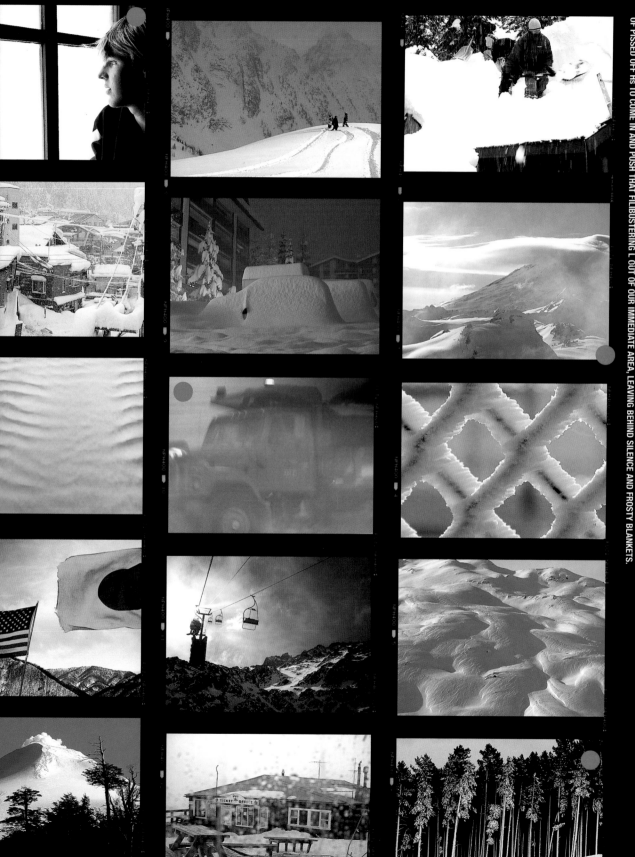

WE'VE QUIETLY PAID OUR DUES STAYING UP SLEEPLESS, STARING AT FORECASTS, DOPPLER IMAGES AND COMPUTER MODELS, LOOKING FOR GANGS OF PISSED OFF Hs TO COME IN AND PUSH THAT FILIBUSTERING L OUT OF OUR IMMEDIATE AREA, LEAVING BEHIND SILENCE AND FROSTY BLANKETS.

WE'VE CANVASSED EVERY DISTRICT IMAGINABLE DURING DRY SPELLS, IN EFFECT PRAYING TO ALL GODS OR GODDESSES WHO MIGHT BE LISTENING, FOR A BREAK IN THE MILD SKIES. AND IN DOING SO WE'VE PROMISED ALLAH, ABRAHAM, BUDDHA AND, OF COURSE, JESUS, MARY, AND JOSEPH THAT WE'D FOLLOW A STRICT ADHERENCE OF THEIR TEACHINGS IF ONLY THEY'D HELP US OUT

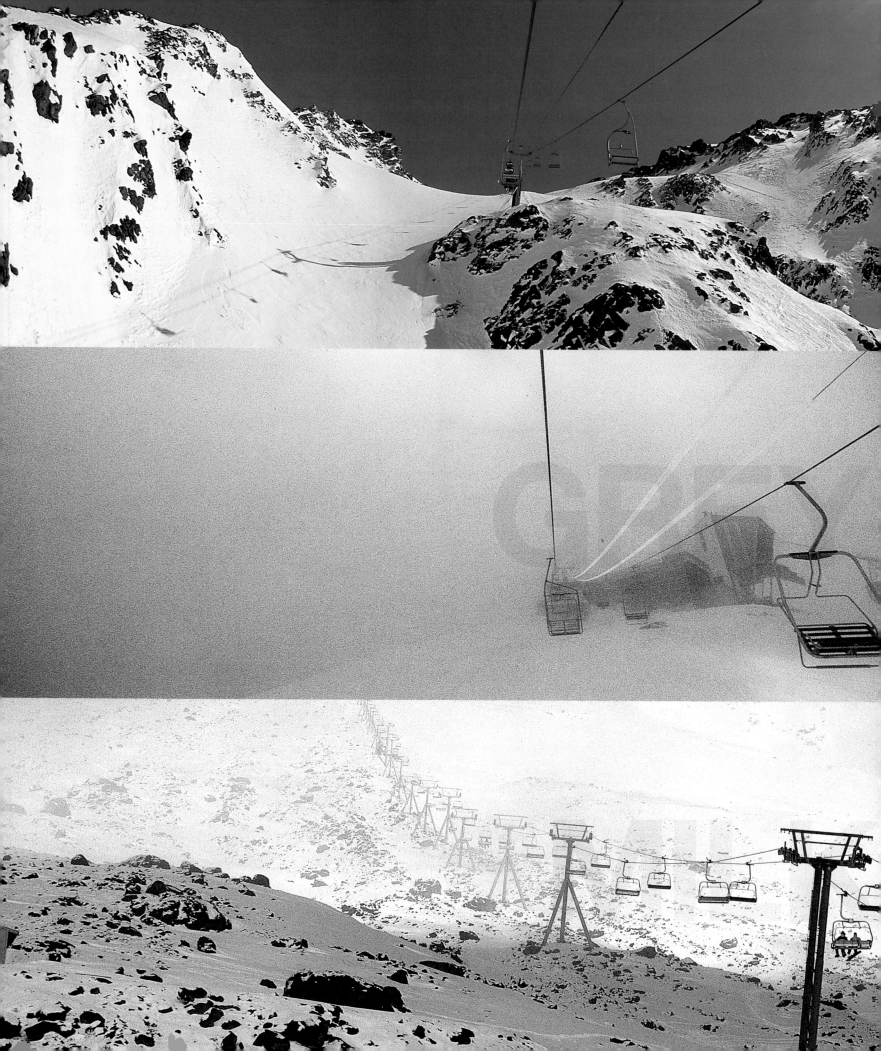

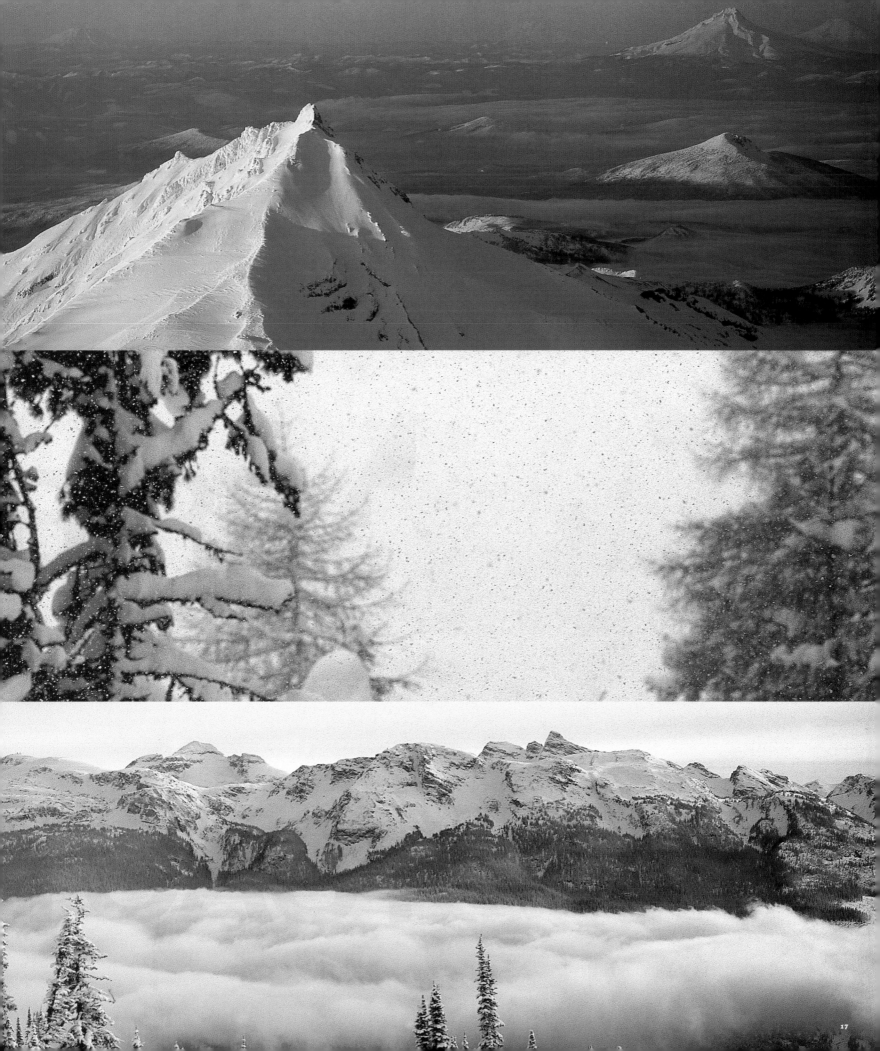

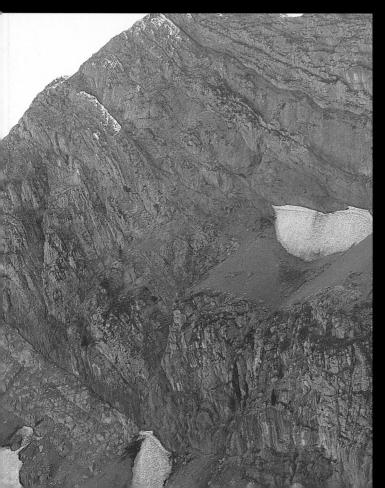

SUMMER.WINTER.SUMMER.WINTER.SUMMER.WINTER.SUMMER.WINTER.SUMMER.WINTER.SUMMER.WINTER.SUMMER.WINTER.SUMMER.WINTER.SUMMER.WINTER.SUMMER.WINTER.SUMMER.WINTER.SUMMER.WINTER.
WINTER.SUMMER.WINTER.SUMMER.WINTER.SUMMER.WINTER.SUMMER.WINTER.SUMMER.WINTER.SUMMER.WINTER.SUMMER.WINTER.SUMMER.WINTER.SUMMER.WINTER.SUMMER.WINTER.SUMMER.WINTER.SUMMER.

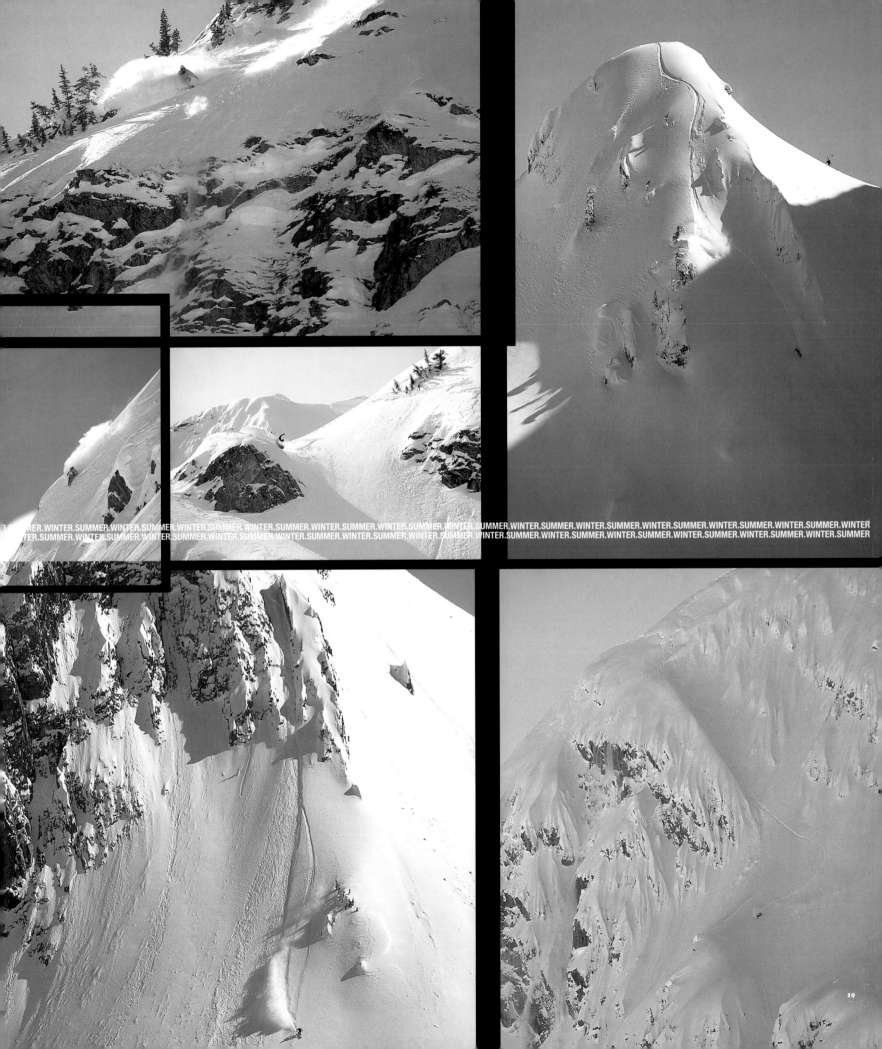

WINTER.SUMMER.WINTER.SUMMER.WINTER.SUMMER.WINTER.SUMMER.WINTER.SUMMER.WINTER.SUMMER.WINTER.SUMMER.WINTER.SUMMER.WINTER.SUMMER.WINTER.SUMMER.WINTER.SUMMER.WINTER.SUMMER.WINTER.SUMMER.WINTER
WINTER.SUMMER.WINTER.SUMMER.WINTER.SUMMER.WINTER.SUMMER.WINTER.SUMMER.WINTER.SUMMER.WINTER.SUMMER.WINTER.SUMMER.WINTER.SUMMER.WINTER.SUMMER.WINTER.SUMMER.WINTER.SUMMER.WINTER.SUMMER.WINTER

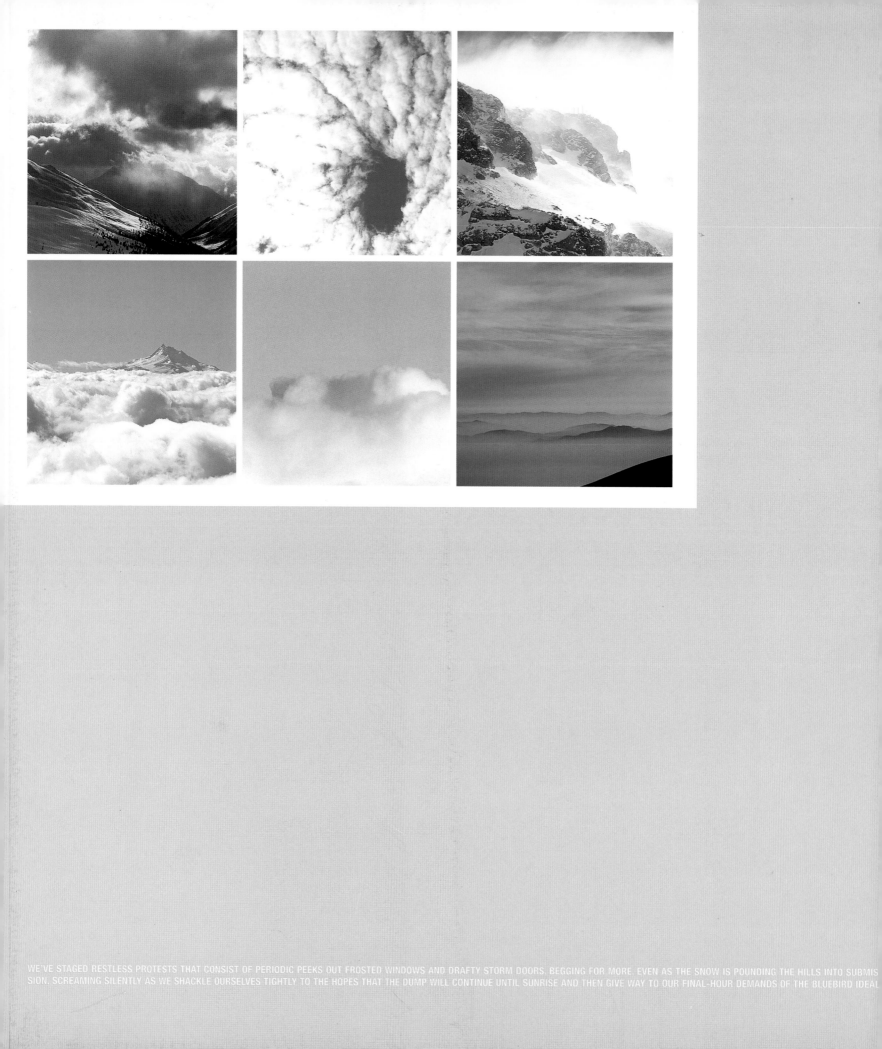

WE'VE STAGED RESTLESS PROTESTS THAT CONSIST OF PERIODIC PEEKS OUT FROSTED WINDOWS AND DRAFTY STORM DOORS, BEGGING FOR MORE, EVEN AS THE SNOW IS POUNDING THE HILLS INTO SUBMIS-
SION. SCREAMING SILENTLY AS WE SHACKLE OURSELVES TIGHTLY TO THE HOPES THAT THE DUMP WILL CONTINUE UNTIL SUNRISE AND THEN GIVE WAY TO OUR FINAL-HOUR DEMANDS OF THE BLUEBIRD IDEAL.

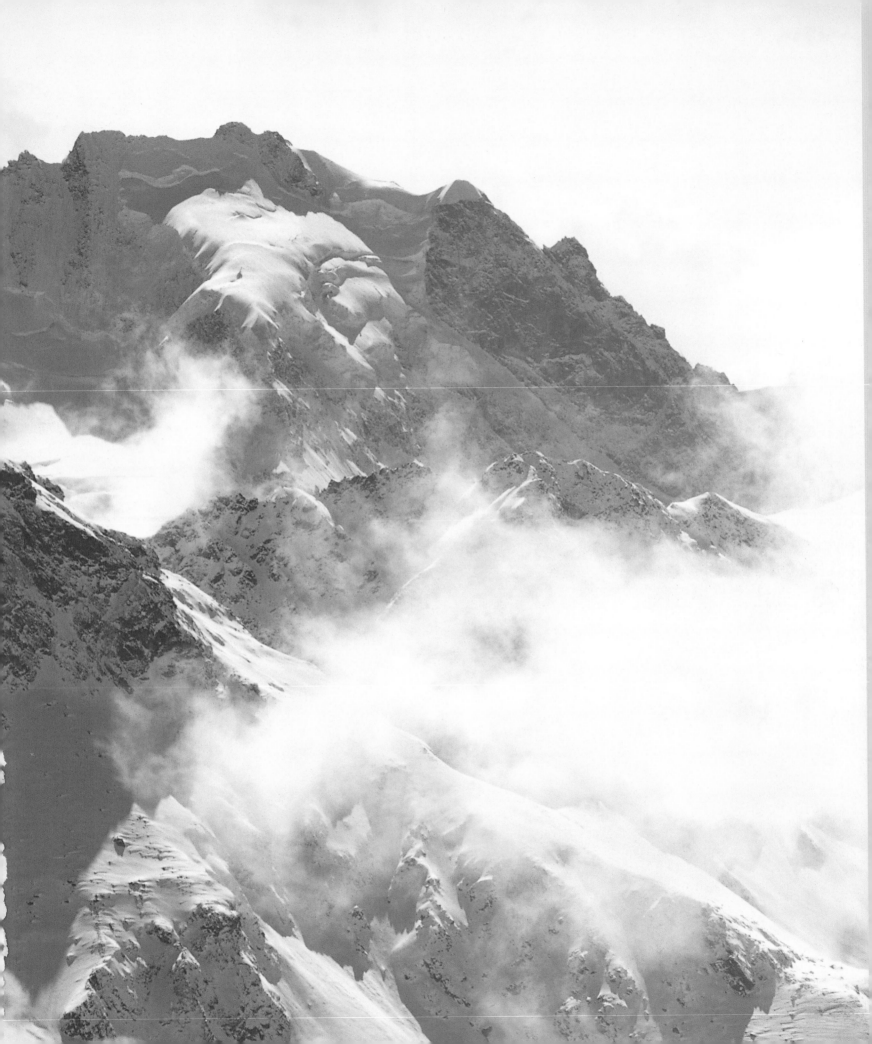

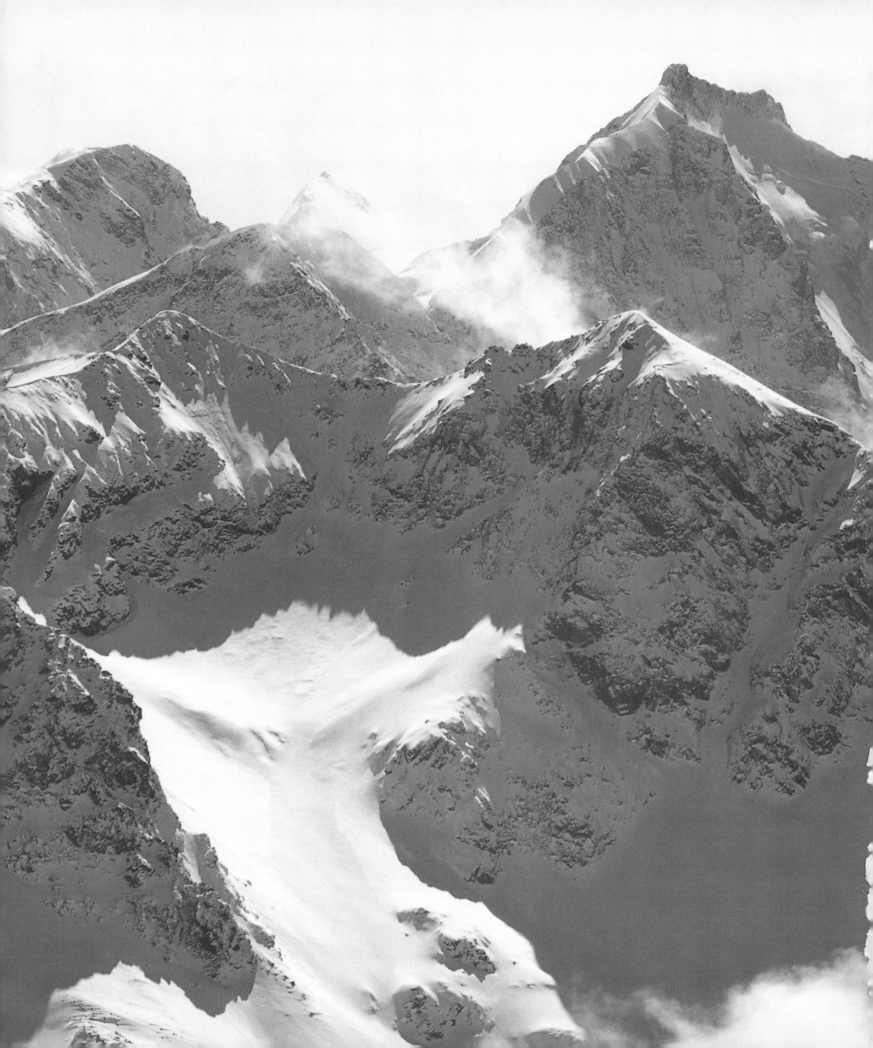

POLITICS ASIDE, WHEN THE VOTE IS CAST, WE'RE HOPING FOR THE NUMBERS TO GENTLY SWING OUR WAY. NOT BECAUSE WE DESERVE FOUR FEET OF FRESH, NOT BECAUSE WE ARE WORTHY OF FINE GRAINED DRIFTS, NOT BECAUSE WE DESERVE THE BENEFITS OF OUR PARTICULAR BRAND OF CONTROL OVER THE BLIZZARDY PRECIPITATION. OH NO. THAT'S NOT WHY.

POLITICS ASIDE, A VOTE SHOULD BE CAST IN FAVOUR OF NATURE. A STATEMENT MADE NOT TO DIG ON THE CAUSTIC OPINIONS OF SOME OTHER PARTY OR TO PROVIDE A TYPEFACE TO THE FACELESS BUT NONETHELESS COWARDLY ONE-WAY JABBER OF THE BUMPER STICKER EDITORIAL. INSTEAD, THIS IS A STATEMENT MEANT PURELY TO GAIN FAVOUR WITH THE MOTHER OF ALL MOTHERS. THE BIG N. AS A POPULATION OF CONCERNED LAW-ABIDING CITIZENS, WE ARE PLEADING WITH WHOEVER MIGHT BE LISTENING IN HOPE THAT EVEN THE SLIGHTEST SPLINTER OF CONTROL OVER THE CONSISTENTLY UNCONTROLLABLE NATURE OF NATURE ITSELF WILL BE HANDED OVER TO US. *

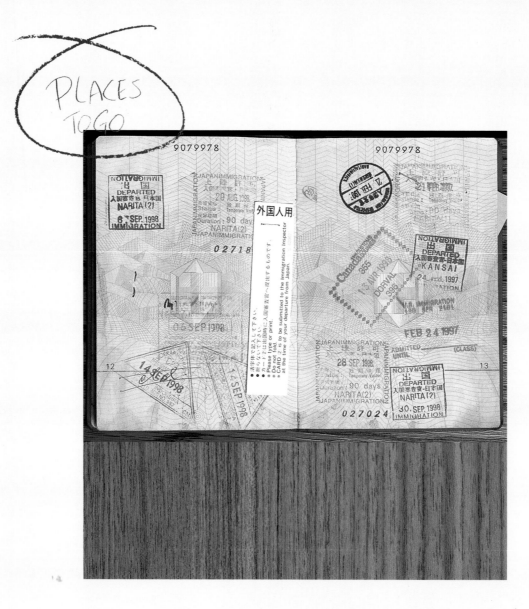

PLACES
TOGO

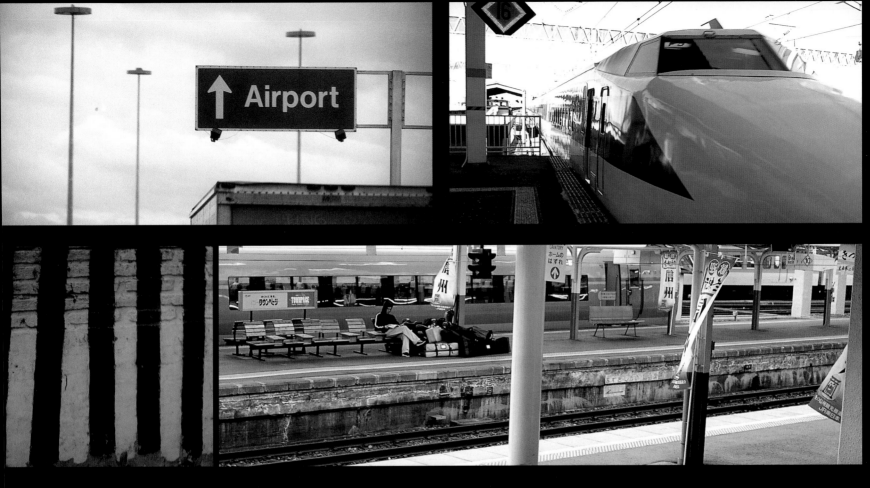

RAVEL

fforts reversed and we went snowboarding, but it was just a time to wait, wait until the
ext gate, seat assignment, in-flight movie, over-packed carry-on, and headphone dead
one.
he snowboarding is now the travel, and the travel is now the destination that we ignore.
he un-goal. Journey has become the shortened moments turning in untouched crystals,
ropping and spinning into the trees, and pausing for a break in the clouds. The hikes and
cooter rides and halting lifts now take the place of the delayed departure. And the once
ivial moments strapping in and brushing off are mild poetry that I carry with me through
ndless days and nights spent lugging a tonnage of board bags and magazines far into
ıy new tense, the future past.
fforts reversed, my voyage has become dozens upon dozens of hours skidding through
ıht fields of the undiscovered, giggling drunk with the freewill to carve that way or this,
ırning to show a friend what I've encountered, but instead finding a groomed roller that
as moved into the place of turbulence at thirty-nine-thousand feet, taking me to
nother airspace.
ı tugging and my bags tug back, and this is my destination, standing to the right of the
echanised walkways. The place that some odd bastardisation of Eastern philosophy
almly asks me to consider, or rather, asks me to consider not.

So, if I've made travel my destination, and thus all of life is about the journey, then also
please let me make the steps of my pilgrimage take place within the confines of a twenty-
one-inch stance with a little more weight on my back foot and plenty of forward lean.

DEPARTURE: \di-'par-cher\ a starting out (as on a journey)

FLIGHT	DESTINATIONS	GATE	TIME
1548U	RENO	10B	0820
117744	VANCOUVER	2C	0930
*****	(DELAYED)	*****	1045) ↑
1022US	ANCHORAGE	5D	1025
1021	NARITA	8A	1120
U1250	INNSBRUCK	9A	1255
125600	BUENOS AIRES	2C	1300
012388	PORTLAND	8B	1400
*****	(DELAYED)	*****	1525) ↑
11225	SANTIAGO	4D	1547
1254	GENEVE	7C	1604
CANCELLED ↑	CANCELLED	CANCELLED ↑	CANCELLE
3452	OSLO	1A	1636
*****	(DELAYED)	*****	1845) ↑
01547	SALT LAKE CITY	3A	1706
1258AA	DENVER	1A	1838
USB13	BURLINGTON	3C	1900
025100	HELSINKI	6B	2005

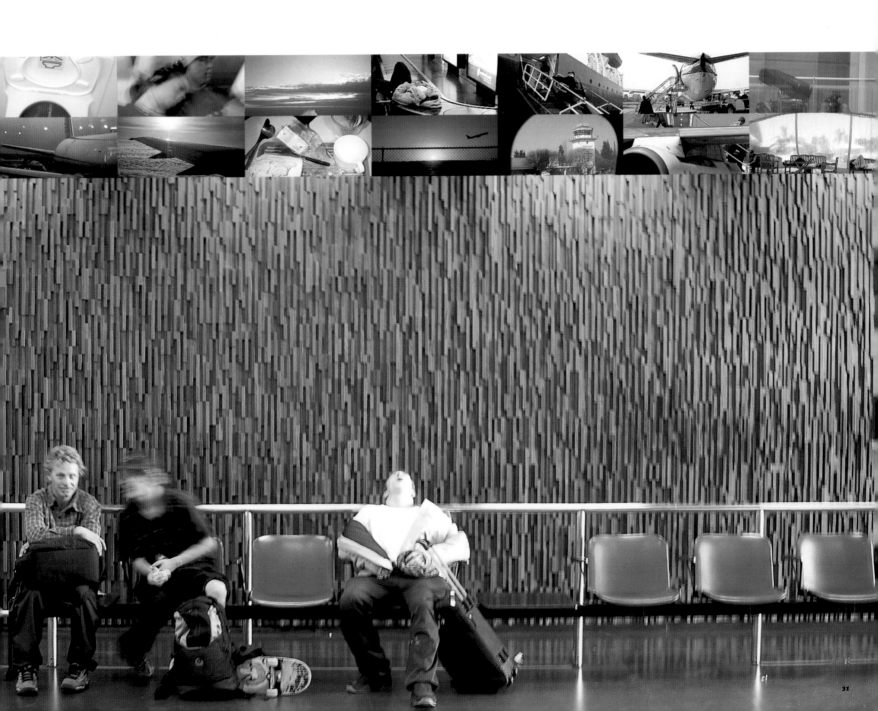

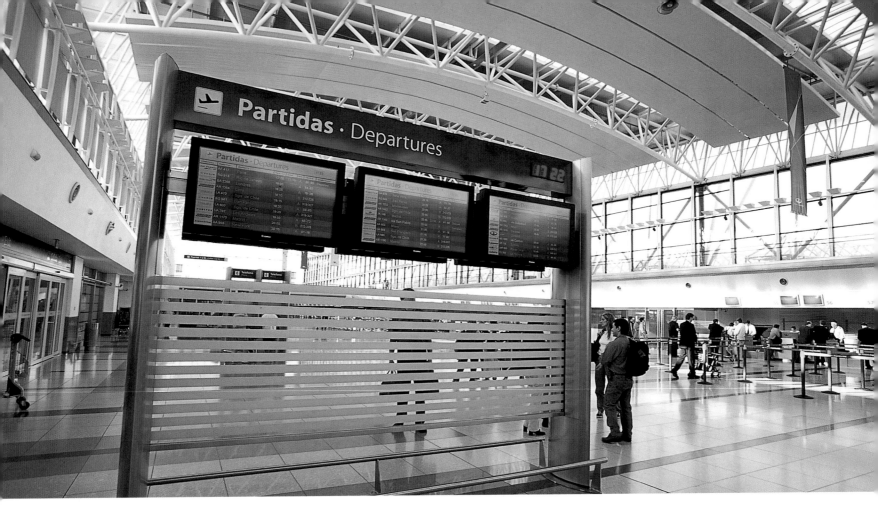

I'M TUGGING AND MY BAGS TUG BACK, AND THIS IS MY DESTINATION – STANDING TO THE RIGHT OF THE MECHANISED WALKWAYS.

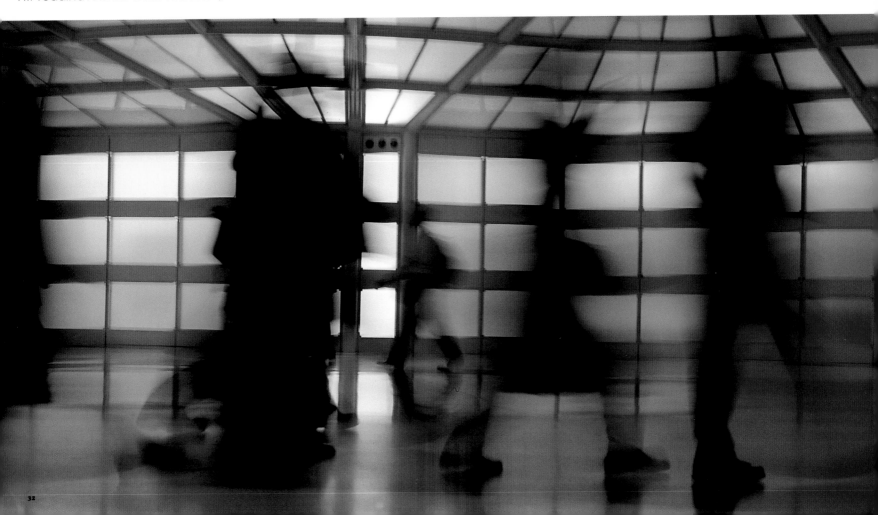

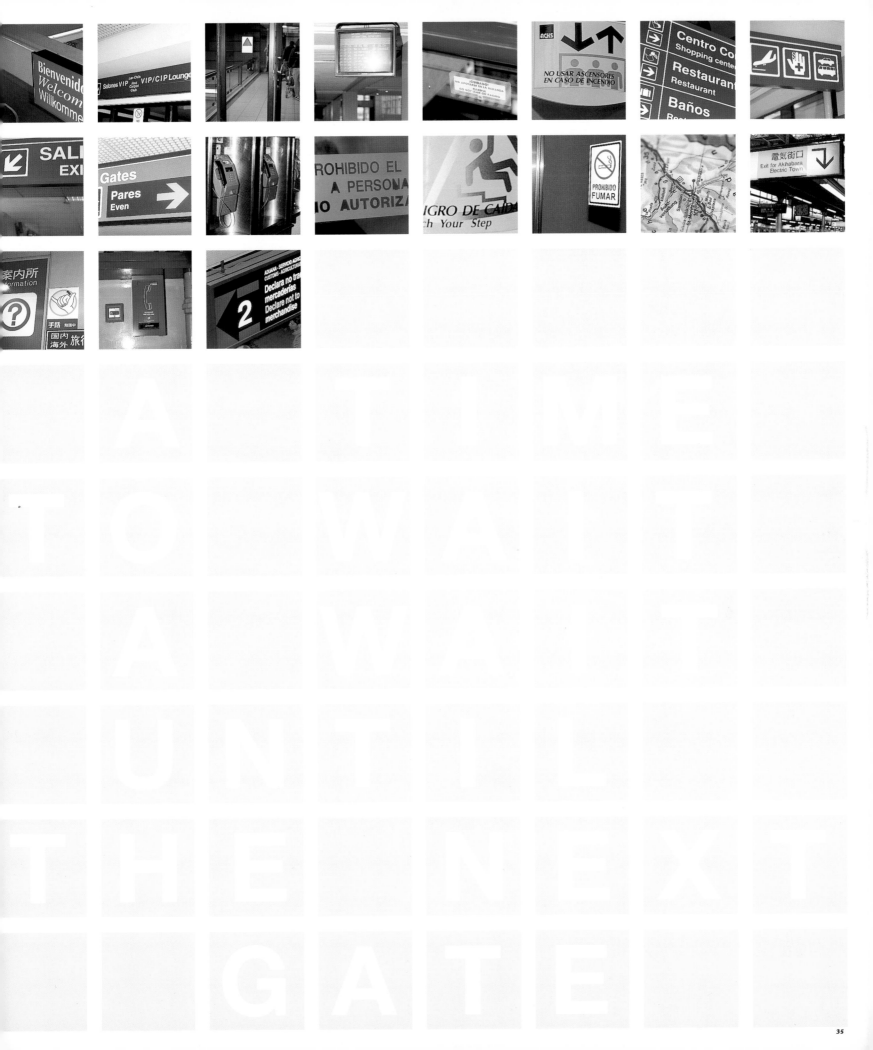

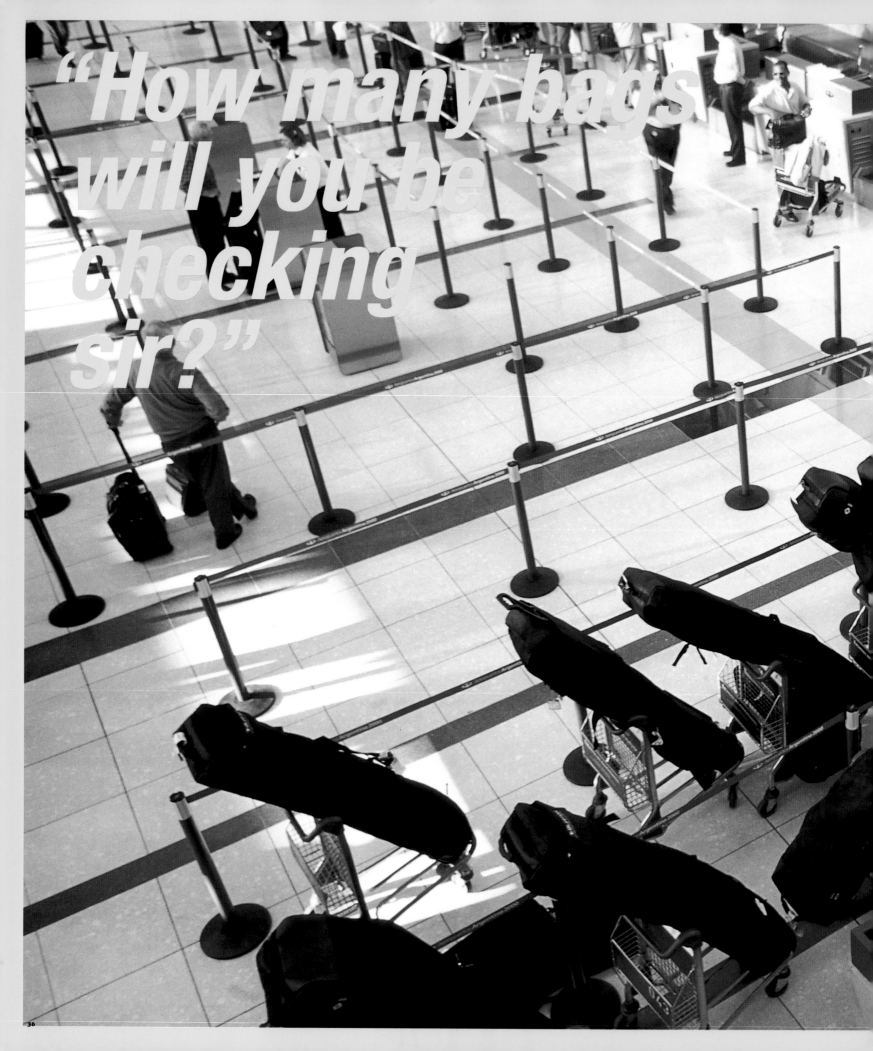

"How many bags will you be checking sir?"

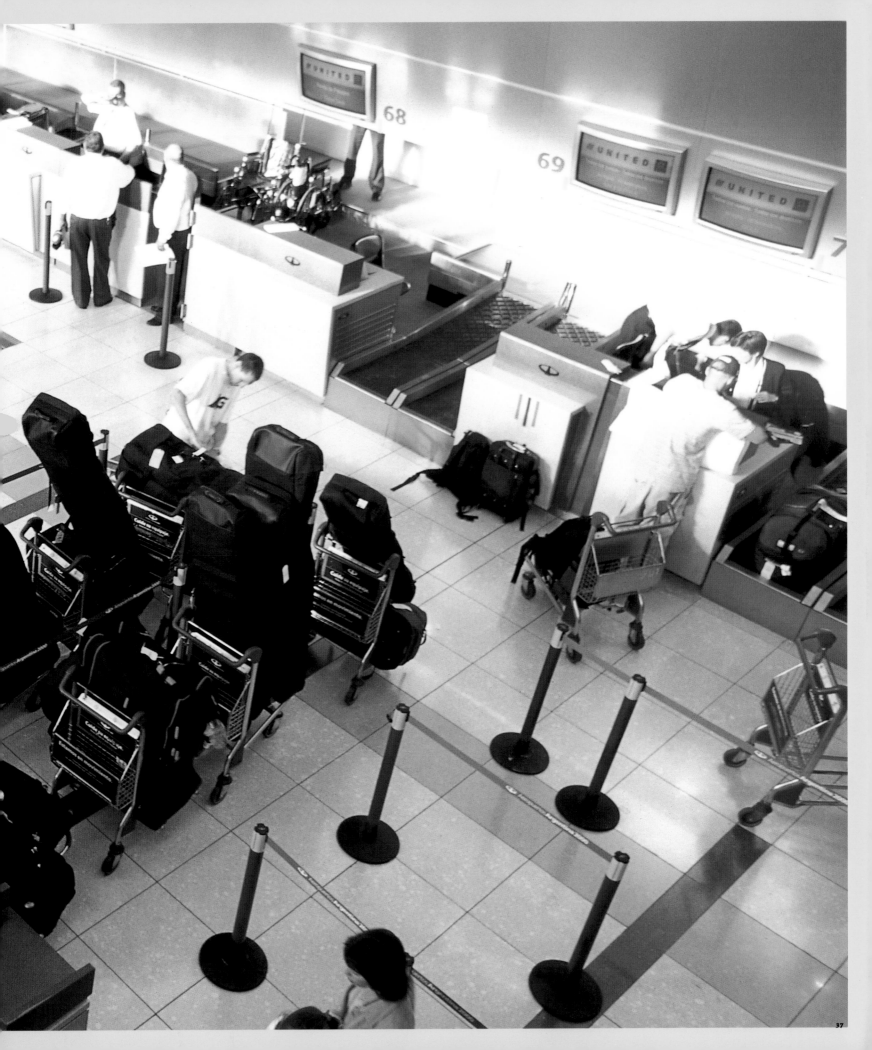

From: Burlington. | To: Chicargo, Denver, Salt Lake City, Portland, | | | | shington
To: Burlington | From: Portland, Denver, Salt Lake City, Mounthood, | | | | Chincarg

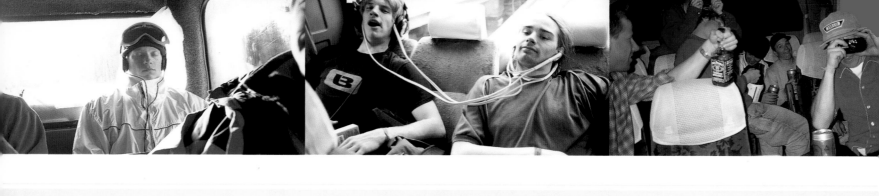

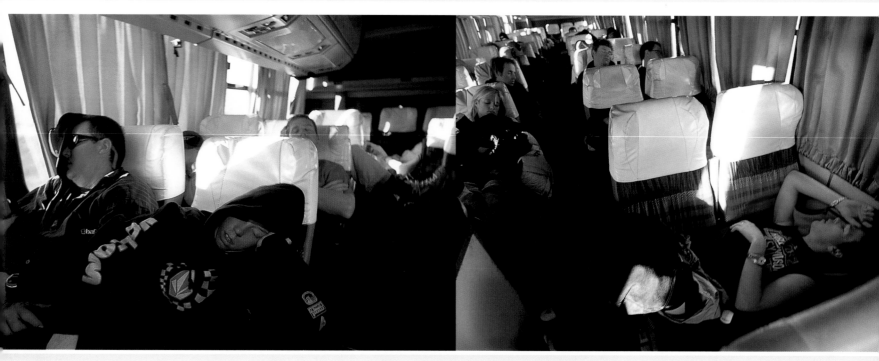

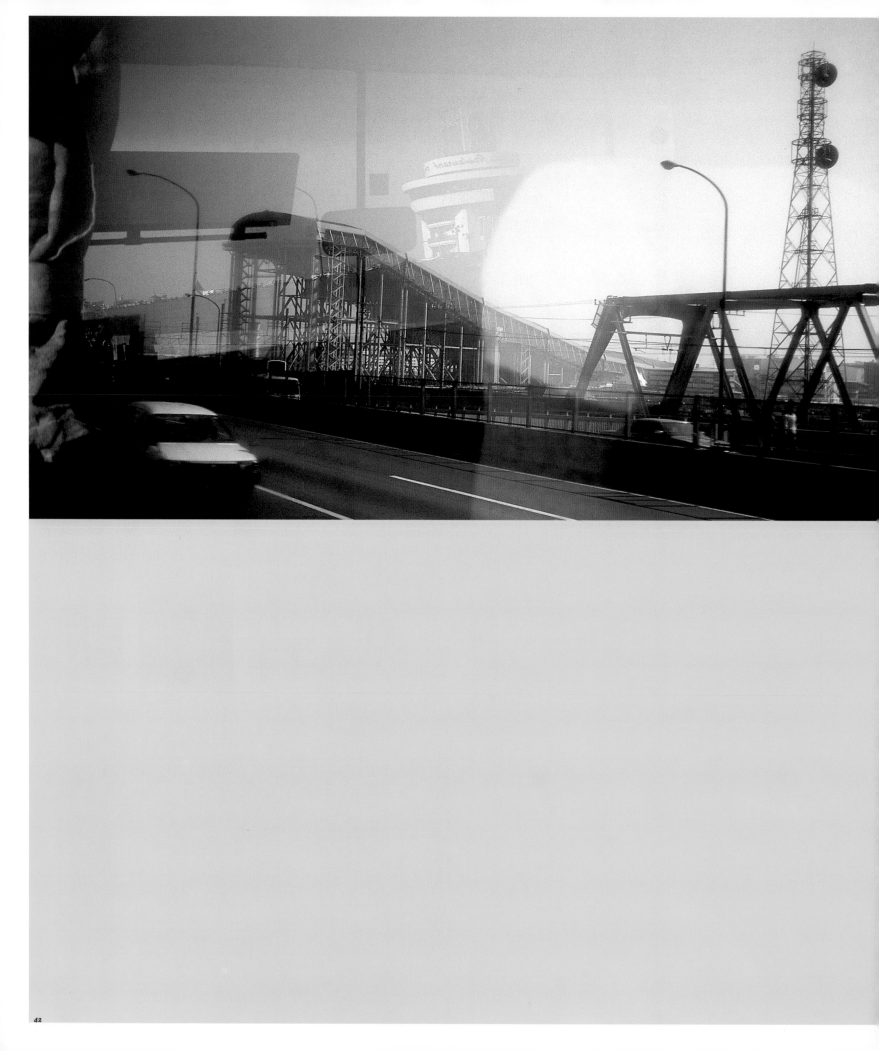

AND WHILE I'M PLEADING, CAN I ALSO GET YOU TO CHECK AND SEE IF THE EMERGENCY EXIT SEATS ARE STILL AVAILABLE? EFFORTS REVERSED, MAYBE I'LL GET THE CHANCE TO STEAL A FEW MOMENTS

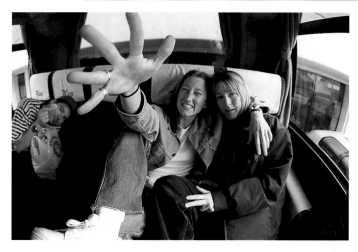

BACK FROM THE UN-DESTINATION, AND STRETCH MY LEGS OUT.

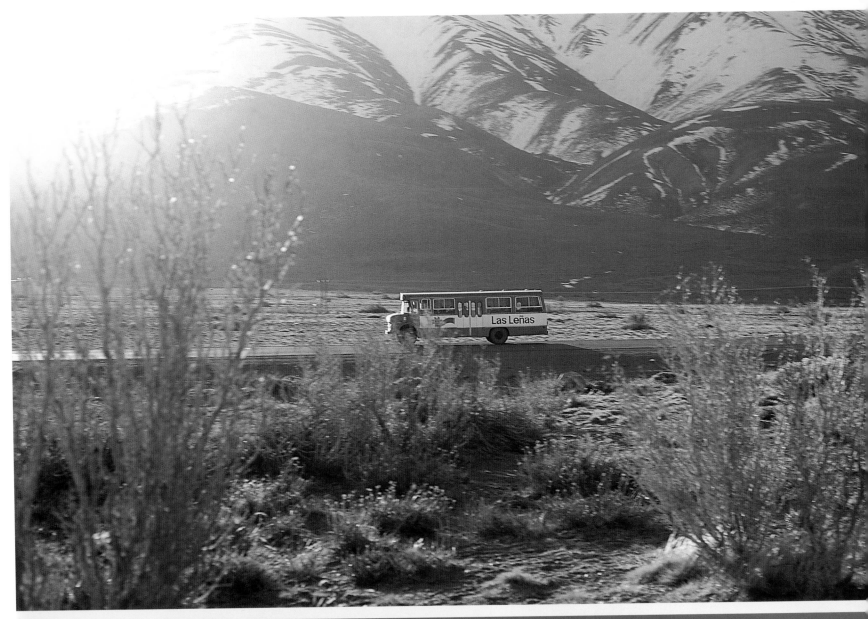

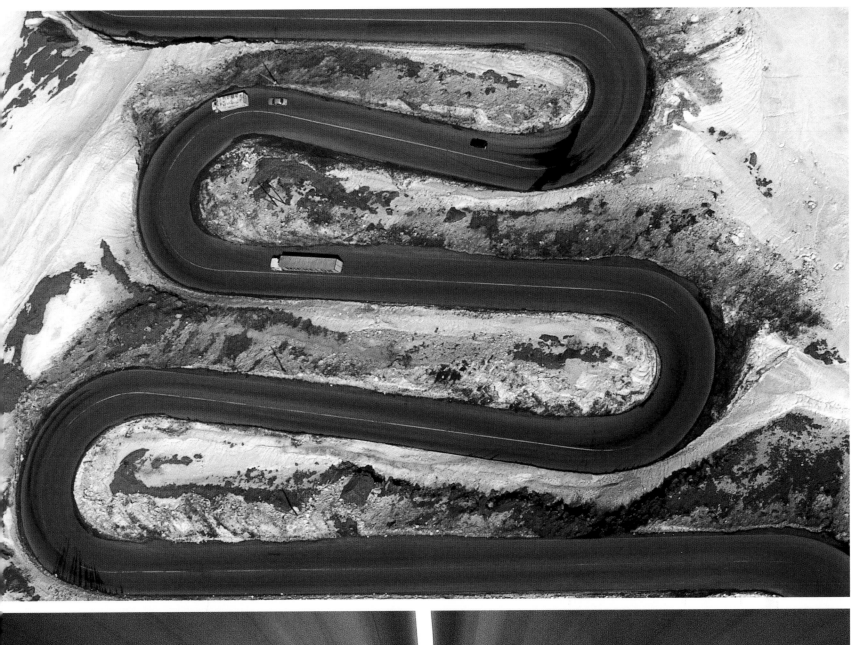

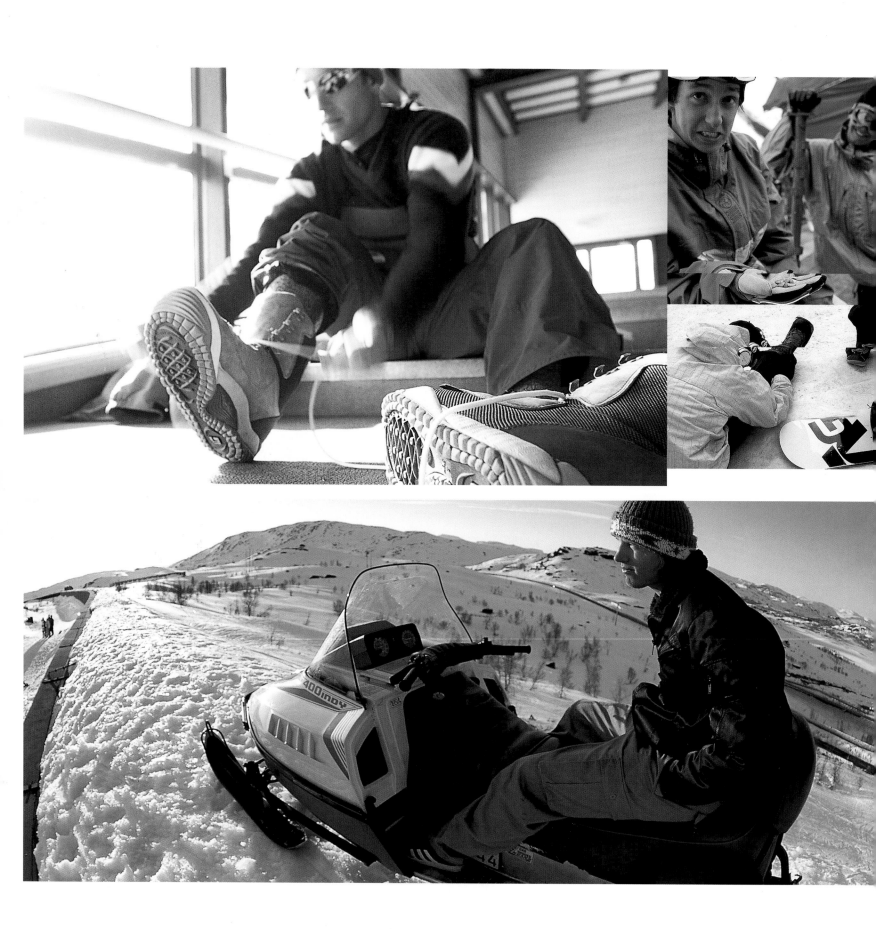

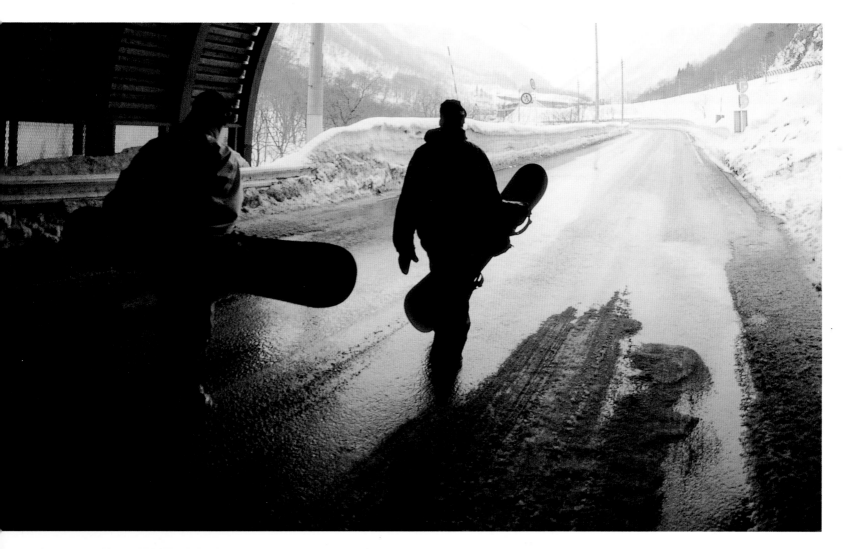

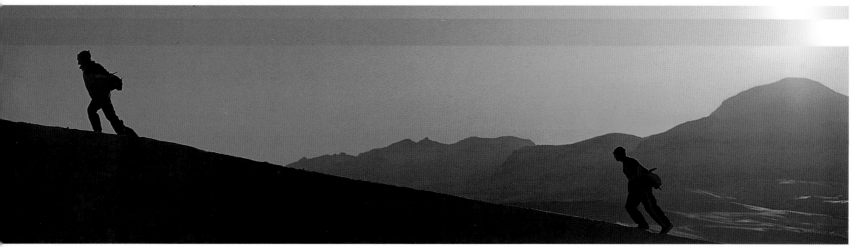

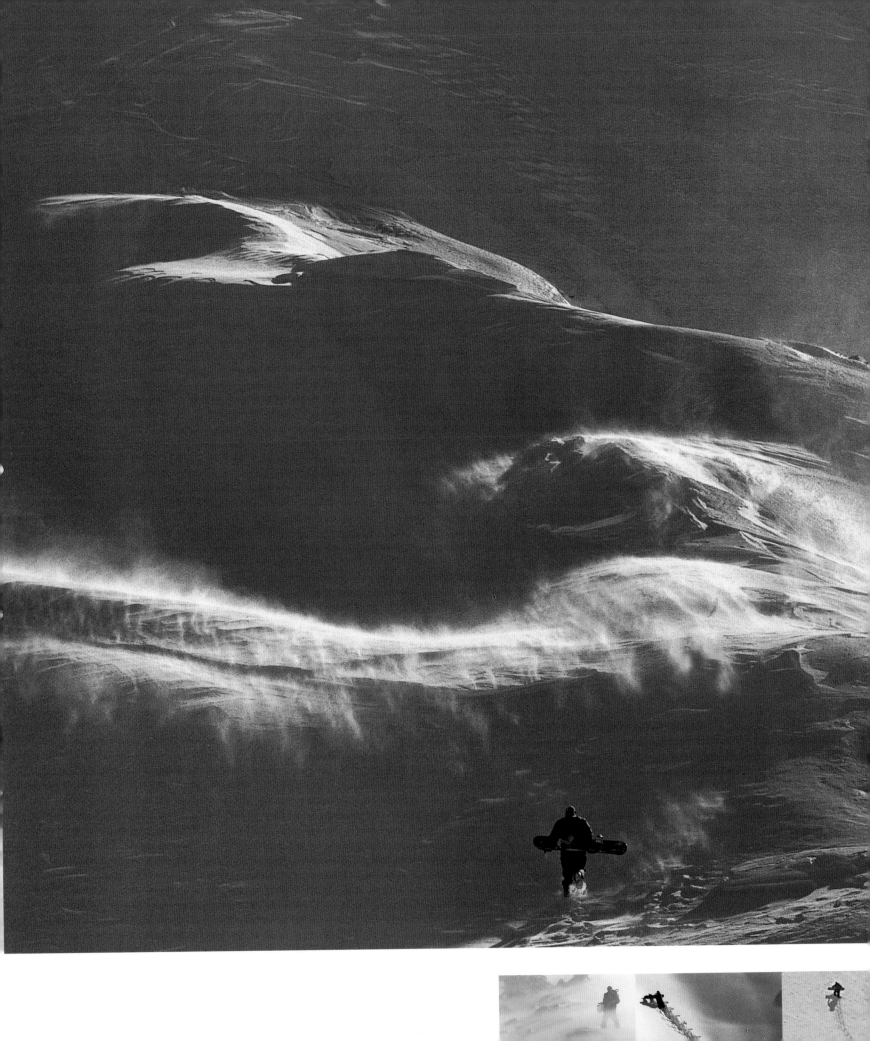

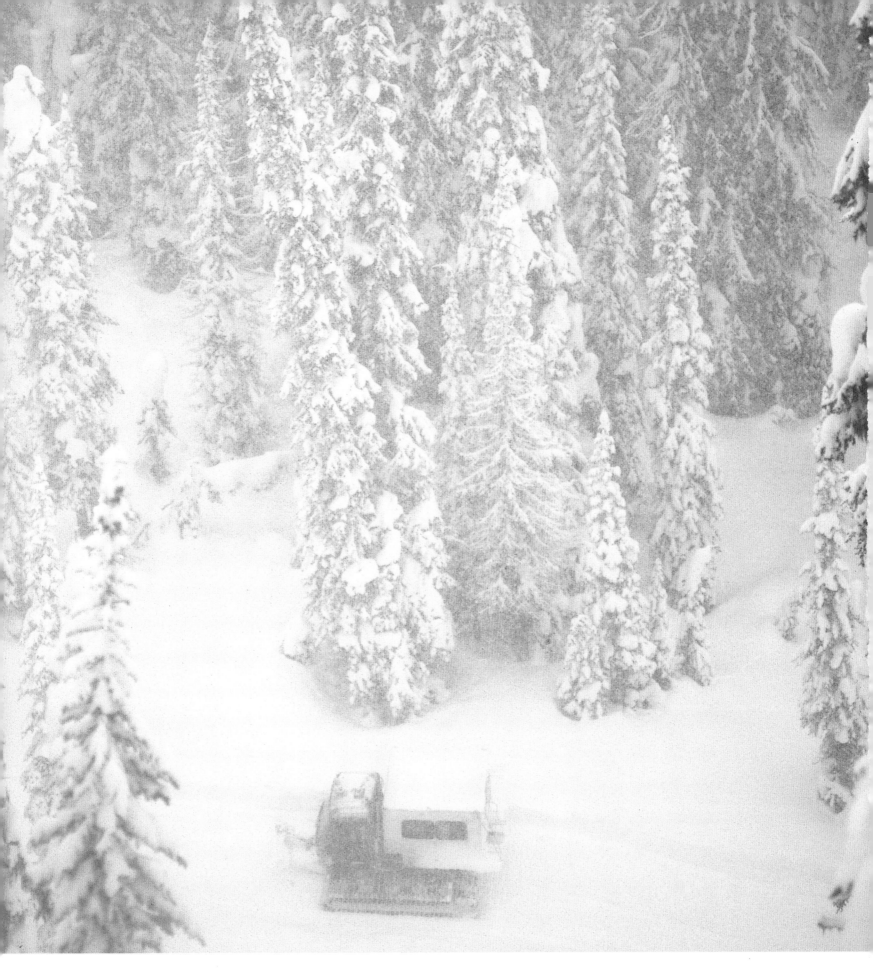

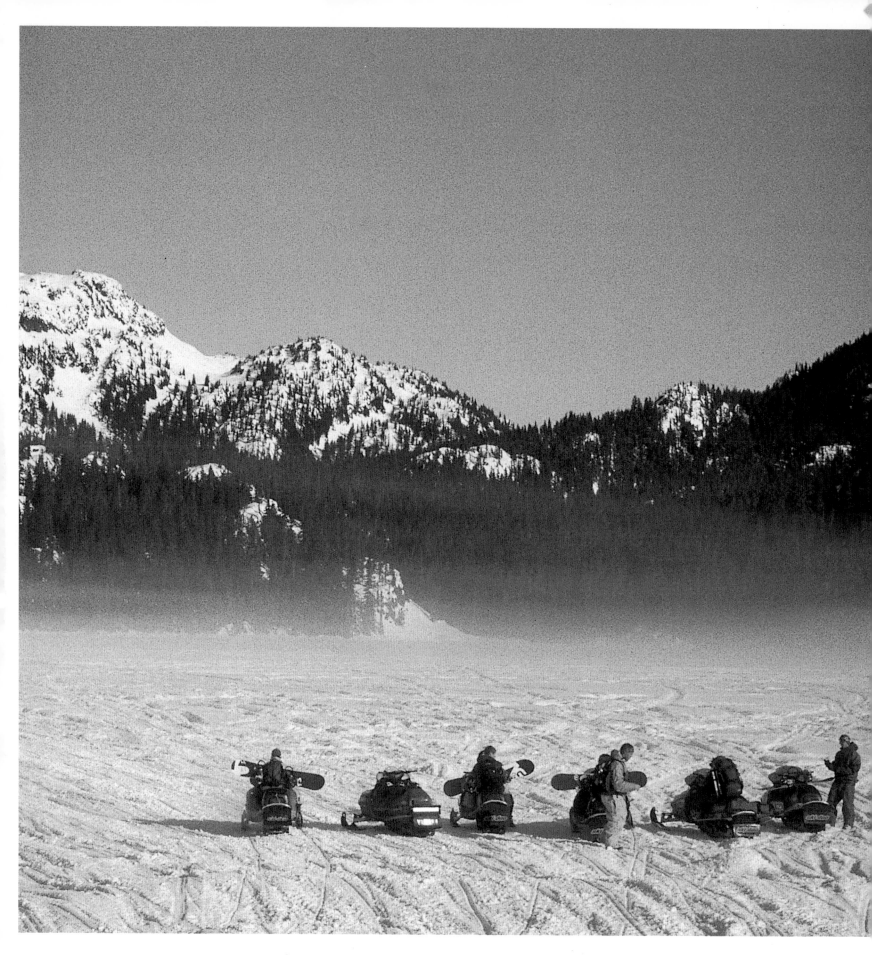

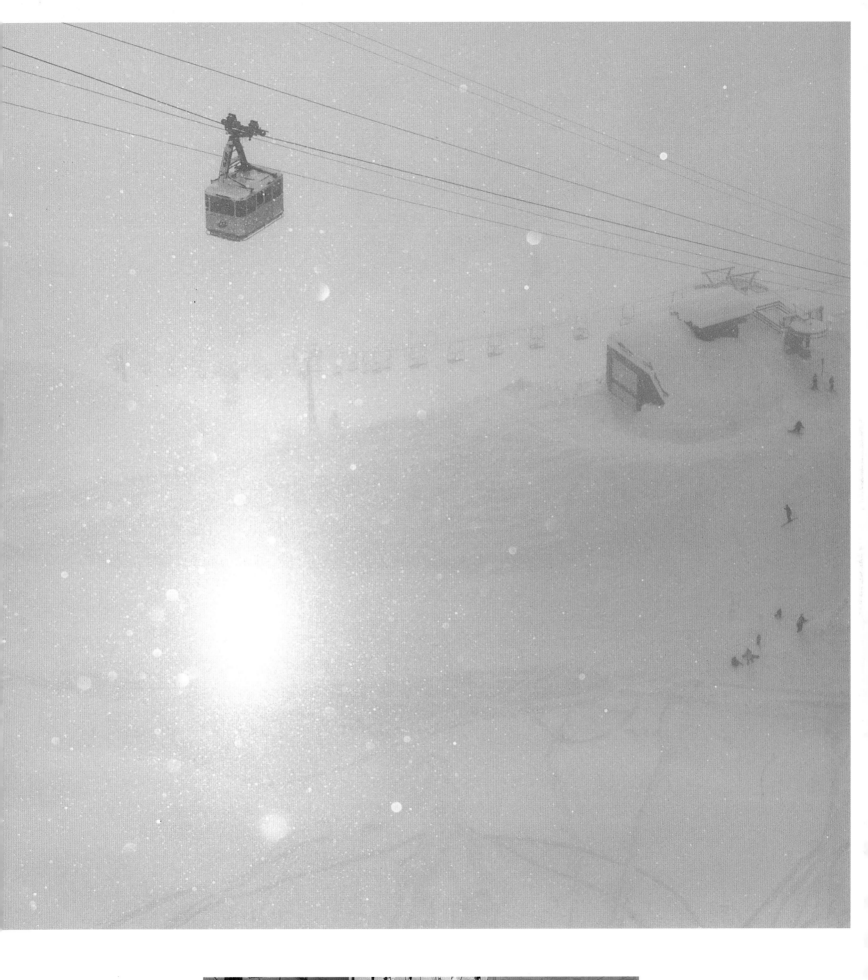

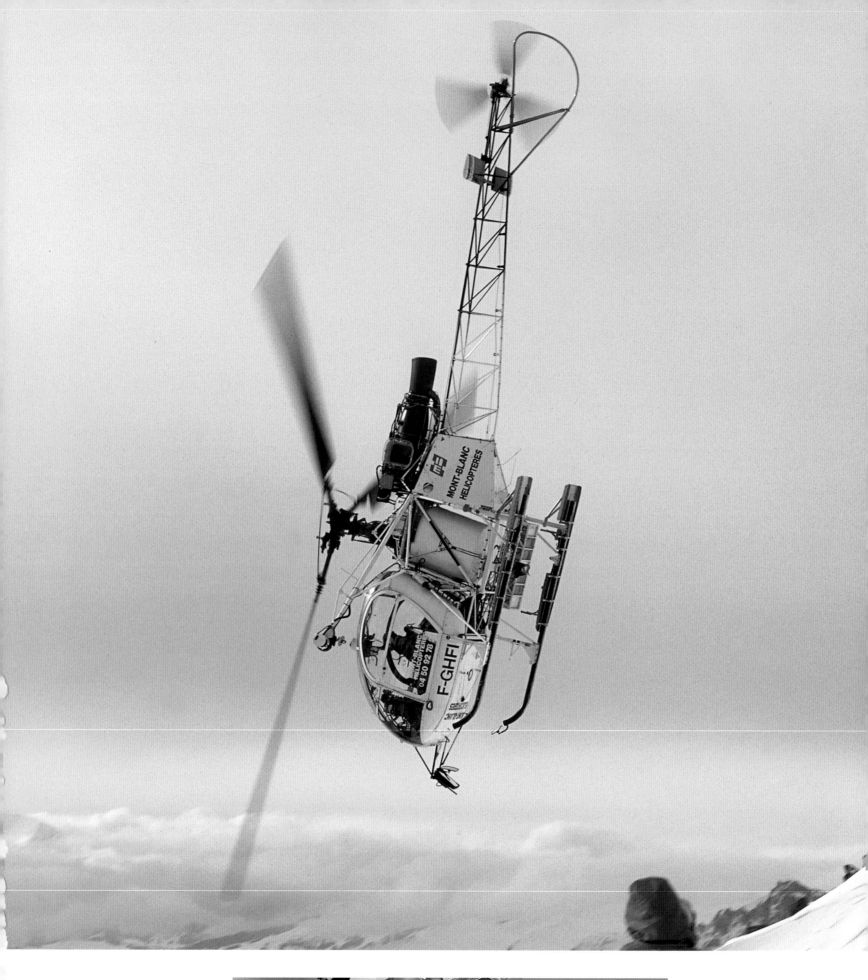

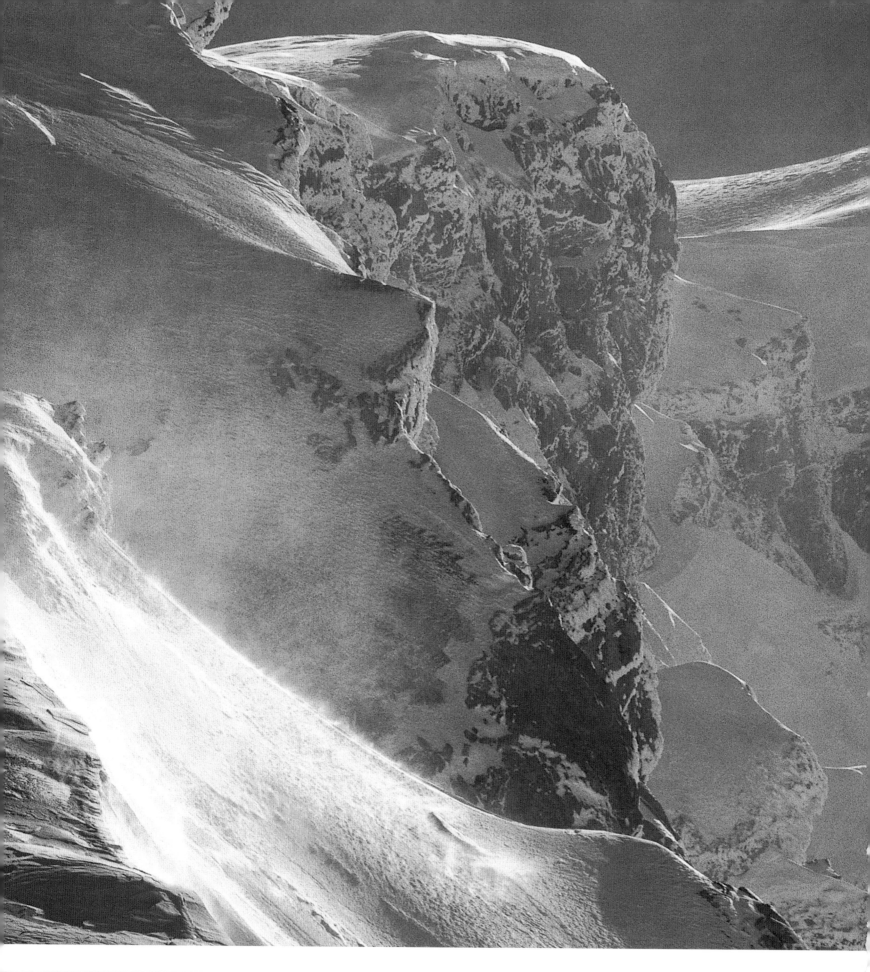

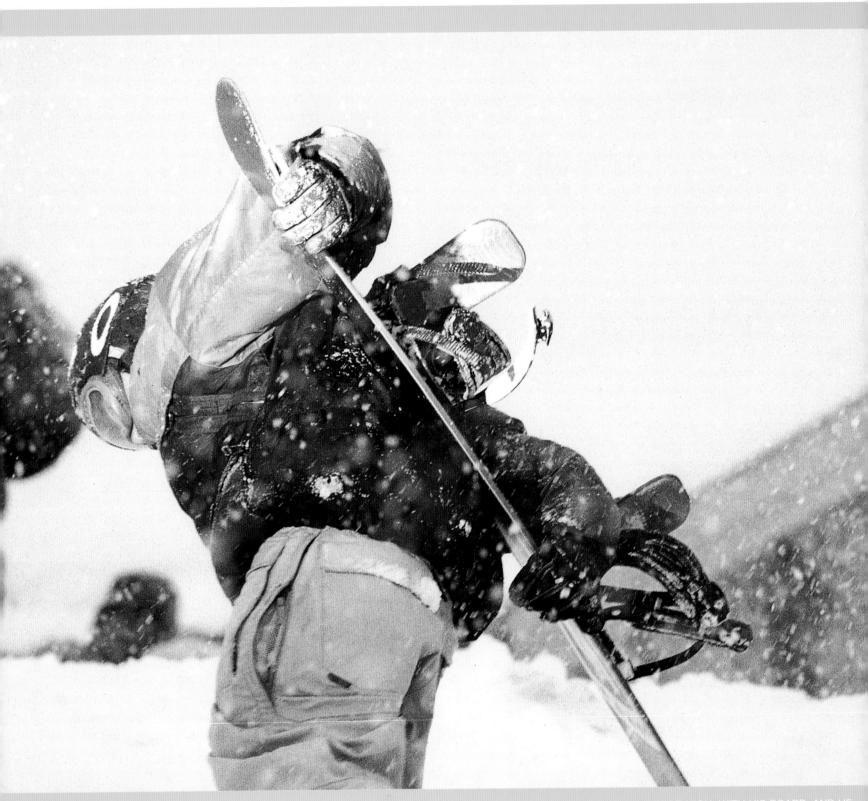

WE WENT TO THIS PARK JUST THE OTHER DAY THAT HAS HANDRAILS ALL OVER IT, AND THERE WAS THIS KID FROM JUNIOR HIGH, WITH HIS BOARD, AND HE CUT CLASS AND BUILT A LITTLE MOUND JUMP. HE WAS THERE ALL ALONE SESSIONING IT WHEN HE SHOULD HAVE BEEN IN CHEMISTRY CLASS. IT WAS SO

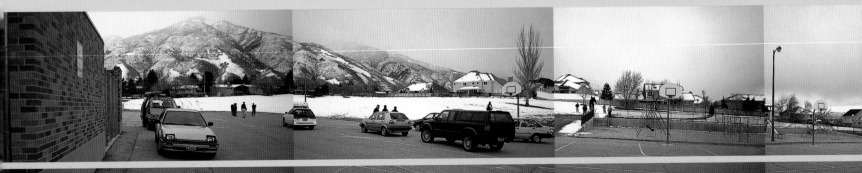

AMAZING. IT'S LIKE SKI RESORTS ARE OBSOLETE, WE DON'T EVEN NEED THEM.
– ANDY WRIGHT

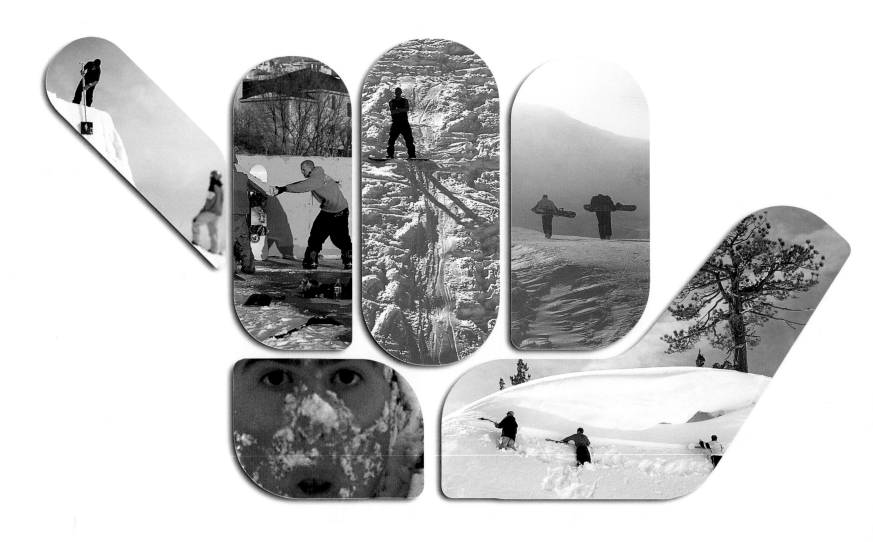

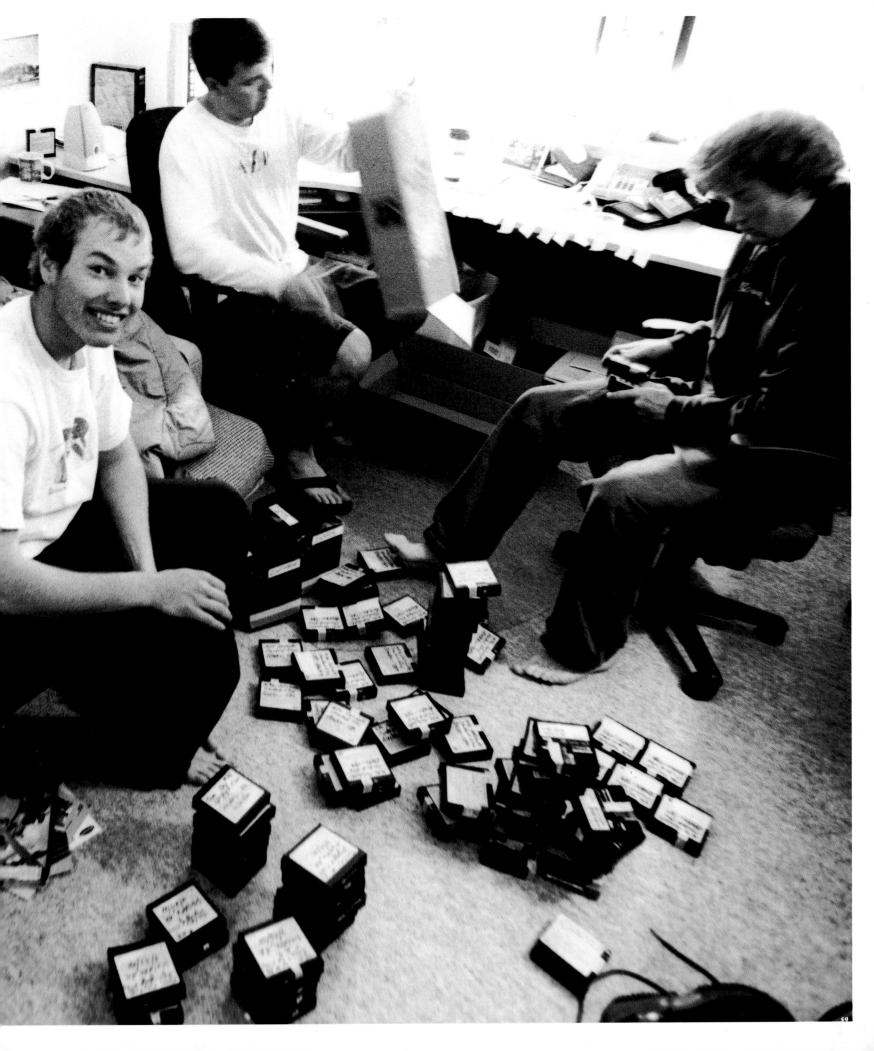

fall Bash

Saturday, October 2, 1999 JAKE'S HOUSE VERMONT

This year the open would be different, different because the pipe was the right type. Most said it was the best open they had ever seen. Finally the day has come i riders natural ability & skills is the limit, not the transition size limiting the ability.

US OPEN : STRATTON mtn. VERMONT. 2000

NIPPON/
OPEN 2000

NIPPON/OPEN 2000 BURTON

The stoner move that almost made me run the Visa for new Nikon equipment.

I was at Baker a few days before the Baker Slalom to shoot with Terje. It was bluebird and pow, but there really isn't much you can do to rally Terje, he pretty much takes his time. He made Norwegian crepes, did a little stretching and yelled at me for eating his cereal.

We made it to the hill at about noon. We did a long hike with Temple Cummins and Barrett Christy up Table Mountain, to a little backcountry spot out of bounds, accessible from Baker. Stuff was pretty shady since we were so late, but the snow was good and we had a good run. The hike out of there is a long flat walk along a creek to the upper parking lot at Baker.

The lot was closed, since the lifts there were not running, but it still had a few cars in it as people park there for the backcountry run. We gathered at the car after the tiring walk and were just hanging out, loading the truck and whatever. Haakon ran into a few Norwegian friends of his so he gave them the phone number to the house where we were staying. We packed up and headed down to Glacier in Sypnewski's truck.

We got down to the house and started unpacking the truck and I realised that my camera bag wasn't there. I freaked. I remember contemplating throwing it in the back of the pick-up but decided it was too bouncy. In my indecision, I had left it in the parking lot behind the truck.

I jumped in Syp's truck and almost killed myself driving up that turning and icy Mount Baker highway. It seemed like it took forever; it's a forty-five-minute drive. I think, I think I did it in about fifteen.

I got up to the parking lot and, of course it was gone, along with most of the cars. There was however a camper van still parked, so I knocked on the door and inquired about the bag and the dude said that he had heard some people outside discussing a bag or something. He said that from their conversation they sounded like they knew whose bag it was. I had done all I could, so I headed home.

On the drive down I came to terms with the $20,000 in lost camera gear. I convinced myself that it was only material, I had the film from the day in my pocket, and everything else could be replaced. Deep somewhere I was actually kind of excited about maybe looking into Nikon gear to replace all of my Canon stuff.

I was still in shock when I got to the house. I decided my next move was to drive to Bellingham to look at camera equipment. Just as we were heading out the door the phone rang. It was a local Washington snowboarder named Ryan who said: "it's your lucky day". Thirty minutes later I met Ryan at some roadside pub on the way to Bellingham, I walked in, introduced myself. I bought him a seven-dollar pitcher of beer, and he handed me back my life.

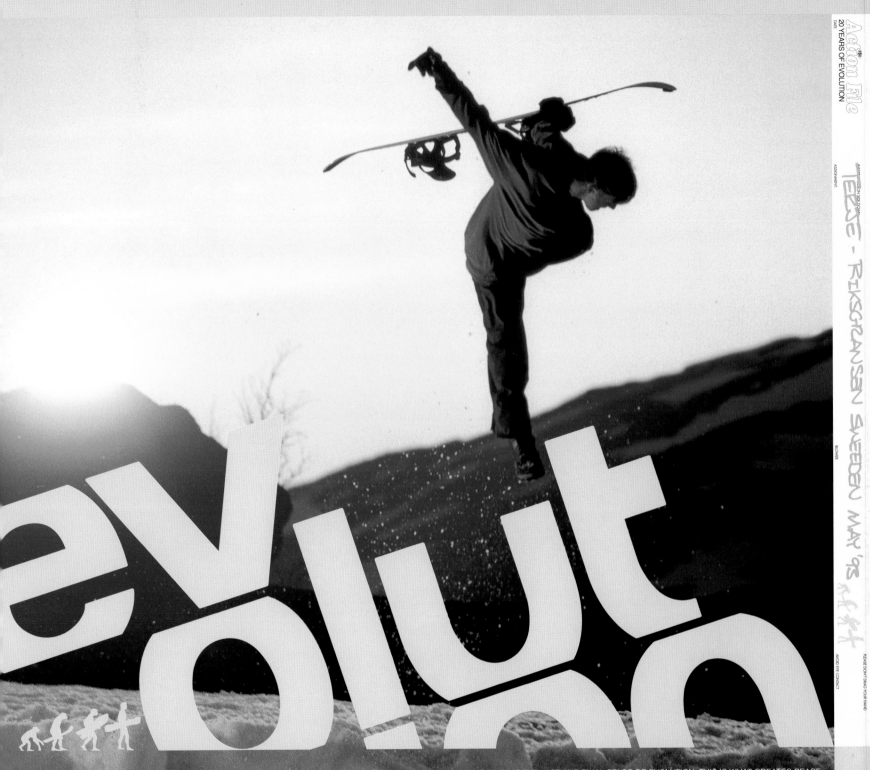

TEESE - RIKSGRANSEN SWEEDEN MAY '93

IT'S HUMAN NATURE TO FEEL THAT THE PRESENT REPRESENTS THE HEIGHT OF AWARENESS AND THAT THE CURRENT STATE IS THE LAST AND FINAL STAGE OF EVOLUTION. THIS IS WHAT CREATES PEACE, COMFORT AND COMPLACENCY AND ALLOWS US TO LEAD NORMAL LIVES. IN CONTRAST, EVOLUTION IS UNSETTLING, UNPREDICTABLE AND FRIGHTENING. CHANGE CAN COME FROM ANYWHERE, AND USUALLY FROM THE LAST PLACE IT'S EXPECTED. AS TIME PASSES, VISIONARIES STEP FORWARD TO CHALLENGE THE STATUS QUO. IN SNOWBOARDING, VISIONARIES PUSH THE ENVELOPE, BRINGING THE SPORT TO NEW HEIGHTS, DISTANCES AND LEVELS OF DIFFICULTY.

AS WE INCH INTO THE FUTURE WE HAVE THE OPPORTUNITY TO LOOK BACK AND SEE EVOLUTION AS PROGRESS IN A LOGICAL AND LINEAR PATTERN, AND LAUGH AT THE APPARENT LACK OF VISION OF OUR FOREBEARS. IT'S EASY TO FORGET THAT THEY DIDN'T HAVE THE BENEFIT OF HINDSIGHT.

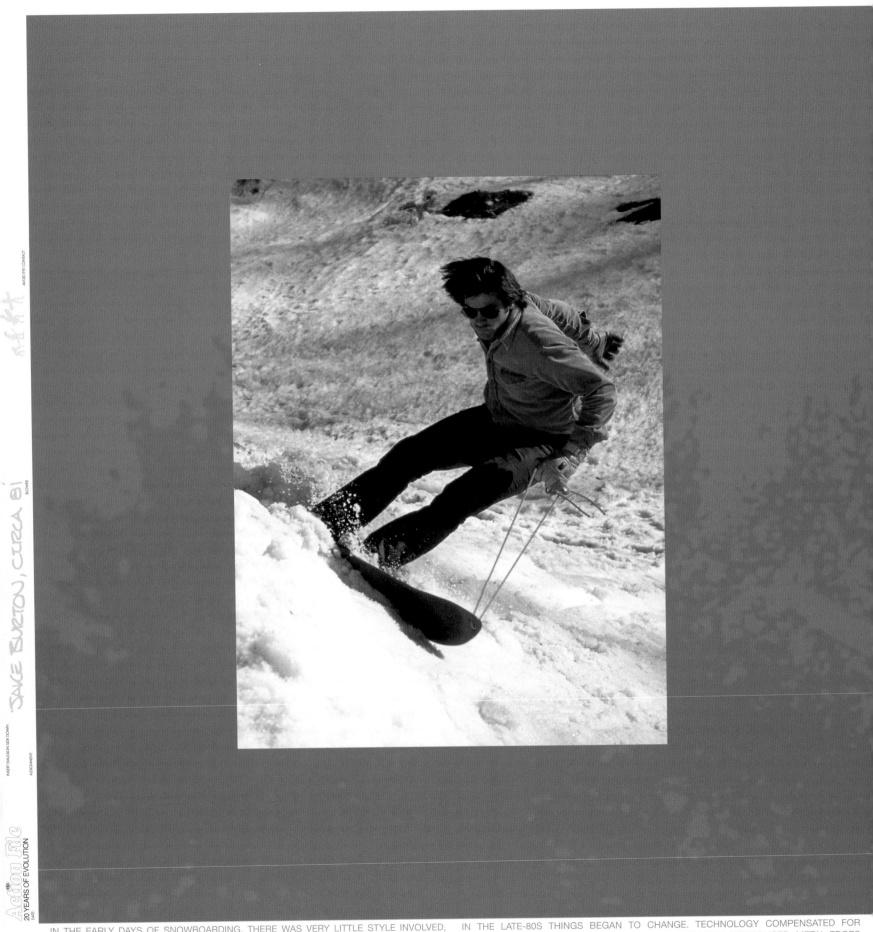

"SAGE BURTON, CIRCA 81'
BLOWER
ASSIGNMENT:
INSERT EMULSION SIDE DOWN
AVOID EYE CONTACT

IN THE EARLY DAYS OF SNOWBOARDING, THERE WAS VERY LITTLE STYLE INVOLVED, THERE WAS NO HISTORY TO DRAW FROM, AND EVEN THE PIONEERS WEREN'T REALLY SURE WHAT IT WAS THAT THEY WERE TRYING TO DO. FOR THE PHOTOGRAPHER, IT WAS SIMPLY A MATTER OF GETTING A PHOTO OF SOMEONE STANDING UP OR TURNING, WHICH IN THE DAYS OF NO BINDINGS WAS A PIONEERING EFFORT.

IN THE LATE-80S THINGS BEGAN TO CHANGE. TECHNOLOGY COMPENSATED FOR WEAKNESS IN HUMAN PHYSIOLOGY, THE HIGHBACK WAS INTRODUCED, METAL EDGES BECAME STANDARD AND TRICKS WERE INVENTED, BORROWED OR STOLEN FROM SKATEBOARDING. SNOWBOARDING HAD BECOME A WINTER-SPORT LIKE SKIING, WHERE FORM AND TECHNIQUE WAS FAR MORE IMPORTANT THAN SCALE. FOR A TIME IT WAS

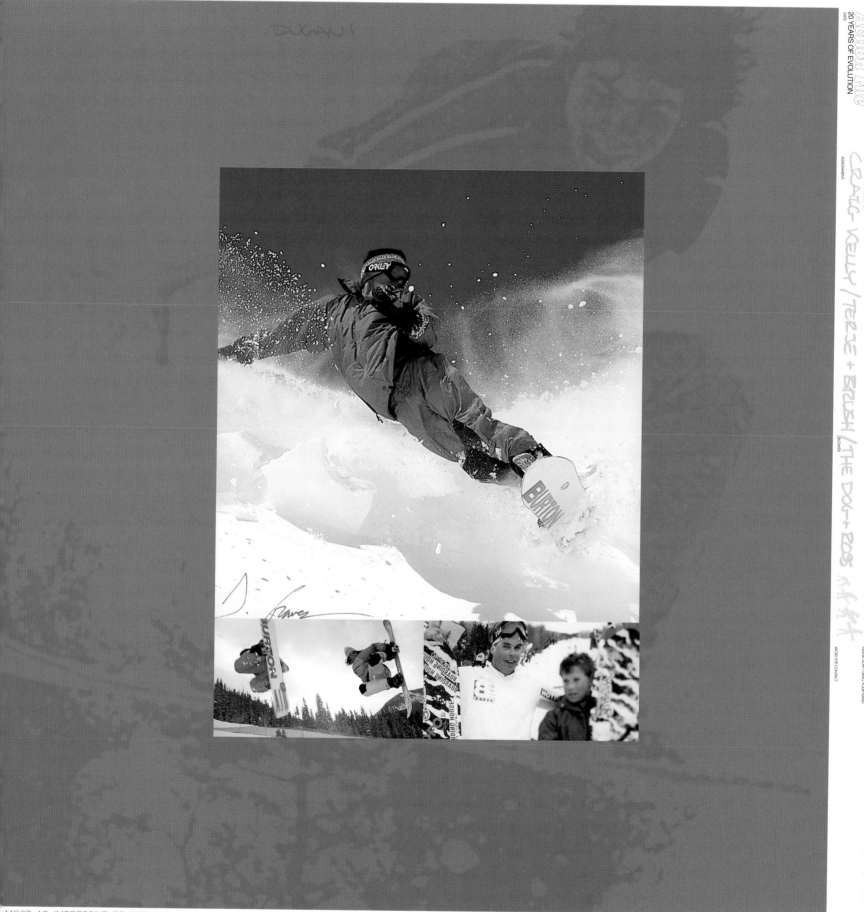

action file
20 YEARS OF EVOLUTION
DATE

RIDER: ERIKSSON (DER DOWN)
CRAIG KELLY / TERJE + BRUSH (THE DOG + ROS
ASSIGNMENT: BLOWER

PLEASE DON'T DRAG YOUR HAND

AVOID EYE CONTACT

LMOST AS IMPRESSIVE TO SEE A "TAIPAN" ON A TRAMPOLINE AS ON SNOW AND
OCKEY STOPS" QUALIFIED AS POWDER TURNS. IF THE LIP WAS INCLUDED IN THE
HOTO BY THE PHOTOGRAPHER IT WAS GENERALLY CROPPED OUT BY THE DESIGNER
O AS TO FOCUS ON THE FORM OF THE RIDER OR TO CLEARLY READ THE BRANDING.

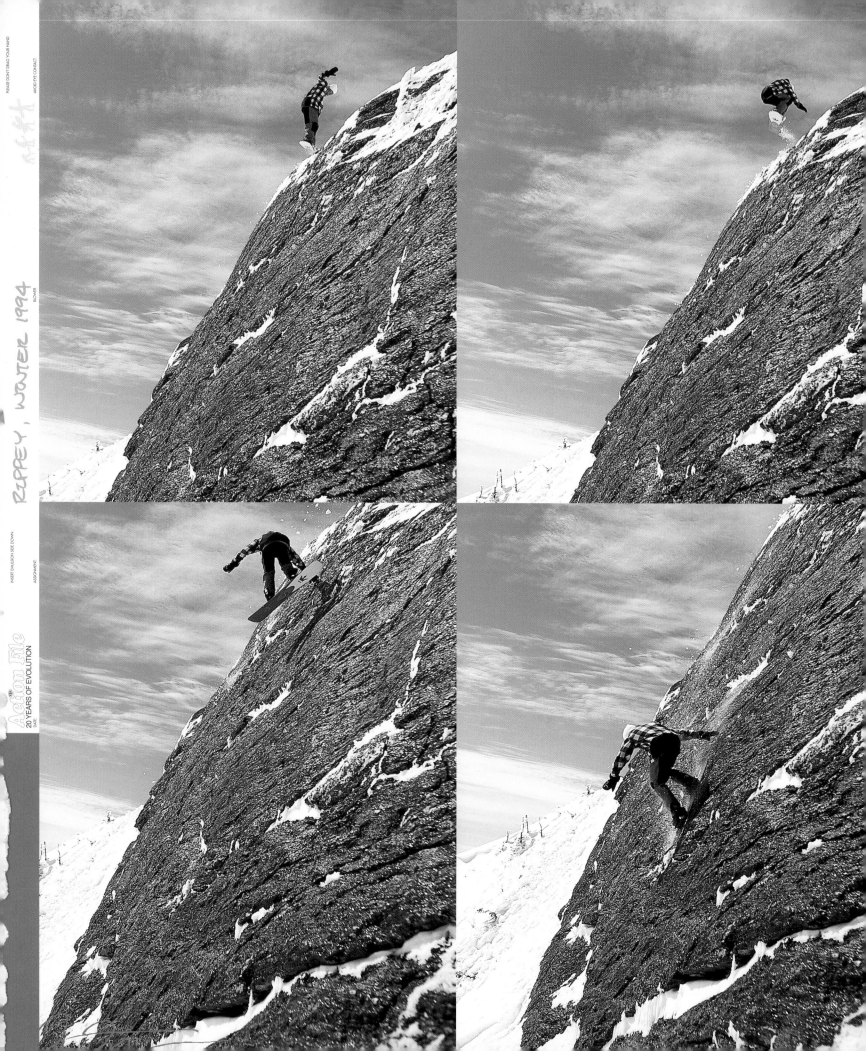

RIPPEY, WINTER 1994

Action File
20 YEARS OF EVOLUTION

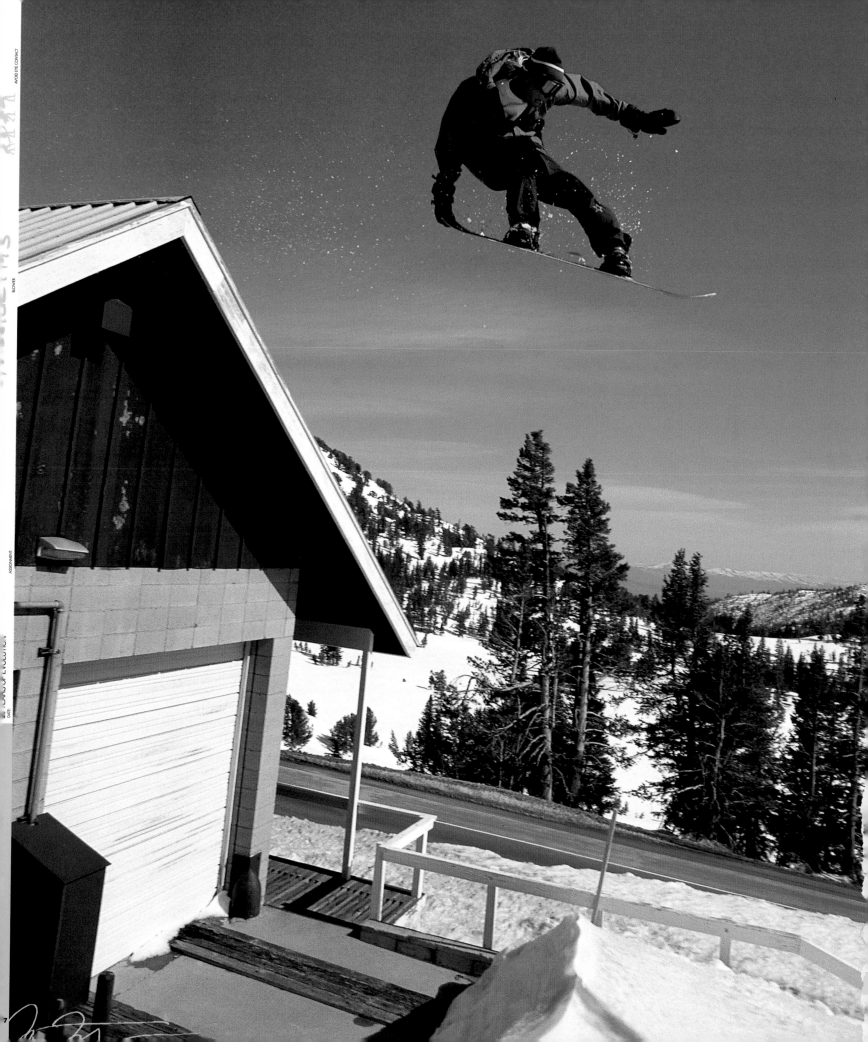

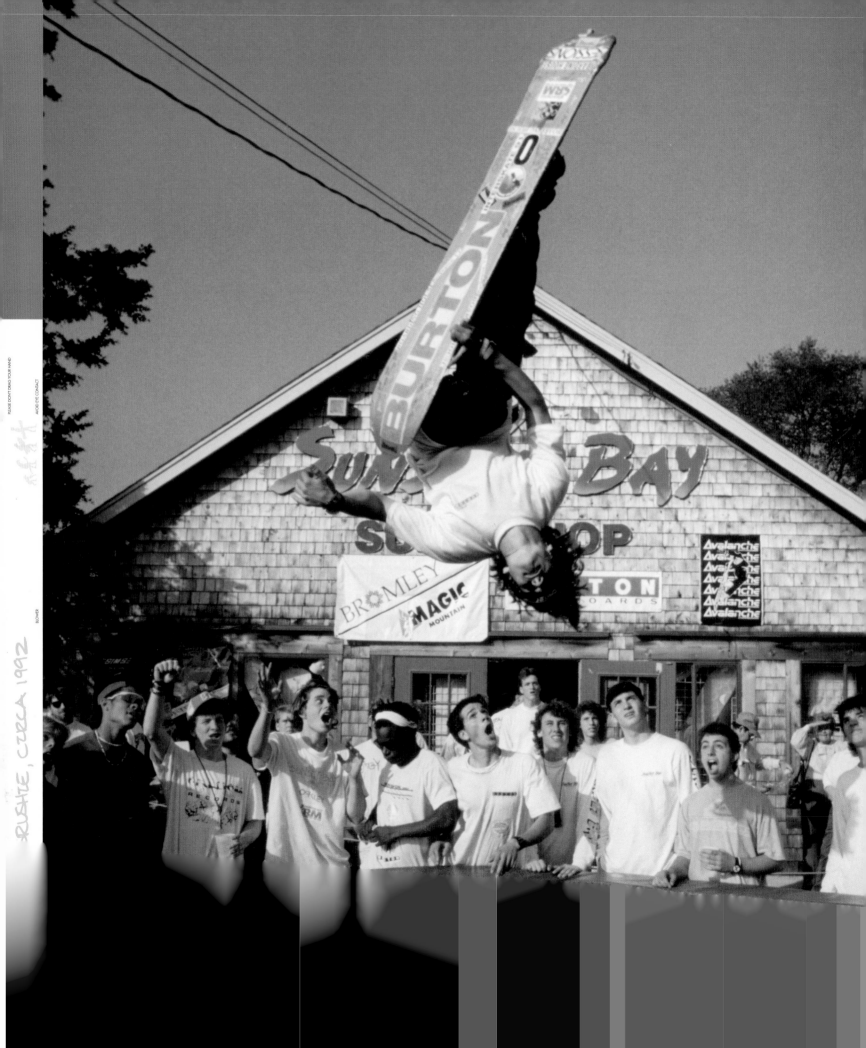

RUSHIE, CIRCA 1992

BLOWER

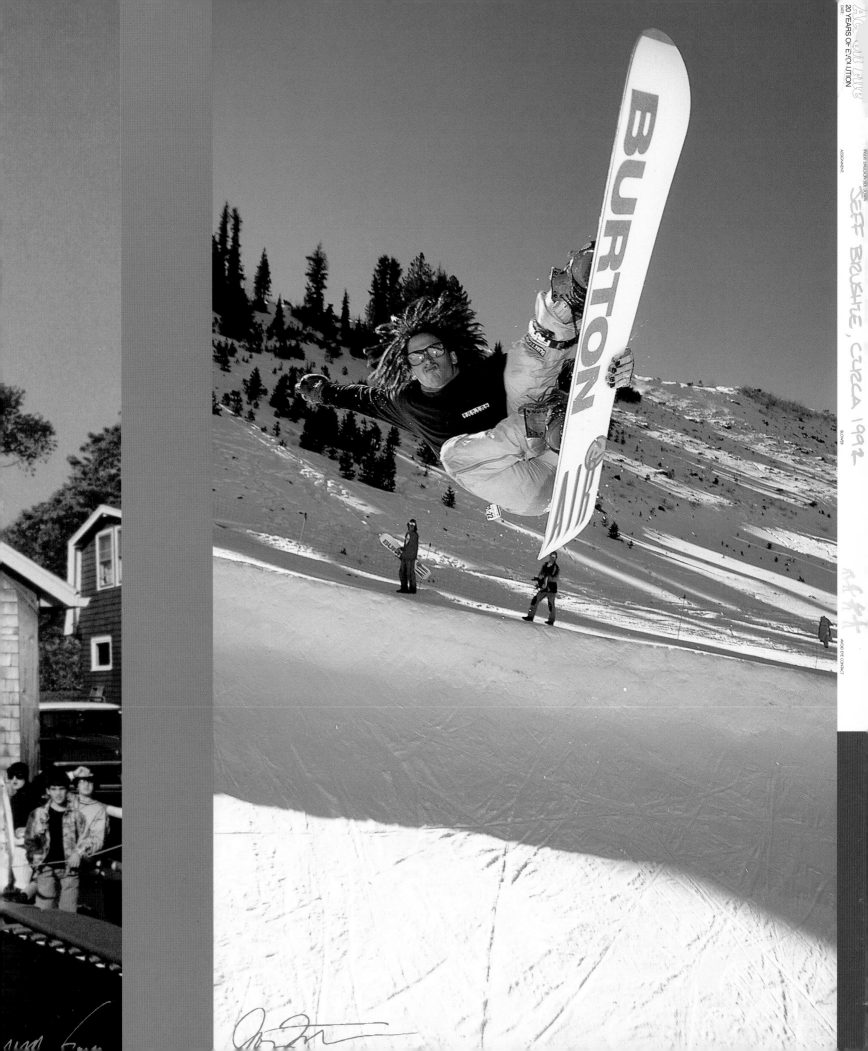

JEFF BRUSHIE, CIRCA 1992

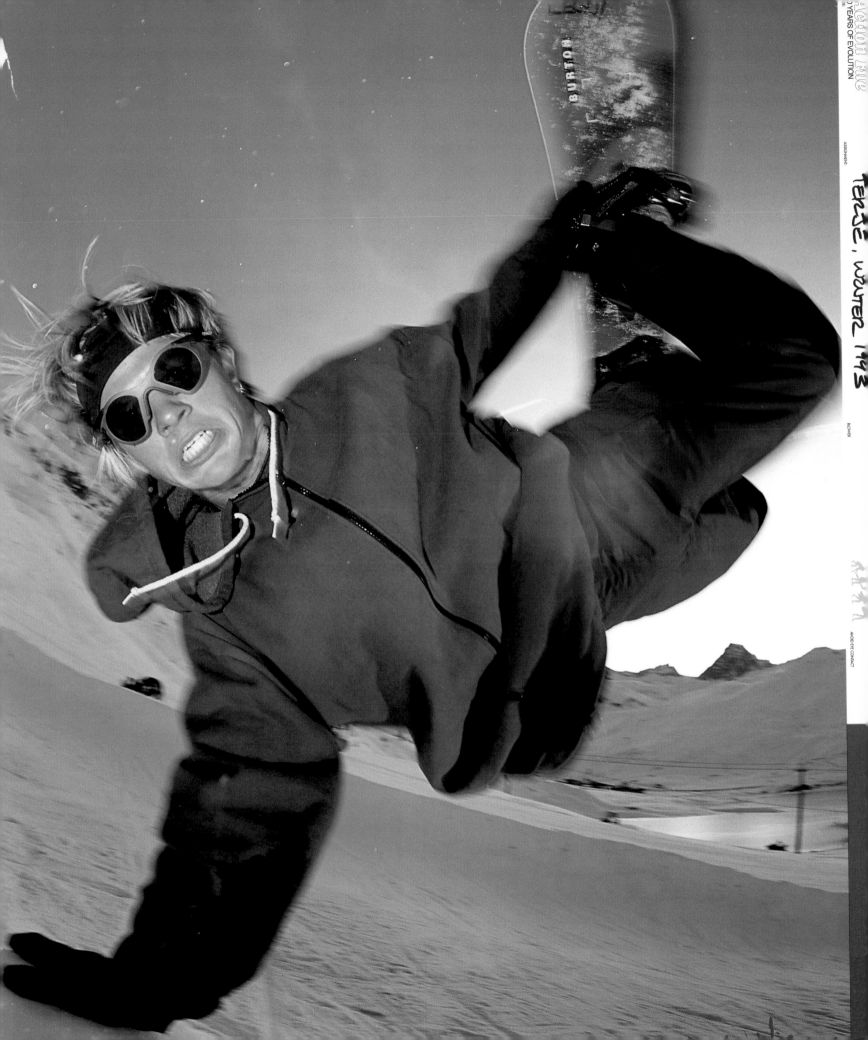

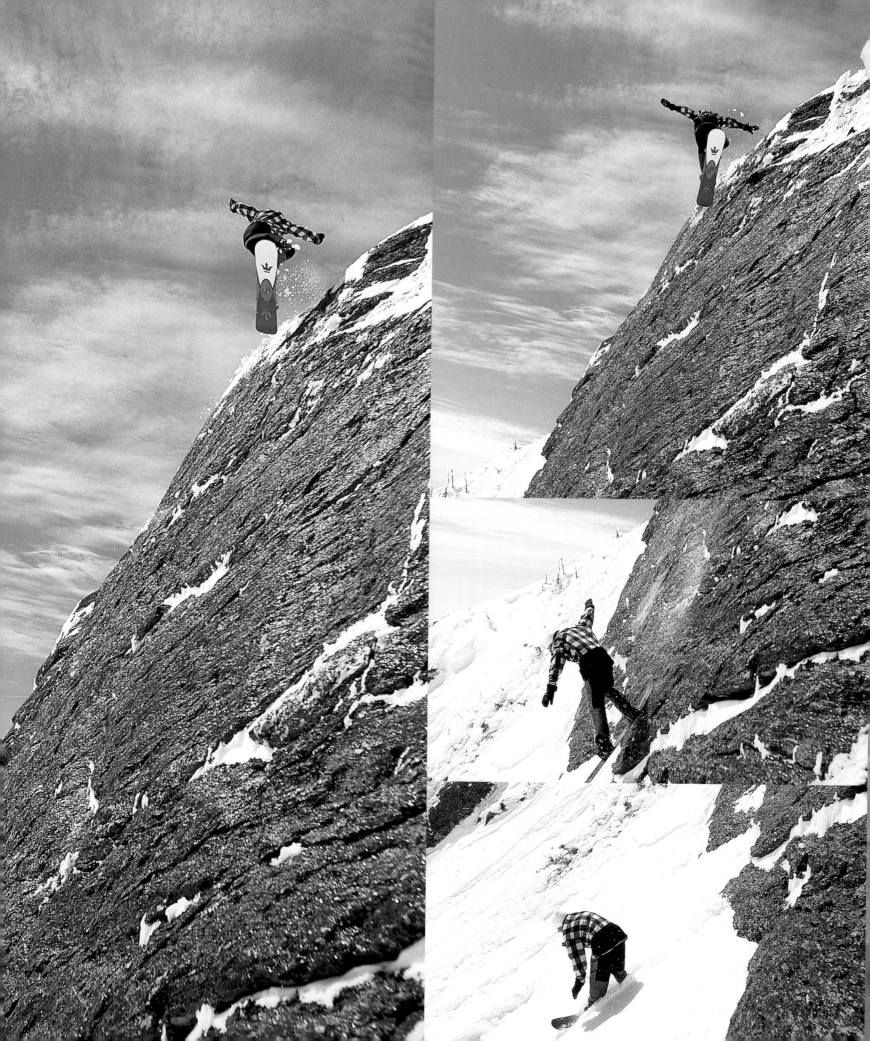

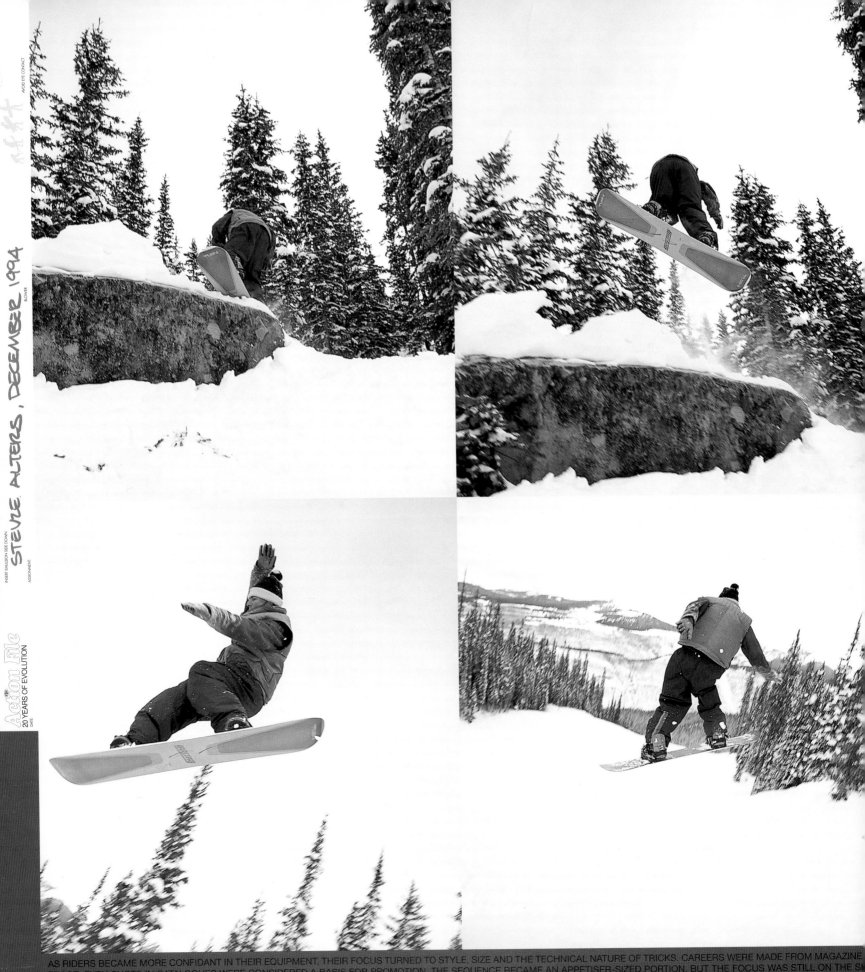

AVOID EYE CONTACT

STEVIE ALTERS, DECEMBER 1994

BLOWER

INSERT EMULSION SIDE DOWN

ASSIGNMENT:

Action File

20 YEARS OF EVOLUTION

DATE:

AS RIDERS BECAME MORE CONFIDANT IN THEIR EQUIPMENT, THEIR FOCUS TURNED TO STYLE, SIZE AND THE TECHNICAL NATURE OF TRICKS. CAREERS WERE MADE FROM MAGAZINE ERAGE; EVEN SHOTS IN CATALOGUES WERE CONSIDERED A BASIS FOR PROMOTION. THE SEQUENCE BECAME AN APPETISER-SIZED PORTION, BUT THE FOCUS WAS STILL ON THE S CAREER-MAKING BANGER IN THE MAG. THE VIDEO GUY WAS PUSHED INTO THE BACKGROUND, BEHIND THE PHOTOGRAPHER OR DITCHED IN THE PARKING LOT. THE CHALLENGE A FOR THE PHOTOGRAPHER TO MAKE THINGS LOOK BIGGER AND PRETTIER. CAMERAS WERE SLOWER (3.5-5 FRAMES PER SECOND) AND AIRS WERE LOWER. SEQUENCES CONSISTE FIVE TO EIGHT FRAMES AND USUALLY THE APEX OF THE TRICK HAD TO BE A SECOND SHOT TO GET THE GRAB AND TWEAK IN THE RIGHT SPOT. THIS WAS THE PHOTOGRAPHER'S HE A ROLL OF FILM COULD POTENTIALLY HOLD SIX SEQUENCES.

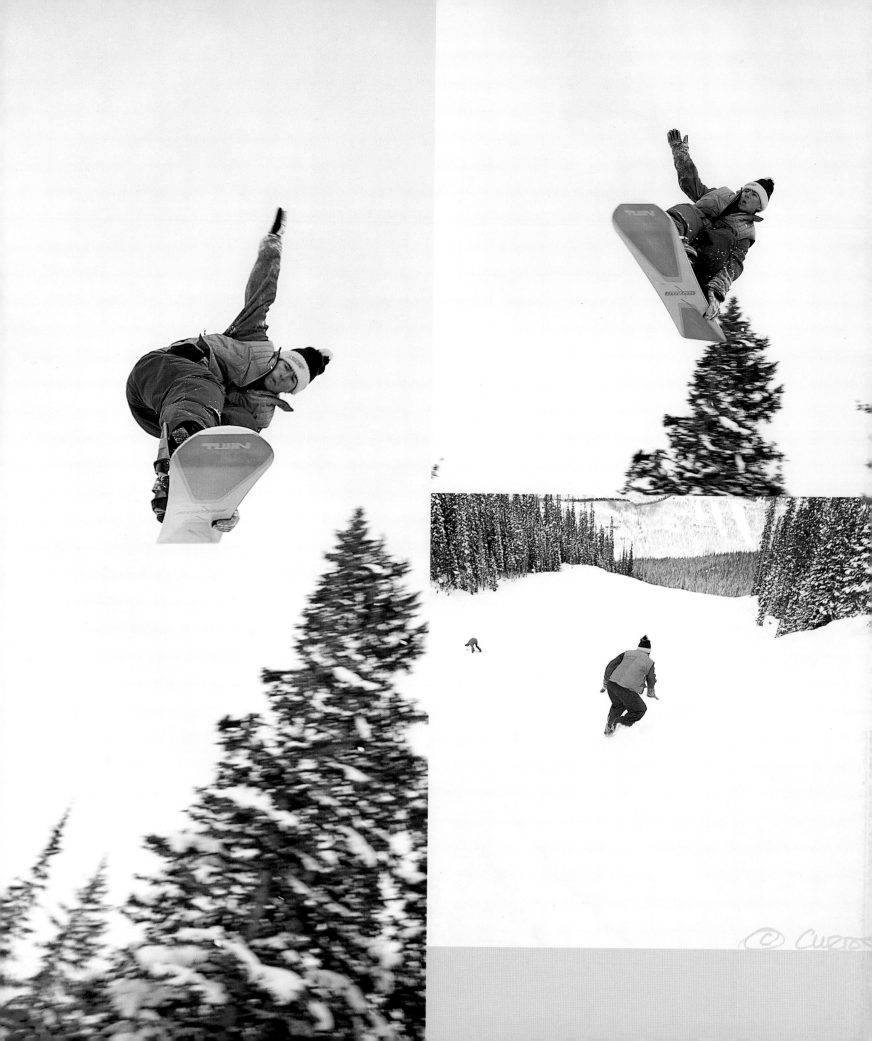

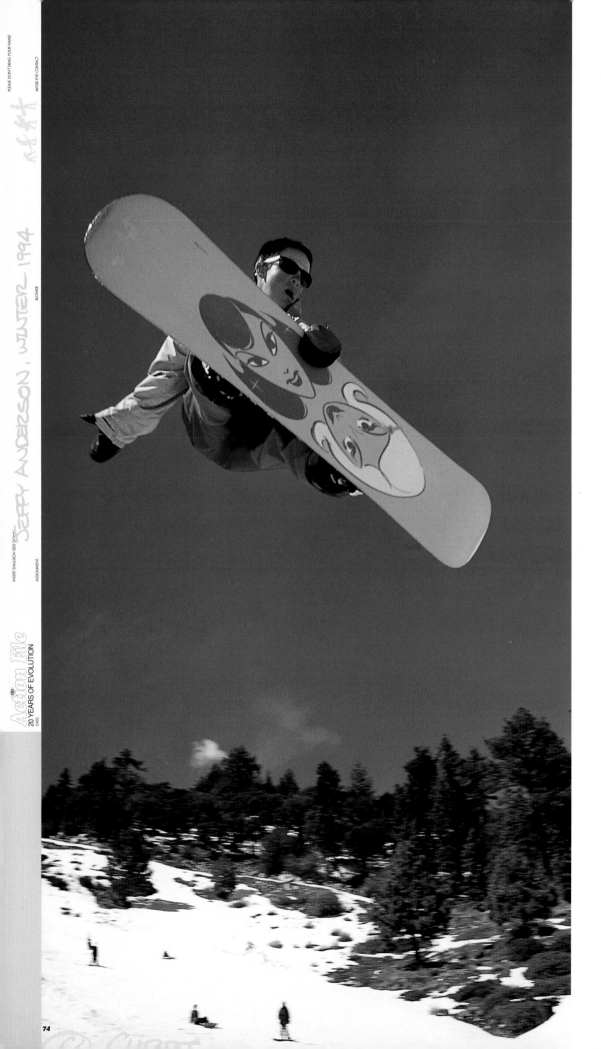

PLEASE DON'T DRAG YOUR HAND

AVOID EYE CONTACT

秋秋秋秋

JEFFY ANDERSON, WINTER 1994

BLOWER

INSERT EMULSION SIDE DOWN

ASSIGNMENT:

Action File
20 YEARS OF EVOLUTION
DATE:

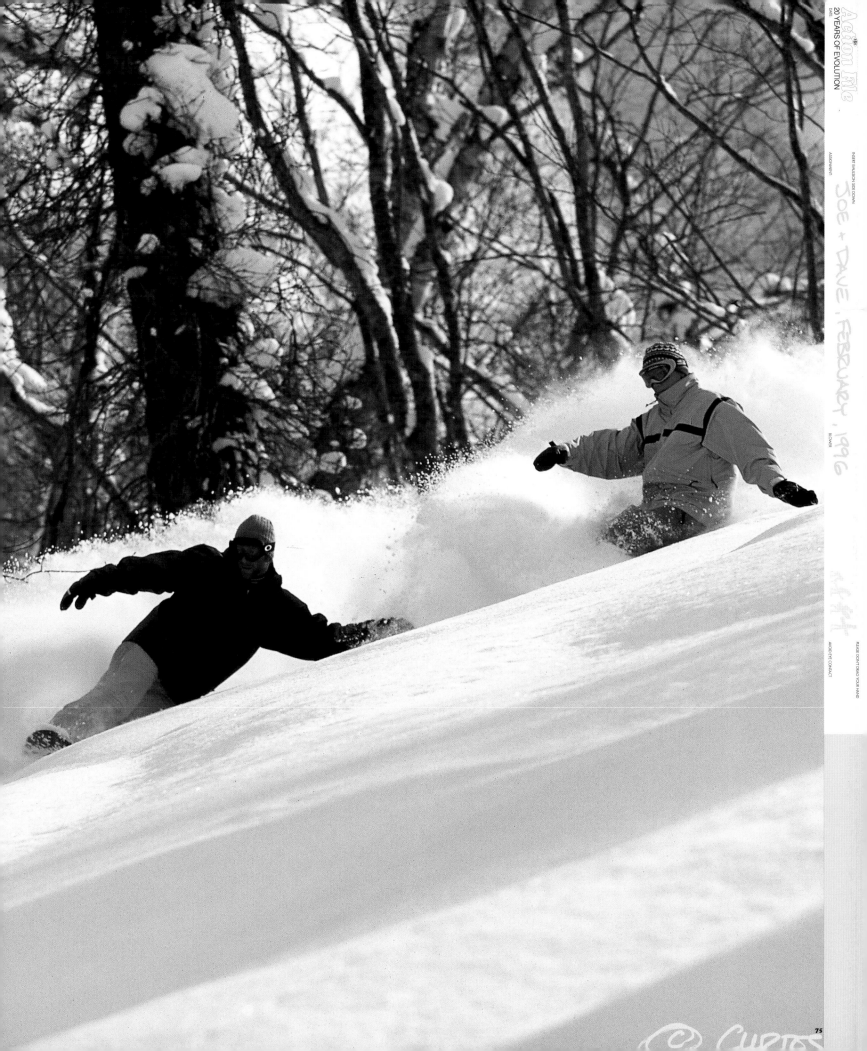

INSERT EMULSION SIDE DOWN

ASSIGNMENT:

DATE:

JOE + DAVE, FEBRUARY, 1996

BLOWER

PLEASE DON'T DRAG YOUR HAND

AVOID EYE CONTACT

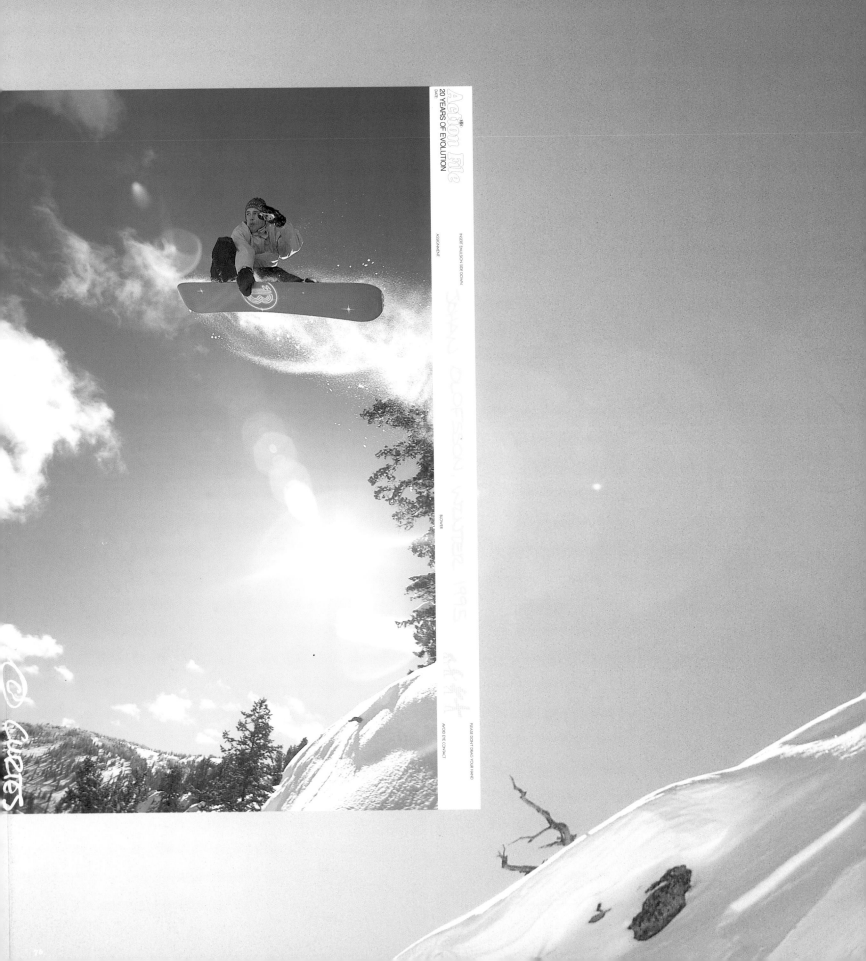

INSERT EMULSION SIDE DOWN

ASSIGNMENT

INGEMAR OLOFSSON, WINTER 1995

BLOWER

PLEASE DON'T DRAG YOUR HAND

AVOID EYE CONTACT

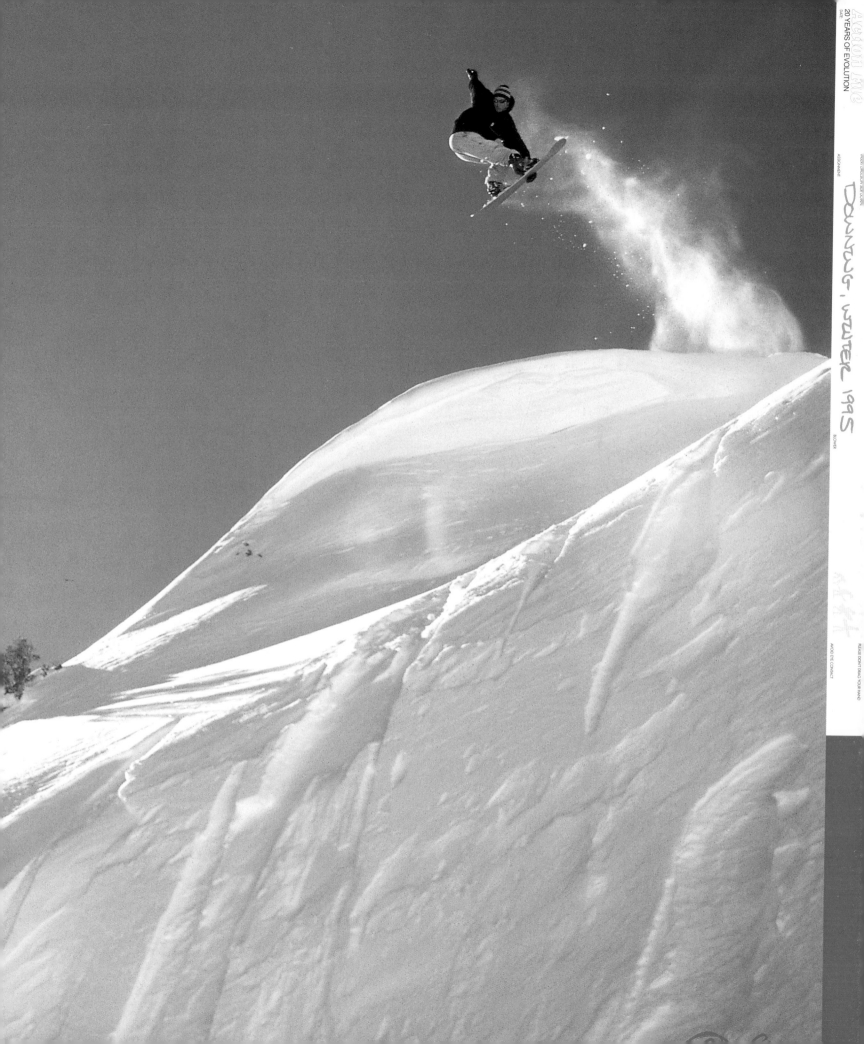

DOWNING, WINTER 1995

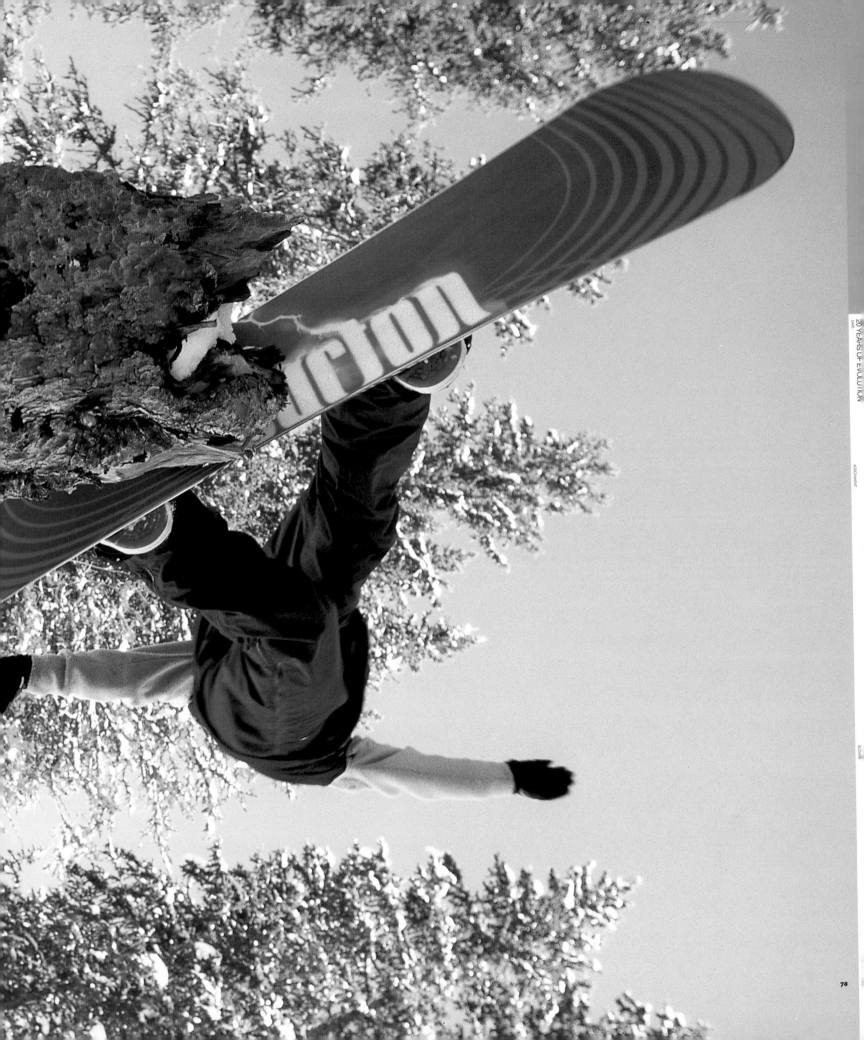

AN ANOMALY TO THE ENTIRE EQUATION IS THE JIB, WHICH CAN'T BE EXPLAINED IN TERMS OF ANYTHING HISTORICALLY RELATED TO WINTER SPORTS. IT WAS CLEARLY BORROWED FROM SKATEBOARDING AND TRANSFERRED TO SNOW AT A TIME WHEN SNOWBOARDING WAS TAKING ITSELF TOO SERIOUSLY. SUDDENLY, VISIONARIES WERE LEAVING THE RACECOURSE AND THE TRAILS TO SEEK OUT STUMPS, ROCKS AND LOGS. THE VERY SAME "UNMARKED OBSTACLES" THAT THE FINE PRINT ON YOUR SKI PASS WARNED YOU ABOUT. THE ACT OF WILFULLY DESTROYING YOUR OWN EQUIPMENT AND INTENTIONALLY TRYING TO RIDE OBSTACLES THAT ARE TRADI-TIONALLY EQUATED WITH DEATH AND INJURY DEFIED CONVENTIONAL WISDOM AND MADE IT CLEAR THAT SNOWBOARDING WAS NOT SKIING. IN THE EARLY DAYS IT WAS A CHALLENGE BEYOND JUST THE ACT OF JIBBING

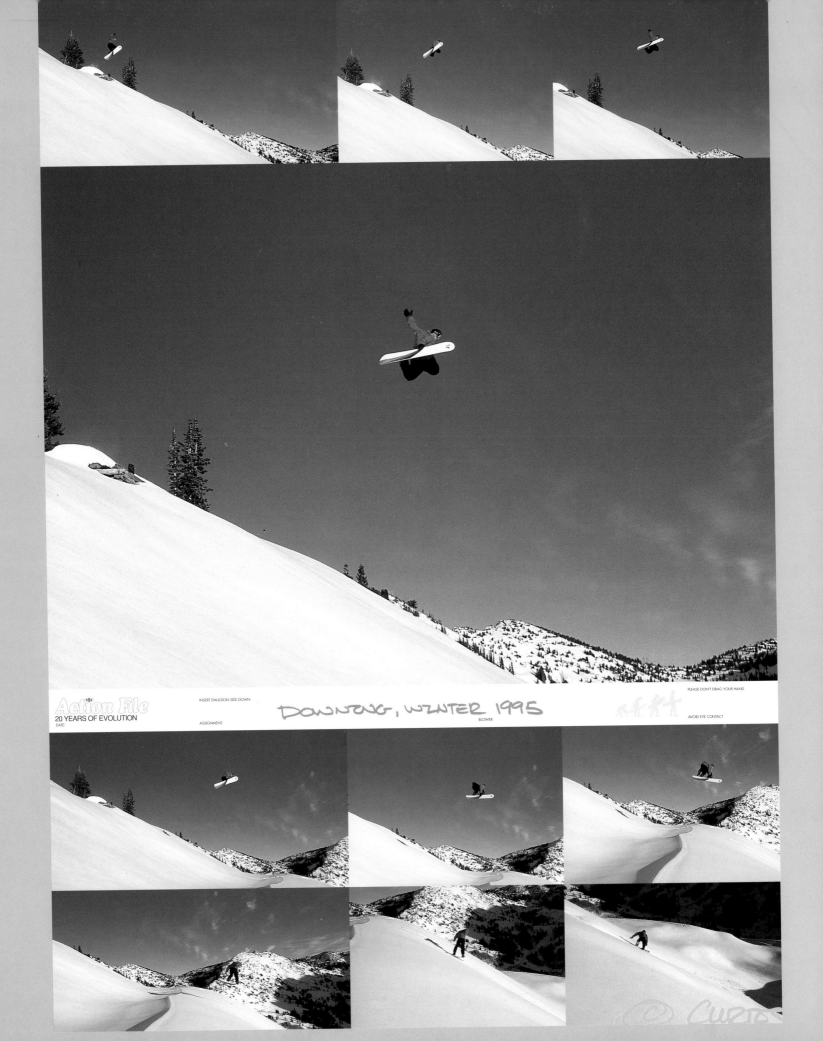

INSERT EMULSION SIDE DOWN

ASSIGNMENT:

DOWNING, WINTER 1995

BLOWER

PLEASE DON'T DRAG YOUR HAND

AVOID EYE CONTACT

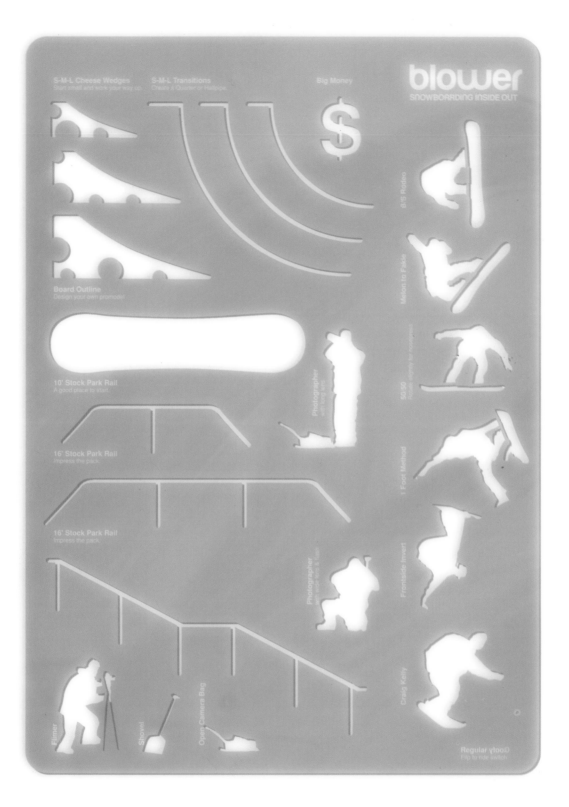

blower
SNOWBOARDING INSIDE OUT

S-M-L Cheese Wedges
Start small and work your way up.

S-M-L Transitions
Create a Quarter or Halfpipe.

Big Money

Board Outline
Design your own promodel

10' Stock Park Rail
A good place to start.

16' Stock Park Rail
Impress the pack.

16' Stock Park Rail
Impress the pack.

Filmer

Shovel

Open Camera Bag

Photographer
with long lens

Photographer
with wide-angle & flash

B/S Rodeo

Melon to Fakie

50-50

1 Foot Method

Frontside Invert

Craig Kelly

Regular ylooD
Flip to ride switch

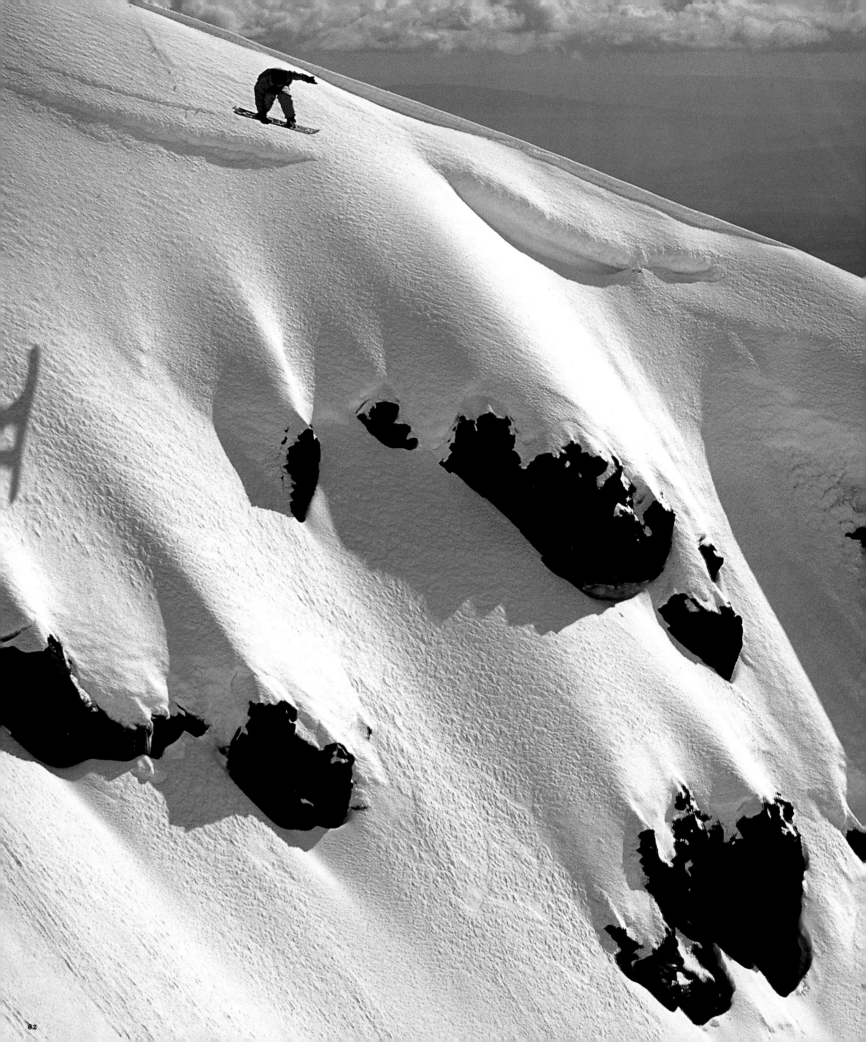

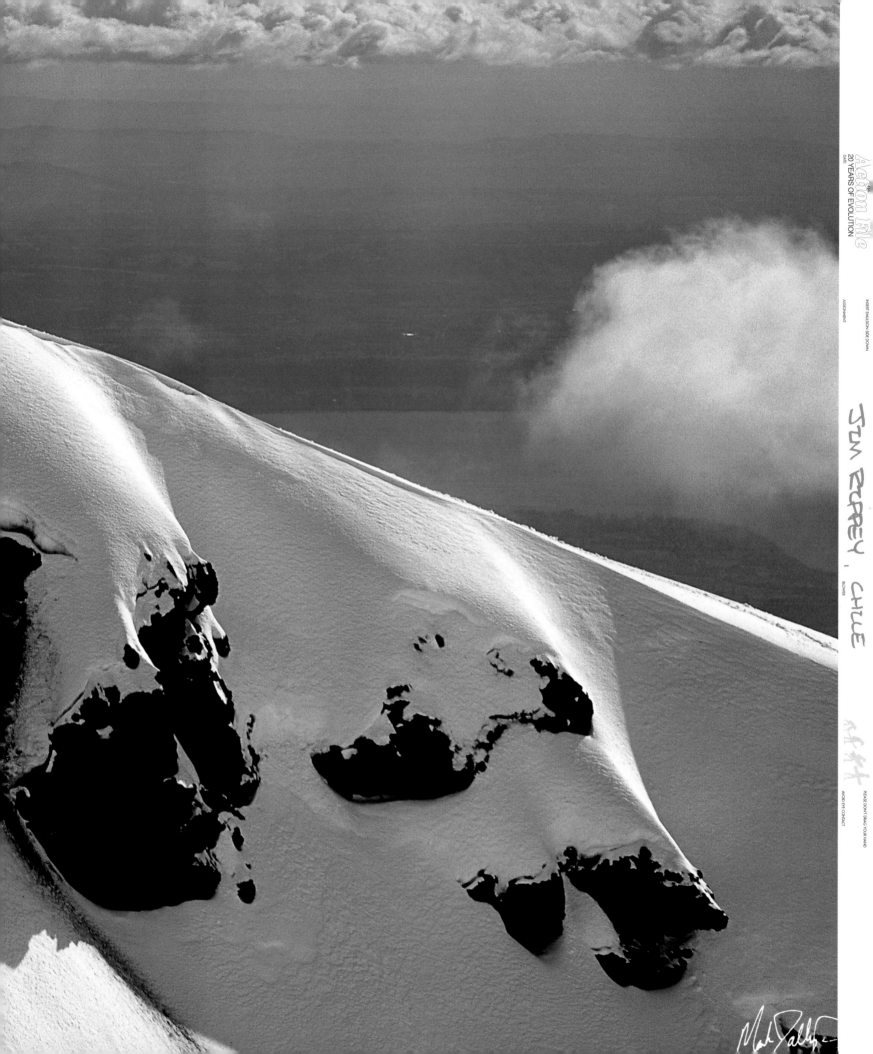

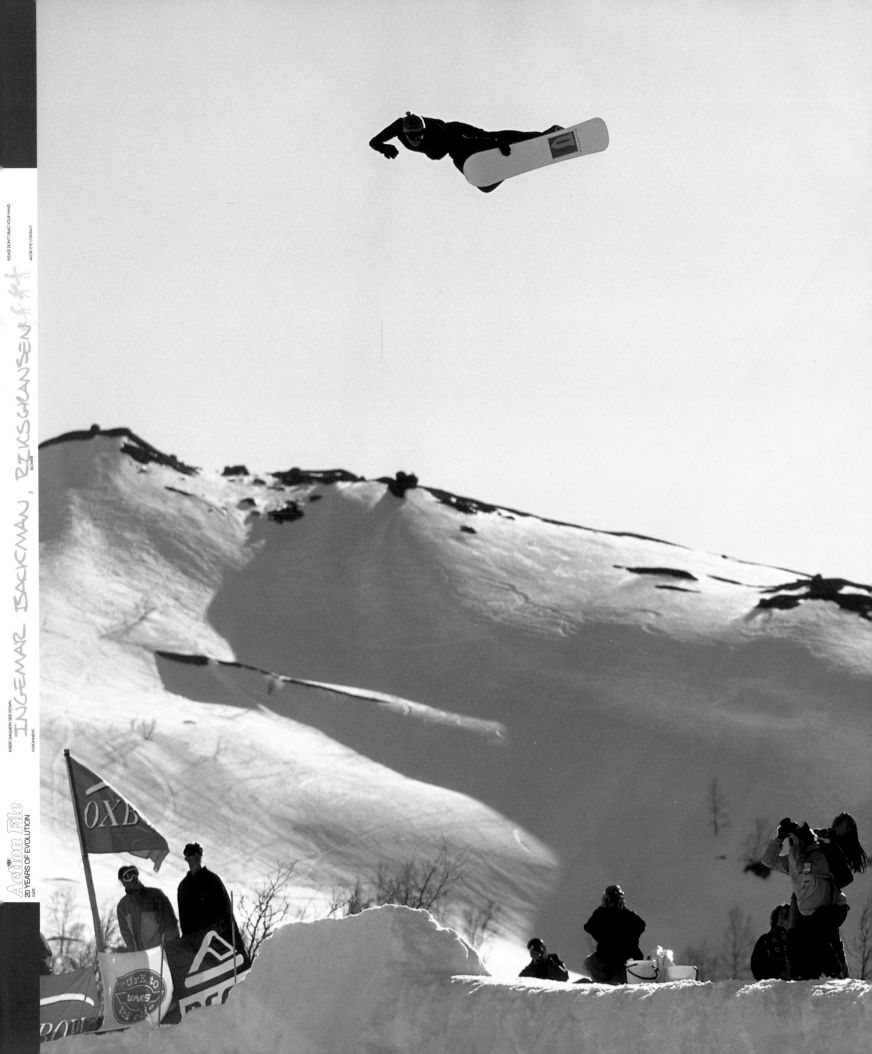

INGEMAR BACKMAN, RIKSGRANSEN

INSERT EMULSION SIDE DOWN
ASSIGNMENT:
DATE:

PLEASE DON'T DRAG YOUR HAND
AVOID EYE CONTACT
BLOWER

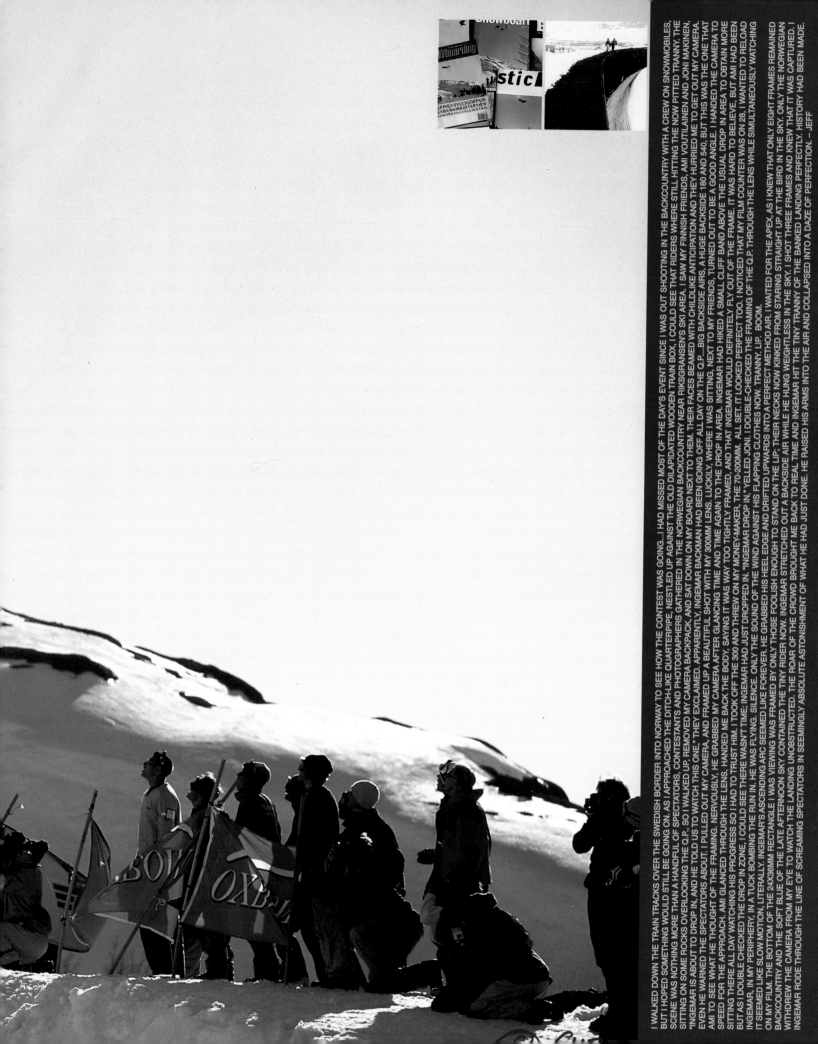

I WALKED DOWN THE TRAIN TRACKS OVER THE SWEDISH BORDER INTO NORWAY TO SEE HOW THE CONTEST WAS GOING...I HAD MISSED MOST OF THE DAY'S EVENT SINCE I WAS OUT SHOOTING IN THE BACKCOUNTRY WITH A CREW ON SNOWMOBILES, BUT I HOPED SOMETHING WOULD STILL BE GOING ON. AS I APPROACHED THE DITCH-LIKE QUARTERPIPE, NESTLED UP AGAINST THE OLD DILAPIDATED WOODEN TRAIN BOX, I COULD SEE THAT RIDERS WHERE STILL HITTING THE NOW PITTED TRANNY. THE SCENE WAS NOTHING MORE THAN A HANDFUL OF SPECTATORS, CONTESTANTS AND PHOTOGRAPHERS GATHERED IN THE NORWEGIAN BACKCOUNTRY NEAR RIKSGRANSEN'S SKI AREA. I SAW MY FINNISH FRIENDS, AMI VOUTILAINEN AND JONI MAKINEN, SITTING ON SOME ROCKS OVERLOOKING THE Q.P., SO I WALKED UP, REMOVED MY CAMERA BACKPACK, AND SAT DOWN ON MY BOARD NEXT TO THEM. THEIR FACES BEAMED WITH CHILD-LIKE ANTICIPATION AND THEY HURRIED ME TO GET OUT MY CAMERA. "INGEMAR IS ABOUT TO DROP IN, AND HE TOLD US TO WATCH THIS ONE," THEY EXCLAIMED. APPARENTLY, INGEMAR BACKMAN HAD BEEN GOING OFF ALL DAY ON THE Q.P....BIG BACKSIDE AIRS, A HUGE BACKSIDE 180 AND 540. BUT THIS WAS THE ONE THAT AMI TO SEE WHAT HE WARNED THE SPECTATORS ABOUT. I PULLED OUT MY CAMERA, AND FRAMED UP A BEAUTIFUL SHOT WITH MY 300MM LENS. LUCKILY, WHERE I WAS SITTING, NEXT TO MY FRIENDS, TURNED OUT TO BE A GOOD ANGLE. I HANDED THE CAMERA TO AMI TO SEE WHAT HE THOUGHT OF THE FRAMING. NERVOUSLY, HE GRABBED MY CAMERA AFTER GLANCING TIME AND TIME AGAIN TO THE DROP IN AREA. INGEMAR HAD HIKED A SMALL CLIFF BAND ABOVE THE USUAL DROP IN AREA TO OBTAIN MORE SPEED FOR THE APPROACH. AMI GLANCED THROUGH THE LENS, HANDED ME BACK THE BODY, SAYING IT WAS WAY TOO TIGHTLY FRAMED, AND THAT INGEMAR WOULD DEFINITELY FLY OUT OF THE FRAME. IT WAS HARD TO BELIEVE, BUT AMI HAD BEEN SITTING THERE ALL DAY WATCHING HIS PROGRESS SO I HAD TO TRUST HIM. I TOOK OFF THE 300 AND THREW ON MY MONEY-MAKER, THE 70-200MM. ALL SET. IT LOOKED PERFECT TOO. I NOTICED THAT MY FILM COUNTER WAS ON 28. I WANTED TO RELOAD BUT AS I DOUBLE CHECKED THE DROP IN ZONE, I COULD SEE THERE WASN'T TIME; INGEMAR HAD JUST DROPPED IN. "INGEMAR DROP IN," YELLED JONI. I DOUBLE-CHECKED THE FRAMING OF THE Q.P. THROUGH THE LENS WHILE SIMULTANEOUSLY WATCHING INGEMAR, IN MY PERIPHERY, IN A TUCK BOMBING THE RUN IN. HE WAS FLYING. SILENCE. ONLY THE SOUND OF THE WIND AGAINST HIS FLAPPING CLOTHES NOW. TRANNY. LIP. BOOM. IT SEEMED LIKE SLOW MOTION, LITERALLY. INGEMAR'S ASCENDING ARC SEEMED LIKE FOREVER. HE GRABBED HIS HEEL EDGE AND DRIFTED UPWARDS INTO A PERFECT METHOD AIR. I WAITED FOR THE APEX, AS I KNEW THAT ONLY EIGHT FRAMES REMAINED ON MY FILM. THE BOTTOM OF THE 24X36MM RECTANGLE I WAS VIEWING WAS FRAMED BY ONLY THOSE FOOLISH ENOUGH TO STAND ON THE LIP; THEIR NECKS NOW KINKED FROM STARING STRAIGHT UP AT THE BIRD IN THE SKY. ONLY THE NORWEGIAN BACKCOUNTRY AND THE SOFT BLUE OF THE LATE AFTERNOON SKY CONTAINED THE TINY RIDER NOW. INGEMAR STRETCHED OUT A BACKSIDE AIR WHILE HE HUNG WEIGHTLESS IN THE SKY. I SHOT THREE FRAMES AND KNEW THAT IT WAS CAPTURED. I WITHDREW THE CAMERA FROM MY EYE TO WATCH THE LANDING UNOBSTRUCTED. THE ROAR OF THE CROWD BROUGHT ME BACK TO REAL TIME AND INGEMAR HIT THE TINY TRANNY OF THE BANKED LANDING PERFECTLY. HISTORY HAD BEEN MADE. INGEMAR RODE THROUGH THE LINE OF SCREAMING SPECTATORS IN SEEMINGLY ABSOLUTE ASTONISHMENT OF WHAT HE HAD JUST DONE. HE RAISED HIS ARMS INTO THE AIR AND COLLAPSED INTO A DAZE OF PERFECTION. – JEFF

85

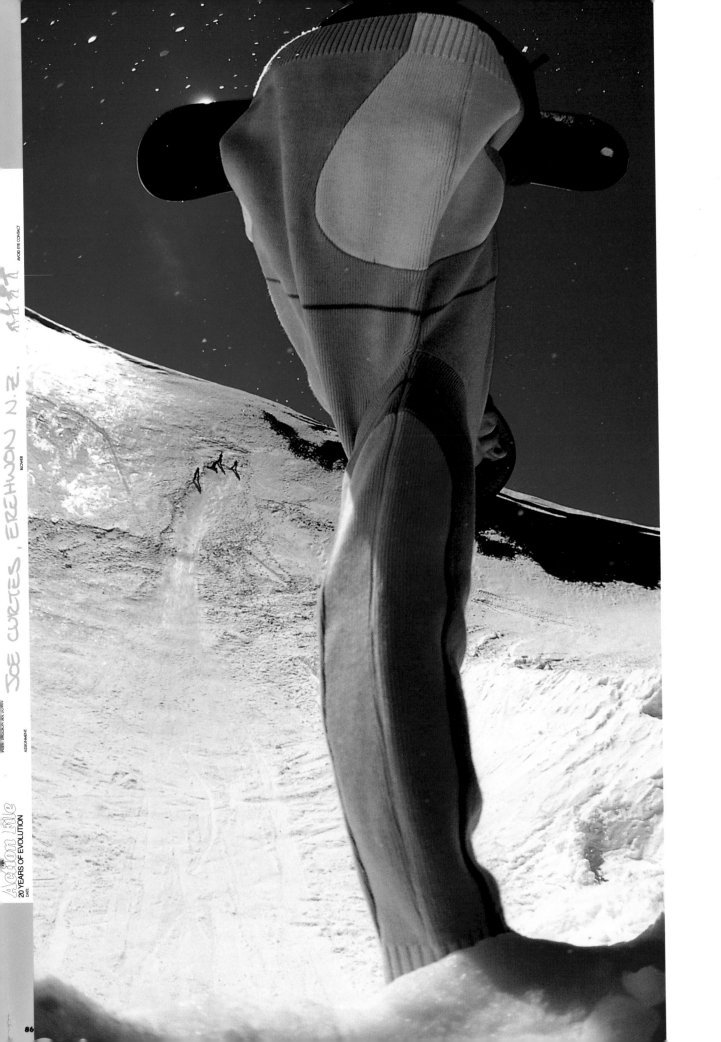

ANGLE EYE CONTACT

BLOWER

ASSIGNMENT

DATE

Action file

20 YEARS OF EVOLUTION

JOE CURTES, EREHWON N.Z.

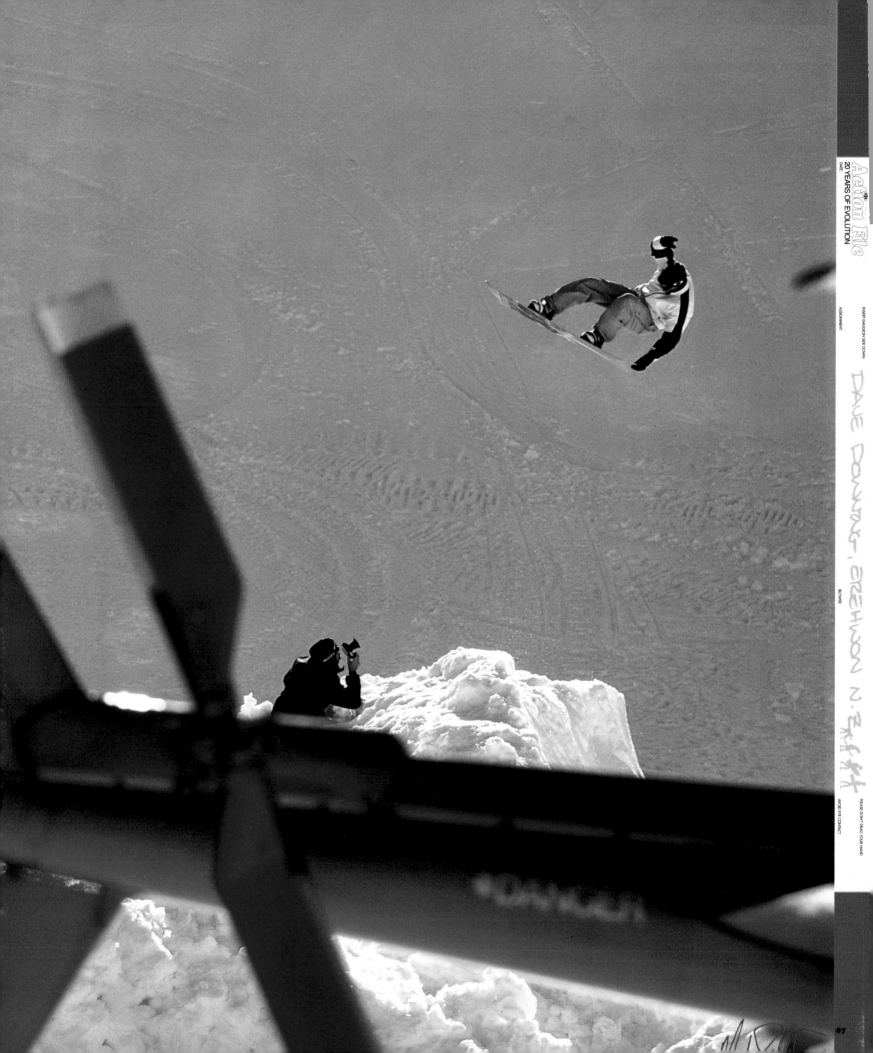

20 YEARS OF EVOLUTION

DAVE DOWNING, TREBLE CONE N.Z. 3 of 4

INSERT EMULSION SIDE DOWN

PLEASE DON'T DRAG YOUR HAND

INSERT EMULSION SIDE DOWN

ASSIGNMENT:

KEIR DILLON, MT. HOOD

BLOWER

PLEASE DON'T DRAG YOUR HAND

AVOID EYE CONTACT

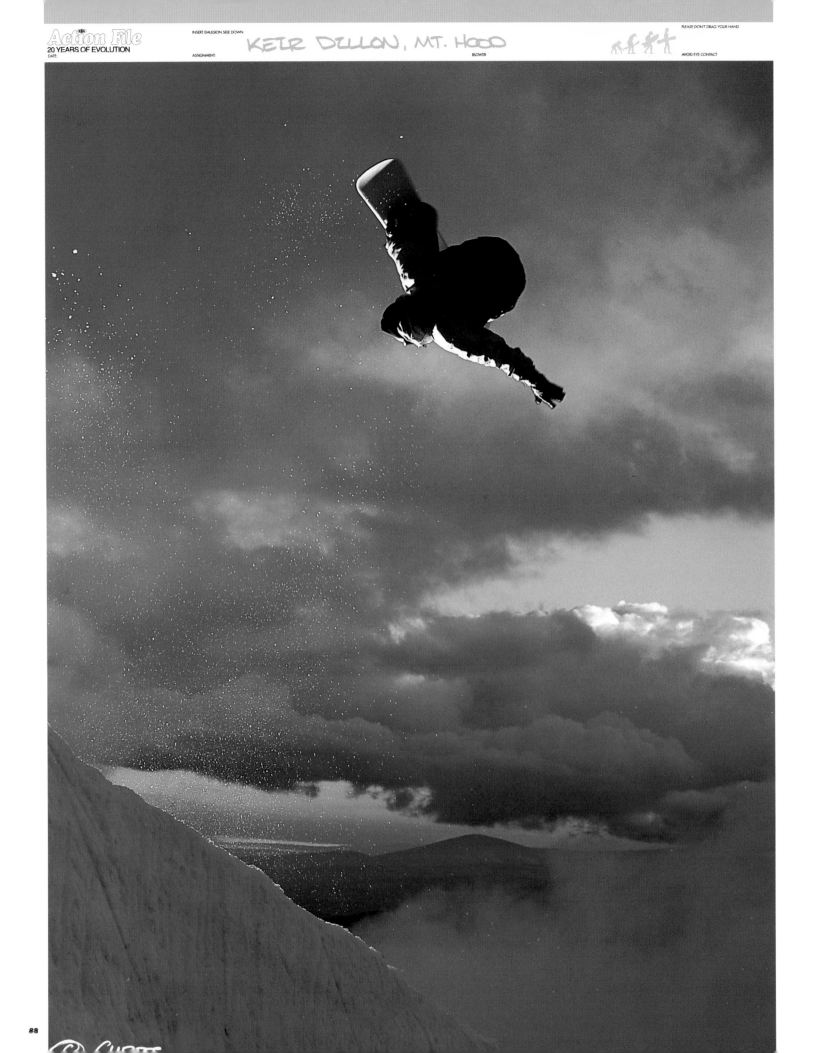

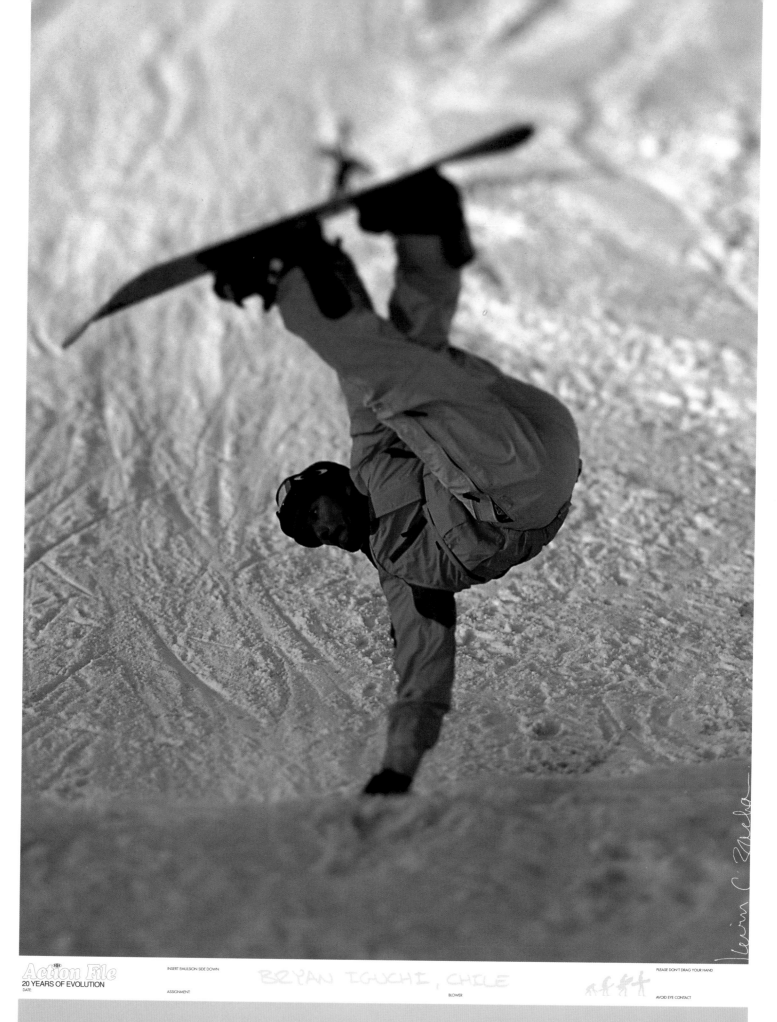

Action File
20 YEARS OF EVOLUTION
DATE

INSERT EMULSION SIDE DOWN

BRYAN IGUCHI, CHILE

ASSIGNMENT

BLOWER

PLEASE DON'T DRAG YOUR HAND

AVOID EYE CONTACT

89

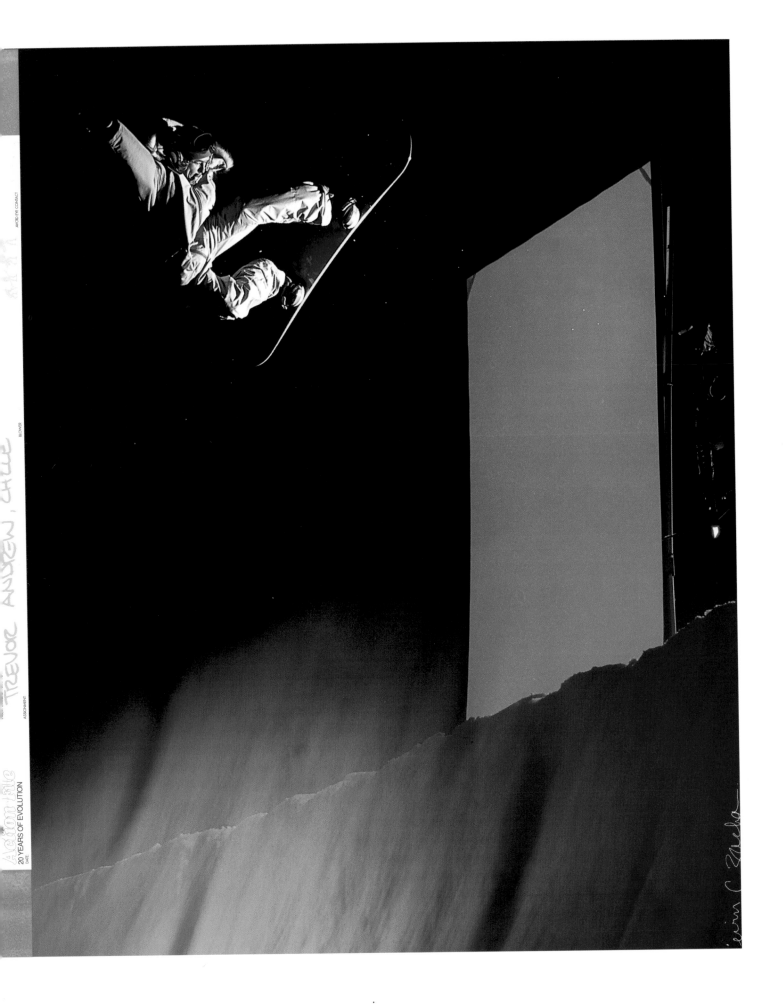

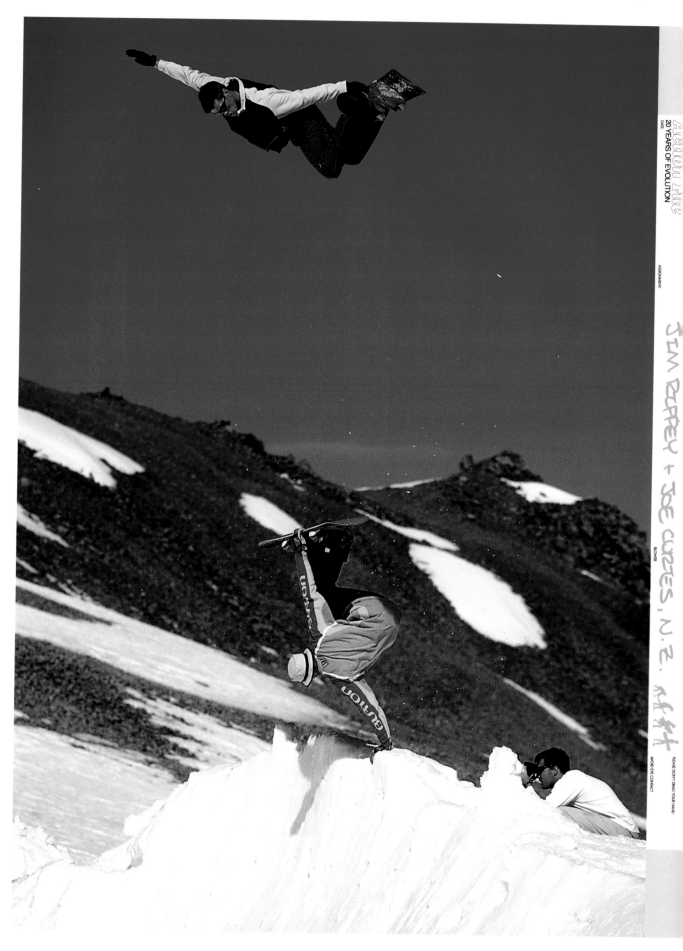

EVOLUTION LIVE
20 YEARS OF EVOLUTION
DATE:
ASSIGNMENT:
JIM RIPPEY + JOE CURTES, N.Z.
BLOWER
PLEASE DON'T DRAG YOUR HAND
AVOID EYE CONTACT

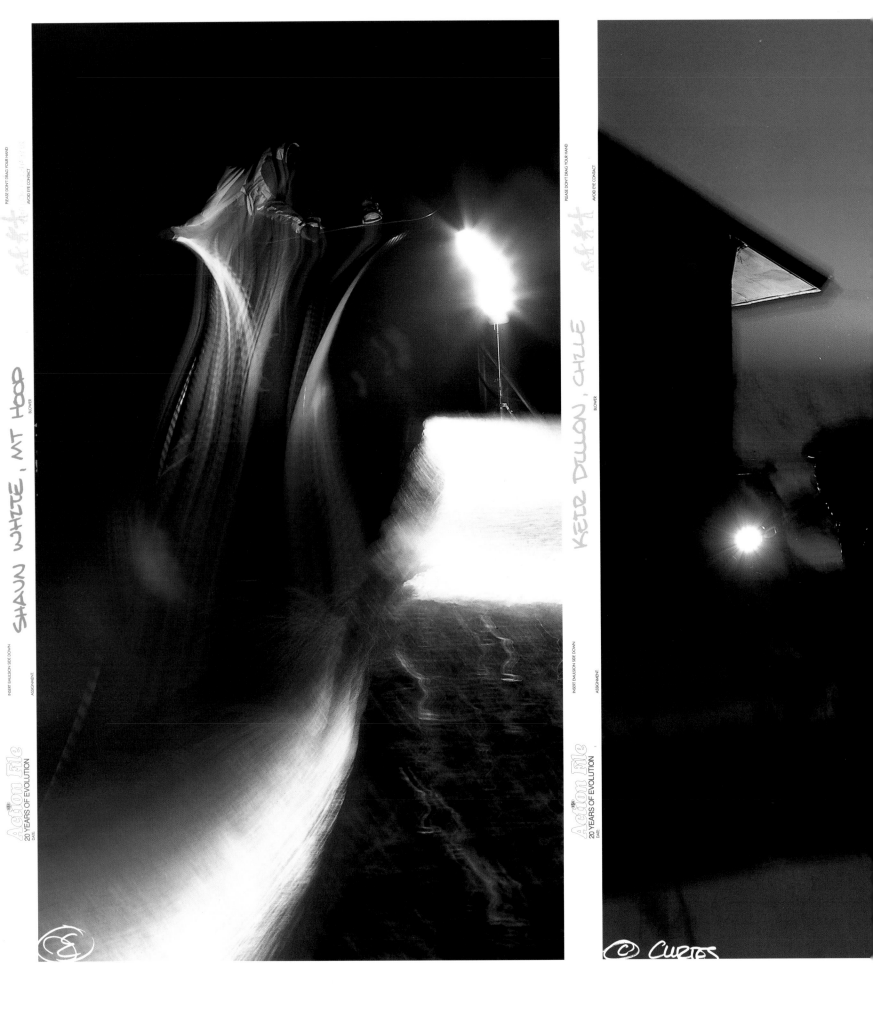

SHAUN WHITE, MT HOOD

KEIR DILLON, CHILE

Action File
20 YEARS OF EVOLUTION
DATE:

Action File
20 YEARS OF EVOLUTION
DATE:

© CURTES

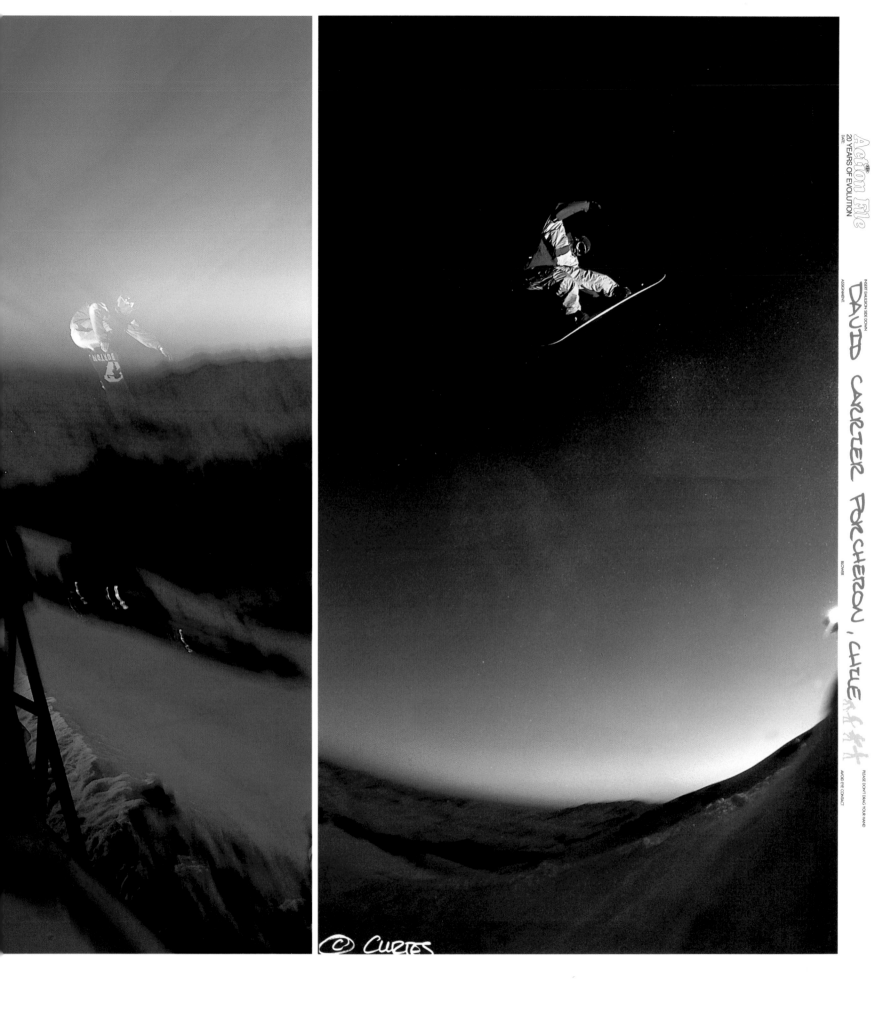

Action File
20 YEARS OF EVOLUTION
DATE

INSERT EMULSION SIDE DOWN
ASSIGNMENT

PLEASE DON'T DRAG YOUR HAND
AVOID EYE CONTACT

DAVID CARRIER POYCHERON , CHILE

BLOWER

© CURTES

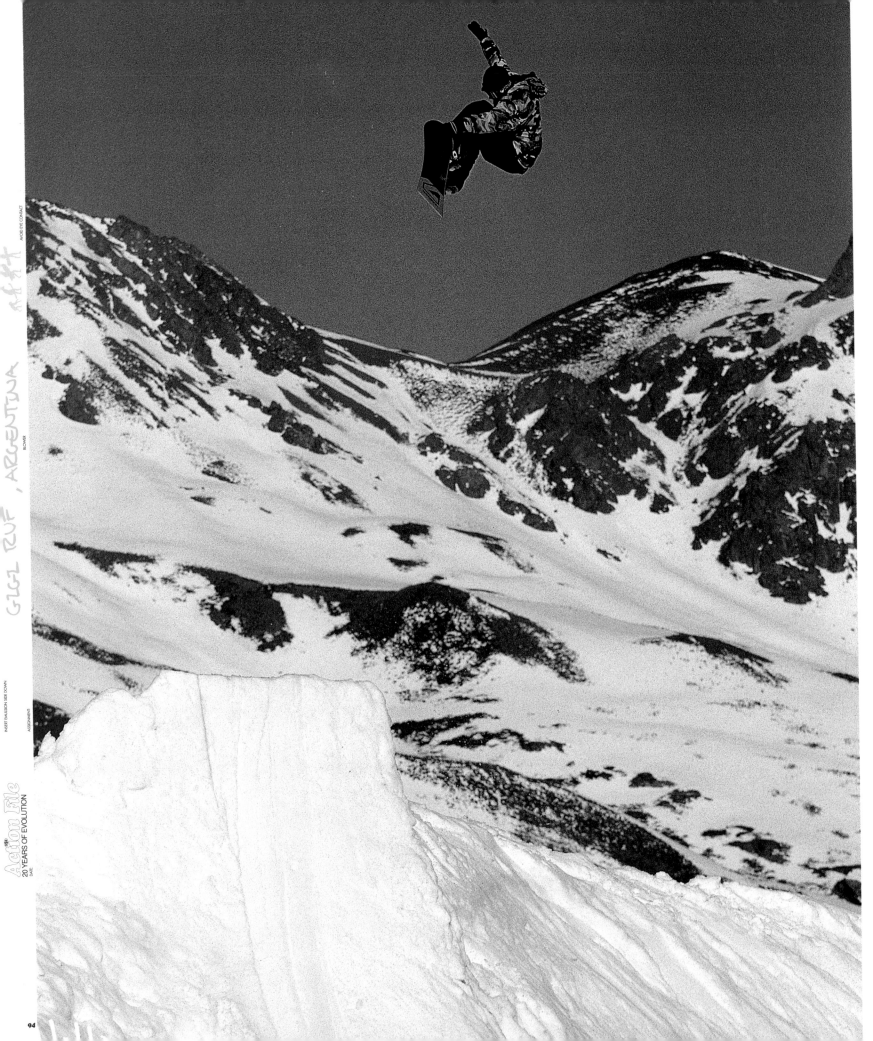

Action File
20 YEARS OF EVOLUTION
DATE:

INSERT EMULSION SIDE DOWN

ASSIGNMENT:

TREVOR ANDREW , CHILE
BLOWER

PLEASE DON'T DRAG YOUR HAND

AVOID EYE CONTACT

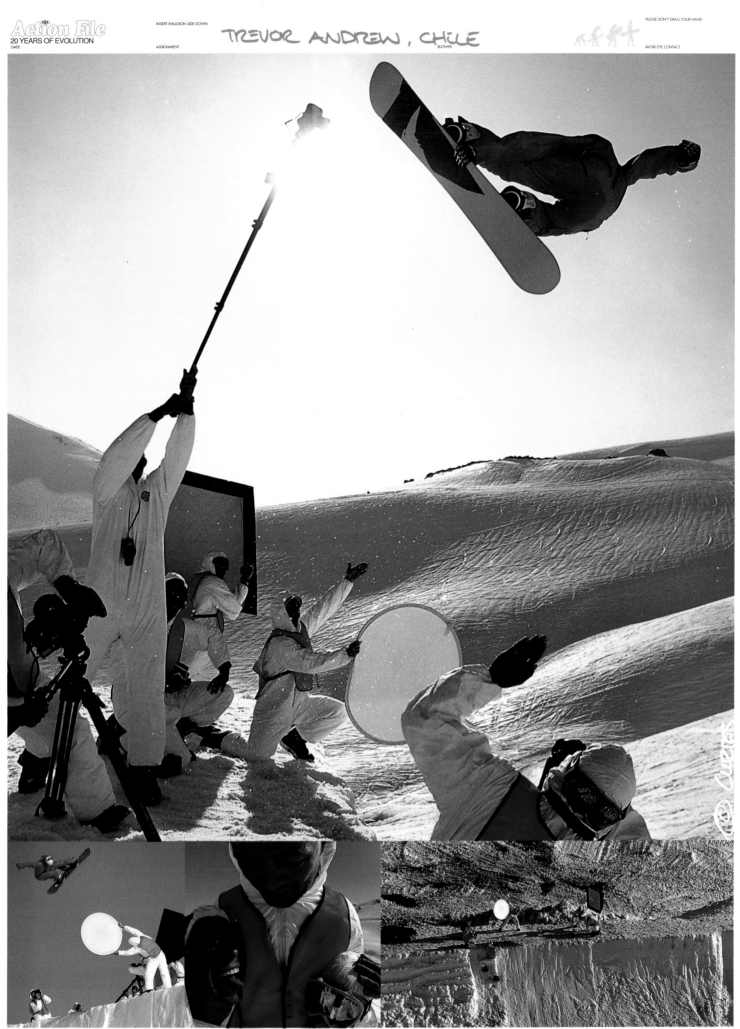

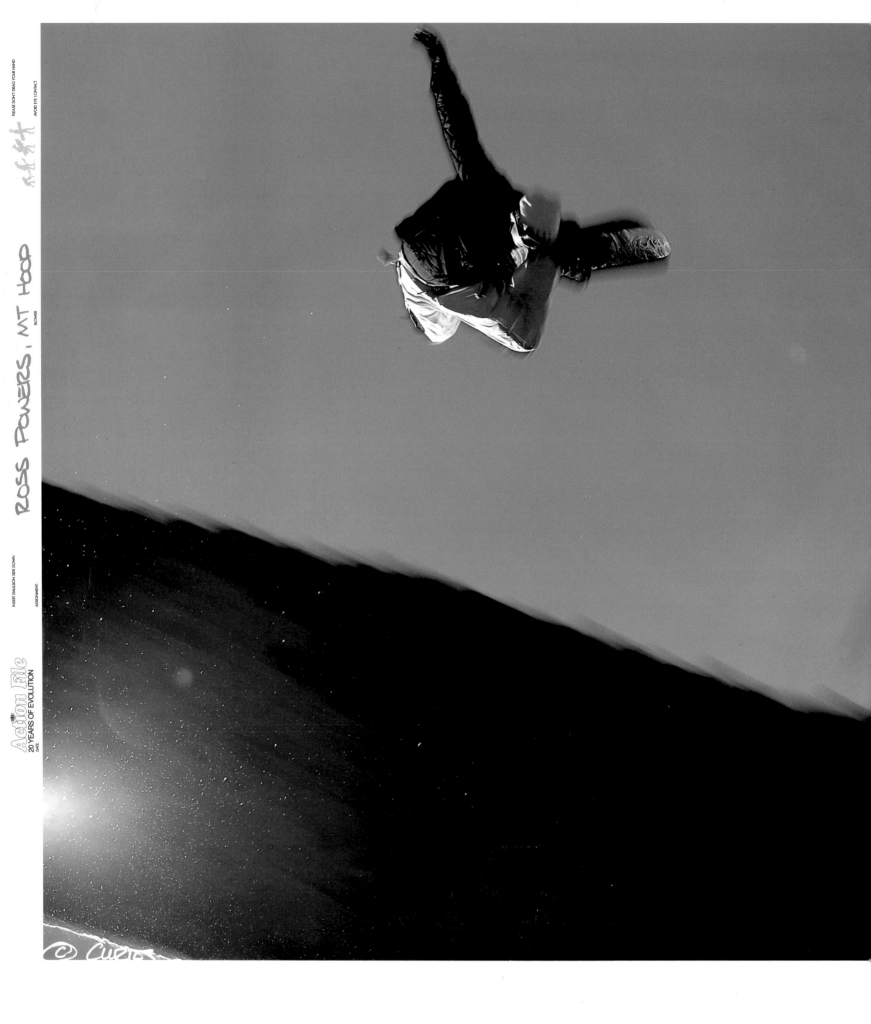

PLEASE DON'T DRAG YOUR HAND

AVOID EYE CONTACT

BLOWER

INSERT EMULSION SIDE DOWN

ASSIGNMENT

Action File
20 YEARS OF EVOLUTION
DATE:

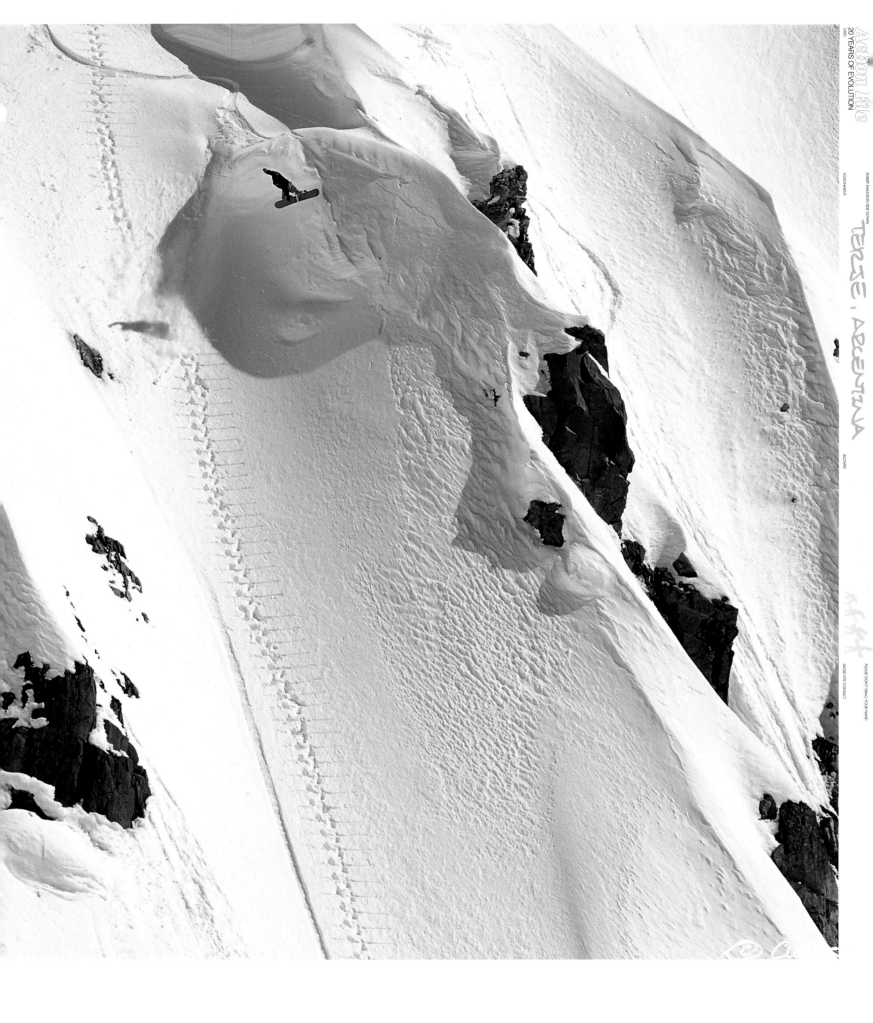

Action File
20 YEARS OF EVOLUTION
DATE:

INSERT EMULSION SIDE DOWN

ASSIGNMENT:

TERJE, ARGENTINA

BLOWER

PLEASE DON'T DRAG YOUR HAND

AVOID EYE CONTACT

97

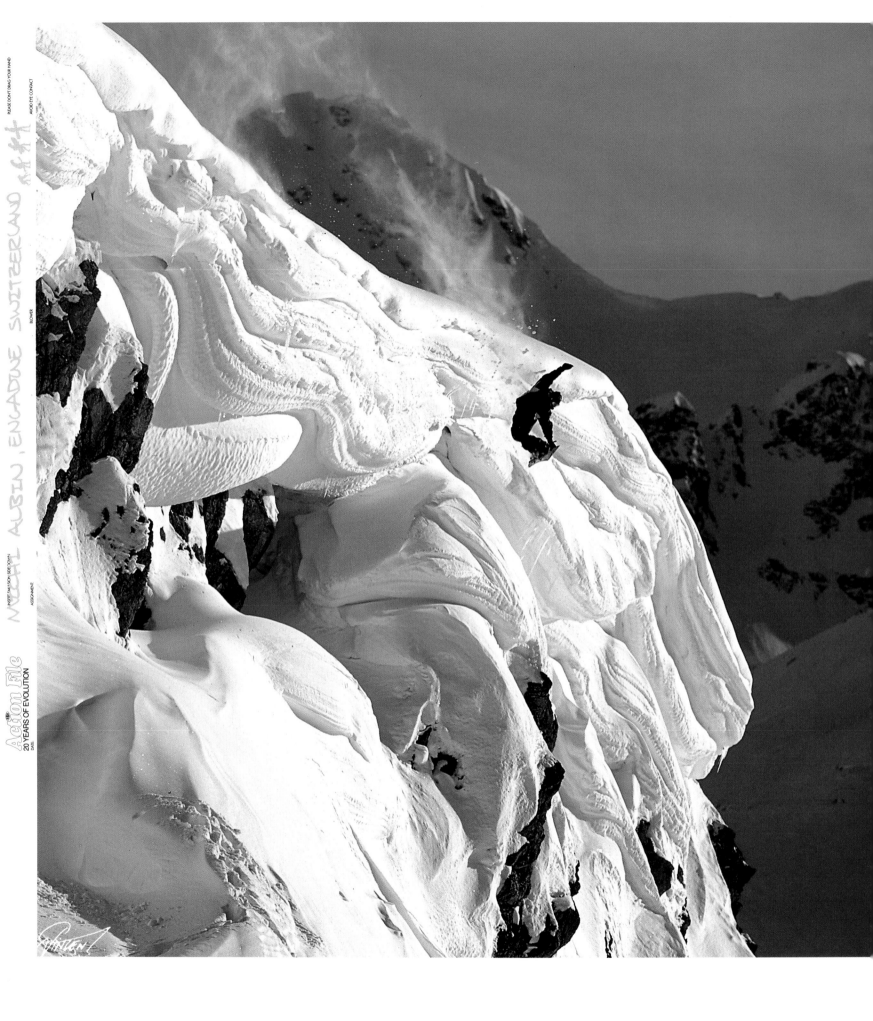

PLEASE DON'T DRAG YOUR HAND

AVOID EYE CONTACT

MICAL AUBIN, ENGADINE SWITZERLAND

BLOWER

INSERT TAB FROM SIDE/OPEN

ASSIGNMENT:

Action File

20 YEARS OF EVOLUTION

DATE:

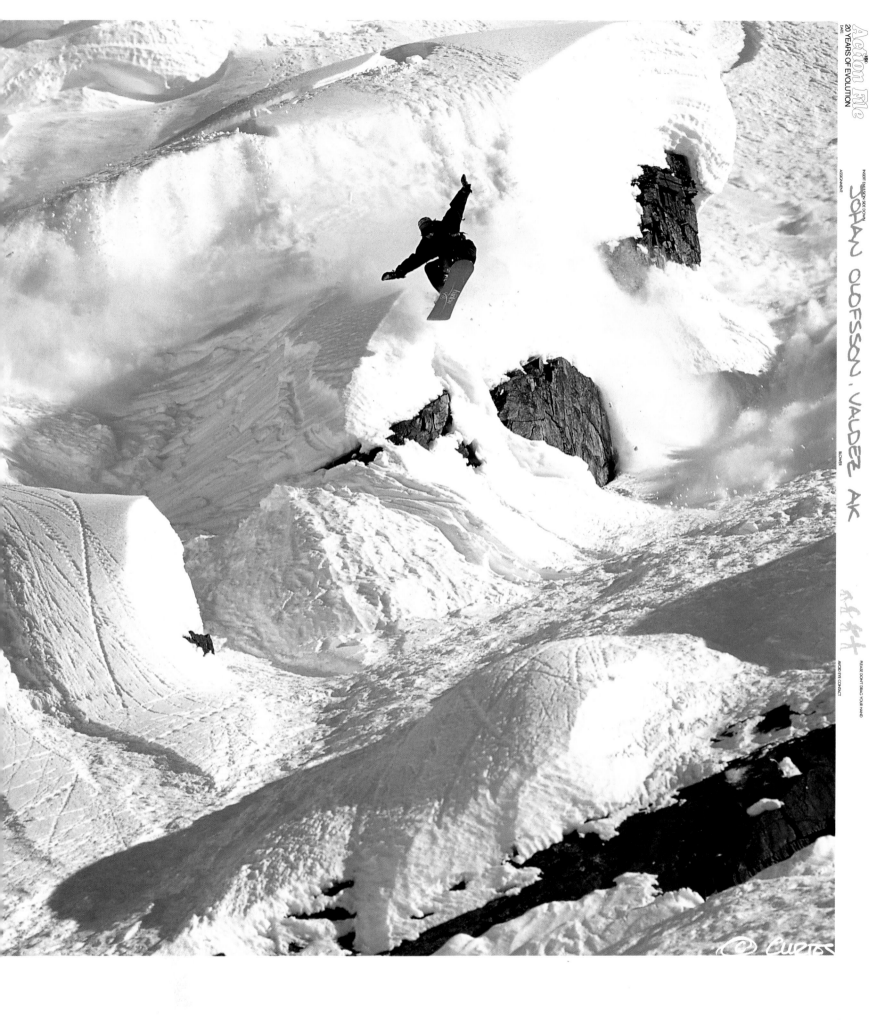

INSERT: HALFDAY'S SIDE DOWN
ASSIGNMENT:

JOHAN OLOFSSON, VALDEZ, AK

BLOWER

PLEASE DON'T DRAG YOUR HAND

AVOID EYE CONTACT

© Curtis

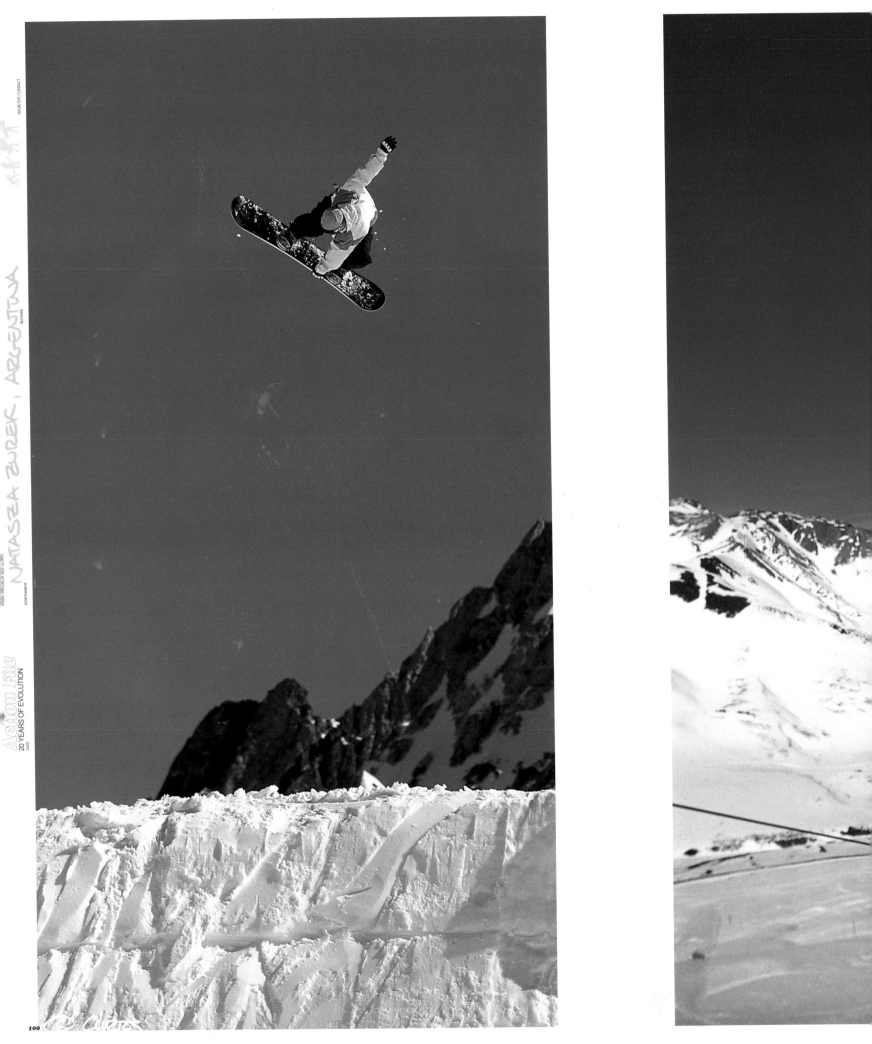

NATASZA ZUREK, ARGENTINA

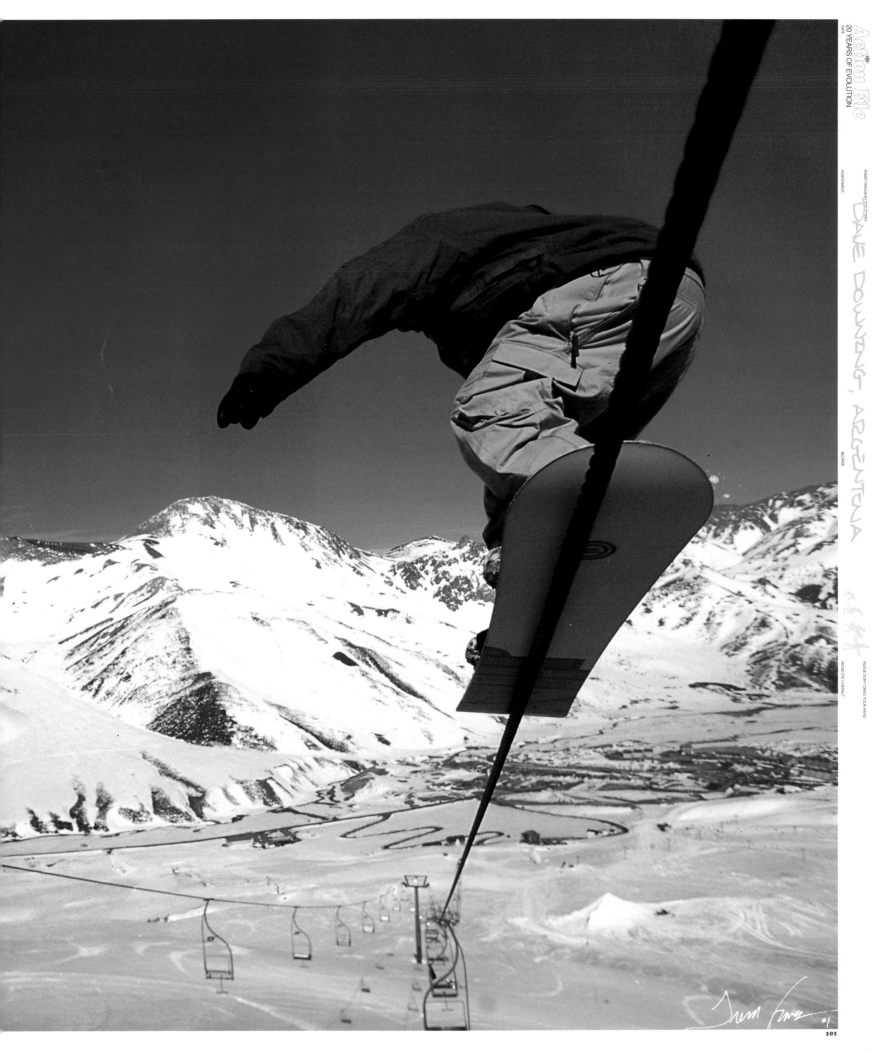

DAVE DOWNING, ARGENTINA

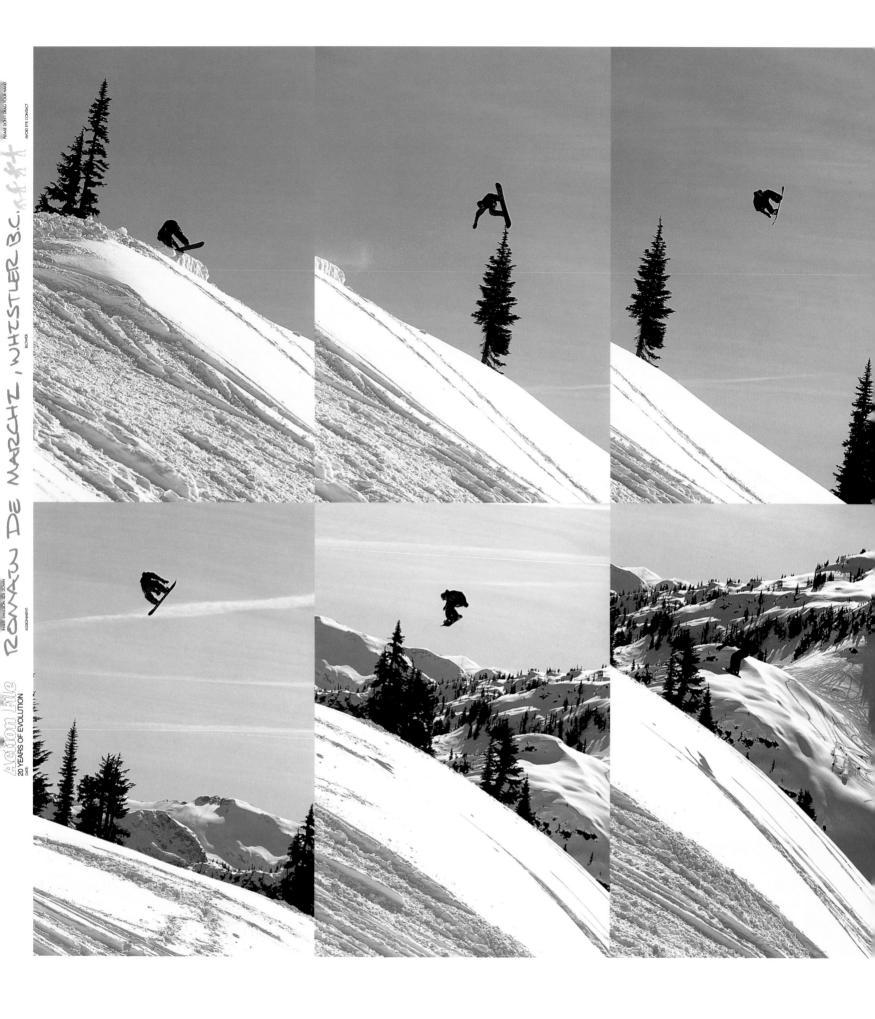

action file
20 YEARS OF EVOLUTION

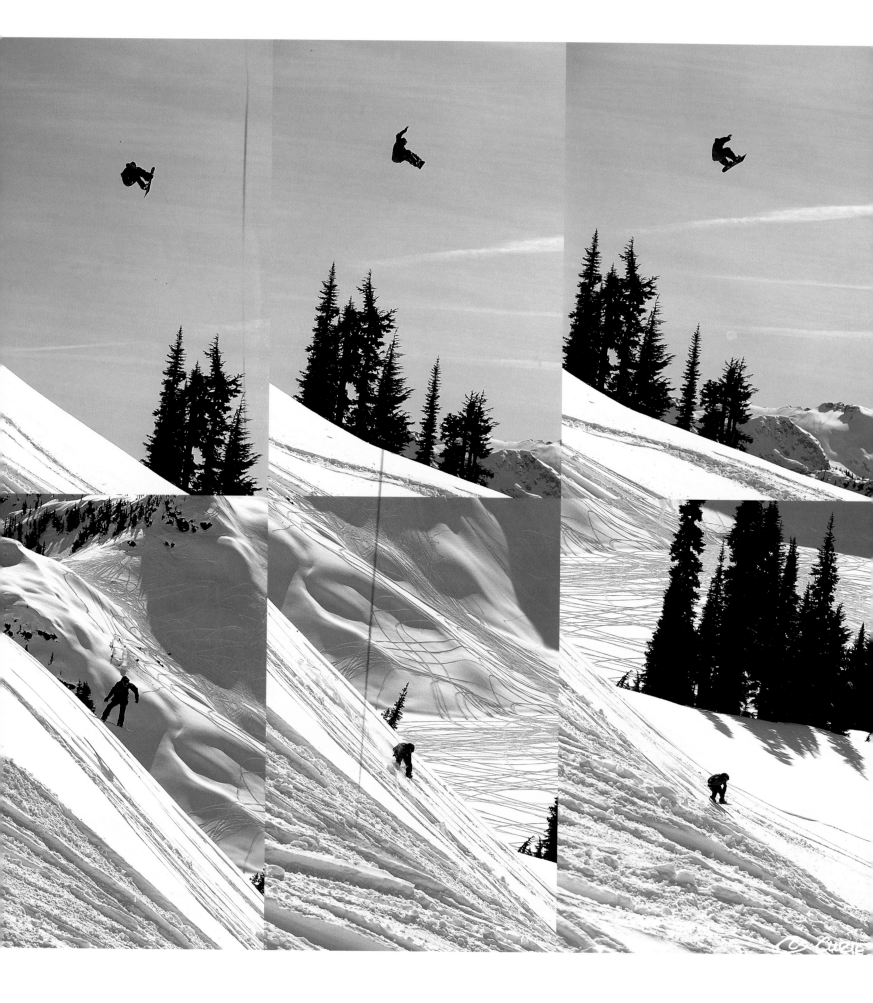

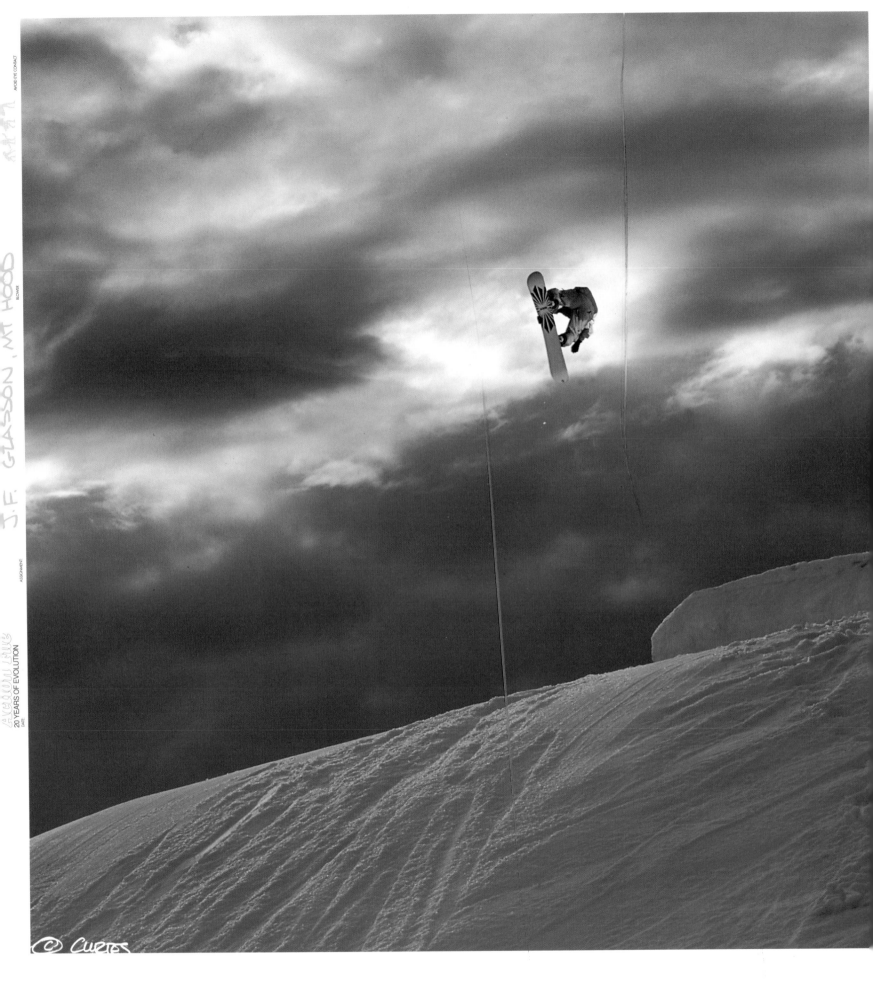

J.F. GLASSON , MT. HOOD

20 YEARS OF EVOLUTION
DATE:

© CURTES

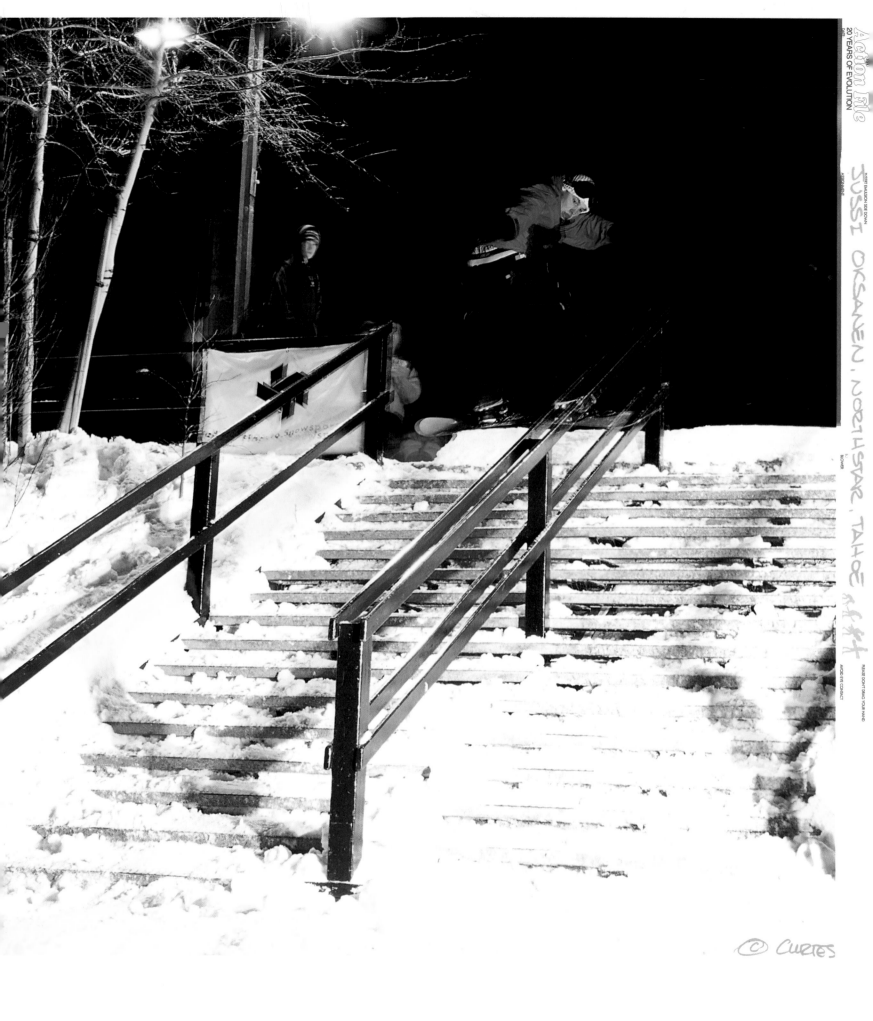

JUSSI OKSANEN, NORTHSTAR, TAHOE

© CURTES

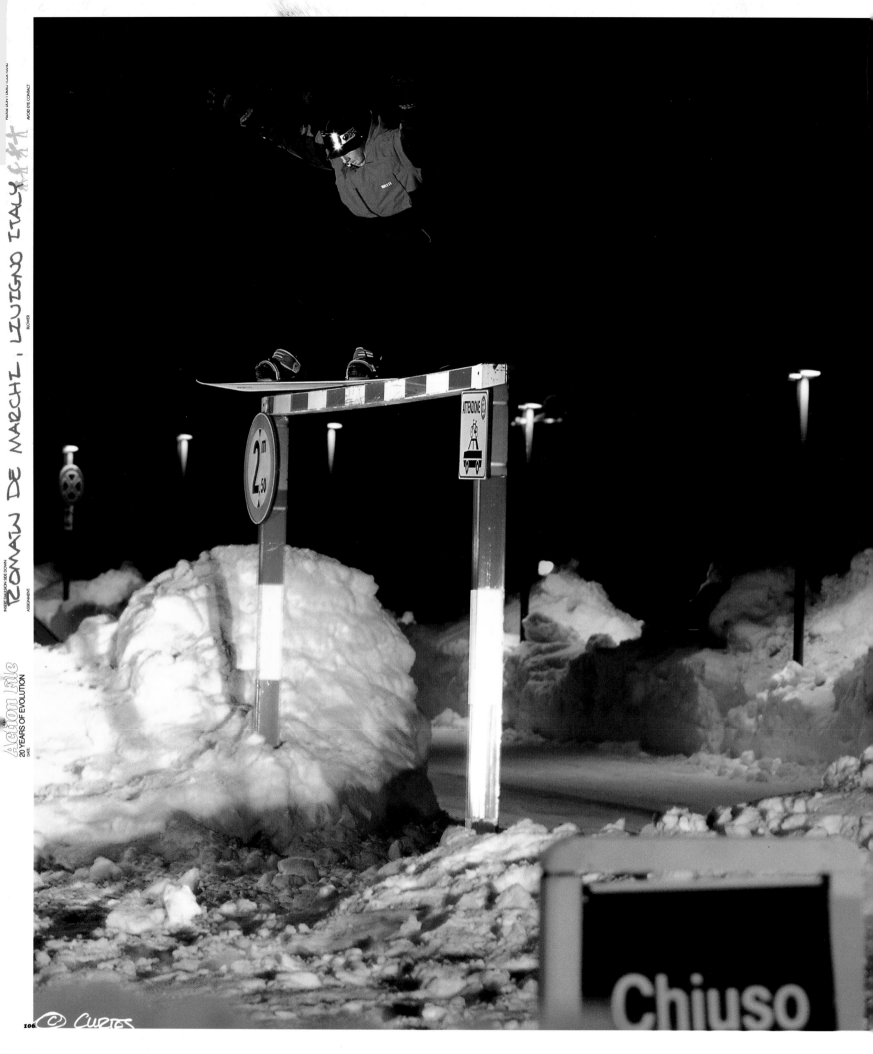

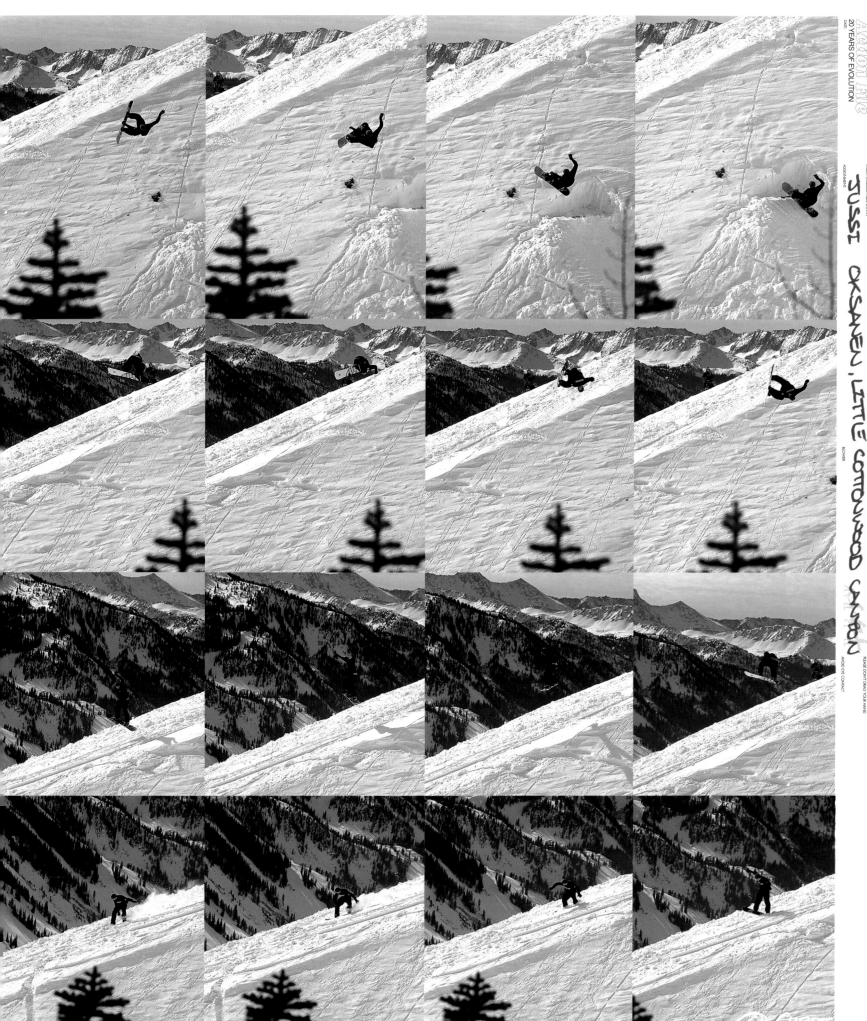

action file

20 YEARS OF EVOLUTION

DATE

INSERT EMULSION SIDE DOWN

ASSIGNMENT:

JUSSI OKSANEN, LITTLE COTTONWOOD CANYON

BLOWER

PLEASE DON'T DRAG YOUR HAND

AVOID EYE CONTACT

107

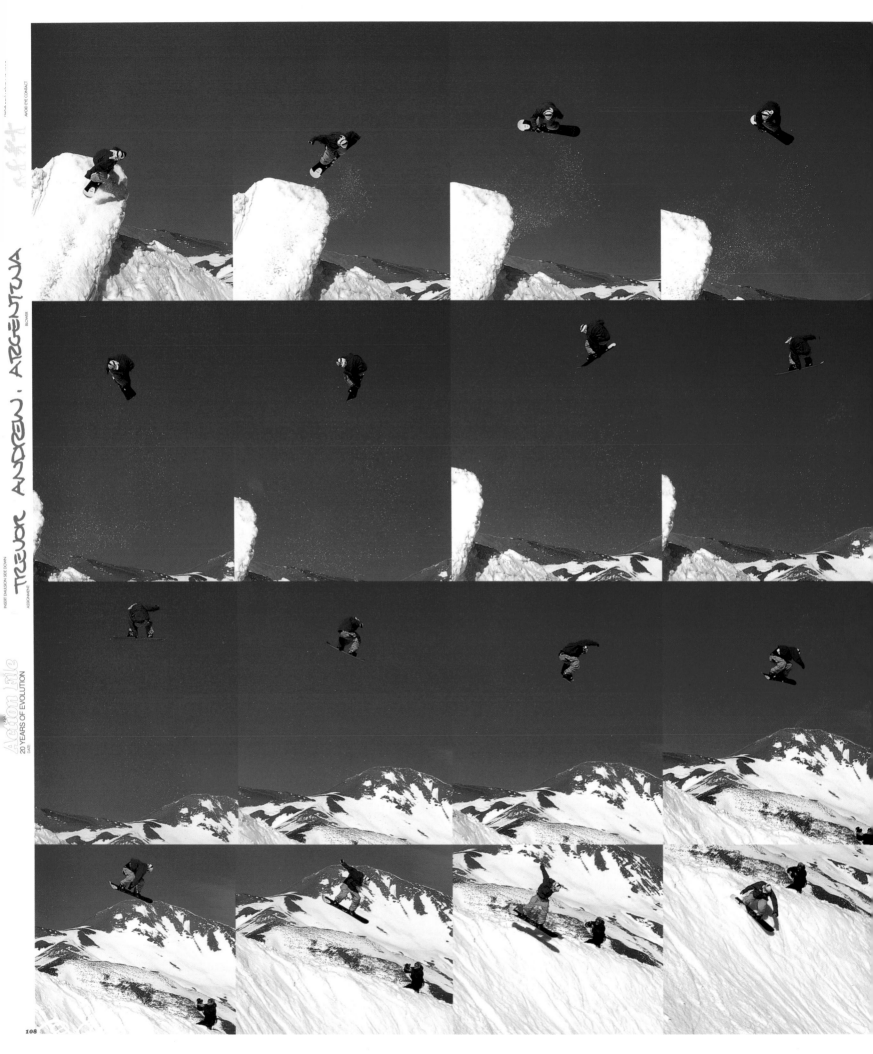

TREVOR ANDREW, ARGENTINA

BLOWER

INSERT EMULSION SIDE DOWN

ASSIGNMENT

DATE:

Action File

20 YEARS OF EVOLUTION

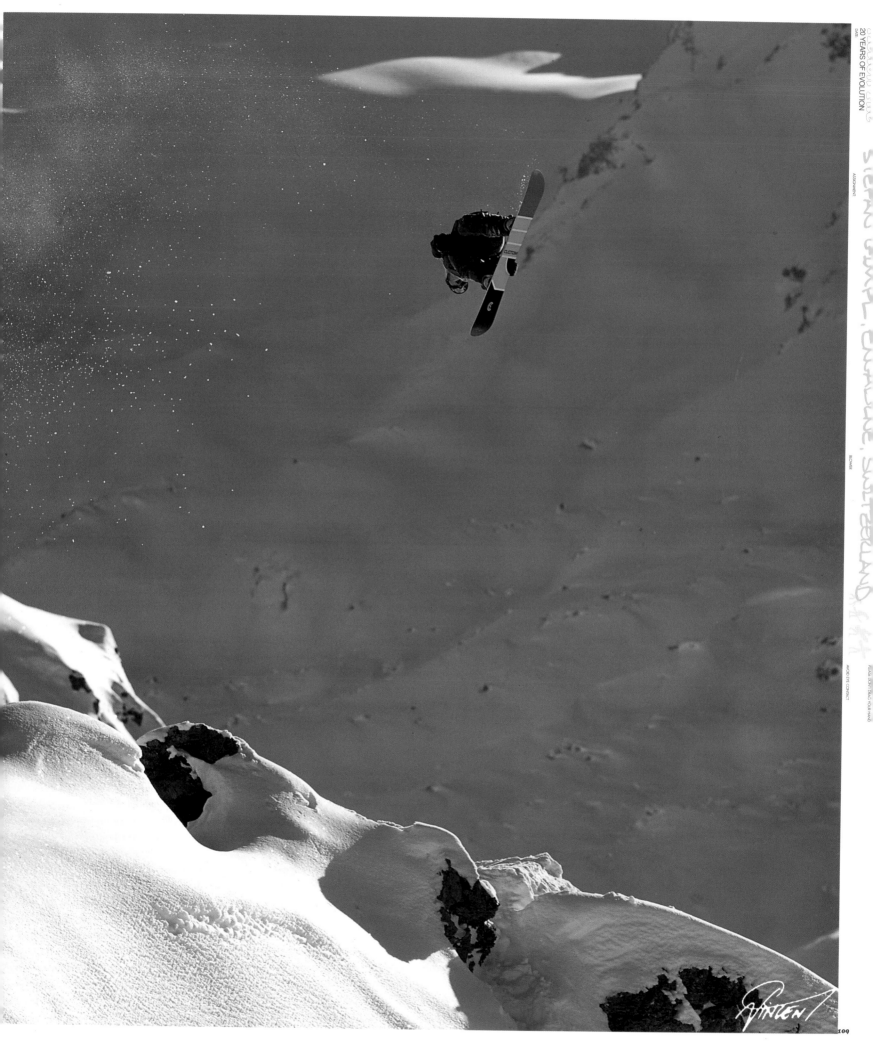

STEFAN GIMPL, ENGADINE, SWITZERLAND

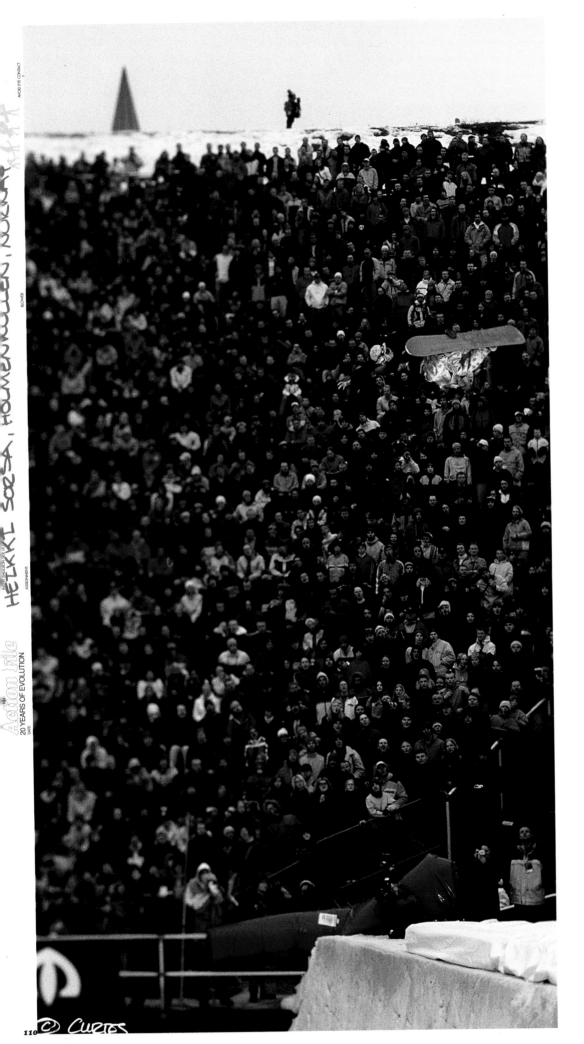

Action file

158

20 YEARS OF EVOLUTION

DATE:

110 © CURTIS

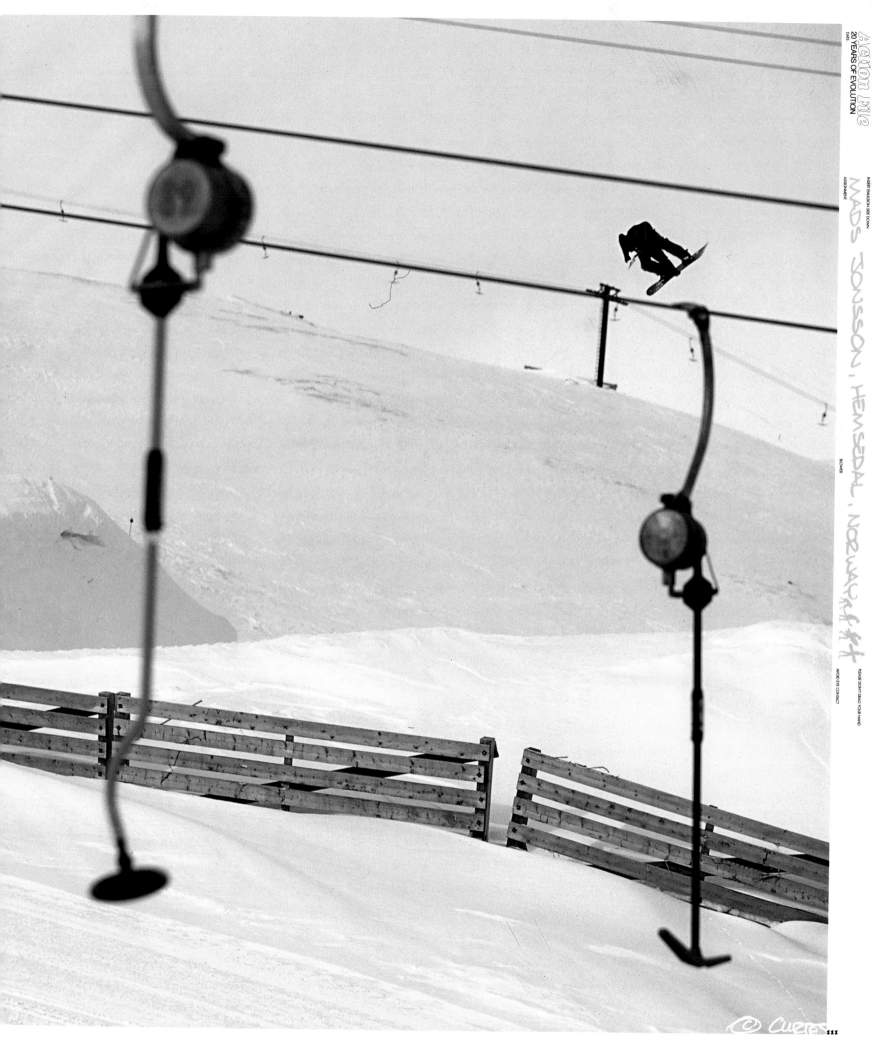

INSERT EMULSION / SIDE DOWN

ASSIGNMENT:

MADS JONSSON, HEMSEDAL, NORWAY

BLOWER

PLEASE DON'T DRAG YOUR HAND

AVOID EYE CONTACT

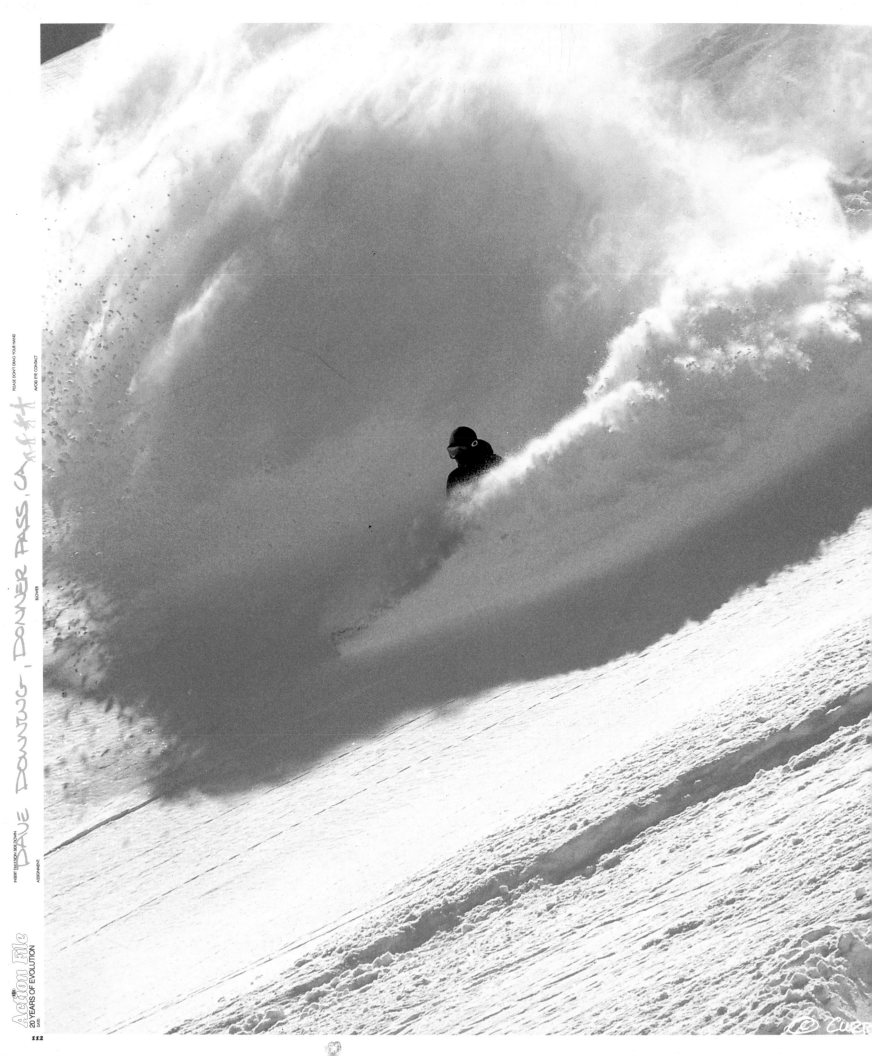

Action File

20 YEARS OF EVOLUTION

DAVE DOWNING, DONNER PASS, CA

INSERT EMULSION SIDE DOWN

ASSIGNMENT

DATE:

BLOWER

PLEASE DON'T DRAG YOUR HAND

AVOID EYE CONTACT

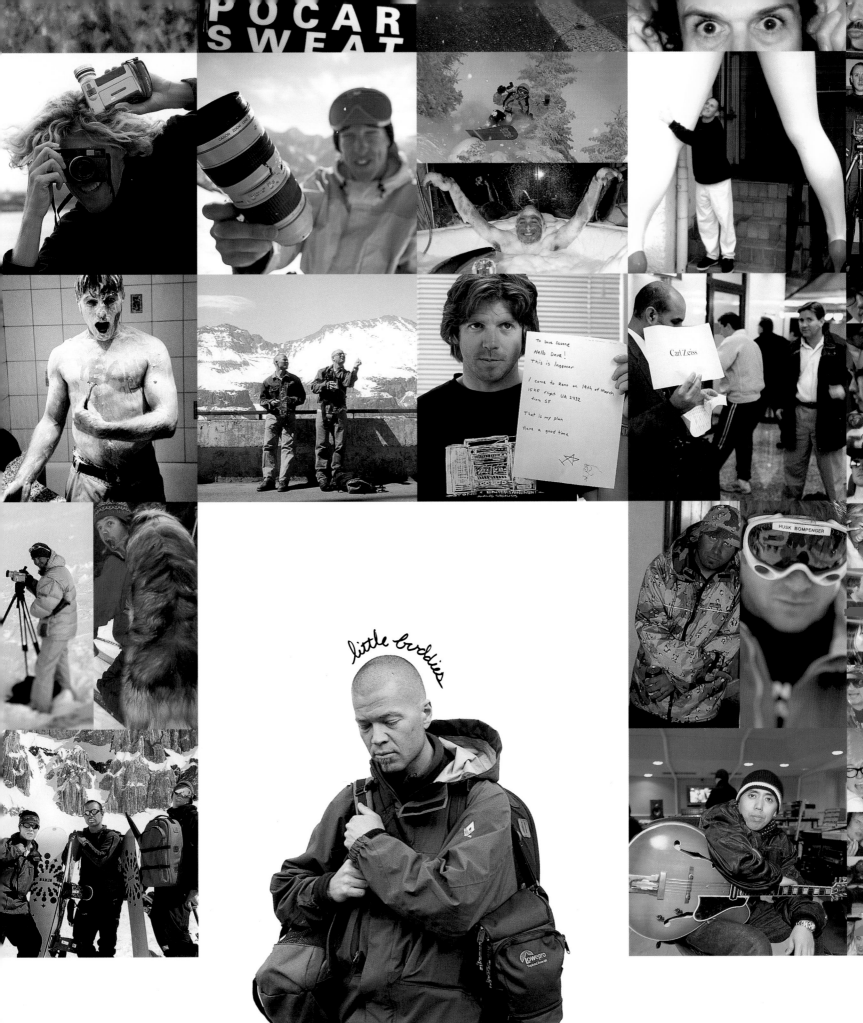

little buddies

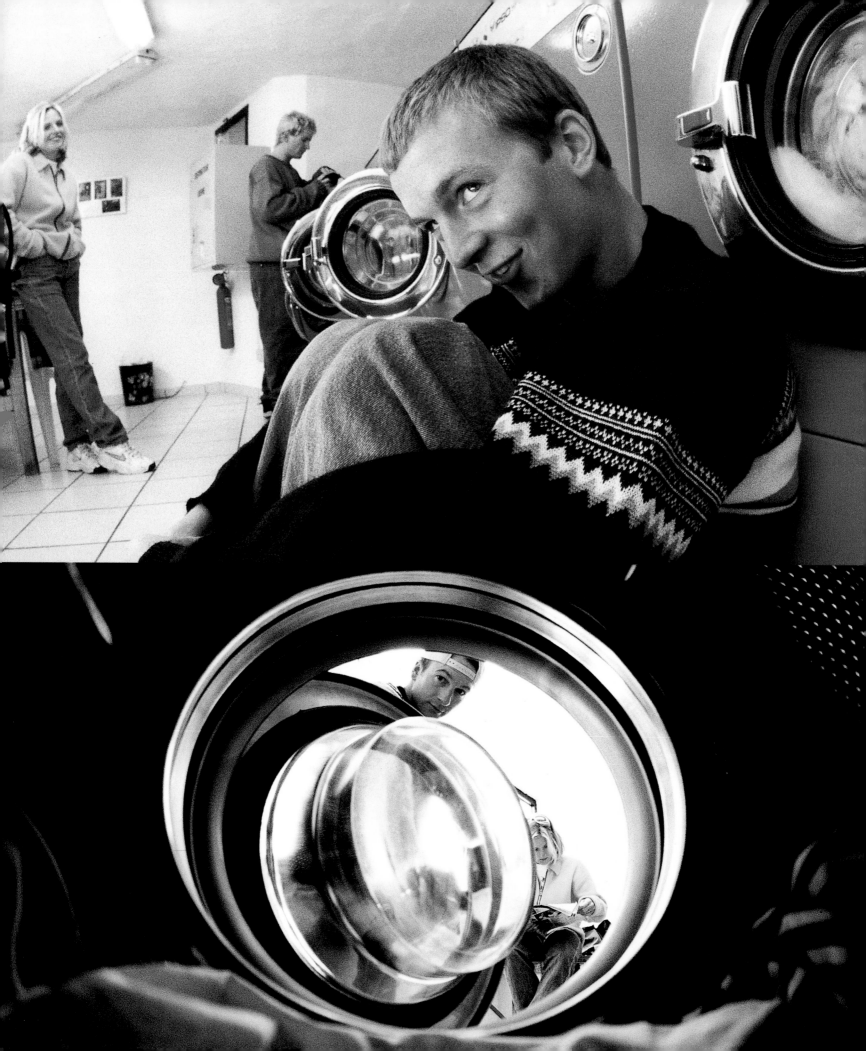

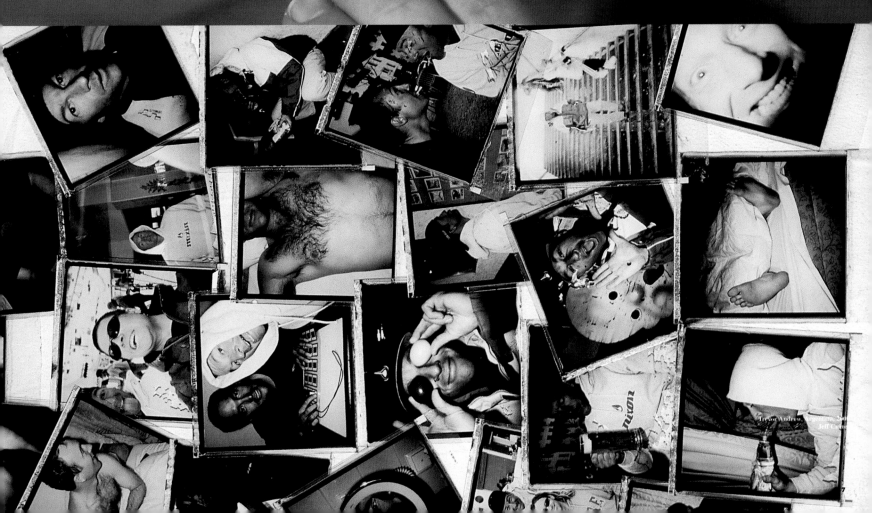

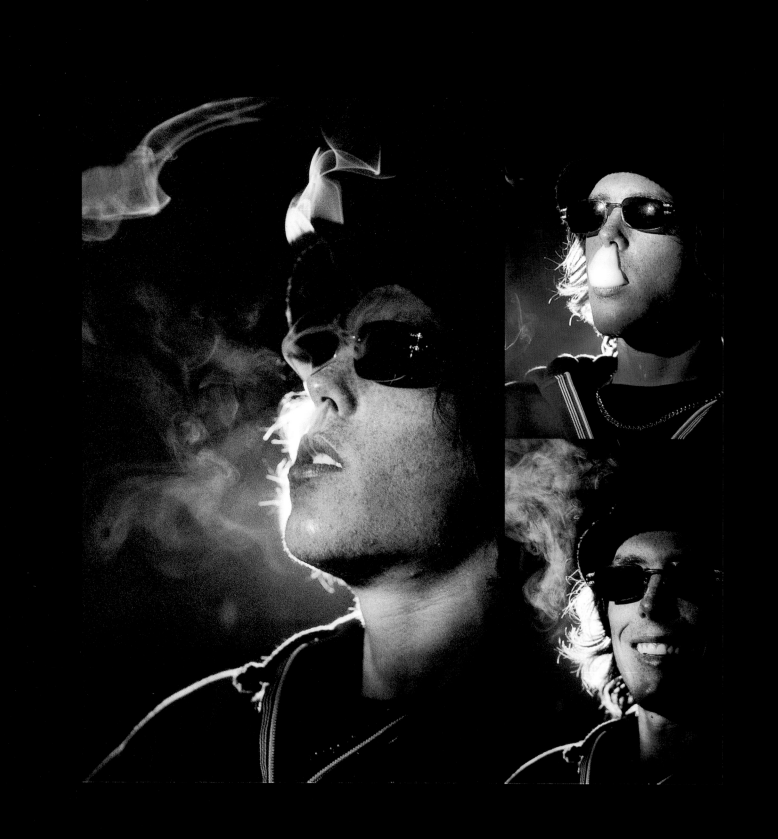

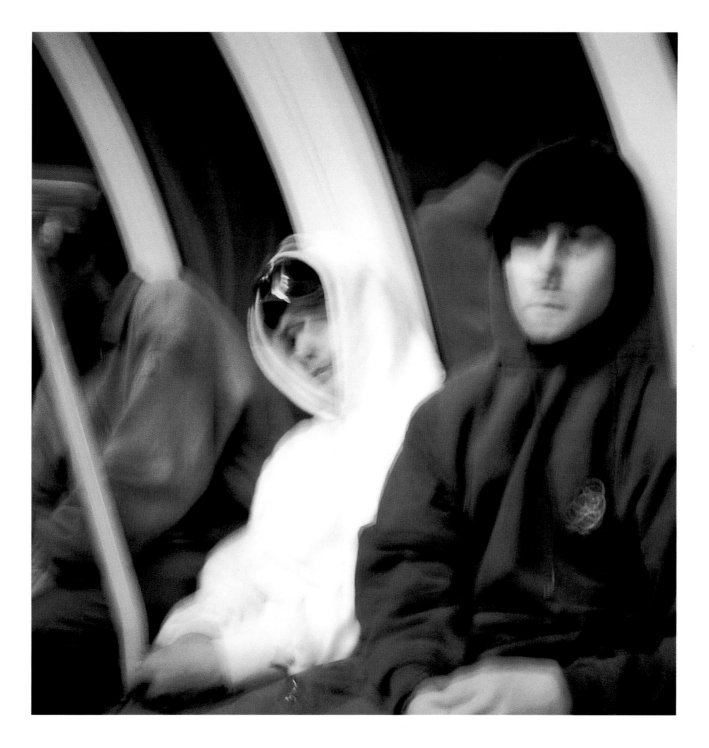

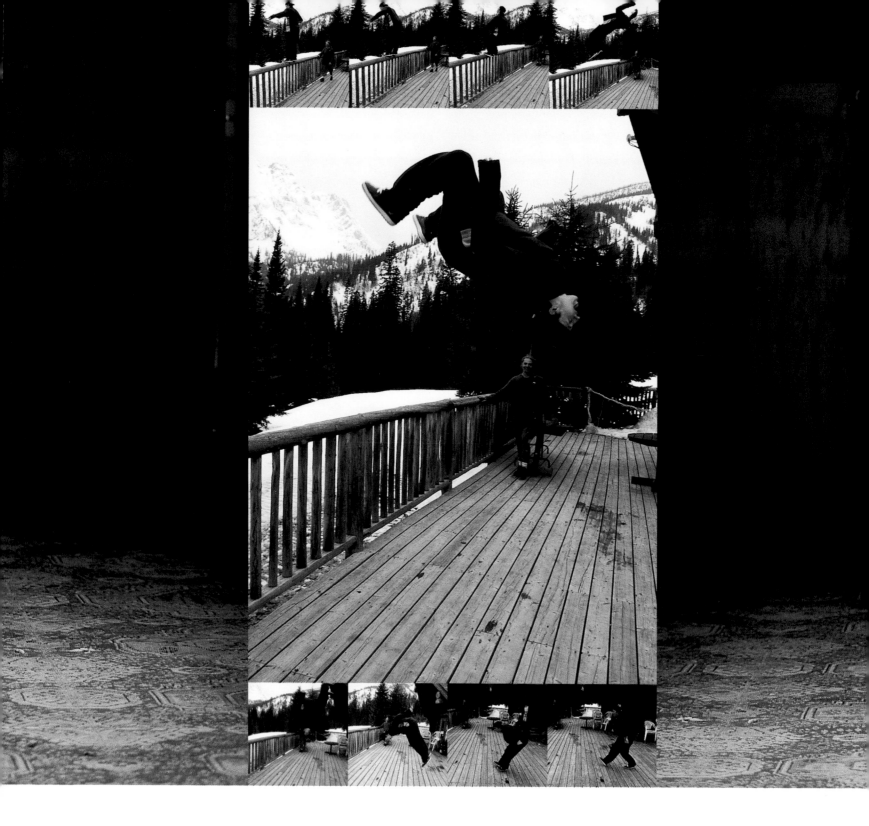

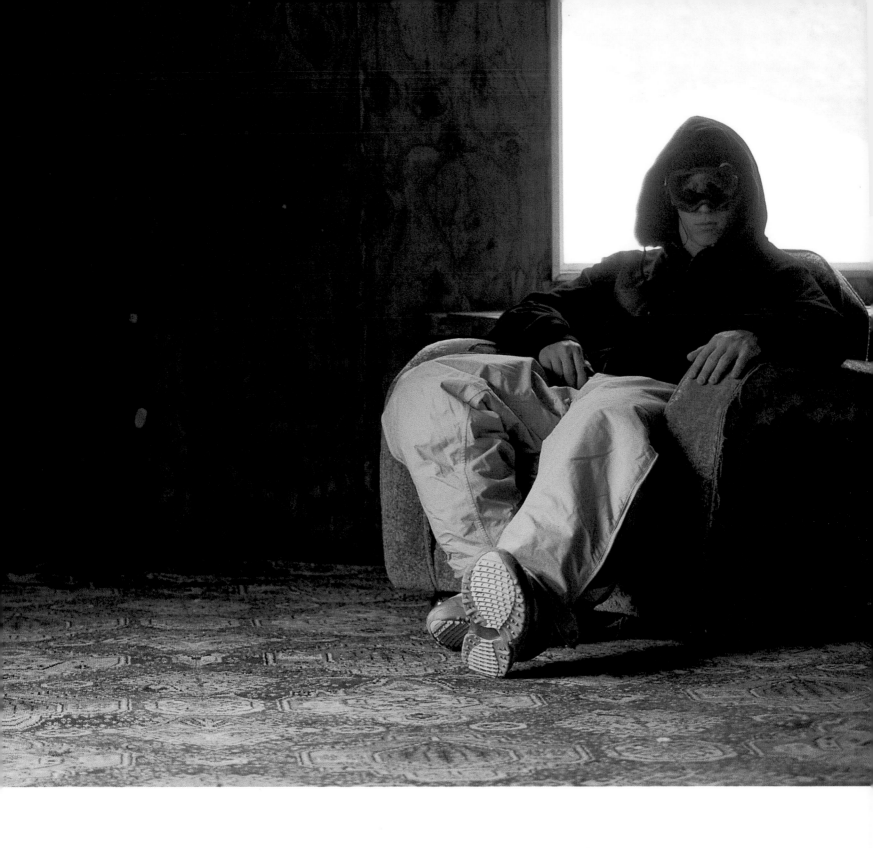

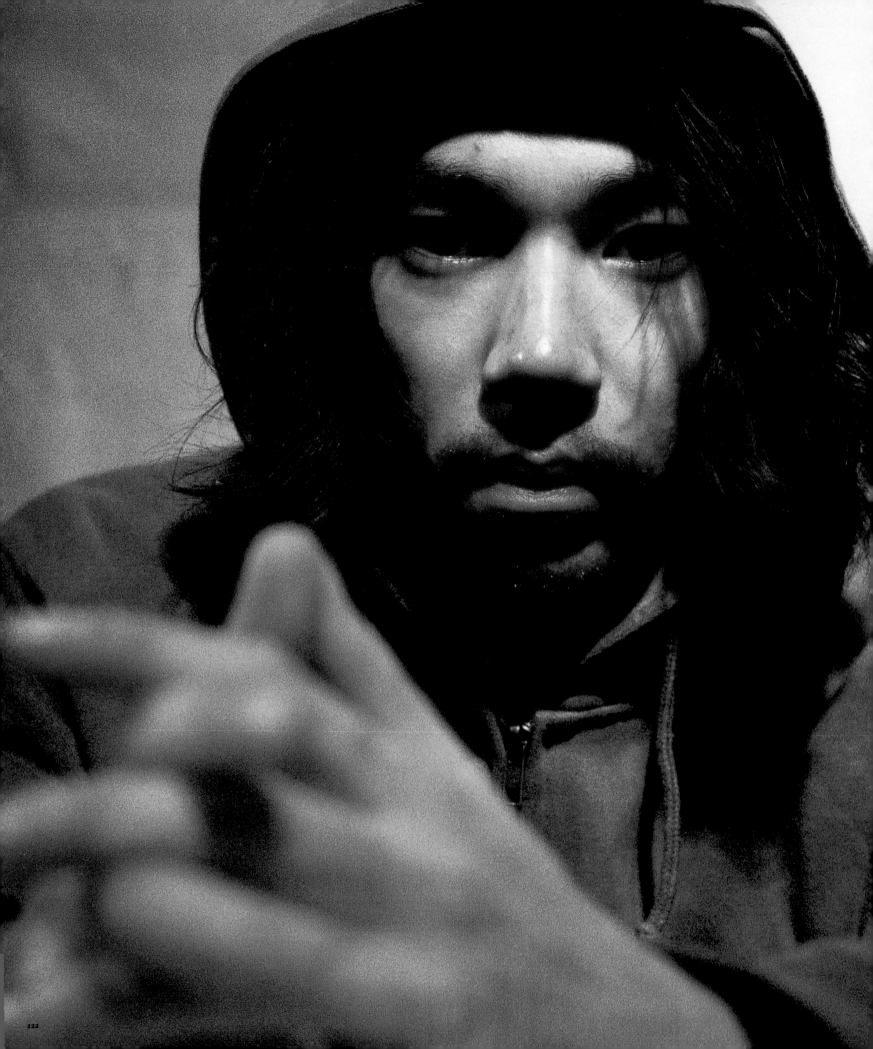

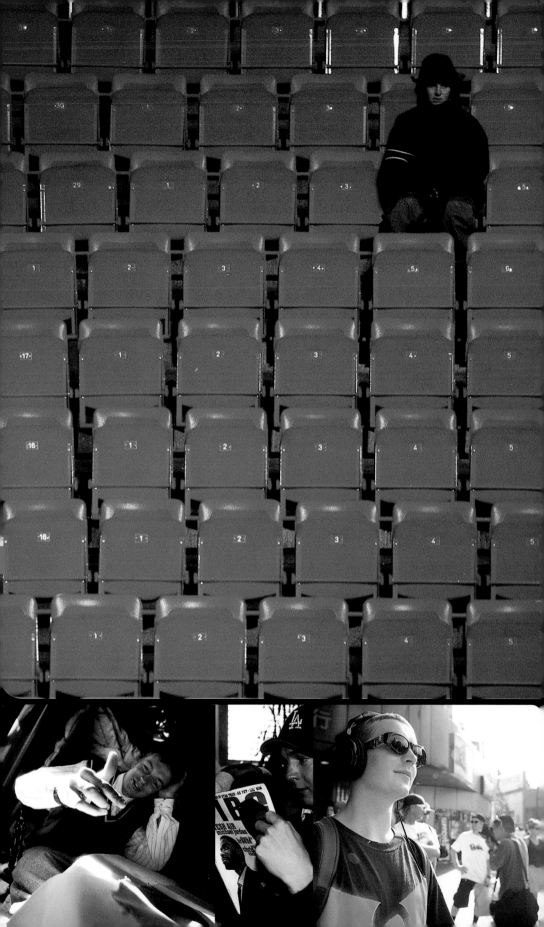

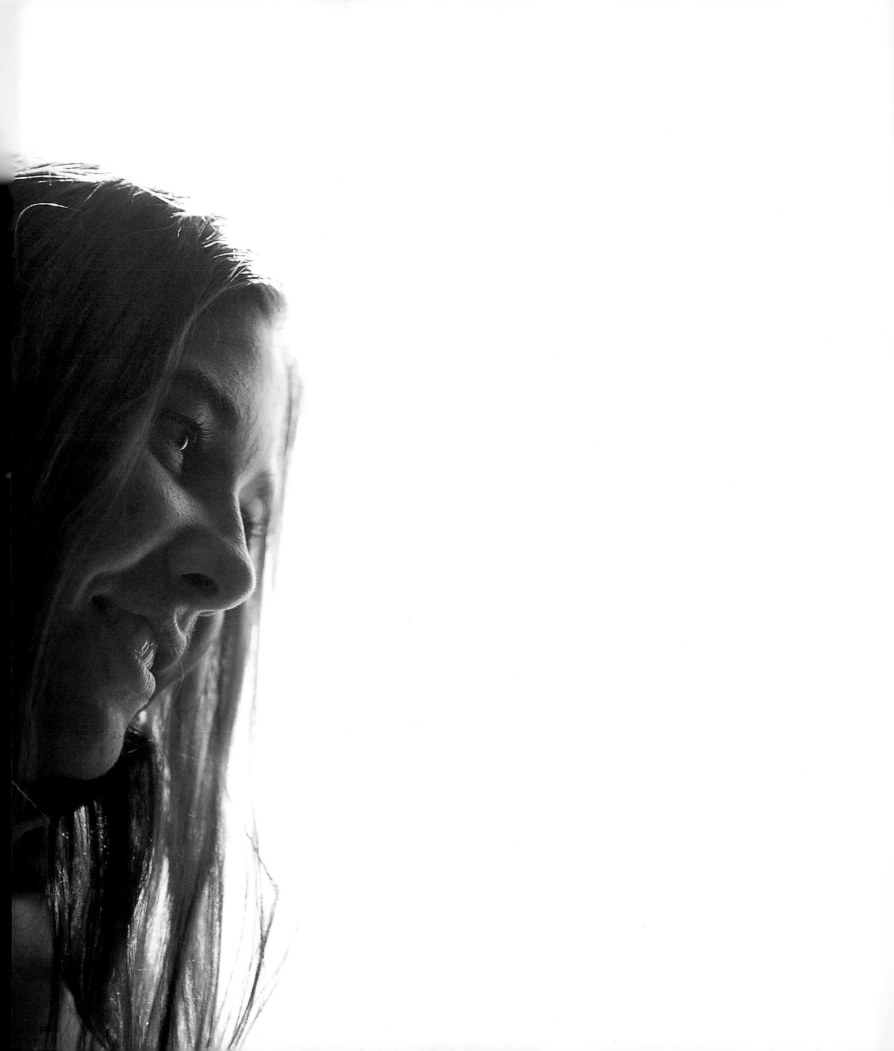

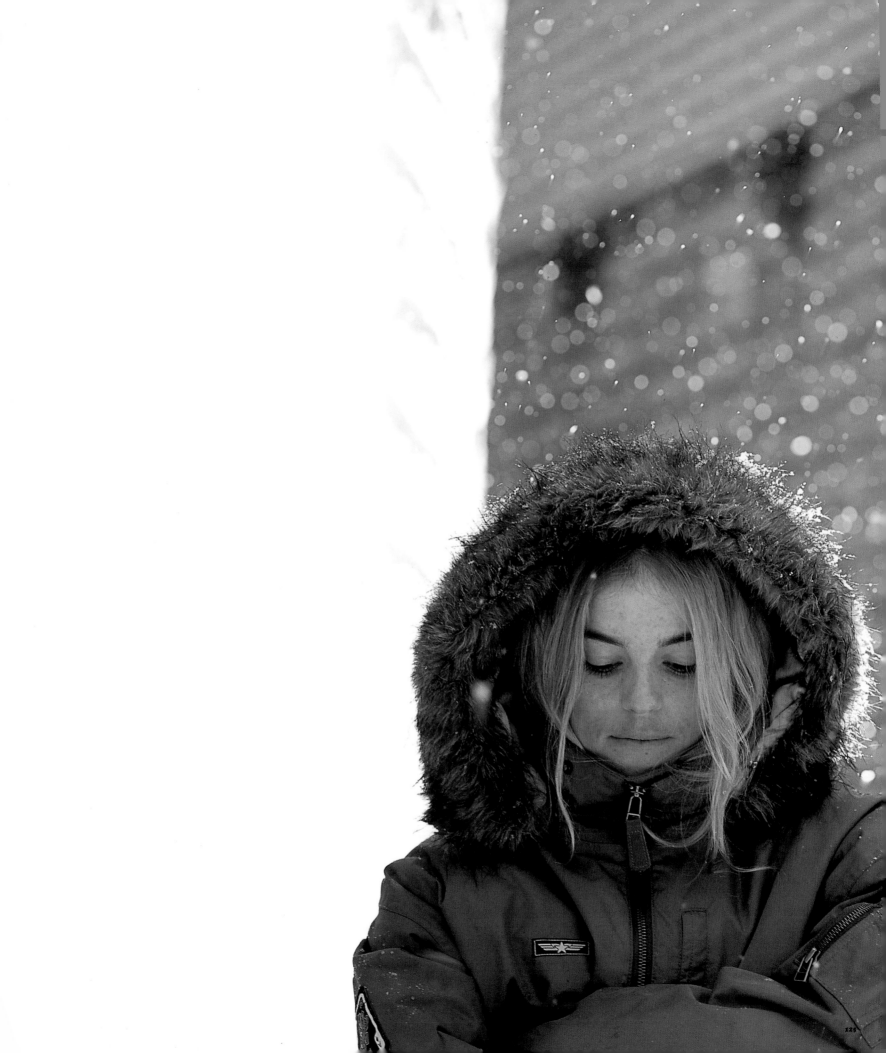

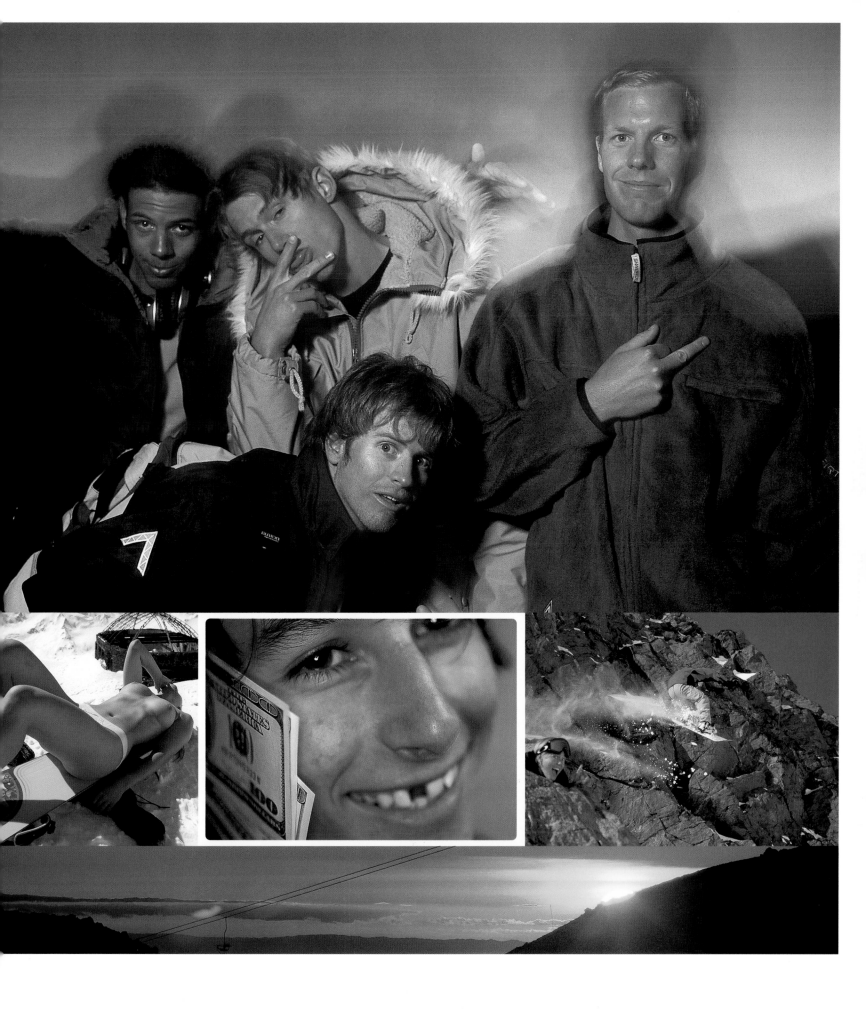

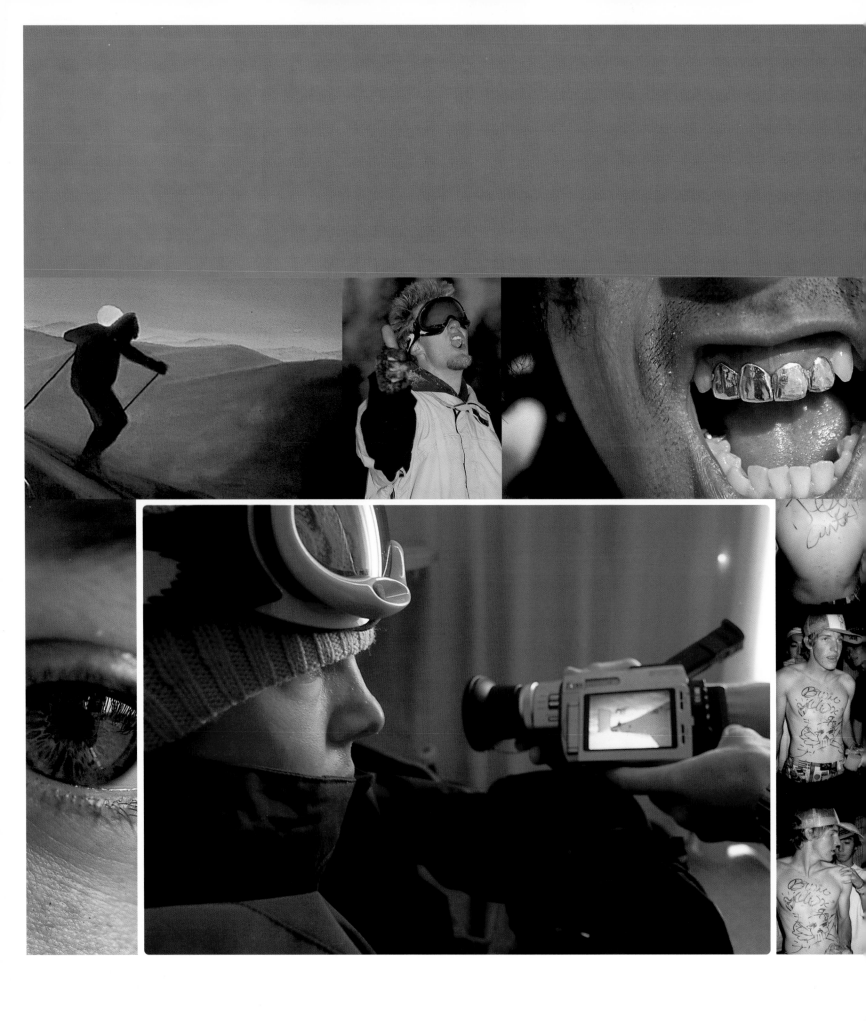

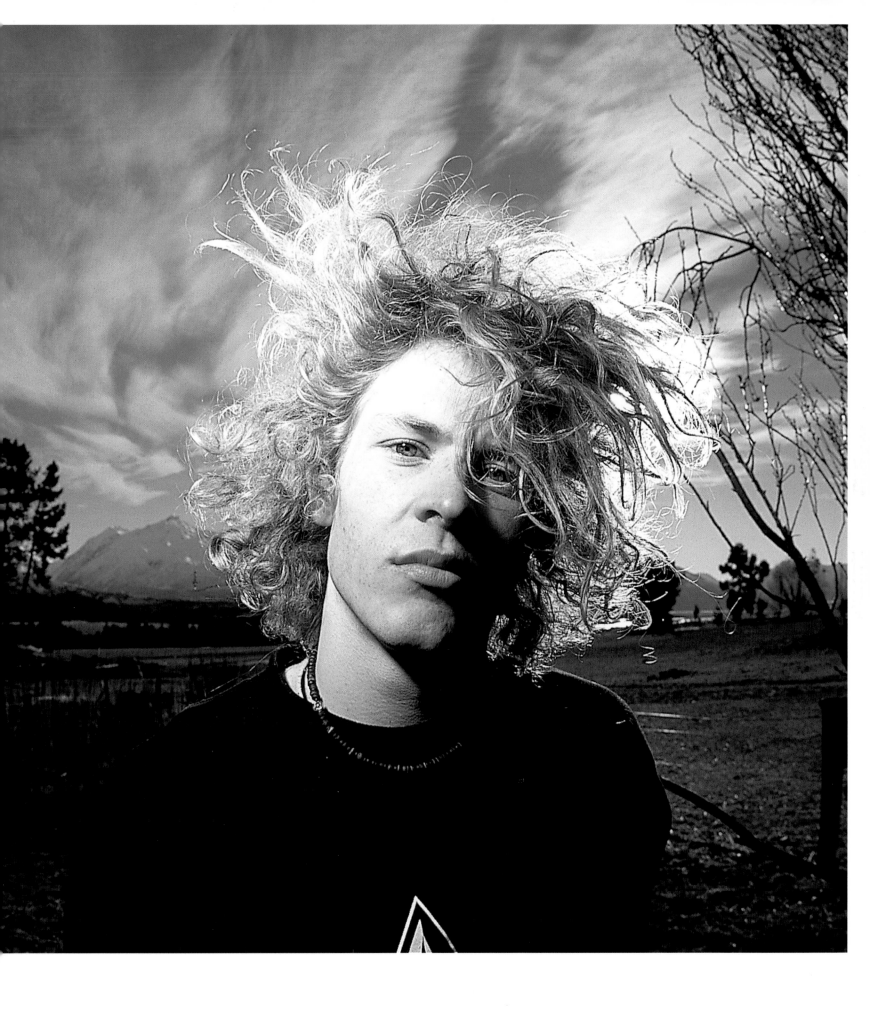

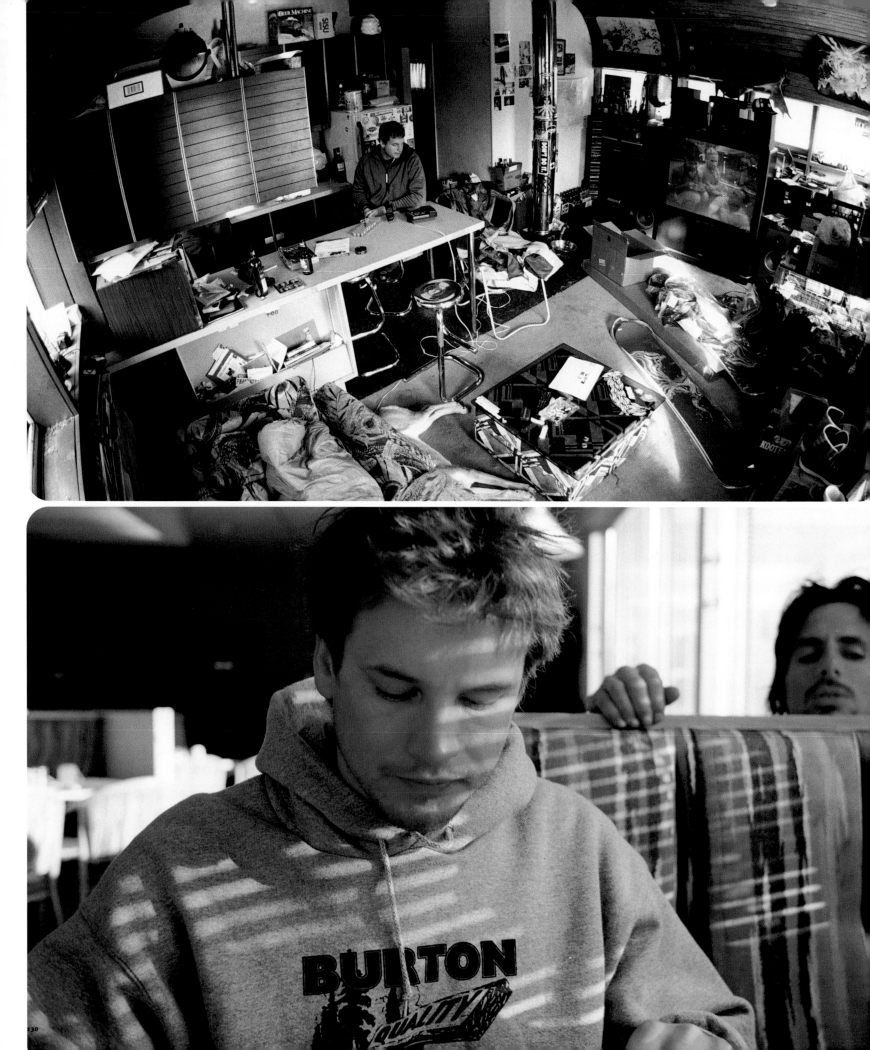

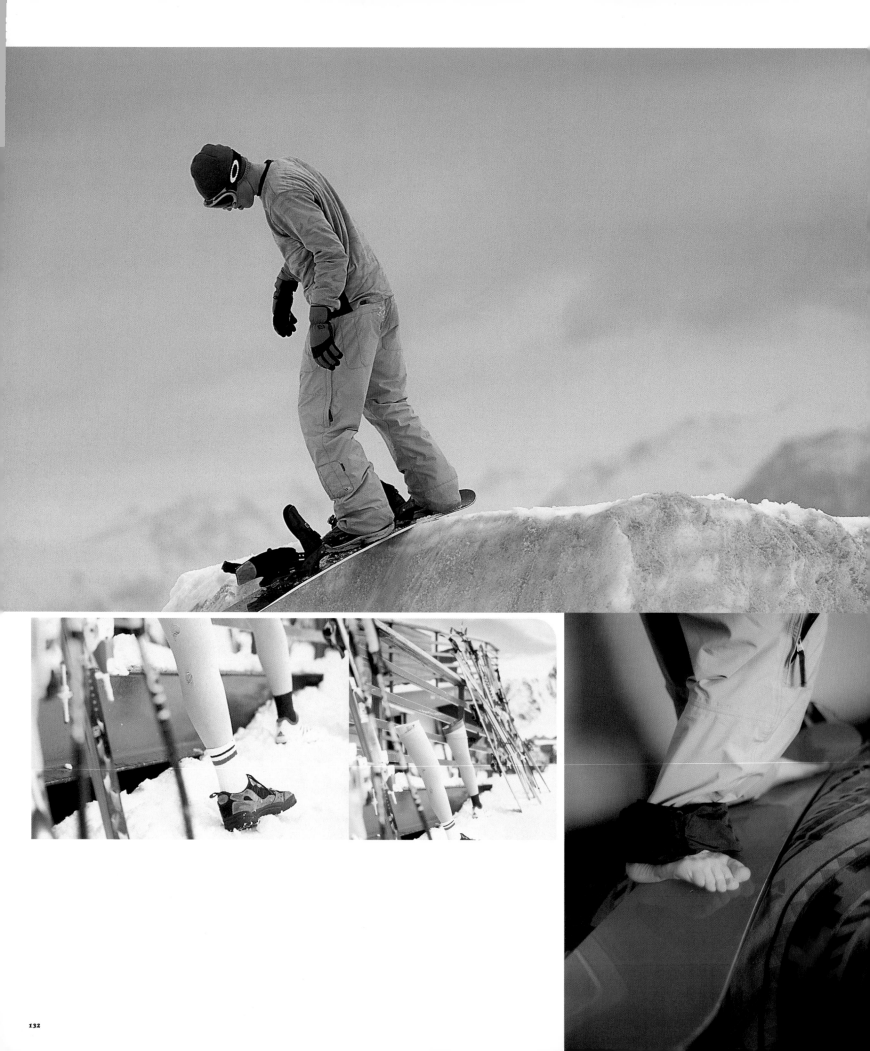

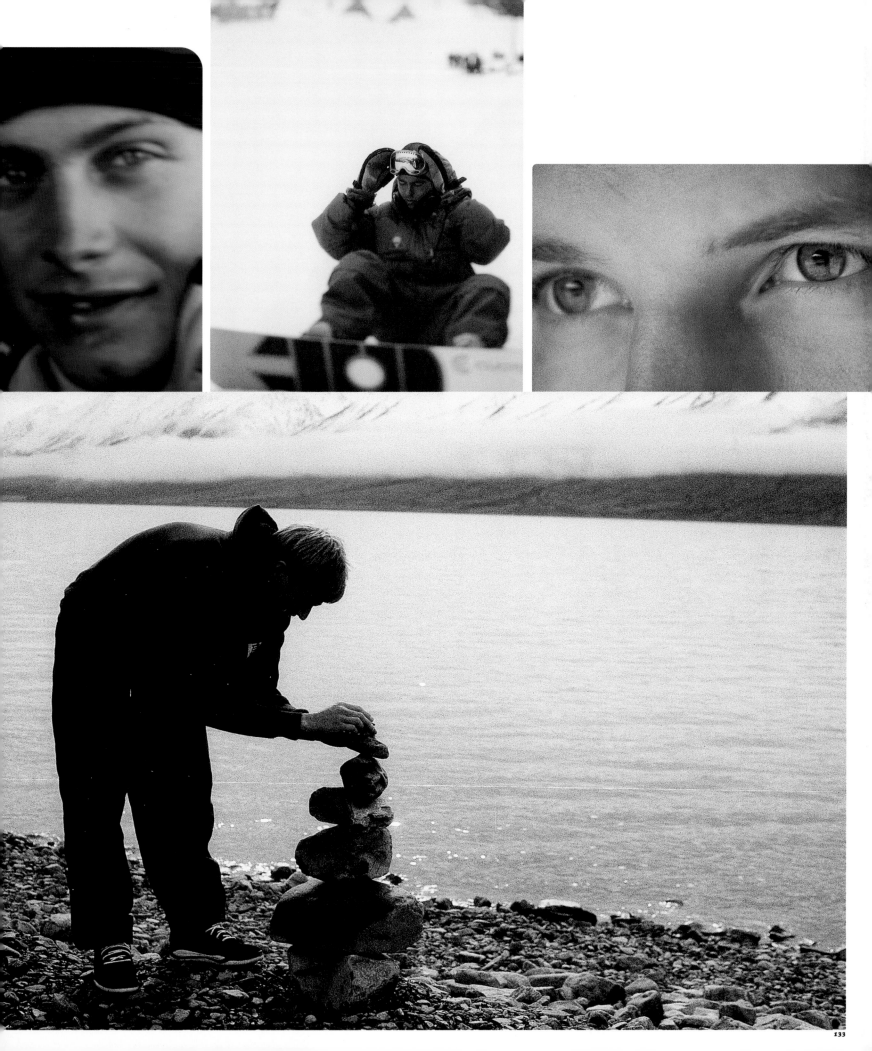

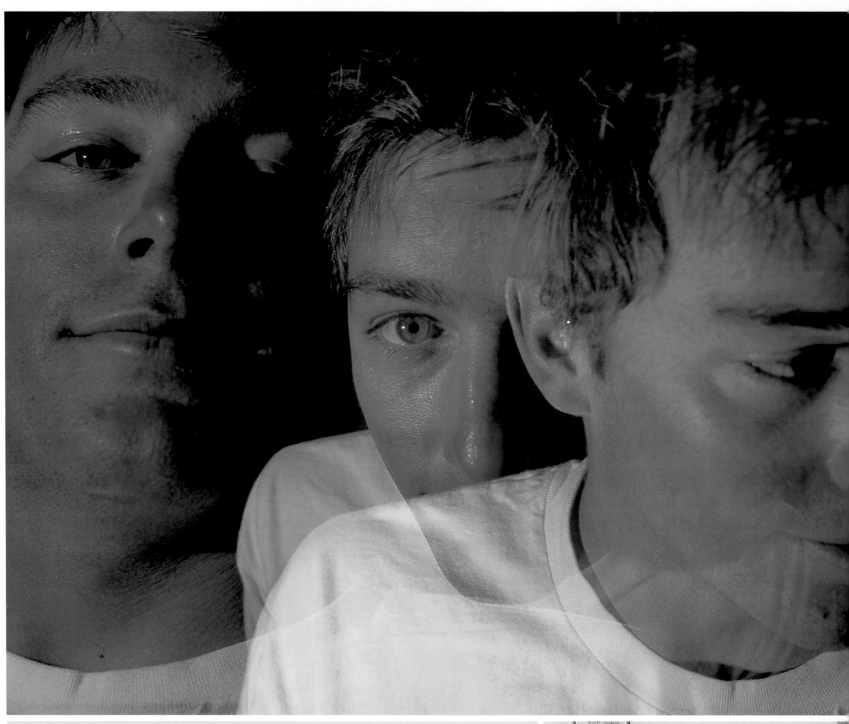

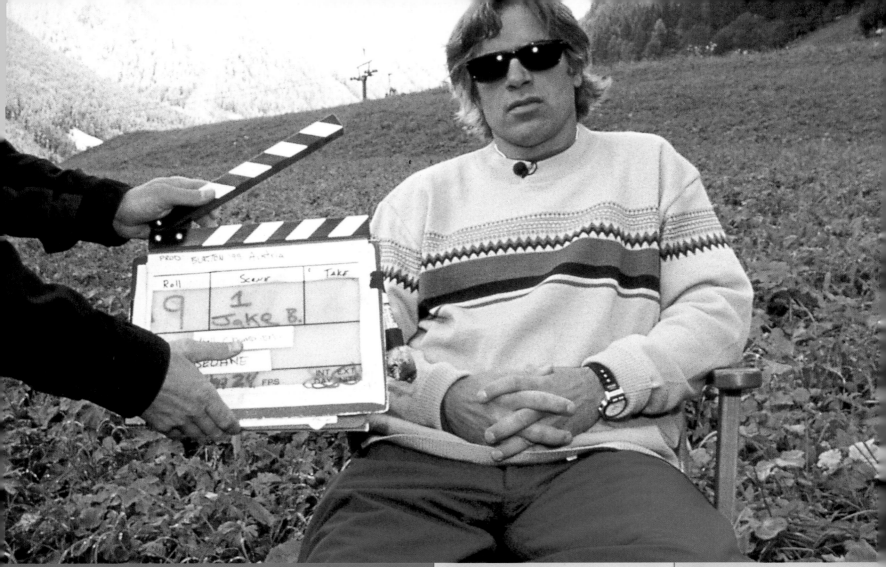

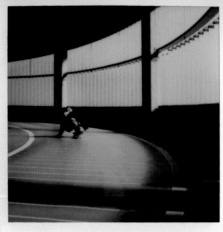
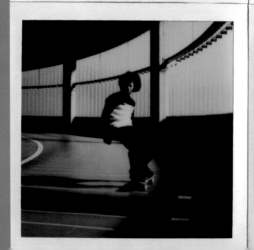

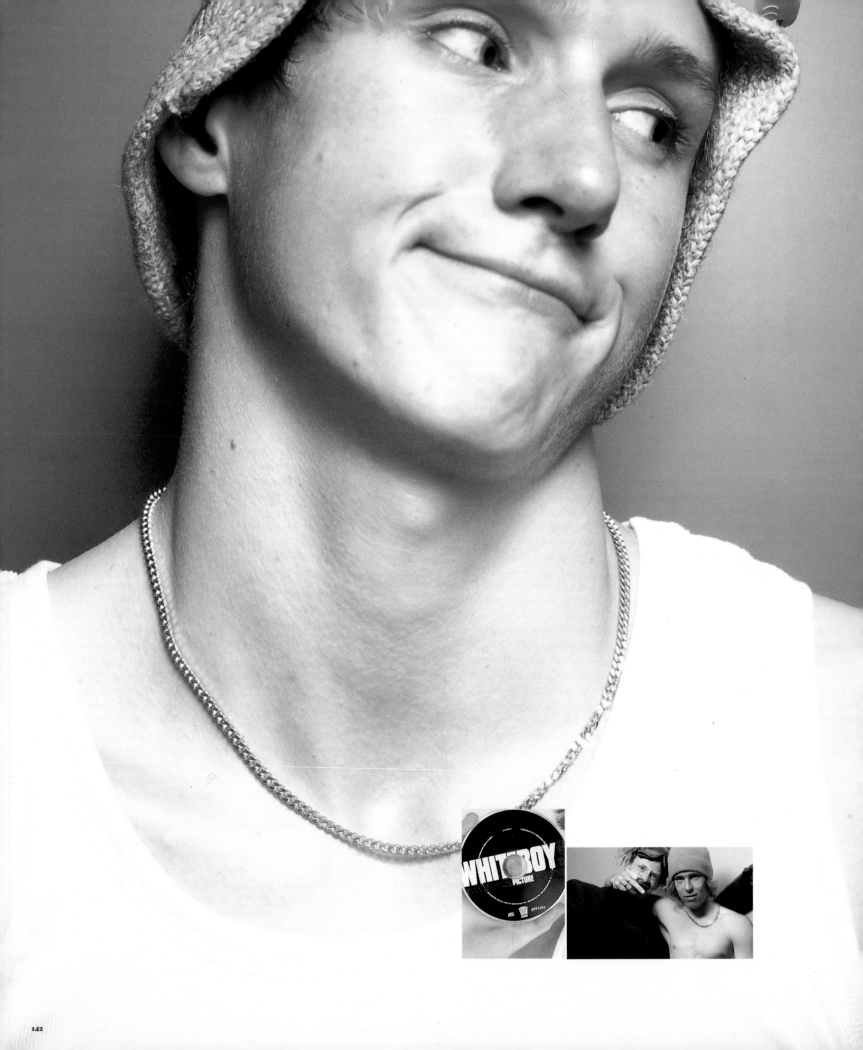

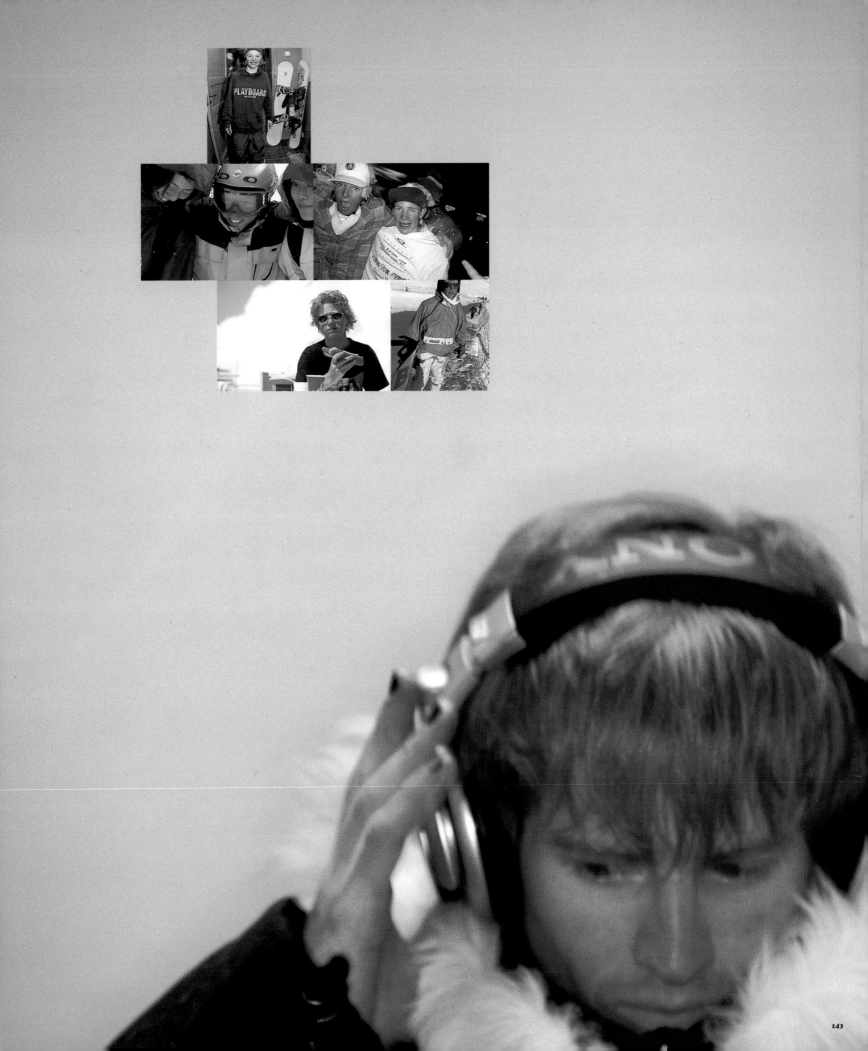

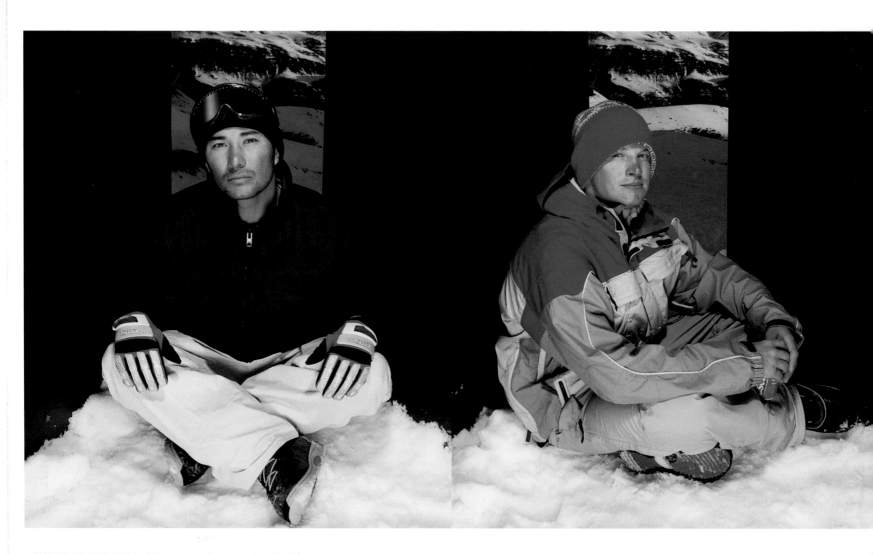

USELESS STORY

WE HAD TO PULL JOHAN + CHUCH AWAY FROM THE BAR AFTER A HARD DAY OF SHOOTING. THEY WERE GOOD SPORTS ABOUT IT, EVEN THOUGH THEY HAD TO GET BACK INTO THEIR GEAR AND HIKE UP TO US. WHEN THEY ARRIVED IN TWELVE ALMOST OUT OF LIGHT. TENSIONS RAN HIGH AS WE WAITED IN THE FREEZING COLD FOR OUR POLAROIDS® TO DEVELOP UNDER HATS TO FIND OUR LOCATION. WE HAD SET-UP ON THE LANDING OF A BIG JUMP THAT WAS PLANNED FOR A NIGHT SHOOT. JUST AS WE GOT STARTED SHOOTING A CREW SHOWED UP TO HIT THE JUMP. THEY WERE SITTING 80 INCHES AWAY FROM US AND YOU'D NEVER GUESS.

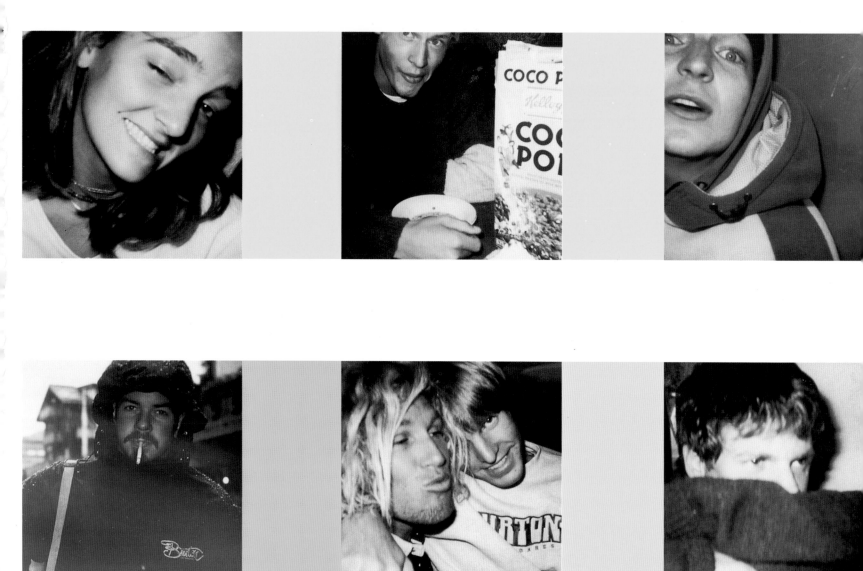

MIKE HATCHETT'S FAVOURITE LINES
(HE HAS EVER FILMED)

TB3 – MENDENHALL TOWERS. BECAUSE IT WAS ONE OF THE FIRST "BIG LINES" ON FILM.

TB4 – TOM DAY ON CHIMNEY CHUTE. HE WAS ON SKIS THOUGH. SO I DON'T KNOW IF YOU WANT TO MENTION IT.

TB5 – JOHAN DOING CAULIFLOWER CHUTES IN 50 SECONDS (OR WHATEVER IT WAS) TOP TO BOTTOM.

TB5 – JOHAN'S STRAIGHT RUN IN TAHOE.

TB5 – JOHAN IN ALASKA DOING 7 TURNS OR SO ON THE SPINE WITH BIG SLUFFS. THEN A BACK SIDE 360 OFF THE CLIFF.

TB6 – TOM BURT ON CORDOVA PEAK.

TB7 – JOHAN ON ODDEN'S LADDER.

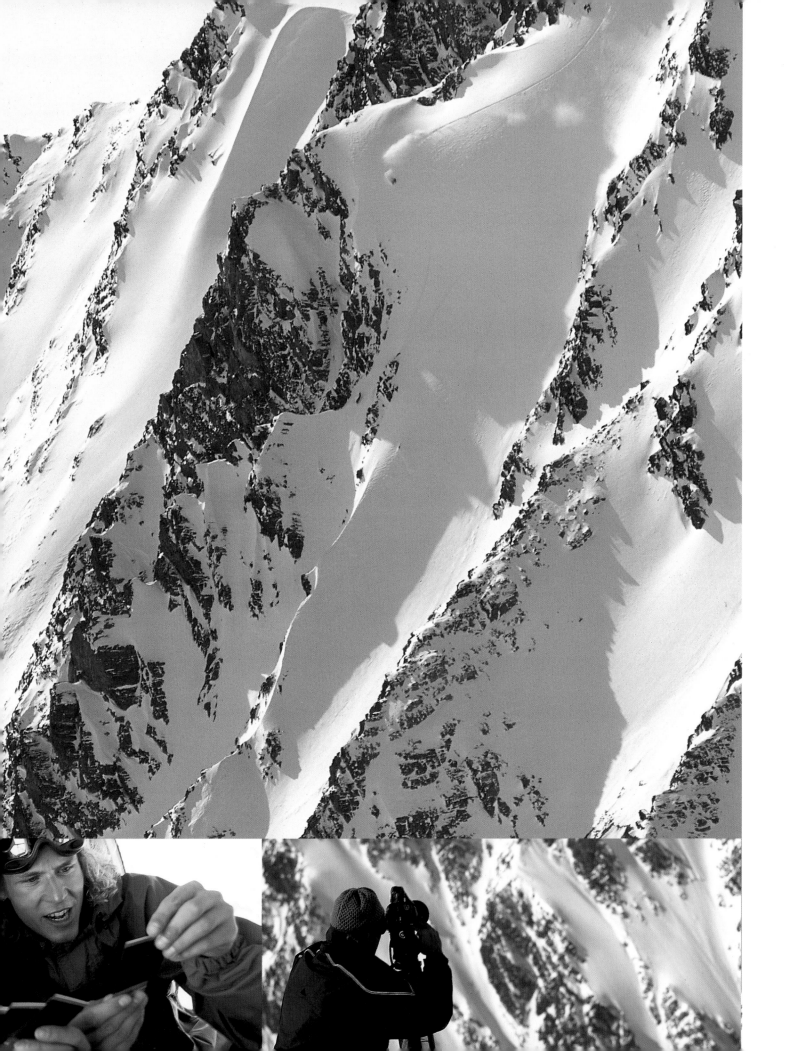

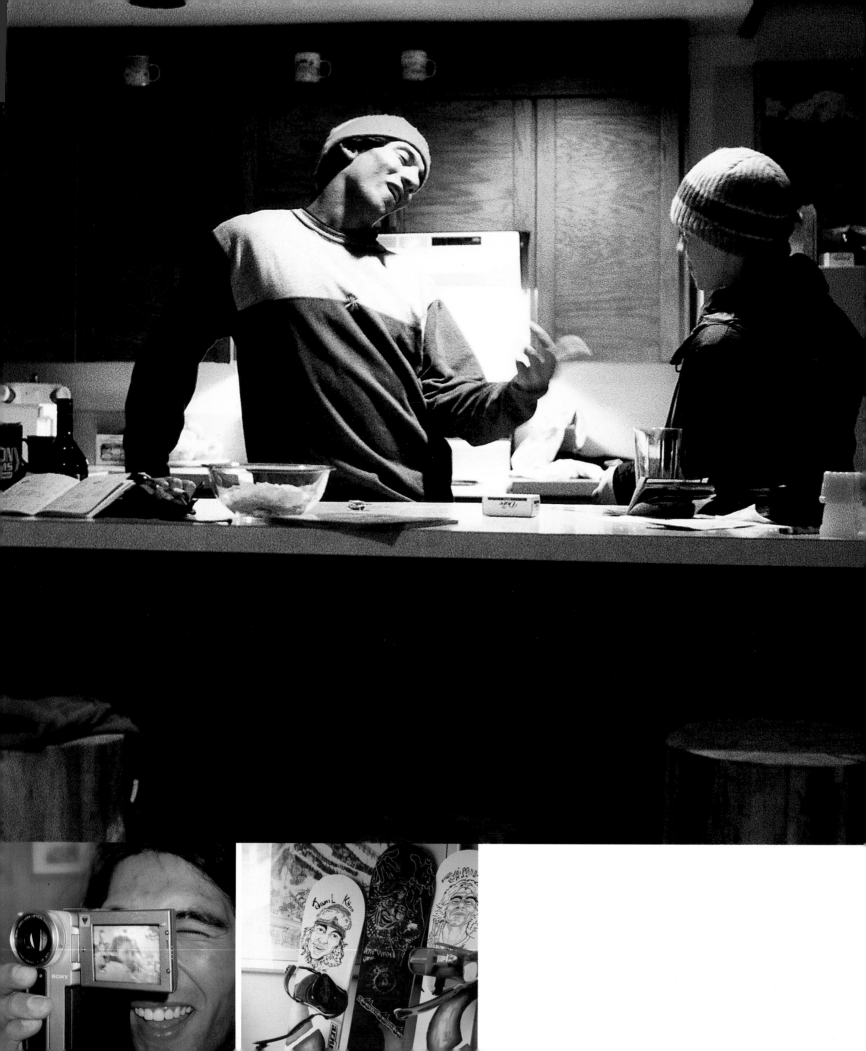

(un**process**ed)

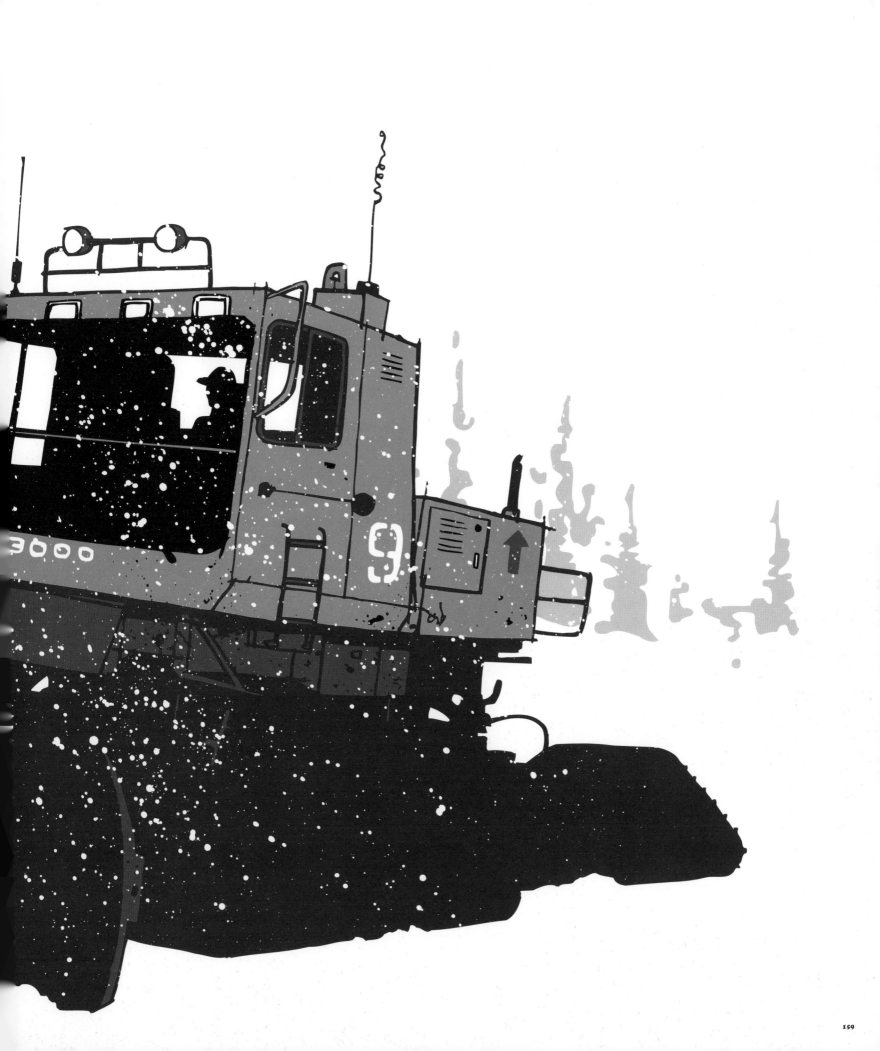

Scott Leonhardt
www.ScottLeonhardt.com

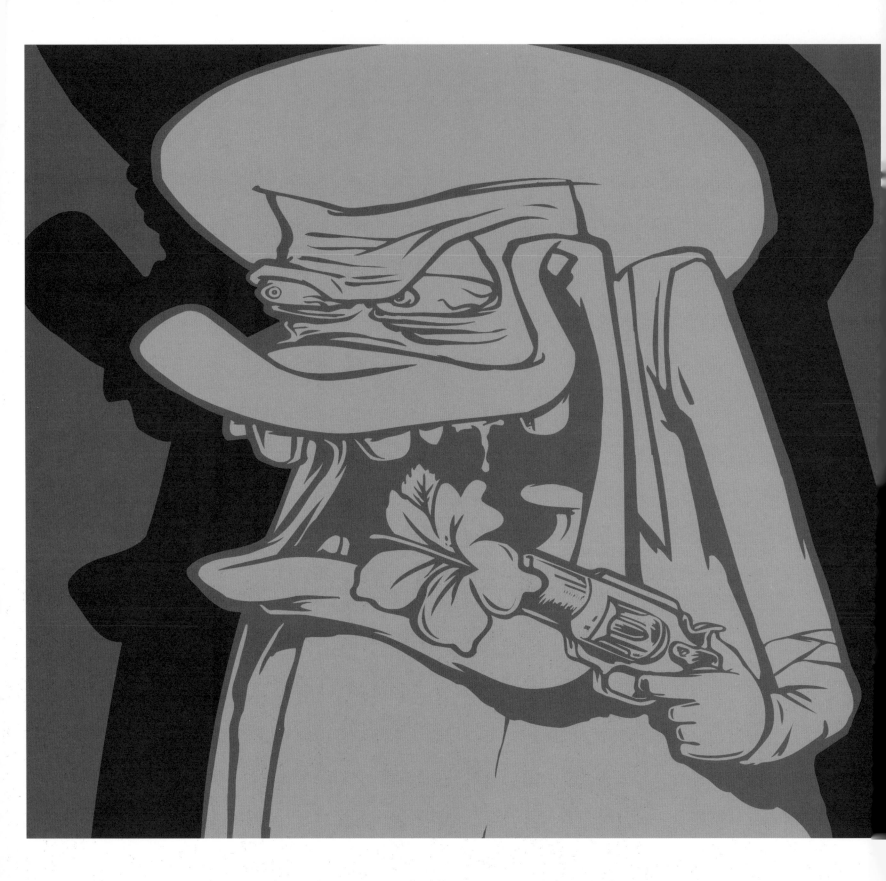

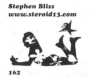

EAU DE CADET

Andy Mueller
www.ohiogirl.com

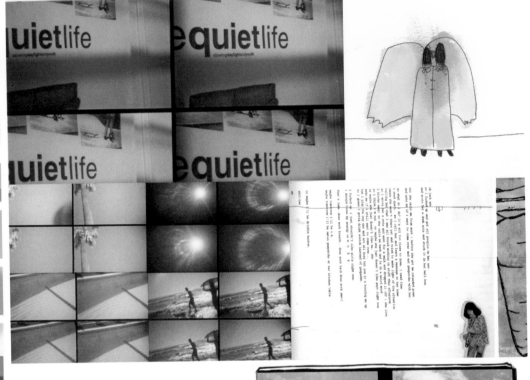

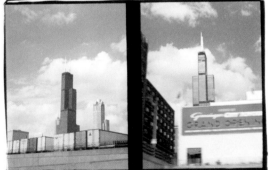

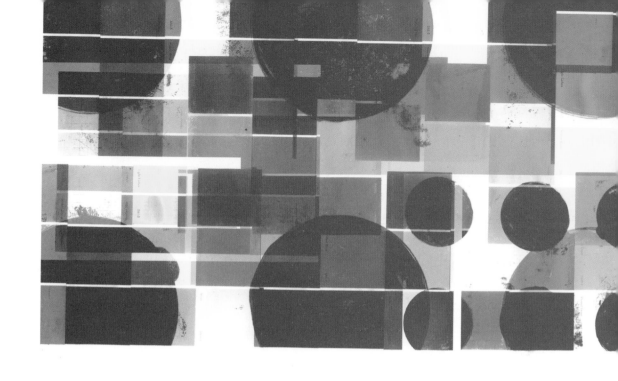

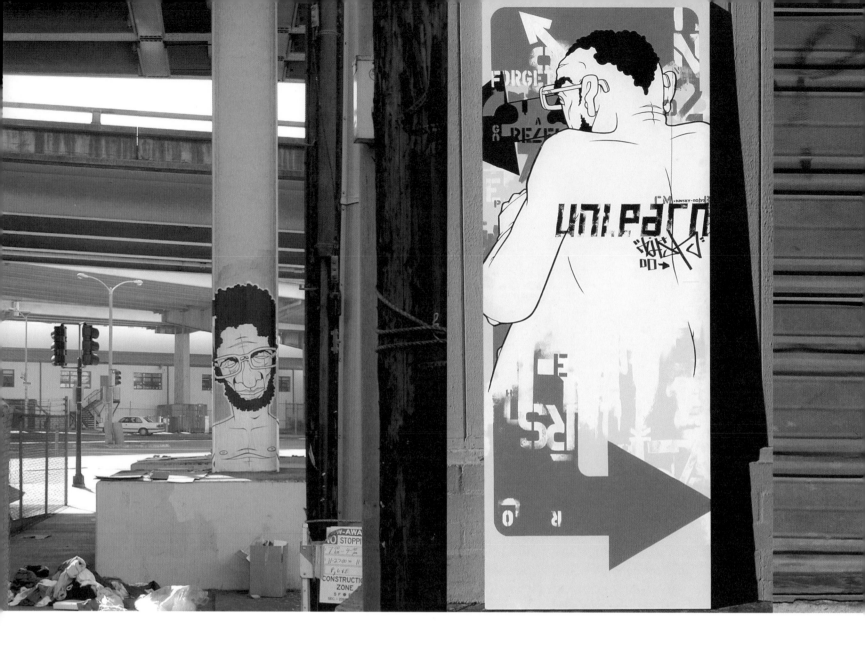

Dave Kinsey
www.kinseyvisuals.com

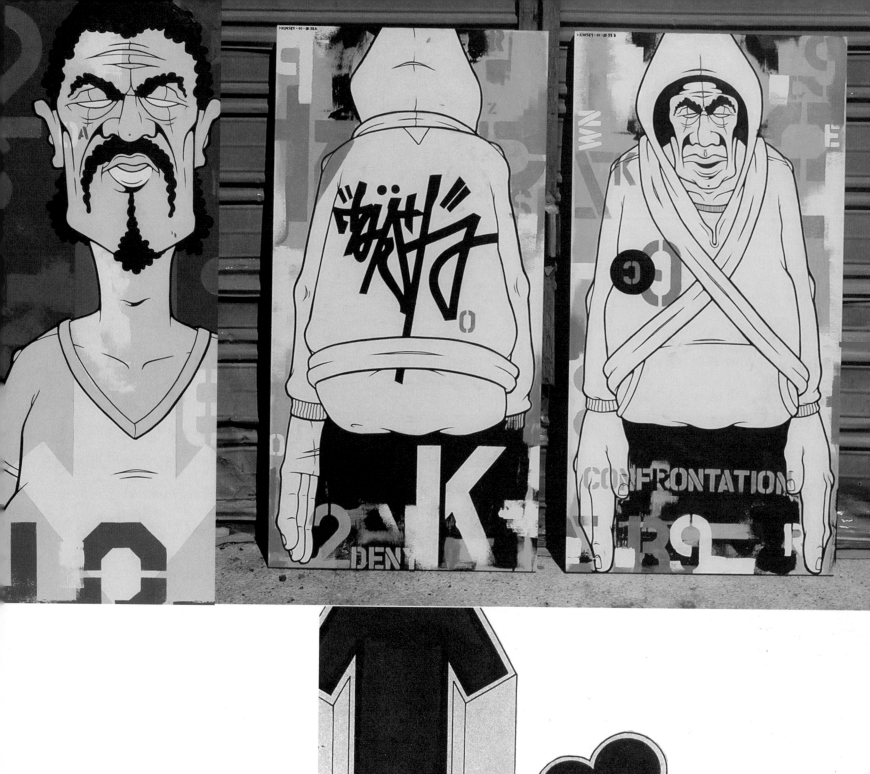

Jason Brashill
www.jaseyjas.co.uk
www.caned99.freeserve.co.uk

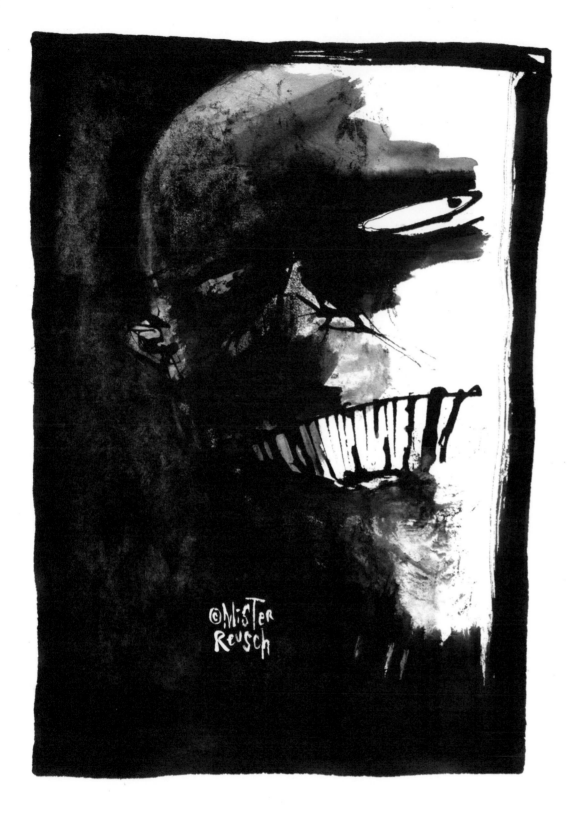

Mark Reush
www.misterreush.com

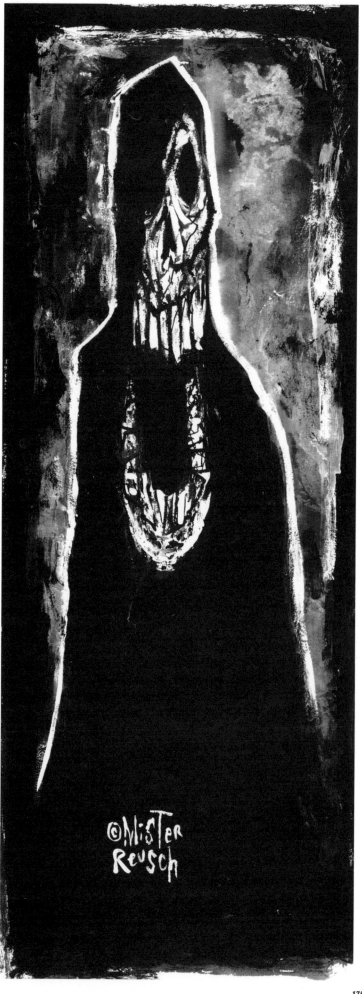

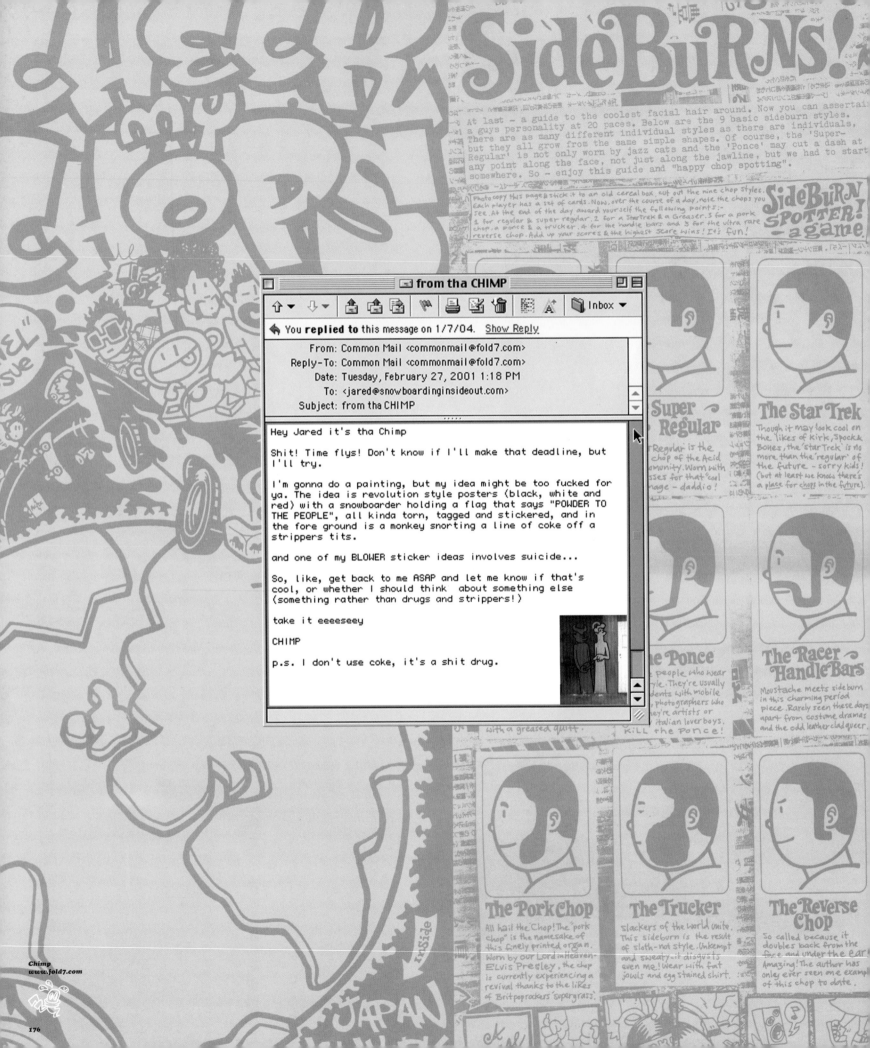

SideBuRNs!

At last — a guide to the coolest facial hair around. Now you can assert a guys personality at 20 paces. Below are the 9 basic sideburn styles. There are as many different individual styles as there are individuals - but they all grow from the same simple shapes. Of course, the 'Super-Regular' is not only worn by jazz cats and the 'Ponce' may cut a dash at any point along the face, not just along the jawline, but we had to start somewhere. So — enjoy this guide and "happy chop spotting".

Photocopy this page & stick it to an old cereal box, cut out the nine chop styles. Each player has a set of cards. Now, over the course of a day, note the chops you see. At the end of the day award yourself the following points:- 1 for regular & super regular. 2 for a StarTrek & a Greaser. 3 for a pork chop, a Ponce & a trucker. 4 for the handle bars and 5 for the ultra rare reverse chop. Add up your scores & the highest score wins! It's fun!

SideBuRN SPOTTER! - a game

from tha CHIMP

You **replied to** this message on 1/7/04. Show Reply

From: Common Mail <commonmail@fold7.com>
Reply-To: Common Mail <commonmail@fold7.com>
Date: Tuesday, February 27, 2001 1:18 PM
To: <jared@snowboardinginsideout.com>
Subject: from tha CHIMP

Hey Jared it's tha Chimp

Shit! Time flys! Don't know if I'll make that deadline, but I'll try.

I'm gonna do a painting, but my idea might be too fucked for ya. The idea is revolution style posters (black, white and red) with a snowboarder holding a flag that says "POWDER TO THE PEOPLE", all kinda torn, tagged and stickered, and in the fore ground is a monkey snorting a line of coke off a strippers tits.

and one of my BLOWER sticker ideas involves suicide...

So, like, get back to me ASAP and let me know if that's cool, or whether I should think about something else (something rather than drugs and strippers!)

take it eeeeseey

CHIMP

p.s. I don't use coke, it's a shit drug.

Super Regular

Regular is the chop of the Acid community. Worn with glasses for that 'cool image - daddio!

The Star Trek

Though it may look cool on the likes of Kirk, Spock & Bones, the 'StarTrek' is no more than the 'regular' of the future - sorry kids! (but at least we know there's a place for chops in the future).

The Ponce

The people who wear this style. They're usually students with mobile phones, photographers who think they're artists or Italian loverboys, with a greased quiff. KILL the Ponce!

The Racer Handle Bars

Moustache meets sideburn in this charming period piece. Rarely seen these days apart from costume dramas and the odd leather clad queer.

The Pork Chop

All hail the 'Chop! The 'pork chop' is the namesake of this finely printed organ. Worn by our Lord in Heaven - Elvis Presley, the chop is currently experiencing a revival thanks to the likes of Britpoprockers 'supergrass'.

The Trucker

Slackers of the world unite. This sideburn is the result of sloth - not style. Unkempt and sweaty - it disgusts even me! Wear with fat jowls and egg stained shirt.

The Reverse Chop

So called because it doubles back from the face and under the ear. Amazing! The author has only ever seen one example of this chop to date.

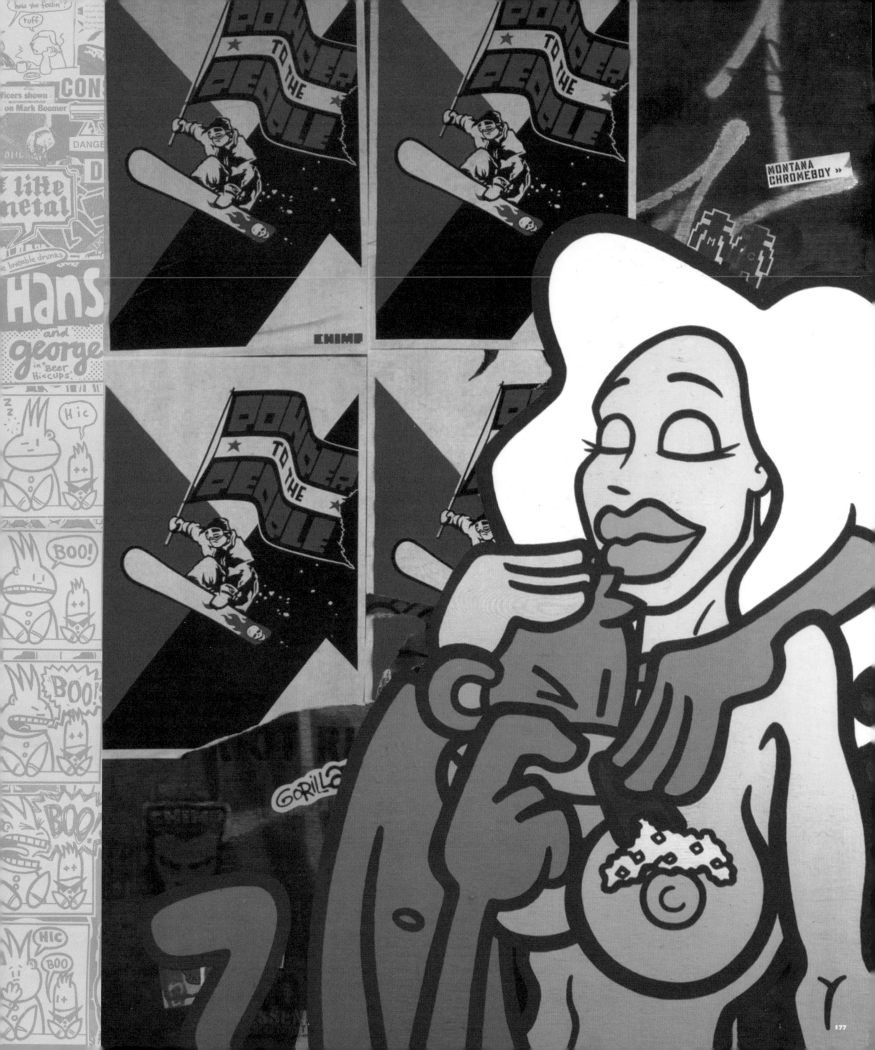

RIGHT? WHAT THE HELL AM I THINKING?

PENS
ON

10
10
97

THE LINE IS PRETTY ELUSIVE. AND
ALL OF IT DEPENDS ON THE
LITERAL LINE. I USED TO FEEL
PRETTY CONFIDENT BUT NOW
I'M MAYBE — RUSTY? THE
LINES FEEL LABORED. I SEE
THE CONFIDENCE IN FROST
AND CAMPBELLS WORK AND
I CRY INSIDE. I LOVE THEM.
I LONG TO BE PART TO FEEL
PART BUT MY LINE IS NOWHERE.
IT'S LOST, NOT RUSTY, LOST.
BUT I'M LOOKING SO IT'S GOOD
IN THAT RESPECT. OR ALRIGHT,
ANYWAY. MY HEAD IS CRAMMED
TIGHT AND SO ARE NUMEROUS
NOTEBOOKS AND BOXES AND MANILLA
FOLDERS... MAYBE I
WILL FIND THE LINE
OR A PLACE FOR IT SOON. I HOPE. —ANDY

Woo Roberts

wo·ol·o·gy

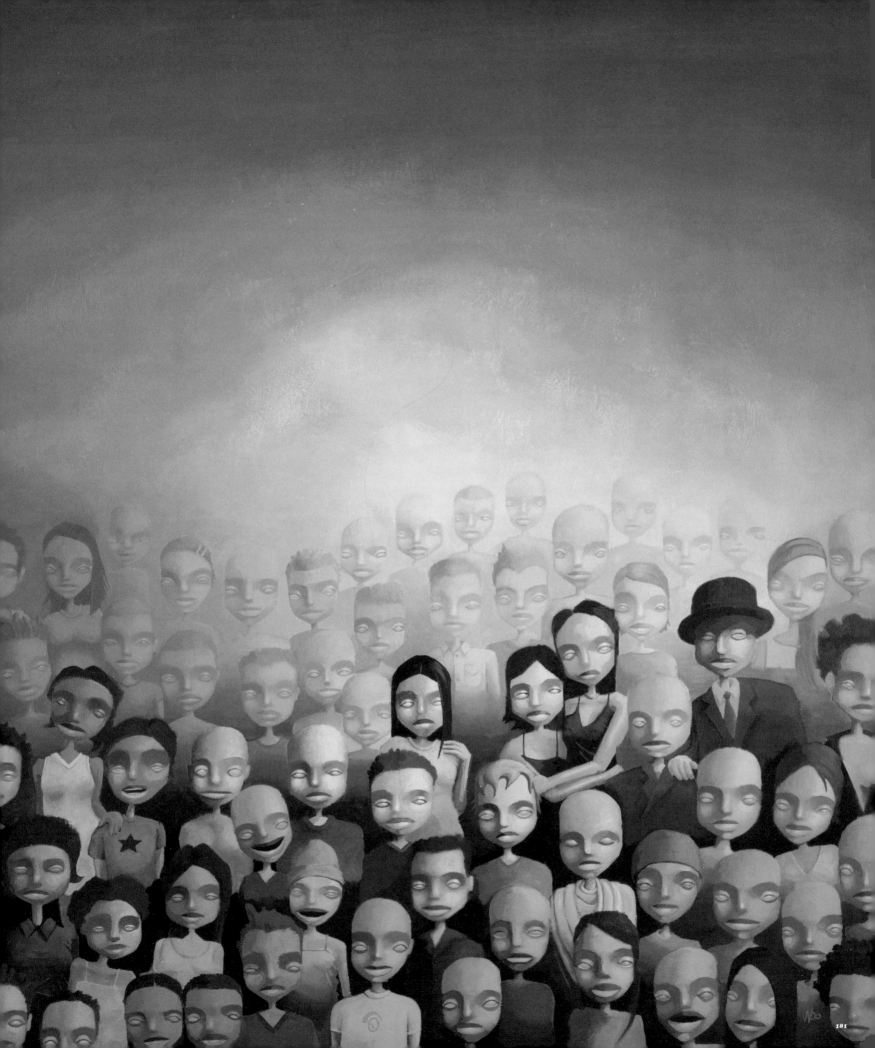

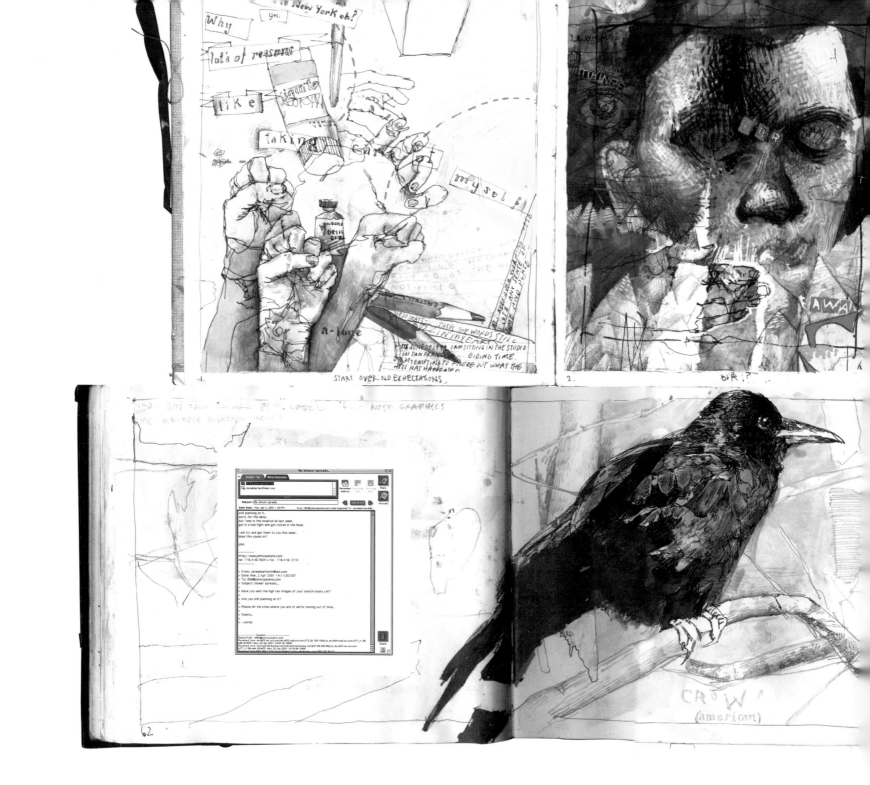

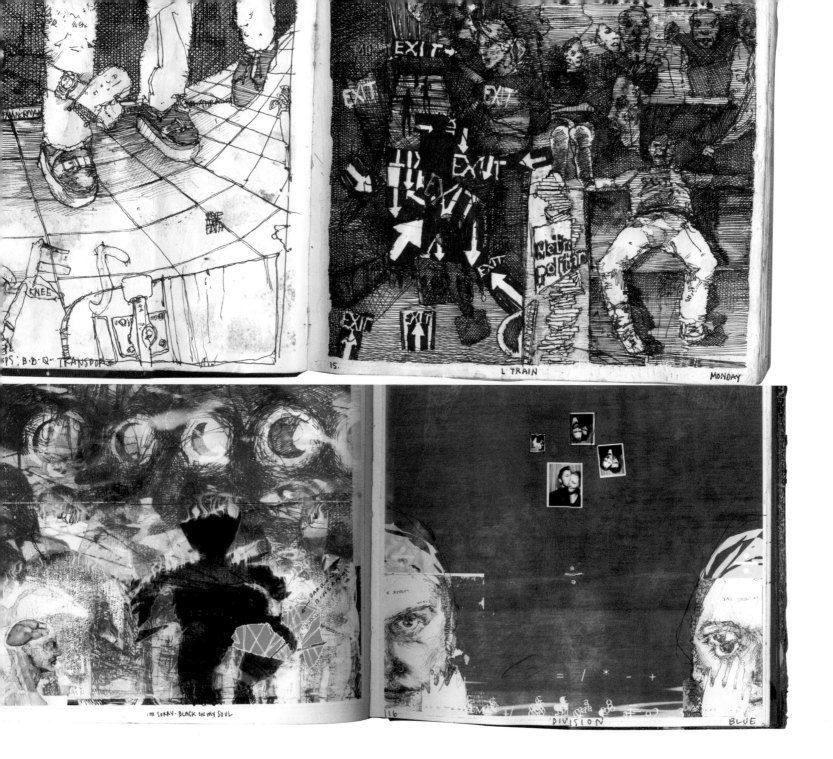

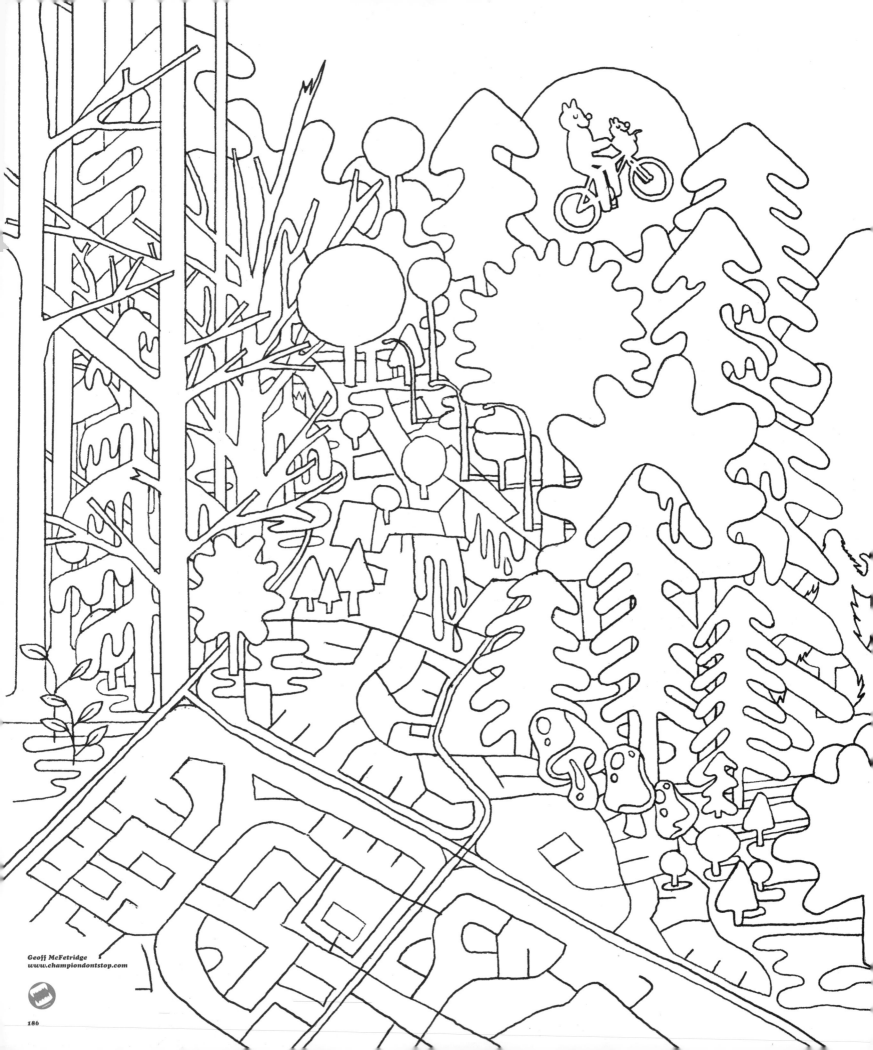

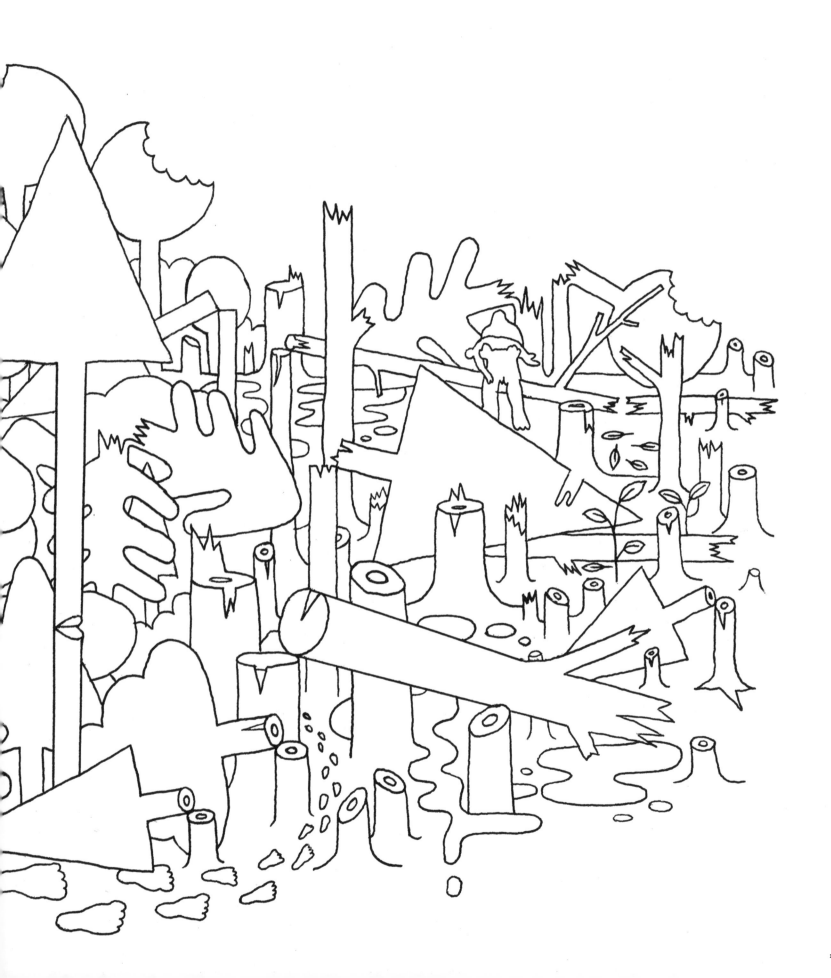

I like my ~~board.~~ **board.** Sometimes I stare at it in the mirror when I'm undressing and wonder what it would look like without any ~~**stickers**~~ like when I was a baby. Sometimes I sit at the edge of the bed and spread my legs. And stare into the mirror and wonder what others see. Sometimes I stick my ~~**feet**~~ in my ~~**bindings**~~ and wiggle it around the dark wetness and feel what a ~~**couch**~~ or a ~~**chair**~~ must feel when I'm sitting on it. I pull my ~~**feet**~~ out and I always taste it and smell it. It's hard to describe it smells like a ~~**tomato**~~ to me fresh and full of life. I love my ~~**board**~~, it is the complete summation of my life. It's the place where all the most painful things have happened. But it has given me indescribable pleasure. My ___ is the temple of learning.

BURTON

As I look back on my friends and heroes of the last 14 years, I see them all standing sideways. They are each unique in their own way with the exception of a mutual passion for riding snowboards. As vividly as I can picture their faces, I can see the boards that they were riding. It's only been a few years since I've come to appreciate what those graphics meant, back then as well as what they mean today. As clichéd as it may sound, the graphics allow us to express ourselves; they allow us to be individual and united all at the same time.

It is the graphic that has the power to take a board that would be perfect for us and turn it something we hate, or stoke us to ride the board that is completely wrong. Actually creatin snowboard graphic is an experience that motivates even the laziest of us to work all night. experience has inspired and built remarkable graphic designers out of would be engineers high school dropouts alike.

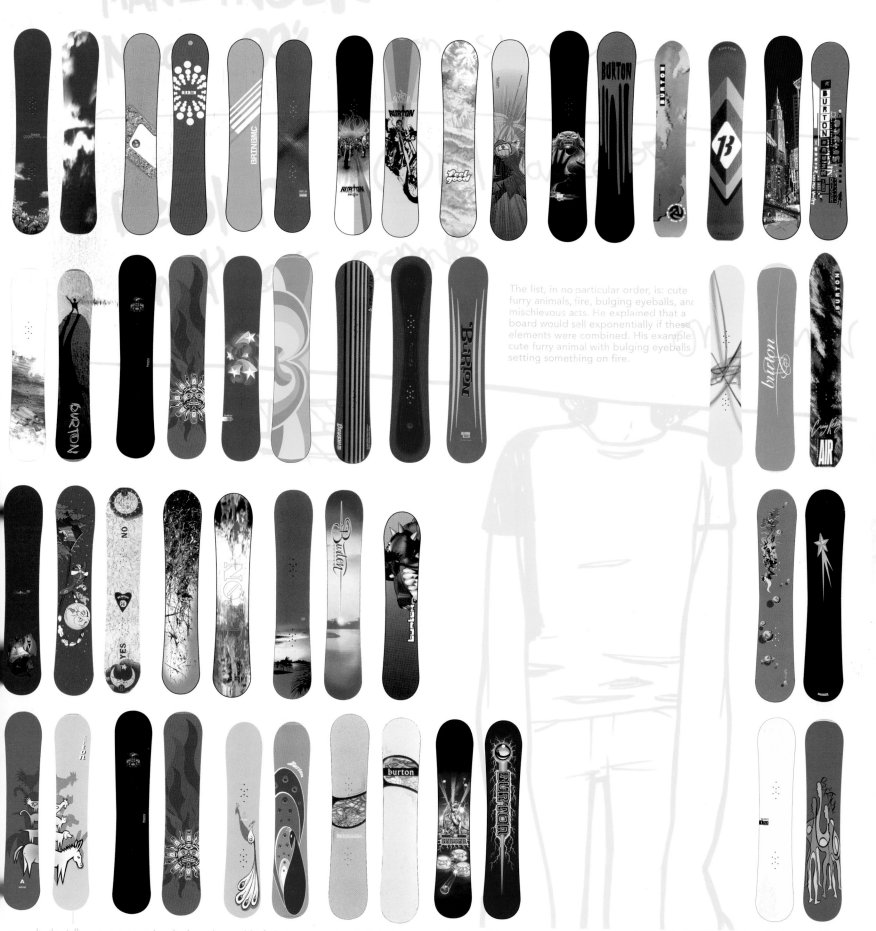

The list, in no particular order, is: cute furry animals, fire, bulging eyeballs, and mischievous acts. He explained that a board would sell exponentially if these elements were combined. His example: cute furry animal with bulging eyeballs setting something on fire.

**Lance Violette
– Design Director JDK**

a result, the influence our sport has had on the world of design cannot be denied. As owboarders we are trying so hard to be different that sometimes we don't even notice that we're lling a design revolution in the process. As graphic designers we receive opportunities for a ative voice that few people get to experience. A snowboard graphic is a well-orchestrated laboration between these designers, artists, marketers, and teamriders and if it's done right, the d result is something that no single person could ever achieve alone.

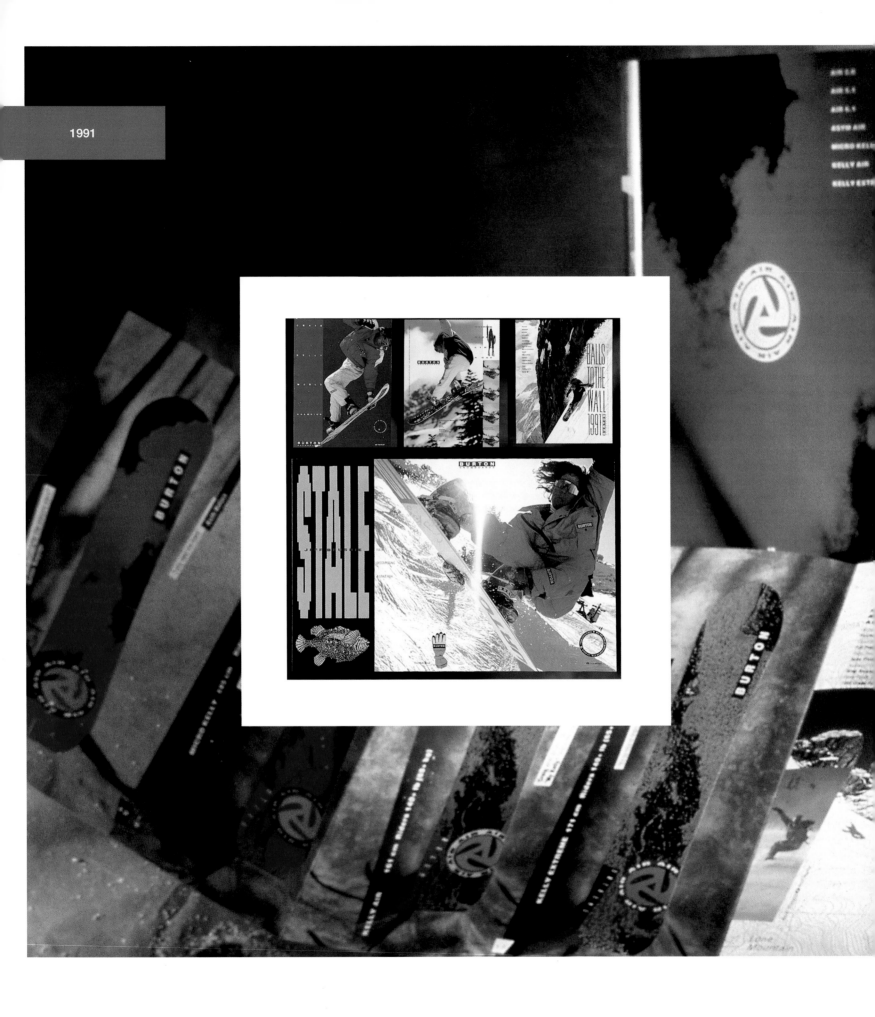

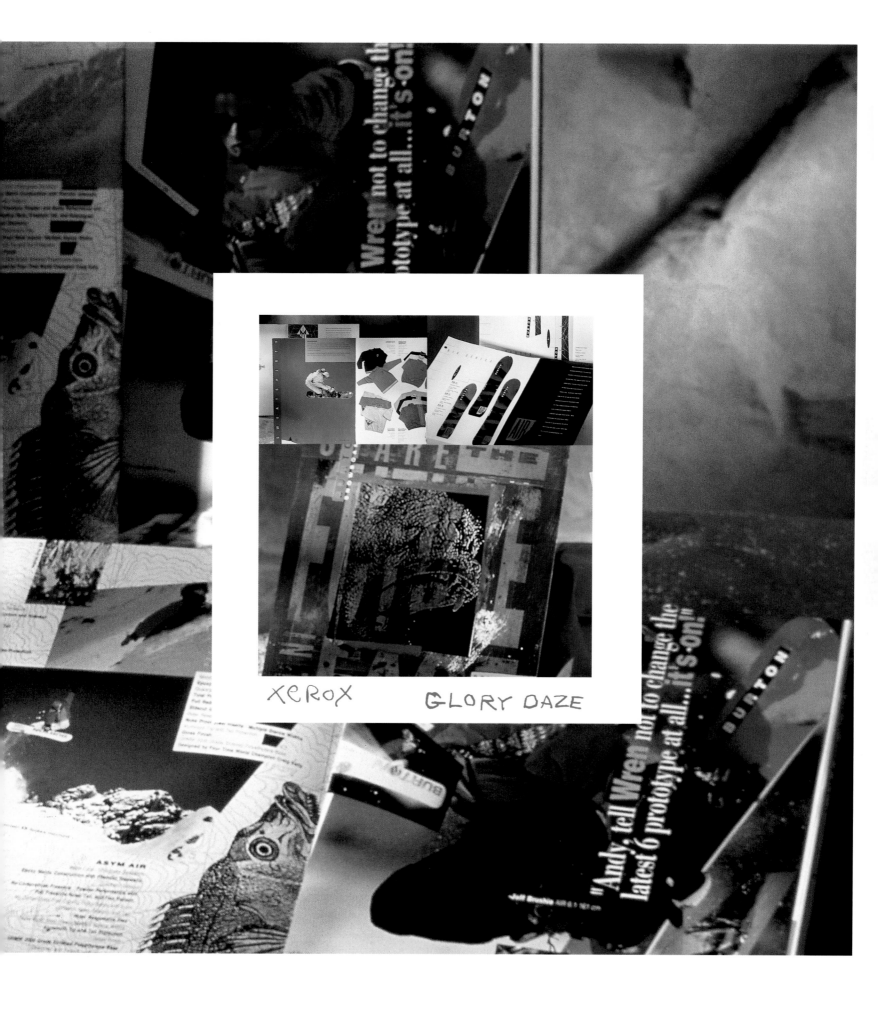

XEROX GLORY DAZE

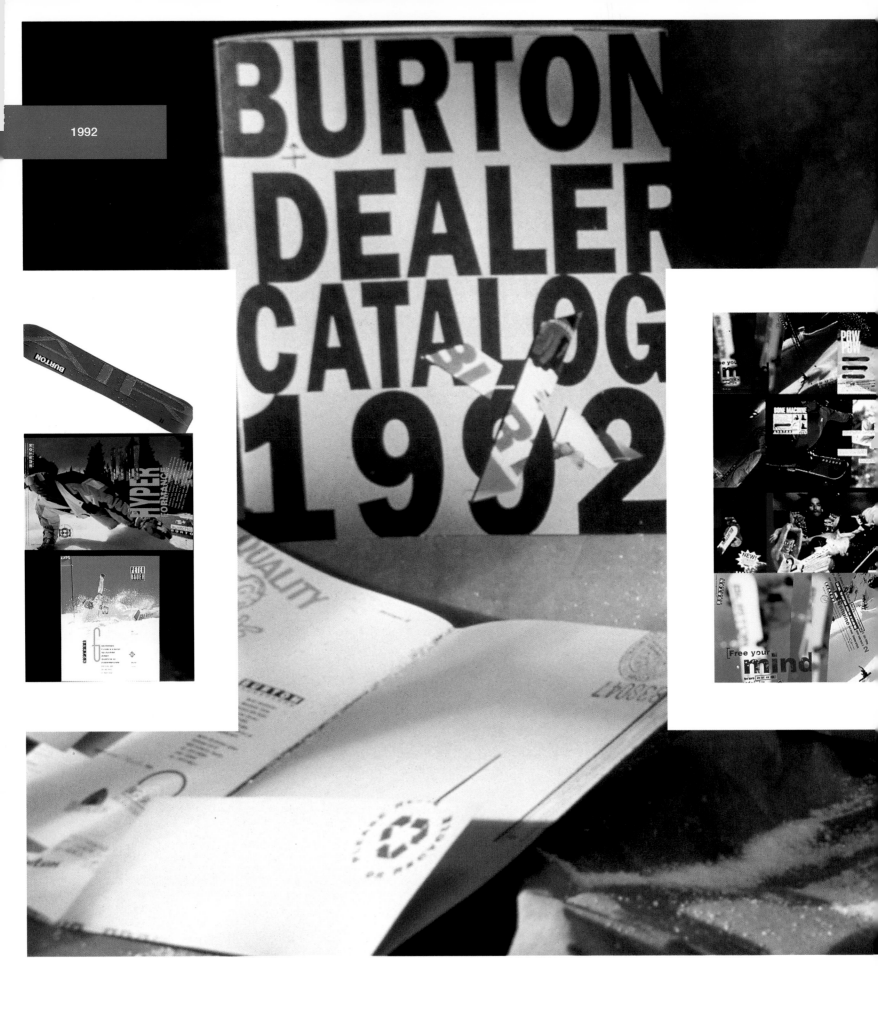

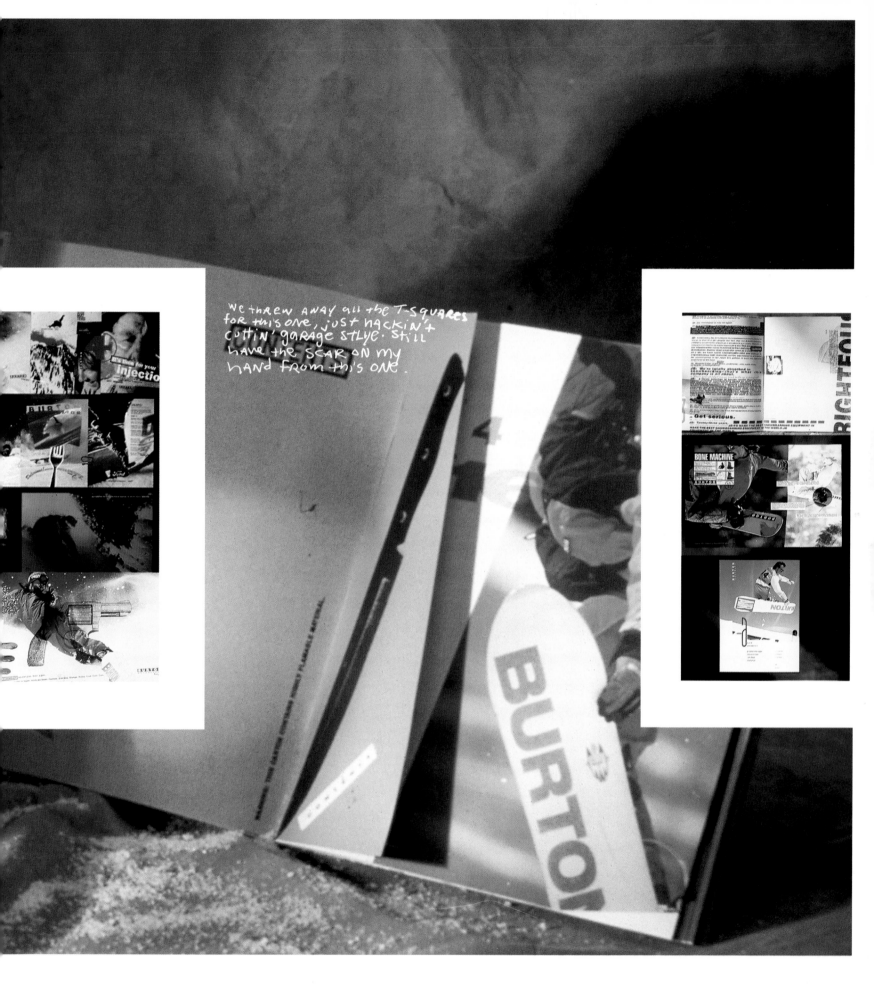

we threw away all the T-squares for this one, just hackin' cuttin' garage stlye. Still have the scar on my hand from this one.

1992/93

lucky strike

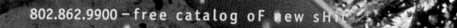

© Jason Gerardi ©JAH

802.862.9900 — free catalog of new shit

⑬

got ALL the RESEARCH FROM my dad, BRUNSWICK High Biology teacher.

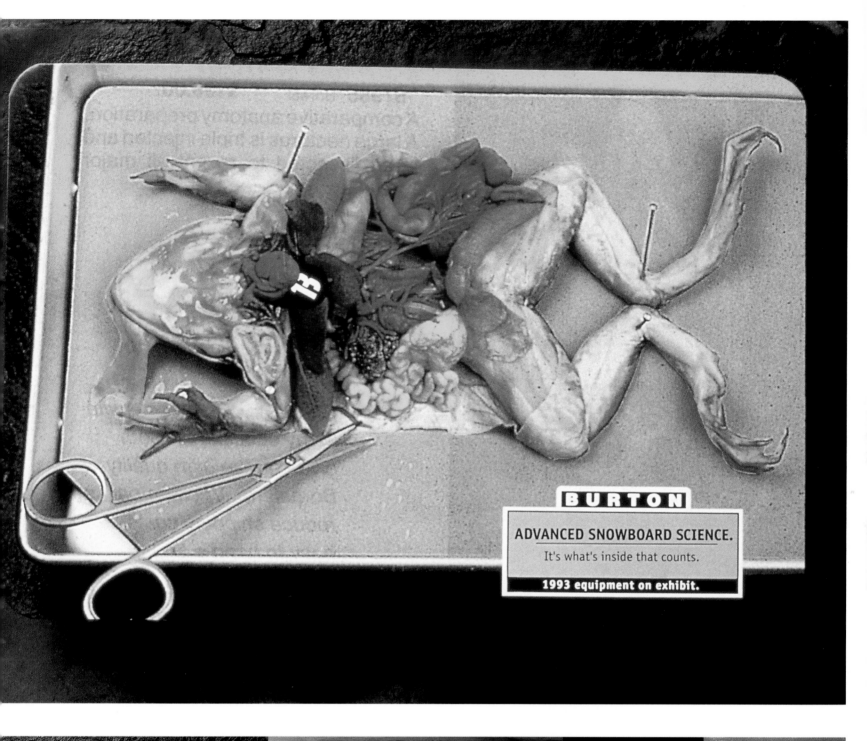

BURTON

ADVANCED SNOWBOARD SCIENCE.

It's what's inside that counts.

1993 equipment on exhibit.

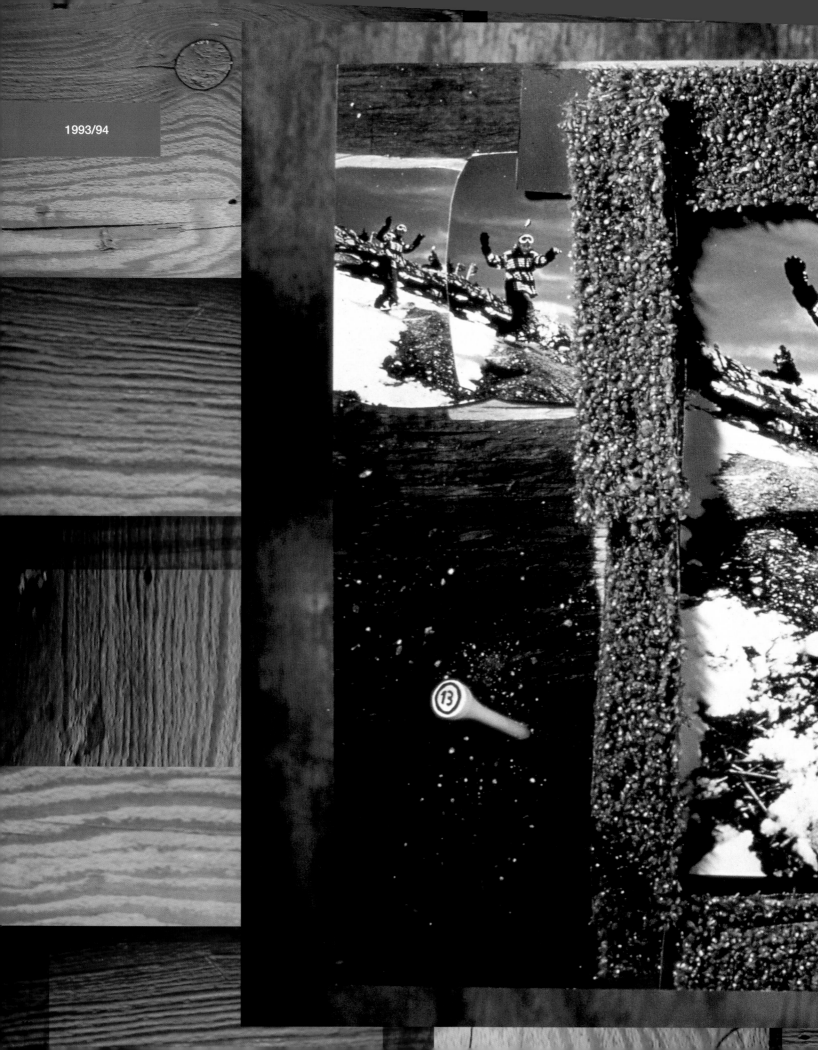

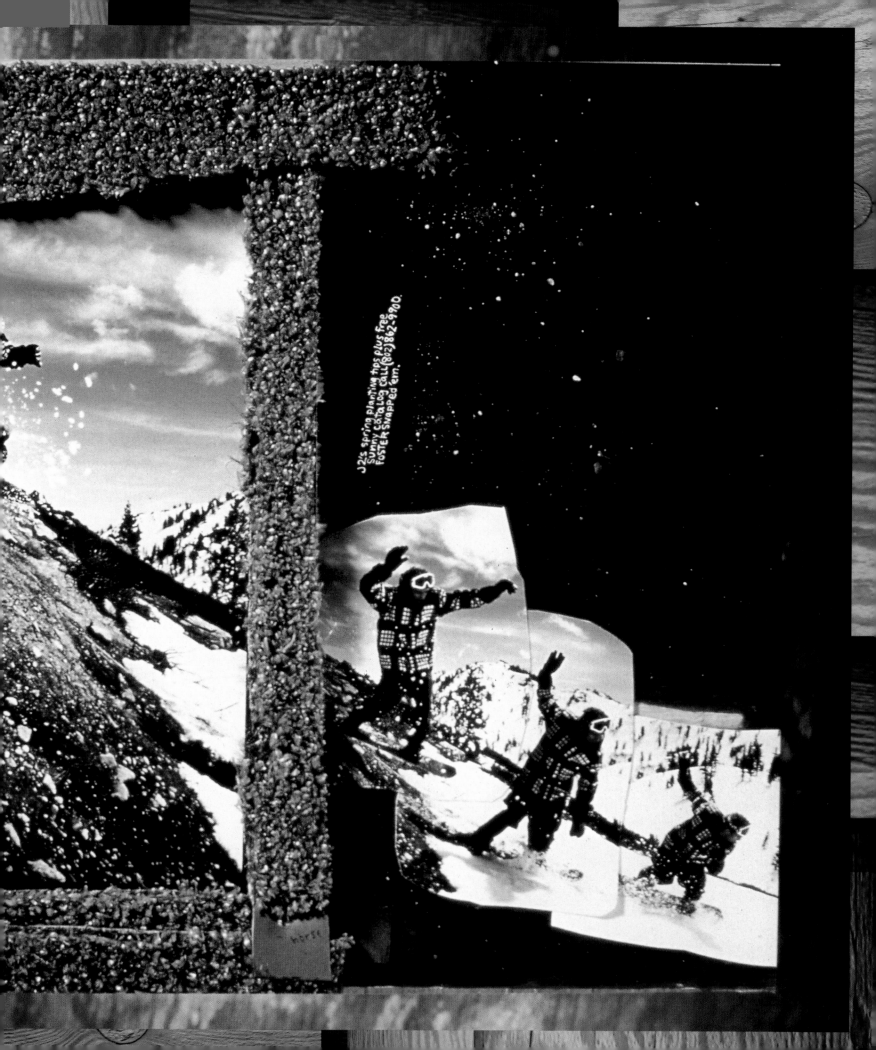

1994

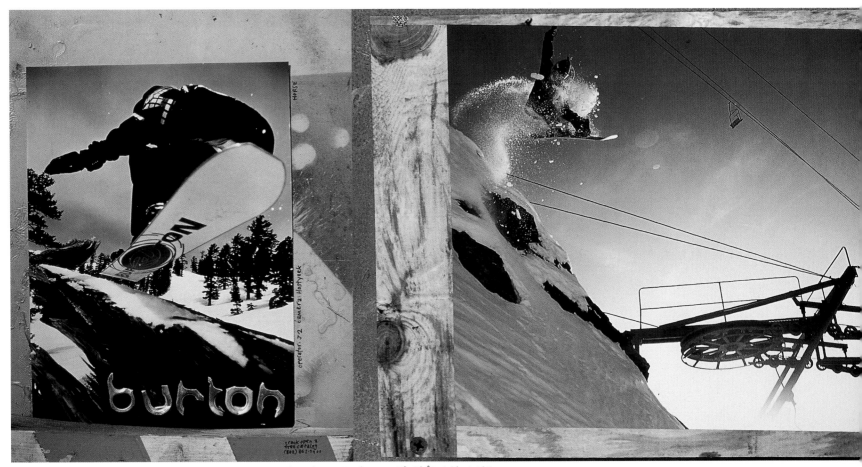

the summer of st. nk, my office on pine street backed up with shit, literally and piled high with junk to make the construction ads. You couldn't walk through the door.

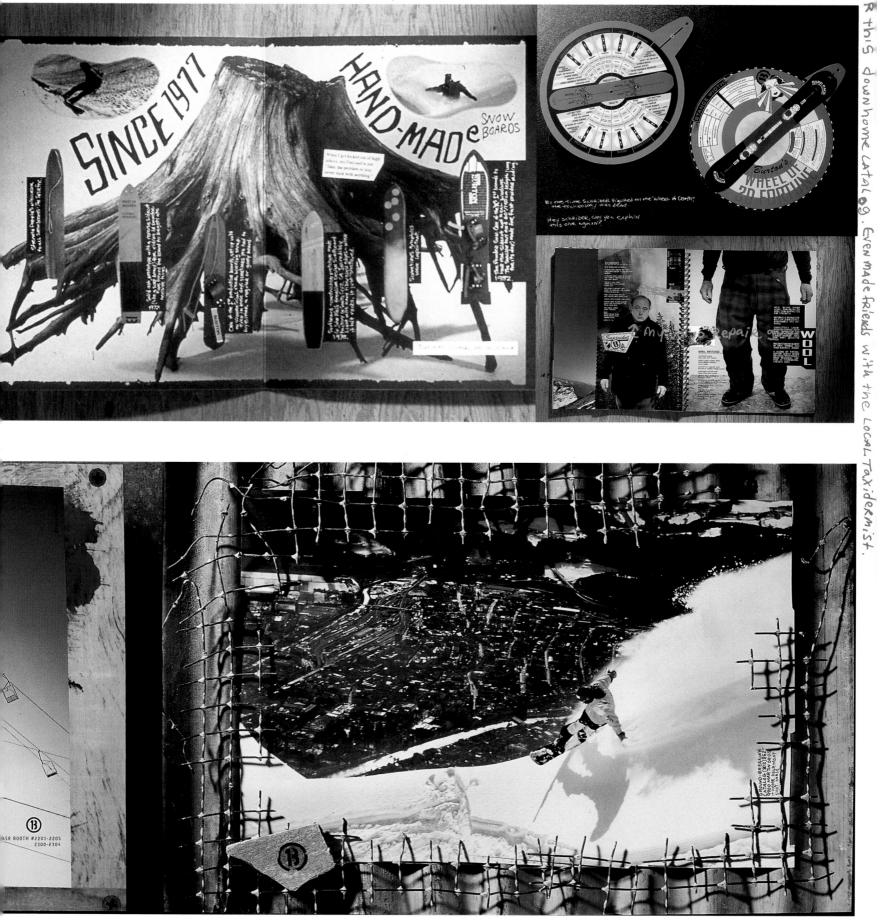

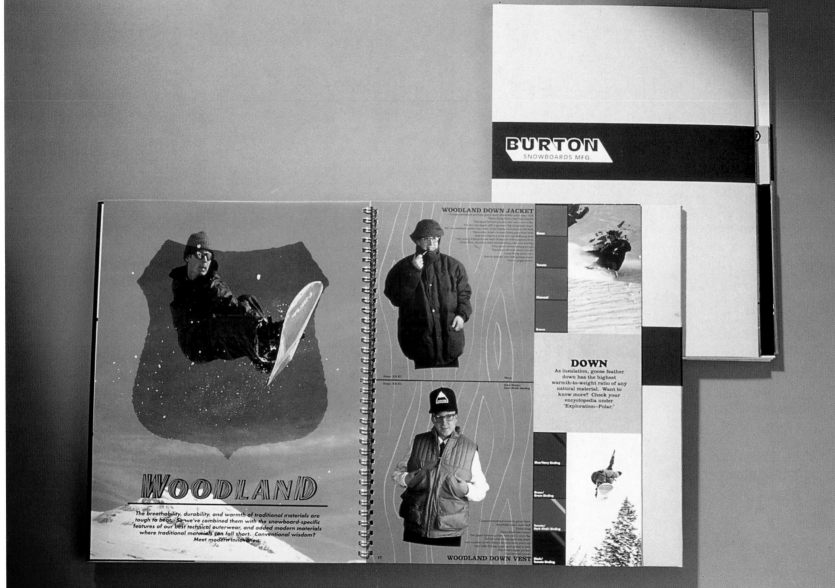

WOODLAND DOWN JACKET

WOODLAND

The breathability, durability, and warmth of traditional materials are tough to beat. So we've combined them with the snowboard-specific features of our best technical outerwear, and added modern materials where traditional materials can fall short. Conventional wisdom? Meet modern innovation.

DOWN

As insulation, goose feather down has the highest warmth-to-weight ratio of any natural material. Want to know more? Check your encyclopedia under "Exploration–Polar."

WOODLAND DOWN VEST

'95 BURTON

BURTON

Burton JAPAN 03-5443-0013

PHOTO: JEFF CURTES

MEANWHILE...
JOE SNOWBOARDER IS CALLING
TOLL FREE 1-(800)-943-1588
FOR A FREE CATALOG

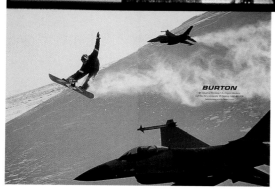

BURTON

photoshop 1.1

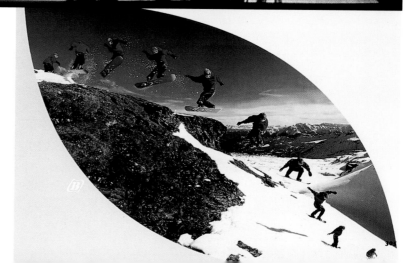

1996

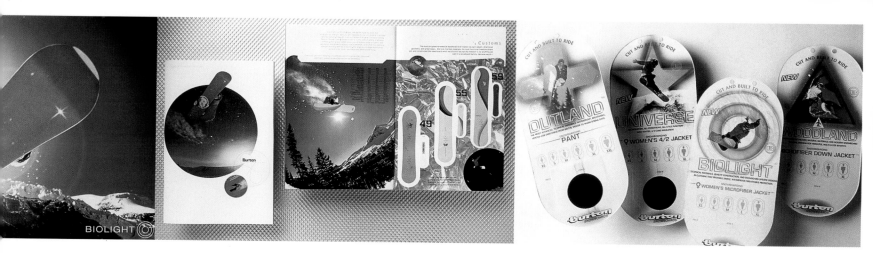

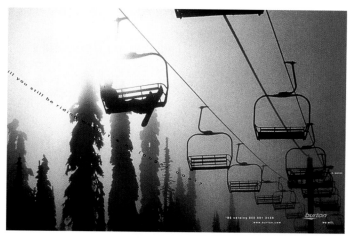

By now, posers were everywhere so we made this ad for the true.

this's one too.

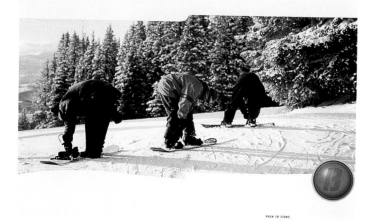

PUSH TO START.

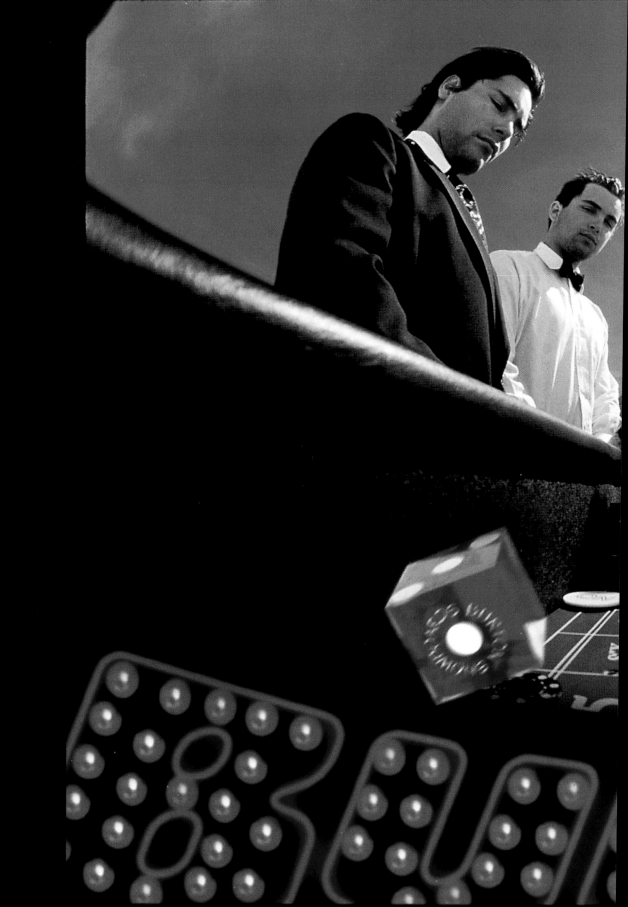

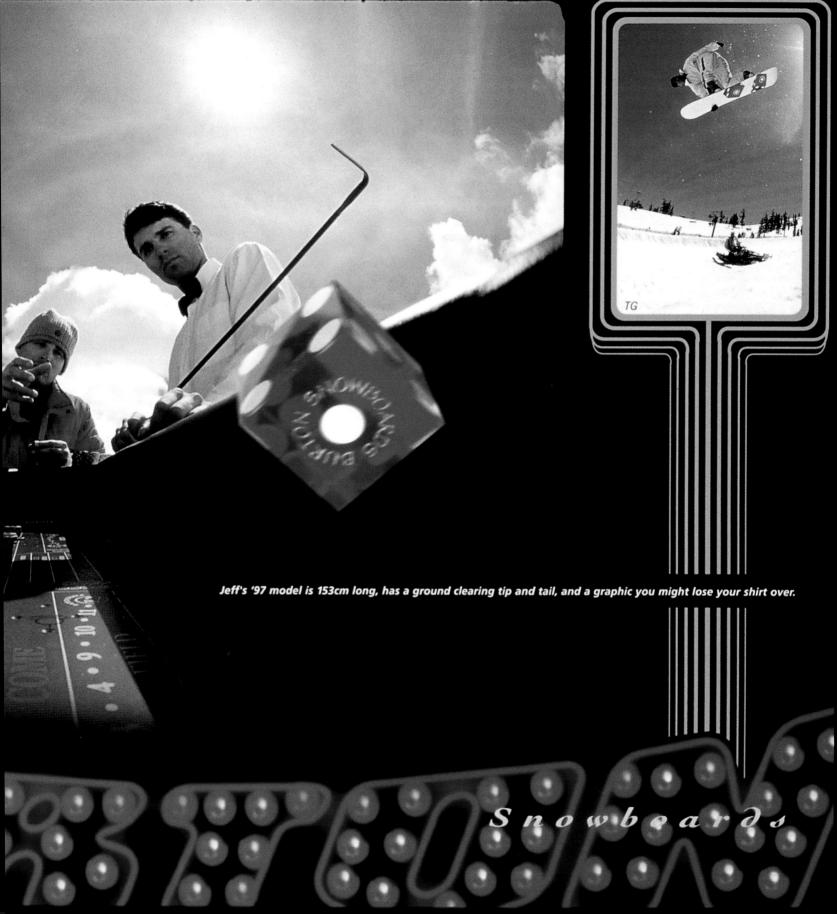

Jeff's '97 model is 153cm long, has a ground clearing tip and tail, and a graphic you might lose your shirt over.

Snowboards

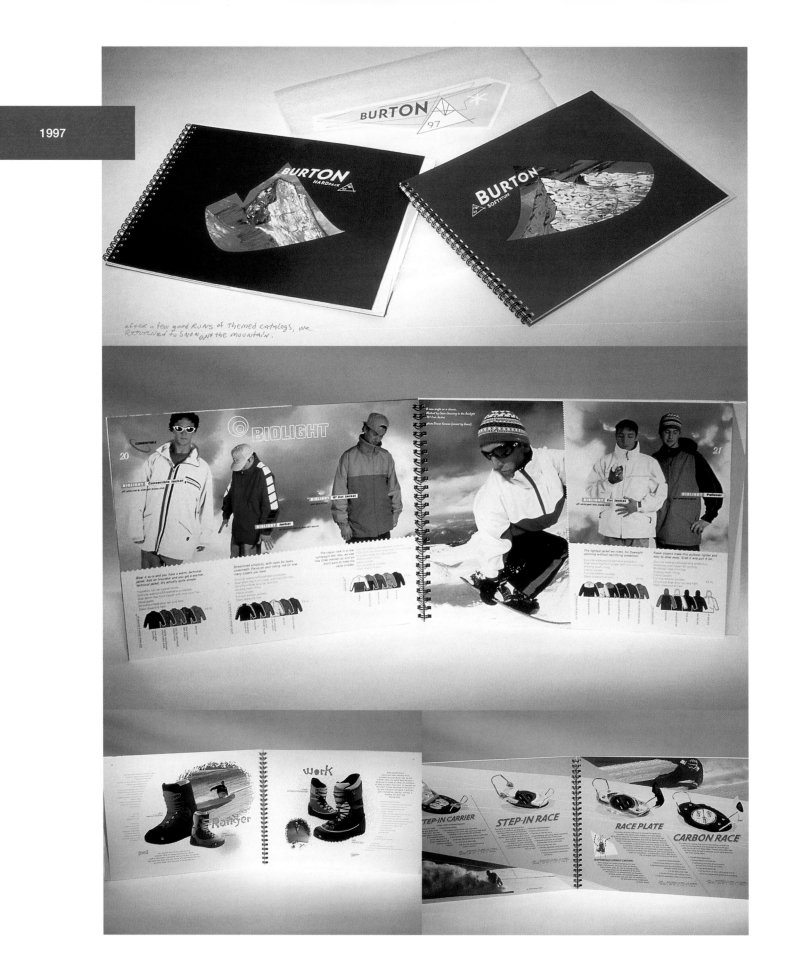

after a few good RUNS of themed catalogs, we
Returned to SNOW and the mountain.

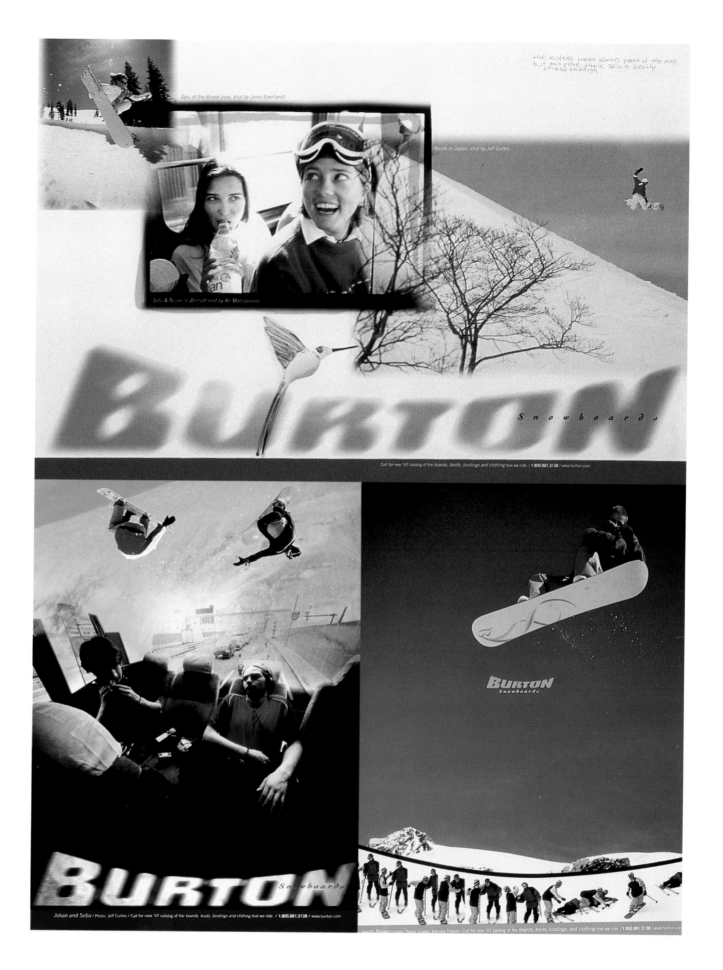

hard book

A day in the life the begining of the "clean" soulful style. The design more in touch with the sport than ever before.

The riding, the equipment, the sport. Every year, it gets better. Thanks to the team that makes it so.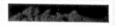

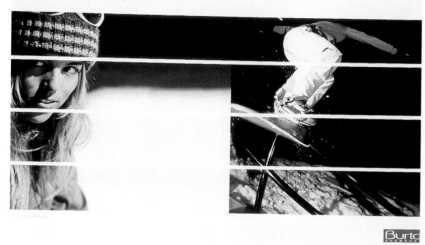

Stuck the Fereotype.

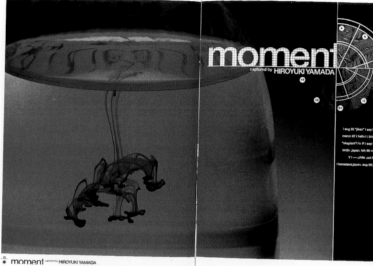

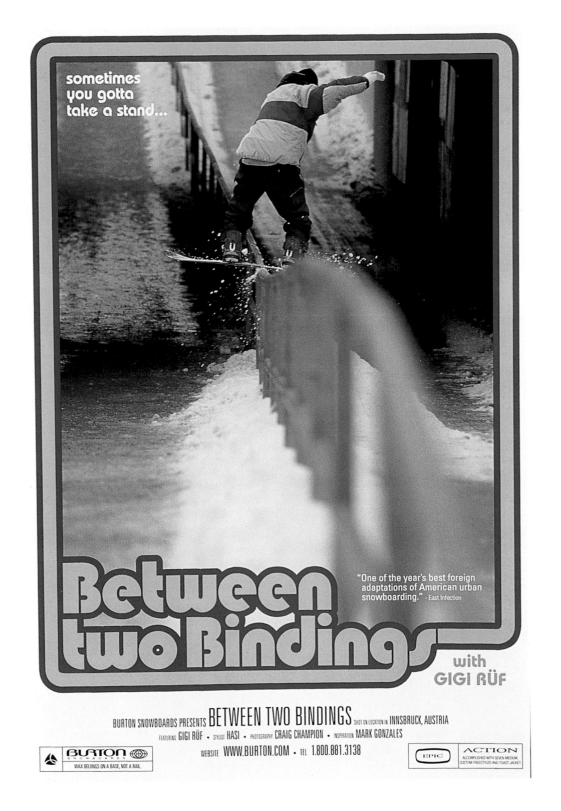

sometimes
you gotta
take a stand...

"One of the year's best foreign adaptations of American urban snowboarding." - East Infection

Between two Bindings

with
GIGI RÜF

BURTON SNOWBOARDS PRESENTS BETWEEN TWO BINDINGS SHOT ON LOCATION IN INNSBRUCK, AUSTRIA

FEATURING GIGI RÜF · STYLIST HASI · PHOTOGRAPHY CRAIG CHAMPION · INSPIRATION MARK GONZALES

WEBSITE WWW.BURTON.COM · TEL 1.800.881.3138

BURTON
SNOWBOARDS
WAX BELONGS ON A BASE, NOT A RAIL.

EPIC | ACTION
ACCOMPLISHED WITH SEVEN MEDIUM CUSTOM FREESTYLES AND TOAST JACKET

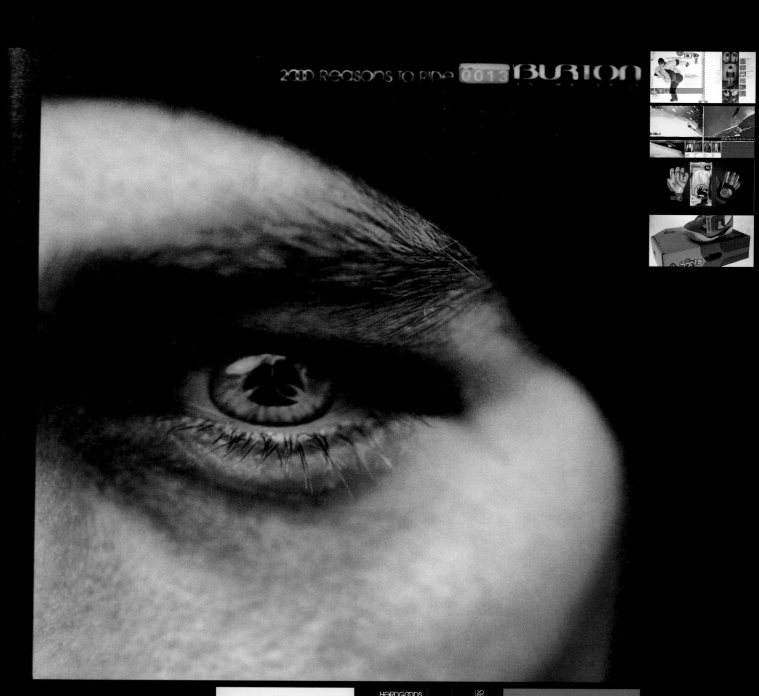

2000 reasons to ride **0013** BURTON

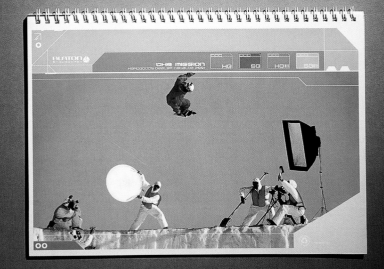

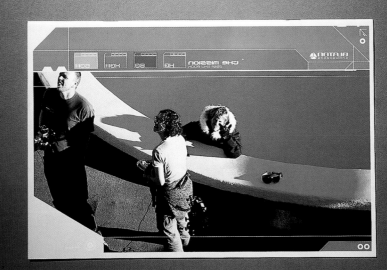

Schedule
Feb.21 [Mon] registration
Feb.22 [Tue] Men's / Women's Half Pipe Pre-Qualification.
Feb.23 [Wed] Men's / Women's Half Pipe Pre-Qualification.
 Men's / Women's Giant Slalom Qualification.
Feb.24 [Thu] Men's / Women's Super Half Pipe Qualification.
Feb.25 [Fri] Men's / Women's Super G Final.
 Men's / Women's Super Half Pipe SemiFinal.
 Men's / Women's Super Big Air.
Feb.26 [Sat] Men's / Women's Super Half Pipe Final.
 Award & Night Party
Feb.27 [Sun] Men's / Women's FreEX

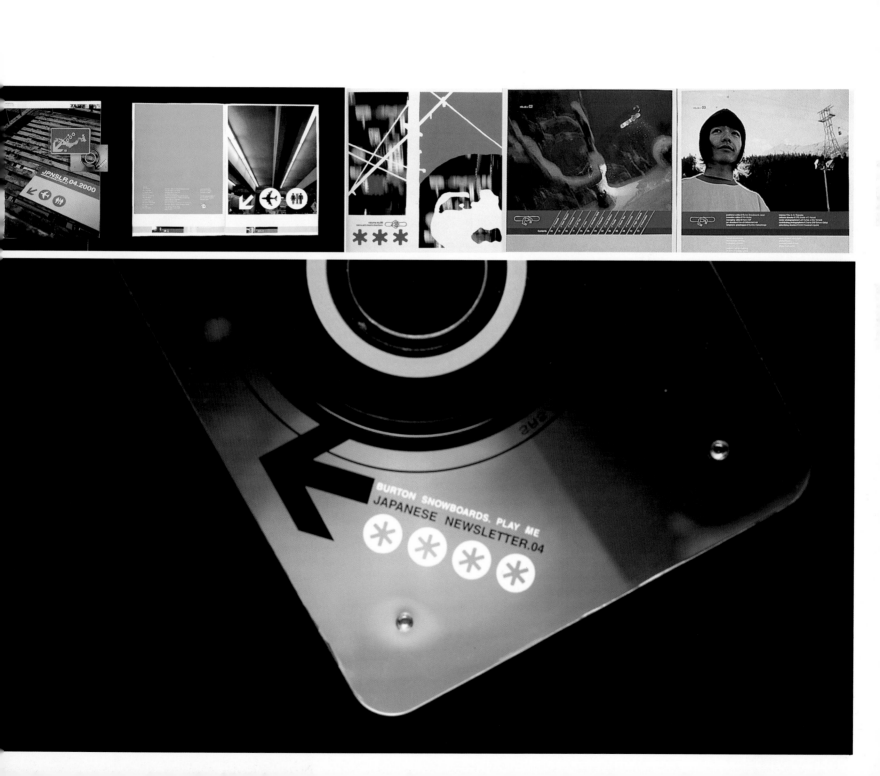

BURTON SNOWBOARDS. PLAY ME
JAPANESE NEWSLETTER.04

2002

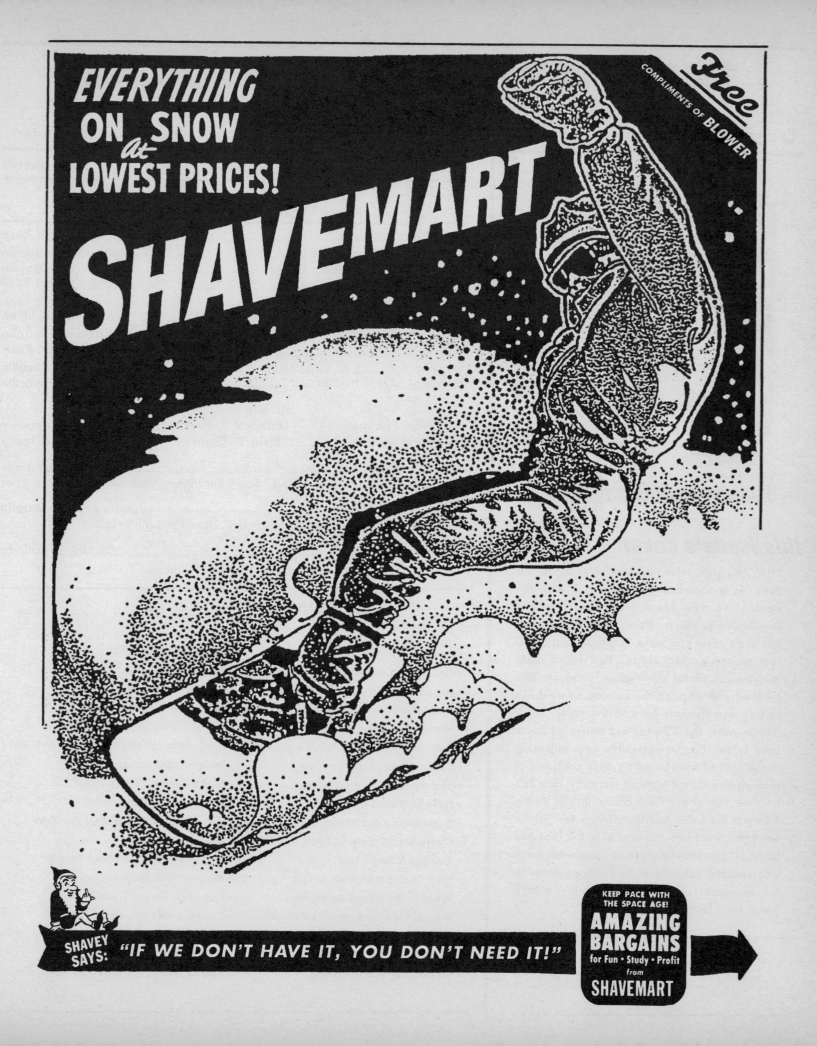

THE SHAVEMART PERIODICAL

Registered in U. S. Patent Office and Canada

Evan Rose, *Founder*

Aaron James Draplin, *Founder*

Volume 99 WINTER Number 1

Address all communications to:
14 Rotary Drive, Suite 2, Los Angeles, Calif.

Managing Editor...Evan Rose
Assistant Managing Editor.....................Aaron James Draplin
Shop Notes and Crafts Editor................Aaron James Draplin
Director...Evan Rose
Associate Director...Evan Rose
Associate Editor.. James Sullivan
Assistant Shop Notes and Crafts Editor..........Aaron James Draplin
Shop Correspondent...Evan Rose
Art Director...................................Aaron James Draplin
Assistant Art Director........................Aaron James Draplin

Assistant Editors

W. Clyde Lammey Leonard F. Hilts Frank N. Stephany
Theodore A. Daum Elsie L. Domin Elliott H. McCleary

Eastern Editor...Evan Rose
NegativeB Ind., South Burlington, Vermont

Mid—Western Editor................................Aaron James Draplin
Draplindustries Design Co., Downtown Minneapolis

Director, Bureau of Information........................ James Sullivan
Homeless Ltd., Gary, Indiana

this issue's cover

SHAVING high, wide and handsome across our cover is a snowboarder equipped with the newest in new from Shavemart Brand snowboard products. Using his full potential, this snow rider can make leaps as long as 50 feet on the perfect slope. You'll find more information about the various products he's outfitted with amongst the catalog, so we'd like to pay compliments here to the rider Barry Dempewolff, the 32-year-old native of South Lake Tahoe, Ca. Dempewolff's apprenticeship in the field of snowboarding once consisted of running errands for a resort secretary. Now he's become one of the most accomplished young riders in the field. Additionally, career girls in our office went into raptures over the face and body of "that snowboarder on the cover." Barry was recently selected to compete oversees in the Shavemart Professional Circuit — a high honor for a former errand boy.

IN THIS ISSUE

- Backyard Jump Bonanaza
- Fools That Can Sing And Dance
- Here Comes The Ski Patrol
- Amphibious Vehicle That Inhales Fish
- Florida Builds An Indoor SnowDome
- How To Successfully Whittle A Core
- Employment Opportunities
- Shavey The Drunken Elf Says...
- How To Mount Bindings & Squirrels
- Snowcatting For Shitheads
- Overpriced Cafeteria Food
- Ruining A Dog's Life
- How To Cope Without Weed
- What To Do About Bad Knees
- Schmolnik's Backcountry Adventure
- Stance Thingamajig
- Unbelievable Testimonials
- Radical Thirst Quenching

- How To Get Loaded
- Unclogging Step-In Bindings
- Stylish Moonboots
- Become A Disc Jockey, Yo
- Ballet Skiing Magazines
- Marketing Miracles With Simple Letters
- Insignificant Bendy Figure
- Slutty Posing Betties
- Things You Don't Need
- The Wonderful World Of Frostbite
- Long Lift Lines
- Dudes Sleeping On Your Couch
- Mastering Bulletproof Ice
- Fun With Carpal Tunnel
- Extreme Gift Wrapping Ideas
- Dinging Electronic Wipeouts
- Insure Your Broke Ass
- Stupid Things For Just About Anyone

Amazing!

MAKE 1000-2000 DOLLARS while watching boring snowboarding contests. Many do and prosper. No experience necessary–will train. Travel the nation and earn absolutely no respect. Many positions available: Yap into a microphone, Coordinate or Be the "Boss." Attn: Greg Martin, 14 River Run, Aspen, Colo.

★ BECOME A SNOWBOARD INSTRUCTOR ★

Time to give a little something back to the kids, eh? There is a saying that states, "Fine instructors make fine disciples." We say, "Fine instructors get good discounts on season passes and resort lodging." Sound good, eh? Got your attention yet? If so, read on. Spend the day with spoiled little bastards who are handed off at 9am (while Mom and Dad hot tub back at the resort). Successful instructors often earn tips in excess of their measly paycheck. Lose respect from the local rippers. Grow a beard. Live in your car. Did we mention the cafeteria benefits? How 'bout the embroidered fleece vest? A sure fire means of striking up conversation in the Apres Ski Lounges. Really.

Limited Availablity: **NEGATIVE-B SKI SCHOOLS, Sun Valley, Idaho.**

SNOWBOARDERS AGREE,
"Eat this and your riding will be sugar coated–just like your resume."

Folks, these snowboarders are talking about this new cereal. Made from the FINEST grains and food colorings, full of nutrients and packed with a backside 360 punch, this is the boost you need for your jump. Other snowboarders who haven't had a spoonful have said, "I feel weak and tired, I need a food that understands what I do...." If your little one loves the hill, you can't afford to feed them something else. Packed fresh for export or domestic use. Produced under inspection from professional riders. Every box manufactured will be purchased–guaranteed. Special packaging available only through SHAVEMART. Don't be left back, for you'll surely come up short. All walks of snowboarding life have benefitted from this remarkable source of nutrition. Chad Fleckwich had this to say: *"Yo, I was hungry in the pipe, whas' up wit dat? So yo, check it out, I ate these and knowwhatI'm sayin', I wuzn't hungry no more. Word. KnowwhatI'msayin'?"*

SHAVEMART, DRIED FOODS DIV., 304 Fenkel St, Truckee, Calif.

Shavey Says:
"Nothing like a little **BOOZE** to *kill* the **PAIN.**"
SHAVEMART NOVELTY CO.

FREE OFFER: CUT ME OUT.

Cut me out, paste me on a postcard and mail to: Shavemart Novelty Company*. I'll bring you the information and knowledge on how to waste your money on useless modern snowboarding products and paraphernalia. Send today for free sample on how to waste a lifetime of income on items that fall under the phenomena of "perceived coolness." Act all at once for this free literature. A years consulting service on how to spend more now given to all first time buyers of this famous cyclopedia of ineffectual crap. Multiple opportunities. Big words.

Name ..
Address ..

Write for big, lavishly illustrated Free Circulars

"Please mention BLOWER when writing for this free offer

SHAVEMART NOVELTY CO.
CONSUMER AFFAIRS DEPT., attn: LINDA BLODGETT
304 Fenkel St., Gary, Indiana

Get this Proven
PAY-RAISING PLAN

LET ME TRAIN YOU IN 'PRO' RIDING

UNTIL YOU GET A GOOD PAY JOB!

"Wow, so easy, even I could do it!"

Successful 'PRO' RIDING

- **BIG MONEY**
- **FREE STUFF** • **VIDEO PARTS**
- **CRIPPLING INJURIES** • **SIGNATURE MODELS**

SPONSORS ARE WAITING TO MANIPULATE YOUR ABILITY AND IMAGE.
Courses include: Tradeshow Lurking, Logo Placement, Inebriation, Stonage, Style Counseling *including* Color Coordination and Pant-Leg Highback Management. **Learn the tricks of the trade.** SIMPLE INSTRUCTIONS. Complete the following maneuvers with easy-to-follow scientific diagrams: Shifties, Backsides, Frontsides, Slides, Kinks, Misty Grabs, Pokers and Tweakers. Special Language tutoring to incorporate words like "Sick" and "So Good" and "Booter" and "Gnarly" and the 'ol standby, "Dude' into your dry vocabulary. Practically guaranteed to work overnight. AGENTS ARE STANDING BY.

NAME...AGE........
ADDRESS...
TOWN......................................STATE........

BE THE ENVY OF YOUR FRIENDS.

Practical Facts You Will Want to Know About
PATENTS TRADE MARKS COPYRIGHTS
of the SNOWBOARD INDUSTRY

INVENTORS!
Patented or unpatented inventions are wanted by thousands of snowboard manufacturers. This amazing book gives valuable sales tips and explains iron-clad methods of protecting unpatented ideas. All for a small sum. Turn around your ideas with the tools we give you to sell your invention for undisclosed amounts. Did you know a kitchen can opener can double as a step-in binding? Steve Lo, a Polynesian Lounge Singer from Hawaii, simply cut down a highback in a freak accident, read this important information and got the paperwork rolling for the "lo-back" craze of the mid-'90s! You too can benefit from this sort of documentation of your useless ideas. Your case will be personally handled by a registered patent attorney who is also a former Pro-Mogul Tour skier. All communications will be strictly confidential. Unless you're a pioneer of the sport, in which, we'll rip you off senseless for your ideas. Many walks of life have succeeded with this process. Stoned surfers with trust funds. Ski binding pioneers. Media affiliates. Beverage manufacturers. Sweatshop shoe companies. Southern California is a hot bed for ingenuity and other unpractical gadgets. All are welcome. **SUBMIT NOW.** ● **SNOW & CO.**

Registered Patent Attorneys Since 1875
1110 Snow Building **Washington, D.C.**

FREE – Valuable Mystery Gift. Inquiries: Approvals Raymax. 37F Maiden Lane, NYC.

INFORMATION – Any subject. Products, books, people, disease, crime, business-snow-related and otherwise. $2.00, Box 5996, Reno, Nevada.

ODD LOT – Random Assortment of Stomp Pads and Leashes. All shapes. Many colors. $3.25. Whipped, Inc., Box 400, Crossville, Tenn.

EXCLUSIVE — A "MUST HAVE"
SNOWBOARD FIGURINES*
ARTICULATE JOINTS • NON-REALISTIC DESIGN

Absolutely **Ridiculous!**

COLLECT THEM ALL

- –NON-TOXIC
- –SHINY PLASTICS
- –WASTEFUL PACKAGING

☐ Freerider
☐ Halfpiper
☐ Backcountry Go-Getter
☐ Washed-Up Hopeful
☐ Pro-Ho
☐ Media Savant
☐ Team Manager

Used and endorsed by successful riders! Big names for flatlanders to wonder about. Full of fun and surprises! These are the tools that have taken so many to the top of the pipe and over the lip! Practice big-time moves in the safety of your own home. Live vicariously through small toys. Various trademarked names, shapes and sizes. Surely what every boarder craves. Molded feet barely fit into supplied "step-in" bindings. Close attention paid to sponsorship placement (that is, if big-time endorsements still exist at time of production). Just might increase in value due to meat market pro rider circuit. Perfect sag in pants. Enjoy a wide array of accessories including: Doo-rags, lease locks and video camera. So good, they should be three times the current price.

Looks nothing like original overpaid professional boarder.

SHAVEMART NOVELTY CO.
ADRENALINE FIGURINES DEPT.
1432 East Rotary Dr., Suite 2000 (In the back.) Los Angeles, Calif.

BECOME A SNOWBOARD PHOTOGRAPHER

Whine. Complain. Demand. Go broke. Imagine yourself on the slope in the company of talented professional riders. Blue sky, white snow, big cameras. Lug excessive amounts of equipment deep into the backcountry only to get pissed and hike back out. **Coach hopeful professionals in the art of illusion.** Build relationships. Build kickers. Make shitty riders look good on film. Prerequisites include: babysitting, dropping out of high school, shoplifting and expensive photography school. Subsidize your career by vying for team manager positions. Learn to fudge invoices. Write for free catalog to get your career clicking away!

VIPER SCHOOL of PHOTOGRAPHY, 304 Fenkel St., Truckee, Calif.

SNOOPY SNO-CONE OFFER

MAKE TASTY SNO-CONES AT HOME WITH SNOOPY AND FRIENDS!

SNOOPY & FRIENDS

SNOOPY

SNO-CONE MACHINE

YOUR TASTE BUDS WILL REJOICE. Endorsed by boarders, crazy like boarders and just plum radical (like the boarders)! Handy. Efficient. Down right GOOD! GOOD! GOOD! And good for you! Sip, chomp and pluck away at these babies. **STICKY FINGERS.** Step up and deliver your eater the carving sensation found in each icy bite. **PERFECT FOR THE YOUNGSTERS, AND REVERED BY ADULTS!** Optional flavors such as Shreddy Strawberry, Backside Blueberry and Gate-Bashing Grape. Complies with current USDA health codes based upon regional ice-making conditions, facilities and food-poisoning track reports.

Bring all inquiries to the attention of: Saul Rosenkrantz

DDC VENDING SPECIALTIES, 14 Madison Ave., Cleveland, Oh.

 Tell 'em you found it at SHAVEMART!

[PAGE]TITLE/
PHOTOGRAPGER/
LOCATION/YEAR
CAPTION/

[Cover]Trees/Jeff Curtes/Cataldo,
Idaho/November, 1996
"Steve Matthew's Peak Adventures Cat
Skiing"

CH1:[1-8]INTRO

[1]Dave Downing/Jeff Curtes/Donner
Pass, Lake Tahoe, California/February,
2001
Blower.

[2]Trevor Andrew/Jeff
Curtes/Skarsnuten, Hemsedal,
Norway/April, 2001

[3]Snowboard park/Vianney
Tisseau/Snow Summit Resort, Big Bear
Lake, California/March, 2000

[4]Burton priorities T-shirt/Jeff
Curtes/Burlington, Vermont/May 3, 2001

CH2:[9-26]WEATHER

[9]Sun ray on tree/Scott
Needham/Montana/Date unknown

[10]Snow/Hiro Yamada/Japan/Winter,
2000

[11]Snow/Jeff Curtes/Livigno,
Italy/December, 2000

[12]Weather Channel/Malcolm
Buick/Winter, 2001

[13]Jeffy Anderson waiting/Jeff
Curtes/Revelstoke, B.C./November, 1996

Three tracks/Jeff Curtes/North Cascade
Heli, Winthrop, Washington/March, 1997
Craig Kelly, Dave Downing and Joe
Curtes riding at North Cascade Heli. It
was easily one of the coldest days of
the year. My hands got so cold on this
run while trying to shoot Craig that I
almost had to puke.

Tahoe storm/Jeff Curtes/Tahoe Vista,
California/Winter, 1997
Mike Hatchett, Dave Downing and Juha
Tenkku on Hatchett's roof.

Japanese snowy town/Jeff
Curtes/Ishiuchi Maruyami,
Japan/February, 2001
Nippon Open 2001, contest day.

Snowed-in cars/Vincent Skoglund/Laax,
Switzerland/Date unknown

Mount Shuksan/Jeff Curtes/Mount
Baker, Washington/January, 2001

Snow ribs/Kevin Zacher/Whistler,
B.C./Winter, 2001

Snow plow/Kevin Zacher/Breckenridge,
Colorado/December, 2000

Snowy fence/Jeff Curtes/Jackson Hole,
Wyoming/December, 1996
Tram dock, Rendezvous Peak.

Flags/Jeff Curtes/Oze Tokura,
Japan/February, 1997
I am the lover, BOP.

Marte chair/Jeff Curtes/Las Lenas,
Argentina/August, 1996

Untitled/Jeff Curtes/Livigno,
Italy/December, 2000

Steaming volcano/Mark Gallup/Pucon,
Chile/September 28, 1999

Snow turns to rain/Jeff Curtes/Porter
Heights, New Zealand/August, 1997

Trees/Kevin Zacher/Salt Lake City,
Utah/Winter, 2001

[14]Solar salt/Jeff Curtes/Mount Hood,
Oregon/July, 1999

Shane Charlebois and Jeffy
Anderson/Jeff Curtes/Peaks Lodge,
Revelstoke, B.C./November, 1996
Charmed life.

Mountain ridge/Jeff Curtes/Las Lenas,
Argentina/September, 2000

Dots/Kevin Zacher/St. Moritz,
Switzerland/Winter, 2001

Puddles/Jeff Curtes/Bariloche,
Argentina/August 12, 1997

Snow plow/Jeff Curtes/Vail Pass,
Colorado/December 23, 1997

Ski run/Kevin Zacher/Hemsedal,
Norway/April, 2001

Forest/Eric Kotch/Oze Tokura,
Japan/February, 1995
EK pioneering first descents year after
year.

Marlboro/Eric Kotch/Buenos Aires,
Argentina/August, 1996

Snowy trees/Jeff Curtes/Whistler,
B.C./February, 2001

F-16/Jeff Curtes/Sonora Pass,
California/March, 2000

Aurora borealis/Hiro Yamada/Valdez,
Alaska/April, 2000

Water droplets on grass/Jeff Curtes/St.
Moritz, Switzerland/March, 2000
Crystal Awards still life.

Sunset on snow/Kevin Zacher/Whistler,
B.C./January, 2001

Snow/Kevin Zacher/Whistler,
B.C./January, 2001

Shaun White and Mikey Rencz/Jeff
Curtes/Buenos Aires,
Argentina/September, 2000
Heading home after a long two week
shoot.

Michi's piss/Jeff Curtes/Las Lenas,
Argentina/September, 2000
"I pee'd my name."

Welcome to Japan/Jeff Curtes/Tokyo,
Japan/February, 1996

Shadows/Trevor Graves/Mount Bachelor,
Oregon/January, 1996

Trillium Lake/Jeff Curtes/Government,
Oregon/July, 2000
Morning view of Mount Hood from down
by the water.

Squaw Valley night pipe/Jeff
Curtes/Squaw Valley, California/March,
1997

Crevasses/Dean Blotto Gray/Hintertux,
Austria/June, 2000

Shannon Dunn/Jeff Curtes/Timberline
Lodge, Oregon/October, 2000

Hands, Eric Leines/Jeff
Curtes/Riksgransen, Sweden/May, 1998
Pray for snow.

Trevor Andrew and Keir Dillon/Jeff
Curtes/Mount Hood, Oregon/October,
2000

Silhouetted trees/Jeff Curtes/Hemsedal,
Norway/April, 2001

Glass/Jeff Curtes/Erehwon, New
Zealand/September, 1998

Contest blizzard/Jeff Curtes/Ishiuchi
Maruyami, Japan/February, 2001
Nippon Open 2001.

Tyrol Basin summer jam/Jeff
Curtes/Mount Horeb, Wisconsin/June 2,
1996
Milwaukee brewers infield cover was
used to save the pipe snow.

Govie/Jeff Curtes/Government Camp,
Oregon/July, 2000

Jussi Oksanen/Jeff Curtes/Livigno,
Italy/December, 2000
Ice cream headache.

Water droplets/Jeff Curtes/Temple
Basin, New Zealand/September, 1996

[15]Yoshimura Narufumi /Jeff
Curtes/Gran Catedral, Bariloche,
Argentina/August 13, 1997
Pray for snow.

[16]Blue bird chair/Jeff Curtes/Marte lift,
Las Lenas, Argentina/September, 2000

Grey bird chair/Jeff Curtes/Les
Diablerets, Switzerland/Summer,1996

Milk toast chair/Jeff Curtes/Mount Hood,
Oregon/July, 2000

[17]Blue bird elements/Trevor
Graves/Cascade Range,
Oregon,Washington/1996

Grey bird elements/Kevin Zacher/St.
Moritz, Switzerland/Winter, 2001

Milk toast elements/Jeff
Curtes/Revelstoke, B.C./November, 1996

[18]Cyclops/Mark Gallup/Island Lake
Lodge, Fernie, B.C./Summer, 1998

Tua rock face/Mark Gallup/Island Lake
Lodge, Fernie, B.C./Summer, 1998

Hollywood chutes/Mark Gallup/Island
Lake Lodge, Fernie, B.C./Summer, 1998

Papa Bear chute/Mark Gallup/Island
Lake Lodge, Fernie, B.C./Summer, 1998

Duck Dive dog-leg/Mark Gallup/Island
Lake Lodge, Fernie, B.C./Summer, 1998

Whale back/Mark Gallup/Island Lake
Lodge, Fernie, B.C./Summer, 1998

[19]Jason Ford, Tua rock face/Mark
Gallup/Island Lake Lodge, Fernie,
B.C./Winter, 1998

Jason Ford, Cyclops/Mark Gallup/Island
Lake Lodge, Fernie, B.C./Winter, 1998

Jason Ford, Duck Dive dog-leg/Mark
Gallup/Island Lake Lodge, Fernie,
B.C./Winter, 1998

Craig Kelly, Papa Bear chute/Mark
Gallup/Island Lake Lodge, Fernie,
B.C./Winter, 1998

Jason Ford, Hollywood chutes/Mark
Gallup/Island Lake Lodge, Fernie,
B.C./Winter, 1998

Rob Duncan, Whale back/Mark
Gallup/Island Lake Lodge, Fernie,
B.C./Winter, 1998

[20]Mountain scenic/Kevin Zacher/
St. Moritz, Switzerland/Winter, 2001

Blue hole/Kevin Zacher/Location

unknown/Date unknown

Windy peaks/Jeff Curtes/Zermatt,
Switzerland/October, 1995

View from Palmer Glacier/Jeff
Curtes/Mount Hood, Oregon/July, 1999

Clouds/Kevin Zacher/Whistler,
B.C./Winter, 2001

Santiago smog/Mark Gallup/Valle
Nevado, Chile/September 19, 1999

[21/22]The Swiss Alps/Jeff Curtes/St.
Moritz, Switzerland/March, 2000
Crystal Awards 2000.

[23]A.M./Kevin Zacher/Location
unknown/Date unknown

[24]Frost bite, Rio Tahara/Jeff
Curtes/Ishiuchi Maruyami, Japan/February,
2001

[25]Cold sore, Tyler DeWilde/Vianney
Tisseau/Valle Nevado, Chile/September,
1999

CH2:[27-62]TRAVEL

[27]Tag/Ruby Lee/Burlington,
Vermont/March, 2001

[28]Michi's passport/Vincent
Skoglund/Innsbruck, Austria/December,
1999

[29]Airport/Trevor Graves/Location
unknown/2000

Shinkansen/Jeff Curtes/Tokyo,
Japan/February, 2001
Japanese bullet train.

Tokyo station/Jeff Curtes/Tokyo,
Japan/February, 1997

Roadway/Trevor Graves/Buenos Aires,
Argentina/September, 2000

[30]Departure/Ruby Lee/Burlington,
Vermont/Winter, 2001

[31]Terje sleeping/Kevin Zacher/Buenos
Aires, Argentina/ September, 2000
DCP, Michi and Terje crisp.

Toilet seat/Kevin Zacher/Las Lenas,
Argentina/September, 2000
Pissing.

Kjersti Buaas and Heikki Sorsa
sleeping/Jeff Curtes/Tokyo,
Japan/February, 2001
Burton tour bus to Tokyo.

Chilean summer sky/Kevin
Zacher/Santiago, Chile/September, 1999

Terje sleeping/Trevor Graves/Buenos
Aires, Argentina/September, 2000

Ferry to Lofoten Islands/Jeff
Curtes/Bodo, Norway/April, 1999
Heading to Stamsund for a trial run of
the Arctic Challenge.

Dave Downing and Shannon Dunn/Jeff
Curtes/San Rafael,
Argentina/September, 2000

Pick-up/Jeff Curtes/Denver International
Airport, Colorado/March, 2000
Waiting for Candice.
United plane/Kevin Zacher/Location
unknown/Winter, 2000

Window seat #13A/Jeff Curtes/Europe,
2000

Airline food/Kevin Zacher/Buenos Aires,
Argentina/September, 2000
Economy class.

Departures/Hiro Yamada/Location
unknown/Date unknown

Control tower/Jeff Curtes/San Rafael,
Argentina/September, 2000

Terje disembarking/Kevin Zacher/San
Rafael, Argentina/September, 2000

Crispo's/Jeff Curtes/Buenos Aires,
Argentina/September, 2000
Trevor Andrew, Terje Haakonsen and
Chris Brown hungover.

[32]Partidas, departures/Jeff
Curtes/Buenos Aires,
Argentina/September, 2000

[33]Partidas, departures/Jeff
Curtes/Buenos Aires,
Argentina/September, 2000

O'Hare International Airport/Jeff
Curtes/Chicago, Illinois/February, 2001
Tunnel in United Airlines terminal.

O'Hare International Airport/Jeff
Curtes/Chicago, Illinois/February, 2001
Tunnel in United Airlines terminal.

[34]Schedule/Jeff Curtes/Tokyo,
Japan/February, 1996

[35]Signs/Jeff Curtes/Santiago,
Chile/September, 1999

Akihabara electric town/Jeff
Curtes/Tokyo, Japan/February, 2001

Map/Jeff Curtes/St. Moritz,
Switzerland/December, 2000
The road from Innsbruck to Livigno.

Signs/Jeff Curtes/Santiago,
Chile/September, 1999

[36/37]Board bag soldiers/Jeff
Curtes/Buenos Aires,
Argentina/September, 2000
Blotto settling the team departure.

[38]Malcolm's luggage/Geoff
Fosbrook/Burlington, Vermont/Winter,
2001
Malcolm carried this box containing the
new Burton identity logos for three
weeks through South America, the
United States and Europe.

[39]Jeffy Anderson on phone/Jeff
Curtes/Mammoth Lakes,
California/March, 1999

Airline food/Kevin Zacher/Zermatt,
Switzerland/Date unknown

Driver/Jeff Curtes/Innsbruck,
Austria/December, 2000
Keir driving up to Livigno, Italy cranking
trance beats.

Japanese fans/Jeff Curtes/Hiroshima,
Japan/February, 1997

Bryan Iguchi/Jeff Curtes/Tignes,
France/Date unknown
The Guch spilt my milk.

Denver International Airport/Jeff
Curtes/Denver, Colorado/Winter, 1999

[40]Ian Spiro/Jeff Curtes/Island Lake
Lodge, Fernie, B.C./February, 1996
Ian meditating on the way up.

Johan and Sebu on a bus in Japan/Jeff
Curtes/Tokyo, Japan/February, 1996
This shot should have been a spread.
Burton Japan tour.

Eric Kotch, Victoria Jealouse, Sebu
Kuhlberg, Ingemar Backman and Dave
Seaone/Jeff Curtes/Somewhere in
Japan/February, 1996
The booze cruise.

Trevor Andrew/Jeff Curtes/Las Lenas,
Argentina/September, 2000
Leaving Las Lenas, still drunk after a

long last night.

Roger and Shaun White/Jeff Curtes/Las
Lenas, Argentina/September, 2000
"You just put it out there."

Abe Teter/Jeff Curtes/Las Lenas,
Argentina/September, 2000

[41]Japanese sign/Jeff Curtes/Tokyo,
Japan/February, 1996

[42]S.A.W.S.S./Jeff Curtes/Tokyo,
Japan/February, 1997
Heading to the airport and looking out
the window of the Narita Airport Express
at S.A.W.S.S.(Summer, Autumn, Winter,
Spring, Skiing) indoor ski slope.

[43]Windshield wipers/Kevin Zacher/St.
Moritz, Switzerland/January, 2001

[44]Monitors/Jeff Curtes/Tokyo,
Japan/February, 2001

Trevor Andrew and Chris Brown/Jeff
Curtes/San Rafael,
Argentina/September, 2000
Trev and Browner drunk on champagne.
Ten in the morning at the tiny San
Rafael airport. The authorities made
each of us take a physical exam before
boarding the plane. The Satu and Nicole
of the new millennium.

Gear/Kevin Zacher/Ouray,
Colorado/Winter, 2000
Typical gear for a day of shooting in the
backcountry.

Eric Leines and Jeffy Anderson/Jeff
Curtes/Santiago, Chile/August, 1997
Youth against the Establishment; Jeffy
passed out in the lobby of one of the
nicest hotels in Santiago.

[45]Shaun White/Jeff Curtes/Oslo,
Norway/March 25, 2001
Jet-lagging on the way up to Hemsedal.

Bruno Musso and Joe Curtes /Jeff
Curtes/Tokyo Station, Japan/February,
1997

Jeff Brushie, Tina Basich and Cara Beth
Burnside/Jeff Curtes/Tokyo, Japan/Date
unknown
The Burton Tour. Check out Brush. All
time.

Yoshinari Uemura/Jeff Curtes/Zermatt,
Switzerland/October, 1995

[46]Bus to Las Lenas/Jeff Curtes/Las
Lenas, Argentina/August, 1996

[47]Car sick/Mark Gallup/Santiago, Chile
/September 28, 1999
The road to Portillo.

Tunnel/Jeff Curtes/Near Livigno,
Italy/December, 2000
Tina Basich shot this exact photo back
in 1994 on our first trip to Livigno, Italy
for a Transworld Snowboarding story
called "Travels with Lucifer". It is on the
wall of her house in Salt Lake City. I
re-shot the identical photo this year.

[48]Dave Downing/Jeff Curtes/Tignes,
France/November, 1997
This was one of my first lifestyle
product shots that Burton really liked.

Chemical stretch/Jeff
Curtes/Holmenkollen, Oslo, Norway/April
7, 2001
Romain De Marchi hammering a
handful of Advil (to deal with a bruised
heel) before practice for the Arctic
Challenge Q.P.

Keir Dillon stretching/Jeff
Curtes/Hemsedal, Norway/April 10,
2001

Johan on sled/Vianney
Tisseau/Riksgransen, Sweden/Date
unknown
There is something about this shot that
makes it really special. Maybe it's the
look in his eye, or the light, or both. Its
moodiness is incredible.

[49]Joe Curtes and Dave Downing/Jeff
Curtes/Tenjindaira, Japan/February,
1996

Walking back after riding two feet of fresh on Johan's monkey run.

JJ Thomas and Eric Leines/Jeff Curtes/Riksgransen, Sweden/May, 1996
A classic sunset evening pipe shoot at Riks.

[50]Sledders/Jeff Curtes/Callahan Lake, Whistler, B.C./February, 2001
Anthony Vitale, Trevor Andrew, Chris Brown, Romain De Marchi, Keir Dillon and I head across Callahan Lake prior to the gnarliest sled ride of my life. A windy, rutted nightmare hell, Michi got stuck five times. In the end, the best single day of shooting of my season. I got the shot that is to be the first Burton ad of 2002.

Jussi Oksanen/Vianney Tisseau/Carson City, Nevado/March, 2000
Vianney doing classic Vianney stuff...making a long road trip run and all the time thinking of shooting an interview opener for his magazine, Snow Surf. Jussi on the sled on the back of Hatchett's old pick-up truck.

Johan Olofsson/Jeff Curtes/Whistler, B.C./January, 2001
This was my day with Johan. I drove up from Mount Baker after the banked slalom and spent an entire day with Johan one on one. Epic. Rode Whistler in the morning, POW on Kaibers and headed up Tricone in the afternoon for some sledding...Johan ended up jumping some cliffs and made the day really insane. I left that night for Bellingham stoked.

Derek Heidt/Jeff Curtes/Whistler, B.C./April, 1999
Heidt claiming it with a look-back to Ian Spiro filming.

[51]Revelstoke snow/Trevor Graves/Revelstoke, B.C./January, 1996

Bucket/Jeff Curtes/Hemsedal, Norway/April 12, 2001
Building the Arctic Challenge superpipe under the direction of Scandinavian builder extraordinaire David Ny.

Camo transport/Jeff Curtes/Leknes, Norway/April, 2000
Arctic Challenge, 2000.

Tiller/Jeff Curtes/Tignes, France /November, 1996
Blotto tells me that Gigi coined the phrase "spin iron" for the groomer.

[52/53]Dave Basterachea/Mark Gallup/Diablerets, Switzerland/Date unknown

Heading out/Mark Gallup/Erehwon, New Zealand/September, 1998

Johan Olofsson, JG and Jim Rippey/Jeff Curtes/Tignes, France/November, 1996
Up before first light.

Yoshinari Uemura/Jeff Curtes/Niseko backcountry, Japan/February, 1999

Jonovan Moore/Jeff Curtes/Las Lenas, Argentina/September, 2000

Hiker/Kevin Zacher/Location unknown/Winter, 2000

David Carrier Porcheron/Jeff Curtes/Las Lenas, Argentina/September, 2000

[54]Heli dive/Vianney Tisseau/Chamonix, France/Date unknown
Pilot Pascal Brun shows off in front of Nicole Angelrath and Brad Scheuffele.

Victoria Jealouse, Dave Downing and Joe Curtes/Jeff Curtes/Erehwon, New Zealand/September, 1998
Heli picnic.

Michi Albin and Victoria Jealouse/Jeff Curtes/Valle Nevado, Chile/September, 1999

Sunrise heli/Kevin Zacher/Valle Nevado, Chile/September, 1999

[55]Sparkling tram/Jeff Curtes/Seegrube

Resort, Innsbruck, Austria/January, 1999
Best snow of a decade (dickhead). And where IS the Burton Team?

Up there/Dean Blotto Gray/Myrhofen, Austria/January, 2000
Ever seen the old James Bond movies where 007 is fighting Jaws high above the Swiss Alps atop the tram? Taking a cruise up the Penkenbahn Gondola in Myrhofen, Austria will put you right there in the same situation 'ol James used to get himself into, only you're a bit safer behind the glass.

Poma lift/Jeff Curtes/Hemsedal, Norway/April, 2001

Night chairs/Jeff Curtes/Ishiuchi Maruyami, Japan/February, 2001
Night practice at the 2001 Nippon Open.

[56/57]Shaun White/Kevin Zacher/Hemsedal, Norway/April, 2000

School yard rail/Kevin Zacher/Salt Lake City, Utah/Date unknown

[58]Pat Malendowski and Keir Dillon/Kevin Zacher/Valle Nevado, Chile/September, 1999

Andrew Crawford getting pulled by Jussi Oksanen and David Benedict/Jeff Curtes/Salt Lake City, Utah/January, 2001
Slingshot pull-in to a wall ride jib for Standard's TB10.

Marcus Egge/Kevin Zacher/Las Lenas, Argentina/September, 2000

Bjorn Lindgren and Dave Downing/Jeff Curtes/Tignes, France/November, 1996

Heine highway building/Jeff Curtes/Donner Pass, California/March, 1998
We built this jump for over two hours. Hatchett got pissed at Michi for not helping so he bailed on the session. By the time the jump was done, the sun was setting quickly and the snow was crusting up. Downing stepped up and was the only one to jump it. He jumped it one time. Huge 110 foot indy off the "Jaws" kicker.

Stevie Alters/Jeff Curtes/Saas Fee, Switzerland/November, 1994
Monkey face.

[59]Jussi Oksanen, Wade McCoy and Jess Gibson/Kevin Zacher/Tahoe Vista, California/Winter, 2000
Standard Films Headquarters.

[60/61]Blotto's journal/Jeff Curtes/Location unknown/Winter, 2000
Dean Blotto Gray started making journals while he travelled the world as a Burton team manager.

[62]F-Stop/Jeff Curtes/New Haven, Vermont/November, 2000
The Burton camera bag that I designed, lost and luckily had returned while at Mt. Baker this year. Thank you Ryan.

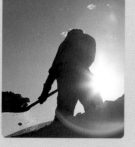

CH2:[63-80]EVOLUTION

[63]Terje Haakonsen/Vianney Tisseau/Riksgransen, Sweden/May, 1993
We found this place right next to the hotel and went there with Terje, Daniel (Franck), and two local kids (Ingemar Backman and Johan Olofsson). The sky

turned totally orange and stayed like this for a very long time. Even if the quarterpipe wasn't that big (compared to the one Ingemar made legendary a few years later), Terje was going pretty big and trying all sort of tricks. I sat right in the angle of the sunset and set up a flash on the lip to light Terje in the air. As he was dropping, photo legend Jon Foster told me I was looking right in the sun and I wouldn't get a good exposure. I shot Terje as he was doing one of the biggest one-foot airs ever seen at this time. I laughed at my good friend Foster when I saw the shot. (The original slide got lost between Onboard European Snowboard magazine and Snowboarder Monster Backside magazine a few years later.) Both Vianney and Terje taking it to another level.

[64]Jake Burton /Burton Archives/Location unknown/Date unknown

[65]Craig Kelly/Trevor Graves/Loveland Pass, Colorado/Winter, 1992

Andy Coghlan and Ross Powers/Photographer unknown/Stratton, Vermont/Date unknown

Terje Haakonsen and Jeff Brushie/Trevor Graves/Location unknown/Winter, 1992

Barry Dugan/Photographer unknown/Stratton, Vermont/Date unknown

[66]Jeff Brushie/Trevor Graves/Connecticut/Date unknown
Crail flip at a tramp demo at Sunset Bay.
Check out Noah Brandon in the crowd!

[67]Joe Curtes/Jon Foster/Lake Tahoe, California/Winter, 1993
Joe told me that after Foster shot this roof jump he immediately claimed it was going to be a cover. He took the roll out of the camera and stashed it in his coat pocket so that it would be safe. It was the cover of Transworld Snowboarding the next month.

[68/69]Jim Rippey/Jon Foster/Stowe, Vermont/Winter, 1994
Sickest sequence ever. "The Chin".

[70]Terje Haakonsen/Vianney Tisseau/Tignes, France/Date unknown
This is a classic Euro Vianney shot. Fisheye and flash, nobody shoots it better than the French-Mexican does.

[71]Jeff Brushie/Jon Foster/June Mountain, California/Date unknown
Nobody had more style than Brush.

[72/73]Stevie Alters/Jeff Curtes/Vail, Colorado/December, 1994
On resort shooting days; this was taken on busy Christmas weekday at Vail, right on Northstar. Stevie Alters and J2 showed me parts of Vail that Joe and I had never found or had ridden past. These guys owned Vail. Stevie pushed himself so hard and rode metal like no one before. He was the first really gnarly rider that I shot who I was actually scared for.

[74]Jeffy Anderson/Jeff Curtes/Bear Mountain, California/Winter, 1994
This was one of my first location shoots for Burton and my first trip to Southern California for snowboarding. I met Dave Downing for the first time in Orange County, he picked me up and we drove up to Big Bear in his toaster Mitsubishi box van. We met Bryan Iguchi in the parking lot. I had heard so much about that guy from my brother, how insane and stylish a rider he was. To this day, this was the best day I've ever had in a snowboard park, and definitely one of the best days of "shooting while riding" ever. Chairlift laps, chasing those guys through the Parillo designed park – Guch slashing the berms, Downing flying off everything switch with a striped polo shirt on (remember that sick Cassimus shot of Dave?). Jeffy Anderson met up with us after school and ripped harder than any kid I've ever

seen. Eva and Natalia Wojcek cruising around in pink sequined bras and gloves. This was the SoCal scene.

[75] Dave Downing and Joe Curtes/Jeff Curtes/Rusutsu, Japan/February, 1996
These were the years that just about every pro snowboarder went to Japan for the month of February and travelled from contest to contest. This was shot during a World Cup halfpipe event at Rusutsu Resort. Dave Downing, Joe Curtes, Eric Kotch and myself, riding in silence as we all thought to ourselves that I am Craig Kelly right now. I still talk about EK dropping off the chairlift like a Navy Seal to get the holeshot in front of us. Three insane days of riding the sickest POW while all of the contest goers littered the hotel lobby waiting for practice to start each day at 3 o'clock. On practice day, Mikey Basich had hiked about 500 feet above the pipe and made a three turn run...he was so stoked on his tracks and was claiming the sickest snow of the season to everyone. Of course, Kotch shut him down with laughter...our goggles still stuffed with POW and our shit eating grins boasting the secret stashes of Steamboat on the other side of the resort.

[76]Johan Olofsson/Jeff Curtes/Brighton, Utah/Winter, 1995
Johan's Stumpies are still in Tina Basich's garage somewhere and his wallet still hidden safely between two cushions on the couch at the Snowberry Inn. Right from the start, Johan looked at everything differently...he flew off everything backwards and didn't stop. Near the end of this day of riding at Brighton, Johan told me his knee was itching. I went to check it out and Johan was rubbing his shin just above his boot. I made him pull up his pant leg. His long underwear was soaked in blood and his leg was gashed to the bone right above his boot line. He slowly remembered that he and Tamus Gannon had bumped into each other in the woods earlier in the day, but it had just started hurting now.

[77/78]Jason Brown/Andy Wright/Brighton, Utah/Spring, 1997
When I saw this shot of Jason Brown published in Transworld Snowboarding, I was so stoked that I called up Andy to high-five him on his work.

[79]Dave Downing/Jeff Curtes/Powder Mountain, Utah/Winter, 1995

[80]Dave Downing/Jeff Curtes/Little Cottonwood Canyon, Salt Lake City, Utah/Winter, 1995
This Grizzly Gulch mineshaft gap was one of the first shots that I knew would be a sick sequence at the time I shot it. Downing saw this thing and jumped it late in the day after a long day of kicker building. It was probably around 5pm when he jumped this gap in the spring conditions. It was huge and Downing stomped it. I think he rode right to the car after this one.

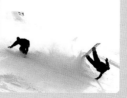

CH2:[81-112]ACTION

[81]Template to shred/Jared Eberhardt/#G25, Winooski, Vermont/March, 2001
Jared told me that he came up with this idea, like most of the creative seen in Blower, on an airplane flight. This time he happened to be flying home to Vermont after a week in California. Jared was nominated for a Grammy Award this year for a record sleeve he

designed for the band Phish. He and Sue spent a week in Los Angeles to join the festivities, to enjoy a little R&R at EK's house, and of course, to take care of Nick.

[82/83]Jim Rippey/Mark Gallup/Pucon, Chile/August, 1994

[84/85]Ingemar Backman/Jeff Curtes/Riksgransen, Sweden/May, 1996
Transworld Snowboarding cover-shot. Vol.10 #2.

[85]Magazine covers/Jared Eberhardt/Salt Lake City/1996
I think Jared shot this for Medium magazine. Ingemar Backman's six covers.

Train box/Jeff Curtes/Riksgransen, Sweden/May, 1996

[86]Joe Curtes/Jeff Curtes/Erehwon, New Zealand/September, 1998
Grant Brittain influenced. Probably the only rider in the world I trust enough to get this close too. How else to make a quarterpipe, that we had shot for over a week, look different? This is my favourite shot of Joe in our history of over ten years of shooting together.

[87]Dave Downing/Mark Gallup/Erehwon, New Zealand/September, 1998
The most expensive quarterpipe ever. We heli'd to this thing everyday for a ten day Burton catalogue shoot. About half a dozen heli loads up and down each day. Bruno had the cash in a camo duffel bag to pay the bill. It was a big duffel.

[88]Keir Dillon/Jeff Curtes/Mount Hood, Oregon/October, 2000

[89]Bryan Iguchi/Kevin Zacher/Valle Nevado, Chile/September, 1999

[90]Trevor Andrew/Kevin Zacher/Valle Nevado, Chile/September, 1999

[91] Jim Rippey over Joe Curtes/Jeff Curtes/Erehwon, New Zealand/September, 1998
Transworld Snowboarding, Vol.12 #8, gatefold poster.

[92/93]Keir Dillon/Jeff Curtes/Valle Nevado, Chile/September, 1999
I poached Vianney's lighting set-up on this one. Total fuckin' bullshit roof drop turns into the cover of the Burton catalogue.

[93]David Carrier Porcheron/Jeff Curtes/Valle Nevado, Chile/September, 1999
Profoto 7B. Go!

[94]Gigi Rüf/Dean Blotto Gray/Las Lenas, Argentina/September, 2000

[95]Trevor Andrew/Jeff Curtes/Valle Nevado, Chile/September, 1999
Tyvek suits Beastie Boys rip-off JDK wet dream. If it weren't for Vianney and his eager French enthusiasm this JDK concept would have never happened. "It's the ad."

Trevor Andrew/Dean Blotto Gray/Valle Nevado, Chile/September, 1999

Vianney Tisseau, Jeff Curtes and Jon Boyer/Jared Eberhardt/Valle Nevado, Chile/September, 1999

Trevor Andrew/Kevin Zacher/Valle Nevado, Chile/September, 1999

[96]Ross Powers/Jeff Curtes/Mount Hood, Oregon/October, 1999

[97]Terje Haakonsen/Jeff Curtes/Las Lenas, Argentina/September, 2000

[98]Michi Albin/Vincent Skoglund/Transcendence/Engadine, Switzerland/January, 2001

[99]Johan Olofsson/Jeff Curtes/Standard Films/Valdez, Alaska/April, 1996

[100]Natasza Zurek/Jeff Curtes/Las Lenas, Argentina/September, 2000
Nat stepped it up on this quarterpipe. Her airs were definitely some of the largest airs I've ever seen by a girl. I was blown away and am backing Nat all the way. Chicken strip.

[101]Dave Downing/Trevor Graves/Las Lenas, Argentina/September, 2000

[102/103]Romain De Marchi/Jeff Curtes/MDP Films/Callahan Lakes, Whistler, B.C./February, 2001
Switch backside 540. Sledland, Whistler backcountry. This was a filming day for MDP and definitely the sickest jump that I shot this season. Thank you Anthony Vitale!

[104]J.F. Giasson/Jeff Curtes/Mount Hood, Oregon/July, 2000

[105]Jussi Oksanen/Jeff Curtes/Standard Films TB10/Northstar, Lake Tahoe, California/January, 2001
Downing called me right when I landed in Reno, Nevada. I went straight from the airport to this rail session with Hatchett and his crew of Parker, Downing, Jussi and Crawford. 17-step switch stance frontside boardside. "Since the only trick that Jussi does on rails is switch frontside boardslide like this one, he is technically a goofy footer and not a regular footer like he claims to be." – Dave Downing

[106]Romain De Marchi/Jeff Curtes/Livigno, Italy/December, 2000
This was a parking lot car tow-in jib. Romain and Joni Malmi killing it.

[107]Jussi Oksanen/Jeff Curtes/Standard Films TB10/Little Cottonwood Canyon, Utah/January, 2001
Grizzly Gulch step-up; cork frontside five.

[108]Trevor Andrew/Jeff Curtes/Las Lenas, Argentina/September, 2000
Melon backside 540. Trev got so sunburned the first day of this shoot that he had to wear a bandana to cover his face.

[109]Stefan Gimpl/Vincent Skoglund/Transcendence/Engadine, Switzerland/January, 2001

[110]Heikki Sorsa/Jeff Curtes/Holmenkollen, Oslo, Norway/April 7, 2001
Arctic Challenge quarterpipe contest. Heikki went fucking huge. I think it was a record breaking 27-feet backside air.

[111]Mads Jonsson/Jeff Curtes/Hemsedal, Norway/April, 2001

[112]Dave Downing/Jeff Curtes/Donner Pass, California/February, 2001
Blower. This shot of Dave was almost used as the cover of the book. It pretty much says it all

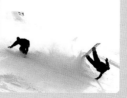

CH3:[113-156]PEOPLE

[113]Card house by Jared Eberhardt/Jeff Curtes/Burlington, Vermont/Winter, 2001

[114]Marcus Egge/Jared Eberhardt/Valle

I WILL SMOKE IT ALL. '96

see you mate.

Nevado, Chile/September, 1999

Malcolm Buick/Jared Eberhardt/Las Lenas, Argentina/September, 2000
The nipple sessions.

Vianney Tisseau/Jared Eberhardt/Valle Nevado, Chile/September, 1999
The French-Mexican.

Michael Jager /Jared Eberhardt/Valle Nevado, Chile/September, 1999
American crackers.

[115]Scott Needham/Jeff Curtes/Lofoten Islands, Norway/April, 2000
Aboard the ferry heading to the Arctic Challenge.

Dean Blotto Gray/Kevin Zacher/Valle Nevado, Chile/September, 1999
Blotto's camera bag fell out of the heli and took about a 1500-feet tumble down rocks. His camera gear was totally destroyed.

Vianney Tisseau/Vincent Skoglund/Chamonix, France/Date unknown
French Photographer.

Bubble-rama/Jeff Curtes/Stockholm, Sweden/May, 1996

Michael Jager/Jared Eberhardt/Frankfurt, Germany/Summer, 1997
This was the first time that Jared had travelled with Michael. This night came after a sleepless work week.

Carl Zeiss' Chauffeur/Jeff Curtes/Frankfurt, Germany/December, 2000

Jon Boyer/Jeff Curtes/Hemsedal, Norway/April 13, 2001
Husk Bompenger. We saw this sticker on the dash of our Norwegian rental car and laughed at how it sounded. "Husk." We must have said that a million times on the drive up to Hemsedal from Oslo not even remotely knowing what it meant. We later found out it means don't forget to pay the toll.

Mike McEntire/Jeff Curtes/Holmenkollen, Oslo, Norway/April 7, 2001
Mack Dawg filming at the Arctic Challenge quarterpipe contest.

Jeff Curtes/Vianney Tisseau/Saas Fee, Switzerland/October, 1998
Little buddies.

Jeff Curtes, Vianney Tisseau and Vincent Skoglund/Jon Boyer/Las Lenas, Argentina/September, 2000
Vincent and I are carrying two camera packs each in this shot. We have our normal shooting packs and our second packs contain our Profoto 7B flashes. The shit is heavy. Is my sunscreen rubbed in?

Candice Wilhelmsen/Jeff Curtes/Hemsedal, Norway/April, 2001
I love Candice more than Firkløver. Jeg Elsker Deg.

Jim Anfuso/Trevor Graves/Tignes, France/October, 1996
Jersey Jim prepping for the Halloween party. Ice cream every night.

Jeff Curtes and Trevor Graves/Kevin Zacher/Valle Nevado, Chile/September, 1999

Dave Seaone/Vianney Tisseau/Dave's house, Lake Tahoe, California/Date unknown
Ingemar Backman sent Dave this fax preparing Dave for his arrival to town.

Greg Dacyshyn/Jeff Curtes/Valle Nevado, Chile/September, 1999 – 2.

Dave Seaone and Dog/Jeff Curtes/North Cascade Heli, Winthrop, Washington/February, 1998
Waiting out bad weather by cross-country skiing. Have you ever seen Seaone, Bryan Iguchi or Downing try to Nordic ski? You don't want to, it's ugly.

[116]Juha Tenkku/Jeff Curtes/Tignes, France/October, 1996

Dave Downing and Shannon Dunn/Jeff Curtes/Tignes, France/October, 1996

[117]Dave Downing/Jeff Curtes/St. Anton, Austria/March, 1999
This was my entry in the Crystal Awards lifestyle category. I got last place. Take off that sweater vest.

[118]Trevor Andrew/Jeff Curtes/Valle Nevado, Chile/September, 1999

[119]Joni Malmi/Jeff Curtes/Tignes, France/Summer, 1997

[120]Terje Haakonsen/Mark Gallup/Island Lake Lodge, Fernie, B.C./Date unknown
Right after I shot this sequence on the deck at the lodge, Terje walked up to me and said, "give me that film". I said, "Excuse me?" He told me that he did that for his filmer (cinematographer) and he didn't want anyone shooting pictures of it. I looked at him and said "fuck you", and walked away. – Mark Gallup

[121]Terje Haakonsen/Scott Needham/Erehwon, New Zealand/September, 1998

[122]Yoshinari Uemura/Jeff Curtes/Niseko, Japan/February, 1999

[123]Juha Tenkku/Jeff Curtes/Gothenburg, Sweden/December, 1996

Juha Tenkku/Jeff Curtes/Harejuko, Japan/September, 1997
Lost in a hip-hop daydream.

Juha Tenkku/Jeff Curtes/Mike Hatchett's house, Tahoe Vista, California/March, 1997

Juha Tenkku/Jeff Curtes/Zermatt, Switzerland/October, 1995
Finger boarding kid.

[124]Anne Molin Kongsgaard/Jeff Curtes/Thunderhead Lodge, Mount Hood, Oregon/October, 1999

[125]Victoria Jealouse/Jeff Curtes/Whistler, B.C./February, 2001

[126]Maria Preteur and monkey/Jared Eberhardt/Hintertux, Austria/October, 1997

[127]Keir Dillon, Chris Brown, Jason Borgstede and Jason Brown/Vianney Tisseau/Valle Nevado, Chile/September, 1999

Nicole Angelrath and Josh Dirksen/Vianney Tisseau/Alagna, Italy/January, 1999
Peek-a-boo.

Gigi Rüf/Kevin Zacher/Happo, Japan/February, 2000

Unknown Russian sunbather/Hiro Yamada/Mount Elbrus, Russia/April 9, 1999
EK said he could look at these forever. "They're spectacular."

Sunset chairs/Jeff Curtes/Termas de Chillan, Chile/August, 1997

[128]Skier painting/Jeff Curtes/Riksgransen, Sweden/May, 1995

Jim Rippey/Jeff Curtes/Lake Tahoe, California/March, 1999
Ozzy horns at the cabin kicker.

Japanese kid with gold teeth/Jeff Curtes/Oze Tokura, Japan/February, 1997

Jeff Anderson/Jeff Curtes/Tokyo, Japan/Date unknown
Jeffy hammered on a typical night of the summer Burton promo tour. Bruno and I had to abuse him with some of our autographs.

Tyler De Wilde/Kevin Zacher/Valle Nevado, Chile/September, 1999

Marcus Egge/Jeff Curtes/Erehwon, New Zealand/September, 1999
Eye. I had just bought a new 60mm macro lens and decided to do a film test upon arrival in Christchurch, New Zealand just to make sure that nothing had been x-ray damaged. I snapped a few shots of Dave Downing's face and his eyes and ran them over to the one-hour photo lab. They were really insane looking. I showed them to Jared Eberhardt, the design director for the shoot, and he encouraged me to shoot the entire team this way. A few weeks later they became the covers of The Declaration, that season's Burton catalogue.

[129]Michi Albin/Scott Needham/Erehwon, New Zealand/September, 1999
This is such an epic shot of Michi. He looks like Mick Jagger after a world tour.

[130]Allan Clark's treehouse/Jeff Curtes/Whistler, B.C./January, 2001
Johan hanging out in Allan Clark's treehouse.

Johan Olofsson and Craig Kelly/Ari Marcopoulos/Location unknown/Date unknown
You gonna finish that? Ari's photos are definitely some of my all-time favourites, this one really says a lot about the way he is able to photograph so unobtrusively and naturally.

[131]Terje Haakonsen/Trevor Graves/New York City, NY/1990

Pasi Voho/Jeff Curtes/Location unknown/1996
Pasi wearing Funsport Snowboarding's Ingemar big air T-shirt.

Craig Kelly/Jeff Curtes/Winthrop, Washington/March, 1997
We slammed these huge 8% alcohol pints of beer, after riding one day, at this tiny bar at North Cascade Heli. Craig was getting pretty loose telling about some POW run or a sick chute or something that happened on one of his insane heli adventures.

Michi Albin/Kevin Zacher/Las Lenas, Argentina/September, 2000
The Argo. We broke the first one and had to buy a second. No big deal though, Bruno had the cash.

Satu Jarvela/Jeff Curtes/Huntington Beach, California/Date unknown

[132]Terje Haakonsen/Vincent Skoglund/Stamsund, Norway/April, 2000
Arctic Challenge.

Johan Olofsson/Vincent Skoglund/Riksgransen, Sweden/Date unknown
Here is Johan with a new prototype.

Wooden leg/Vincent Skoglund/Location unknown/Date unknown

[133]David Carrier Porcheron/Jeff Curtes/Las Lenas, Argentina/September, 2000

Trevor Andrew/Jeff Curtes/Hemsedal, Norway/April, 2001

Johan Olofsson/Scott

Needham/Erehwon, New Zealand/September, 1998

Aleksi Vanninen/Jeff Curtes/Ohau, New Zealand/Date unknown

[134]Marcus Egge/Jeff Curtes/Las Lenas, Argentina/September, 2000

Natasza Zurek/Trevor Graves/Valle Nevado, Chile/September, 1999

Keir Dillon/Vincent Skoglund/Las Lenas, Argentina/September, 2000

[135]Romain De Marchi/Jeff Curtes/Livigno, Italy/December, 2000

Marcus Egge/Jeff Curtes/San Rafael, Argentina/September, 2000

Dave Downing and Stefan Gimpl/Jeff Curtes/Las Lenas, Argentina/September, 2000

[136]Keir Dillon /Jeff Curtes/Yokohama, Japan/August, 1999
"Planet of the Apes" building.

Japanese buildings/Dean Blotto Gray/Tokyo, Japan/Date unknown

[137]Gigi Rüf/Dean Blotto Gray/Highway 395, California/March, 2000
Fresh off the Transworld Team Challenge (2000) at Snow Summit, Gigi and I headed north, aiming for Brad Kremer in Lake Tahoe. A few miles out of Bear we dropped into the lower elevations of the California desert. Gigi said he'd never seen a cactus before as he gazed out the window checking the landscape. I immediately pulled the car over so Smalls could get out and touch one of these cacti. I've always thought this photo captured the pure joy of seeing new things.

Face/Dean Blotto Gray/Tokyo, Japan/Date unknown
This day was a big face on a big wall in a big city.

[138]Jim Rippey and Trevor Andrew/Jeff Curtes/Kyoto, Japan/August, 1998
BB gun warriors. We were cruising on the Burton summer tour and Trevor and Rip had to have the new BB guns. As we drove down the road through Kyoto, they were shooting BBs at random signs, buildings and the occasional passer-by. We left the city and headed onto the highway to go to another promo. About two miles down the highway, there was a five or more car police barricade blocking the road. They were there, waiting for US! Some random Japanese citizen had reported machine gun fire out of a van window. Three hours later, we were free to go from the holding room of the Japanese police station.

Jason Brown/Jeff Curtes/Sendai, Japan/Date unknown
This was Derek Heidt's birthday so J. Brown decided to throw down a little performance of Dinosaur Jr. for him.

Marcus Egge/Jeff Curtes/Erehwon, New Zealand/September, 1998

[139]Jason Brown, Bruno Musso and Trevor Andrew/Jeff Curtes/Oze Tokura, Japan/February, 1998
"Hey Jeffy, hand me my cigarettes."

Chairs/Jeff Curtes/Las Lenas, Argentina/September, 2000

Johan Olofsson/Jeff Curtes/Japanese tour bus, Japan/February, 1996
The original booze cruise.

Bruno Musso, Bryan Iguchi and Jason Brown/Jeff Curtes/S.A.W.S.S., Tokyo, Japan/September 4, 1997
Burton in the Fridge. The Guch threw his boots into the crowd of screaming Japanese fans and had to get carried out off the snow.

[140]Jake Burton

Carpenter/Photographer unknown/Hintertux, Austria/October, 1997
Jake being filmed for the 1998 Burton promo video. Hung-over and black-eyed from a brutal night before.

Juha Tenkku/Bruno Musso/Saas Fee, Switzerland/October, 1998
Parking garage rain day. Bruno kills it with the SX-70.

Youbi/Bruno Musso/Saas Fee, Switzerland/October, 1998

Parking garage/Bruno Musso/Saas Fee, Switzerland/October, 1998

[141]Abe Teter/Jeff Curtes/Thunderhead Lodge, Government Camp, Oregon/October, 1999
Manic pumpkin stealer.

Abe Teter/Jeff Curtes/Mount Hood, Oregon/October, 1999
Teter with his family's homemade maple syrup, Oakley's with no lens and the sculpture that he built for over three days instead of riding.

[142]Chris Brown/Hiro Yamada/Location unknown/September, 1998
"I will never use this photo." – JE

Whiteboy/Vianney Tisseau/Valle Nevado, Chile/September, 1999

Michi Albin and Trevor Andrew/Vianney Tisseau/Valle Nevado, Chile/September, 1999

[143]Jason Brown/Kevin Zacher/Valle Nevado, Chile/ September, 1999

Mikkel Bagn/Jeff Curtes/Hemsedal, Norway/April, 2001
Husk Bompenger.

Billy and Jeffy Anderson/Jeff Curtes/Vail, Colorado/Winter, 1995
Oakley party with Porno for Pyros.

Terje Haakonsen/Trevor Graves/St. Moritz, Switzerland/Winter, 1990

Mikey Rencz/Vincent Skoglund/Las Lenas, Argentina/September, 2000

Shaun White/Jeff Curtes/Oze Tokura, Japan/Date unknown

[144]Bryan Iguchi/Trevor Ray Hart/Valle Nevado, Chile/September, 1999

Johan Olofsson/Trevor Ray Hart/Valle Nevado, Chile/September, 1999

Chairs/Jeff Curtes/Las Lenas, Argentina/September, 2000

[145]Freddie Kalbermatten and Nicolas Müller/Jeff Curtes/Hemsedal, Norway/April, 2001

Natasza Zurek/Jeff Curtes/Buenos Aires, Argentina/September, 2000

[146/150]Trevor Andrew/Jeff Curtes/Las Lenas, Argentina/September, 2000

[147/150]Dave Downing, Lisa, Satan Johan, X-man, Champ, Crisp Joe, Heidi, Michi Pop, Juha, Nicolette, Erehwon crew, Black Ant Skoglund, Conte, Nat, Sami, Christine, Wigz, JB, Bruno, Scotty and Jeffy, Seaone, Sani, Martina (I love Sardinia), ZIP RUFFLE RUFFLE, Trevor, Hector, Jeffy, Crystal, Kenji, Gallup, Baby Satu, Daniel Nordin, Naru, the Guch, Janel/Jeff Curtes and Jared Eberhardt/Erehwon, New Zealand and Saas Fee, Switzerland/September, October, 1998

[152]Helicopter taking off/Mark Gallup/Valle Nevado, Chile/September 19, 1999

Skid/Hiro Yamada/Whistler, B.C./February 9, 2000

Johan Olofsson and Bryan Iguchi/Jeff Curtes/Erehwon, New Zealand/September, 1998

[153]Johan Olofsson/Jeff Curtes/Valdez,

Alaska/April, 1996
Cauliflower Chutes, Johan top to bottom in less than a minute. Mike Hatchett and I were across the valley shooting from another peak almost a mile away and all we could hear was the ruffling of Johan's jacket in the wind from the speed he was carrying.

Mike Hatchett filming/Jeff Curtes/Valdez, Alaska/April, 1996
Mike is the most responsible and stoked filmer I have ever had the opportunity to work with, he is a legend. He makes a good latte too, and can rip the sickest "meth-ikes" ever!

[154]Jeffy Anderson/Craig Abel Champion/Erehwon, New Zealand/September, 1998
"The magic is real."

[155]Trevor Andrew/Craig Abel Champion/Erehwon, New Zealand/September, 1998

[156]Jamil Khan and Ian Spiro/Jeff Curtes/Glacier, Washington/January, 1997
Travelling the northwest with the Jennies (Waara and Jonson).

Blair Rusin's sketches of Jamil/Jeff Curtes/Stratton,Vermont/Date unknown

Jamil Khan/Jared Eberhardt/Hintertux, Austria/October, 1997

CH4 : [157–188]ART

[157]Self-portrait/Mike Parillo

[158/159]Snowcat illustration/Evan Hecox

[160/161]Dinosaurs and spacemen, mixed media/Warewolf, arylic on masonite/Scott Leonhardt

[162/163]Mekon CD, Delta Badhand, Swinger Perfume, Burton Trucks, Smoking Lady/Stephen Bliss

[164/165]Red Paint 2, The quietlifephoto, Two Angels, California, Ode to Eddie, Carrot boy, Two guys, Leaving Chicago, Green collage, Yellow painting/Andy Mueller

[166/167]Afro 2 San Francisco 2000, Forget Release #37, Untitled #39, Confront/Deny 2001 #38A&B, Paris Series#3/Dave Kinsey

[168/169]Untitled/Noah Butkiss

[170/171]Chopper robots/Jason Brashill

[172/173]Artwork for Burton Snowboard's Michi Albin pro model/Mark Gonzales

[174/175]Sketchbook 1, 2, 3/Mark Reush

[176/177]Selected pages from Check My Chops, Powder to the People/Chimp

[178/179]Hack, Face, Post-it #2/Andy Jenkins

[180/181]Spaceboy with dropshadow, Sketches, People/Woo Roberts

[182/183]You are Worthless, BOTS3, Headphones Wood, Canvas, Bitmap

Stereo, Science, Skatedecks, R243V2, Bear, Bigbeetmunky/Struggle, Inc.

[184/185]Sketchbook pages/John Copeland

[186/187]Blowerill/Geoff McFetridge

[188]Blower Letraset/St. Malcolm Buick

CH5:[189-220]
THE PROCESS

[189]Madonna ad/1993
Organised controversy from the desk of Michael Jager and DJ.
This was considered a high-water mark in Burton advertising (the ad was refused by several publishers). After it ran Burton was flooded with calls and letters from angry parents.

[190/191]Assorted board graphics/1991-2001, Dave Downing customising his board/Hintertux, Austria/1997
Dave wasn't happy with the way his board turned out so he stole a can of paint from a supply closet and changed his blue board to black. Upon returning from the photoshoot we spec'd new colours for the Custom 160, black.

Original twin graphic was a "satanic" tool according to some mothers.

Custom butterfly/rainbow graphic started as a restaurant napkin doodle by Joe Curtes.

[192/193]Dealer catalogue, consumer ads/1991
This was the last time DJ allowed a catalogue to have a tortured animal on the cover. The image was intended to be an open challenge to the ski industry. "Stare the future in the face" was a premonition of snowboarding's inevitable growth. People didn't understand what a screaming monkey has to do with any of that and just thought that it was mean.

"Why do you want to hurt small animals?"

Balls to the Wall ad was actually a low angle shot that was tipped in the design process to look "extreme".

[194/195]Burton dealer catalogue/1992
As most good things do, this cover started as a joke. After trying to come up with a cover concept Covell just decided to type "Burton Dealer Catalogue" in 72 point type and the rest was history.

The original Stream of Consciousness campaign...collect all 20 ads and win a prize!

[196/197]Jason Gerardi cigarette ad/1992-1993
One of the classic Burton images, promoting both smoking and destruction of natural resources; which is strange for a hippie company that allows you to bring your dog to work.
This ad ushered in a new era of riding and a new "personality" standard for pro riders.
"This was my first ad presentation ...keep your pants on, rollerskater jumping through flaming hoops, bowl or macaroni, or Girardi smoking a butt...this ad got my vote and was probably my first and best decision inside Burton." – David Schriber

The original J.

[198/199]Advanced Snowboard Science dealer catalogue, Science consumer catalogue, hangtags, envelopes, U.S. Open 1994 poster, Tree consumer catalogue, 1993-1994

This is another high water mark in Burton/JDK history. This catalogue serves as a benchmark of design within JDK and Burton to this day.

Still feeling the recoil from the screaming monkey catalogue cover, Burton shied away from the dissected frog ad. They pulled the plug on it as and ad, instead sending it directly to people's homes as a postcard. Even people working with Burton had difficulty understanding the humour in this one.

I had to write a press release this year to justify why we needed so many boards (15) in the line. (2002 = 146 boards in the line!) – DS

The Warning May Cause Excitability box was hand-folded, Fourth of July weekend, 1992, with a stack of pizza's and a stack of video's from Blockbuster.

Hidden message in envelope; "when you feel the flow, you'll know".

I boot-packed the trail for the riders to get these tracks. And I got to go next. – DJ

[200/201]J2 ad/1993-94
The rest of the industry had discovered Adobe. Burton gained distinction by creating elaborate collages without the help of PhotoShop. Covell's office was literally stuffed full of crap he found out in the dirt.

[202/203]Marmot dealer catalogue, bacon thanks page, Joe Curtes bullwheel ad, handmade ad, wool/1994
Geoff Fosbrook shot the bacon in his kitchen, after the shot he fried it up and made a BLT.
The HORSE signature was JDK's code for their Burton design team. GNU mocked this by signing "UNICORN" on their ads.
The Joe Curtes bullwheel shot cost Michael Jager a beer.

The catalogue cover mascot was in the mid-station lodge in Val Thorens, France where we shot the catalogue.

[204/205]Burton Mfg. dealer book/1995. Burton Snowboards Mfg. consumer catalogue, The Vault of Terror ad, Jetfighters ad, Terje seamless ad/1995
JDK finally gave in to the Adobe side and combined elaborate digital manipulation with four letter words to create classics like the "who the fuck is Terje" ad.

"Woodland look" – plaid, Vermont and Burton all crossed paths with snowboarding. A great marketing coincidence that goes to show that luck only comes to those who are ready.

Log logo. Japanese retailers returned these deadwood Elm signs because they were "defective"...worm holes.

The Burton Mfg. dealer book was the beginning of line segmentation between boards, bindings, and boots.

Terje seamless ad. The height of "late" moves, the kind of tricks that only a sequence can explain, pushed seamless Photoshop techniques into the mainstream of snowboarding design.

Jetfighters; still, quite possibly, the most expensive piece of stock photography we've ever bought.

[206/207]Burton Hard/soft dealer catalogues, "who the fuck is Terje?" ad, outerwear hangtags, soul chair lift ad, push to start ad/1996
This year was influenced by Barbarella, and was deemed the hypertech year.

This is when the industry had just about reached critical mass; there were literally ten-times the number of companies that exist today. Burton combated the onslaught by deciding not to put any Burton logos on the bases of their high-end boards. It was a bold move that left most of the industry scratching their heads.

Hard/soft catalogues. Wired magazine released a cover just weeks after ours that was uncanny in its similarites. We were both using the same printer at the time. Coincidence?

"Who the fuck is Terje?" ad. A magazine in the UK got our ad films, thought they were a mistake, and kindly added the "k" back into the printed version for us.

Does anyone remember the original inspiration for this? Hint: music.

Soul chair ad. I really wanted to run this ad so someday, when the goatees were shaven, the tattoos removed by laser, and the snowboards rusted in the garage, those of us still riding would look back and say "I will".

Push to Start. Sooo real.

[208/209]Brushie Dice ad/1996-1997
A classic ad that took full advantage of the regulation craps table that Brushie based his graphic on. The boards also came with a set of Brushie dice. It's amazing how many people still have the dice and have gotten rid of the board.

Brush actually went out into the desert and shot this ad.

"Neil Drake and Jimmy Love."

[210/211] Consumer catalogues, Satu Jarvela and Nicole Angelrath ad, Johan and Sebu bus ad, Jason Brown skier fight ad/1997
Burton had about a thousand people on the team and 999 of them were in this catalogue; including Brad who made his way in by performing little monkey exercises in front of the camera.

Johan and Sebu Japan bus ad. To this day one of my favourite lifestyle shots. These guys were just sitting in the back of the bus playing with their new MD players.

[212/213]Burton Letters dealer catalogue, Joe Curtes tram dealer book lifestyle opener, Joe Curtes Squaw Valley night pipe ad, waterproof boot ad, letters ad, Jamil Khan snowmobile ad, consumer catalogue/1998
On a whim JDK decided to bring all the letters necessary to spell the word Burton to the fall shoot. The giant foam letters made the otherwise black blue glacier into a fertile photo factory.

Joe Curtes lifestyle opener. Check the fly in the goggle reflection. The fly shows up as early as 1992 when we shot the photos for a tuning manual and hid dead flies in each shot. Then came the Fly core, the Superfly core, the fly costume, and this fly cartoon in the goggles. Don't ask me why.

"Night pipe" enters the resorts' vocabulary.

[214/215] Dealer catalogues, Jason Brown ad, Step Up or Step Back ad, Stuck the Fereotype, Victoria Jealouse ad, Burton in the Fridge 3 poster art, Nippon Open poster art/1999
Victoria wanted to try a handrail. It wasn't very big by today's standards, but we built a ramp and she stomped it in complete darkness.
Victoria has often described her wants for ads and equipment to be "cute and tough". This ad strikes the balance.
Step back and see a misty image from "Star Wars". When we scammed our way into the Skywalker Ranch, JB had us pull over the rental car at the entrance because he was so excited he thought he was going to throw up.

Snowboarding indoors in the middle of

summer in the middle of one of the world's largest cities (Tokyo) with a mirror ball and Auld Land Syne; only in Japan.

[216/217]Between Two Bindings movie poster ad, Japanese newsletter vol. 2, Eye consumer catalogue, The Declaration, Hardgoods and Softgoods dealer catalogues/2000
Curtes bought a new camera in the airport on the way to New Zealand and he decided to run a test roll through it. He shot an amazing portrait of Downing's eye with a new macro lens. If he hadn't shot the test shots we would have probably had some dumb snowboarding shot on the catalogue cover that year.

[218/219]The Mission dealer catalogues, Men, Women, and Youth consumer catalogues, 7 action figure, Nippon Open NO poster art, Japanese newsletter .04 CD-ROM, various Japanese newsletters/2001
For some reason the Japanese have a lot of extra money for things like rectangular CD-ROMS and special action figures. Liam's dreams came true when he got all of the clothing and accessories made for the figures and hand assembled them in his basement over a period of a couple of weeks.

This year we split "the bible" into three. A major statement about the strength and future of the women's and youth markets.

White suits shot. Jason Brown goes home early, Trevor takes his orange suit to ride into infamy.

Action figures. Hiroki and Liam tapped into the latest Japanese micro-trend, (the year before it was ukuleles).

[220]Guide book and work books dealer catalogues/2002
Burton streamlined the buying process by making eight catalogues instead of two. That's enough catalogues to justify including a box. And this time we made our reps fold them.

[221-228]The Shavemart Periodical/written by Evan Rose, designed by Mr. Aaron James Draplin.

[229] Dave Downing pie/Jeff Curtes/Tenjindaira, Japan/February, 1996

Terje Haakonsen ice cream/Jeff Curtes/Hemsedal, Norway/April, 2001 "Just a little bit of Terje in each one."

[230]Crevasses/Dean Blotto Gray/Hintertux, Austria/June, 2000

Johan Olofsson/Jeff Curtes/Tricone, Whistler, B.C./January, 2001

Under mother/Jeff Curtes/Oze Tokura, Japan/February, 1996

[231]David Carrier Porcheron shovelling/Jeff Curtes/Valle Nevado, Chile/September, 1999

Aleksi Vanninen and Sebu Kuhlberg/Vianney Tisseau/Laax, Switzerland/Date unknown
Always try to get away.

Rider unknown/Vianney Tisseau/Hintertux, Austria/October, 1997

[232]Terje Haakonsen with gold bars/Scott Needham/Zurich, Switzerland/1996
"I will smoke it all."

Bryan Iguchi illustration/Jim Anfuso/Red Bank, NJ/Autumn, 2000

[233]Circular saw/Burton Snowboards catalogue archives/location unknown/1991

Mads' cast/Jeff Curtes/Hemsedal, Norway/April, 2001

[234/235]Mount Baker bonfire/Jeff Curtes/Mount Baker,

Washington/January, 2001
The banked slalom annual cook-out in the parking lot of Mount Baker.

[236/237]U.S. Open Crowd/Jeff Curtes/Stratton, Vermont/March, 2001
The crowd at the bottom of the pipe at the new location in the Sun Bowl.

[238/239]Air and Style drop-in/Jeff Curtes/Seefeld, Tirol, Austria/December, 2000

CH6:[240-256]
UNTITLED

[[240]Ian Spiro/Jared Eberhardt illustration, Jeff Curtes photography/Island Lake Lodge, Fernie, B.C./February, 1996

[241]Jaakko Seppala/Jeff Curtes/Hemsedal, Norway/April, 2001

[242/247]Johan Olofsson/Jeff Curtes/Salt Lake City, Utah/Winter, 1995

[243]Gash butt/Dean Blotto Gray/Hintertux, Austria/Date unknown

[244/245]]Johan Olofsson/Jeff Curtes/Salt Lake City, Utah/Winter, 1995

[246]Bloody snowballs/Jeff Curtes/Hemsedal, Norway/April, 2001
Quarterpipe session on the huge Hemsedal Q.P. Kjersti Buaas, a sick new Norwegian rider decked out on about a 15-feet backside air and ate her knees. Lying there bleeding and crying, she asked me how she looked and how bad it was. I said she would be all right. I said it didn't look too serious. I said she looked fine. Her front teeth were bashed in. Her upper lip was already black and blue and needed stitches. Her face gushed with blood. We iced her face, called ski patrol and helped her off the mountain. Within minutes the session resumed. The snowballs remained for three days on the coping.

[248]Keir Dillon bail/Jeff Curtes/Callahan Lakes, Whistler, B.C./February, 2001
Keir's first hits on this massive 110-feet roller jump. Backside three to late front flip. Check out the other film crew's jumps in the distance.

[249]Exploding Q.P./Jeff Curtes/Island Lake Lodge, Fernie, B.C./April, 1998

[250]Jeffy Anderson/Jeff Curtes/Termas De Chillan, Chile/July, 1997

[251]Chilean summer sky/Jeff Curtes/Santiago, Chile/August, 1997

[252/253]JP Solberg/Jeff Curtes/Hemsedal, Norway/April, 2001
Gorgeous Norwegian setting sun and an evening session on the park table top.

[254]Terje Haakonsen dropping in/Jeff Curtes/Table Mountain/Mount Baker, Washington/January, 2001

[255]Candice Wilhelmsen/Jeff Curtes/Ishiuchi Maruyami/February, 2001
Candice learned to snowboard better in one week in Japan after graduating from college than I did after two years of struggling at Little Switzerland in Slinger, Wisconsin.

[256]Nicolas Müller and Mads Jonsson/Jeff Curtes/Hemsedal, Norway/April, 2001

[END PAPERS]Jeff Curtes/Bruno Musso/Tokyo, Japan/Date unknown

THERE ARE VERY FEW THINGS IN LIFE THAT REALLY MATTER IN A PERSON'S LIFE. TO ME, THE BANKED SLALOM IS ONE OF THOSE FEW THINGS. I HAVE NEVER FELT MORE A PART OF AN EVENT IN MY LIFE. ALL THE COMPETITORS FEEL THIS AS WELL. THESE ARE PEOPLE WHO DO NOT COME FOR MONEY. THEY COME FOR A PAINTED ROLL OF DUCT TAPE. AND SOME DON'T EVEN COME FOR THAT. IT IS MOST FITTING THAT THE RACE IS HELD ON SUPER BOWL SUNDAY OF EVERY YEAR, BECAUSE I FEEL IT IS OF EQUAL COMPARISON. IT IS THE SAME TO ME AS THE NBA CHAMPIONSHIPS, THE WORLD SERIES, THE FINAL FOUR.

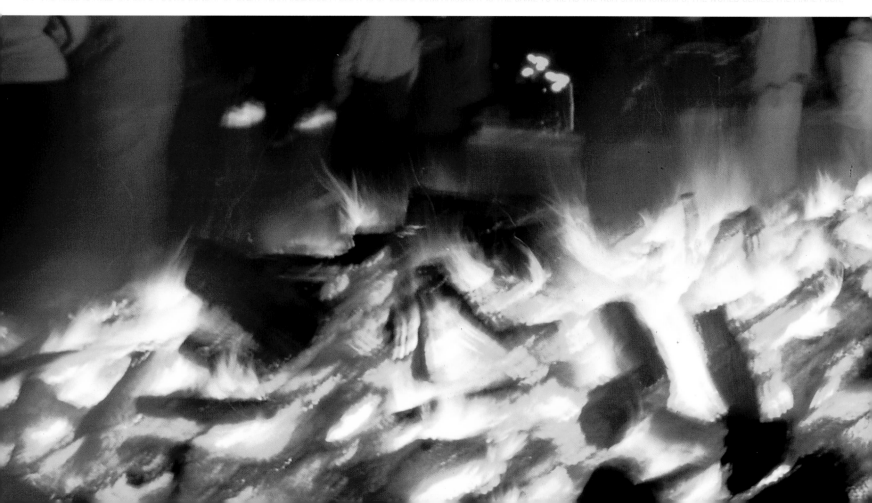

THE STANLEY CUP OR AN OLYMPIC GOLD MEDAL, TO MAKE THE CUT ALONE IS A HEAVY THING, BUT TO WIN, WELL ONE COULD ONLY DREAM. A PERSON WHO WINS LIKE TERJE SHOULD BE COMPARED TO A MICHAEL JORDAN. I COULD NEVER COMPLETELY EXPLAIN THE LEGENDARY BAKER BANKED SLALOM TO YOU, JUST AS ONE COULD NEVER EXPLAIN WHAT IT IS TO BE IN LOVE OR TO FEEL THE HEARTWRETCH OF NOT LIVING UP TO ONE'S OWN EXPECTATIONS. ALL I CAN OFFER IS A PROMISE: IF YOU CAN EVER MAKE IT TO THIS RACE, IT WILL CHANGE YOUR LIFE. — DAVID SYPNIEWSKI

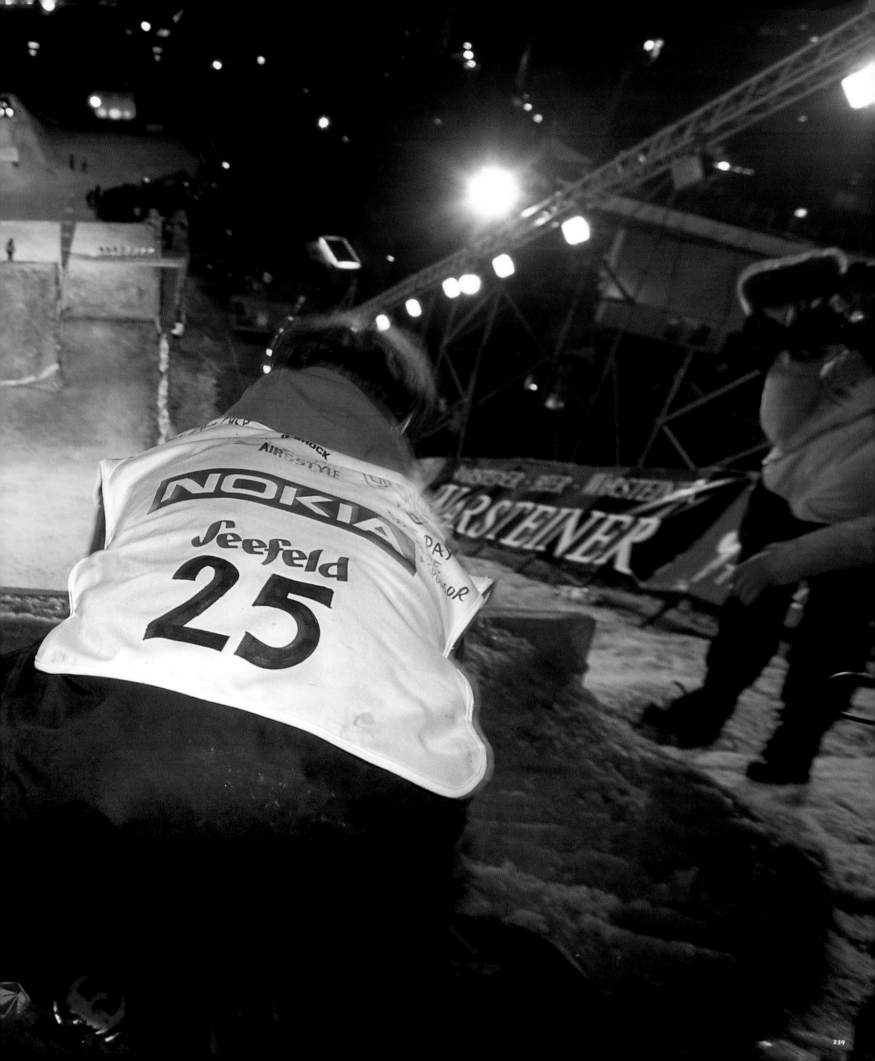

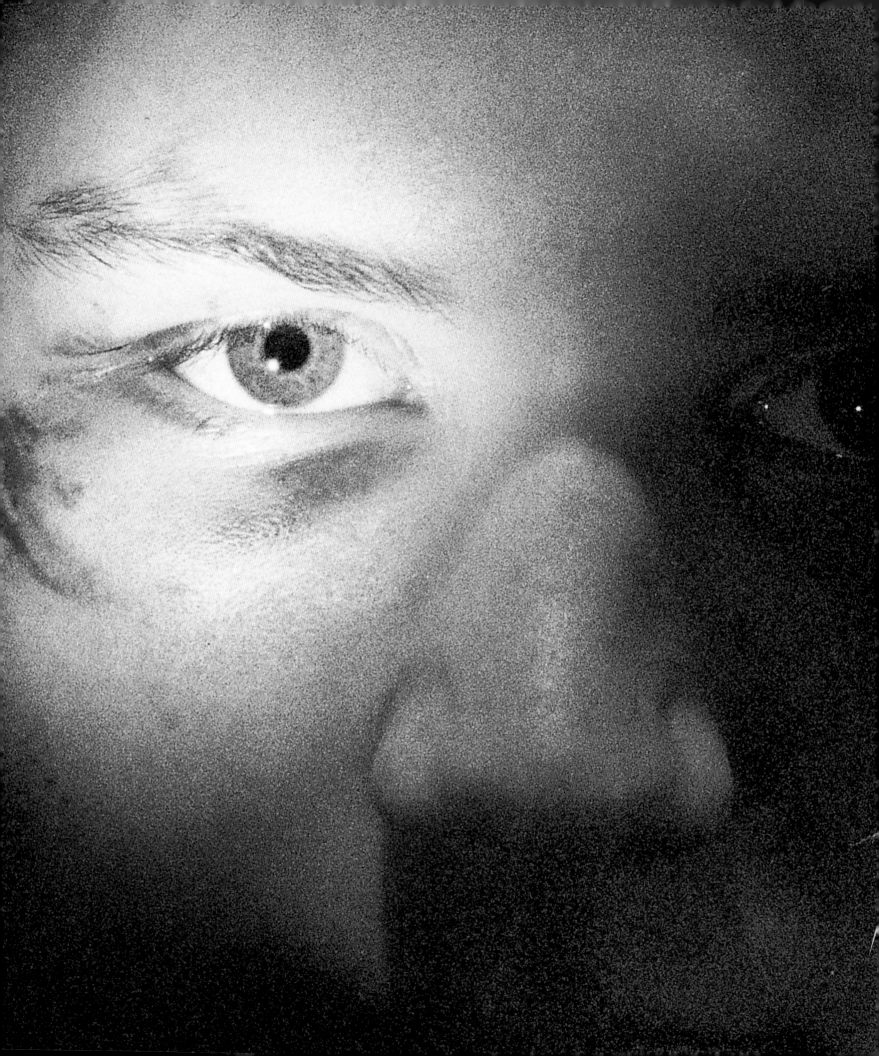

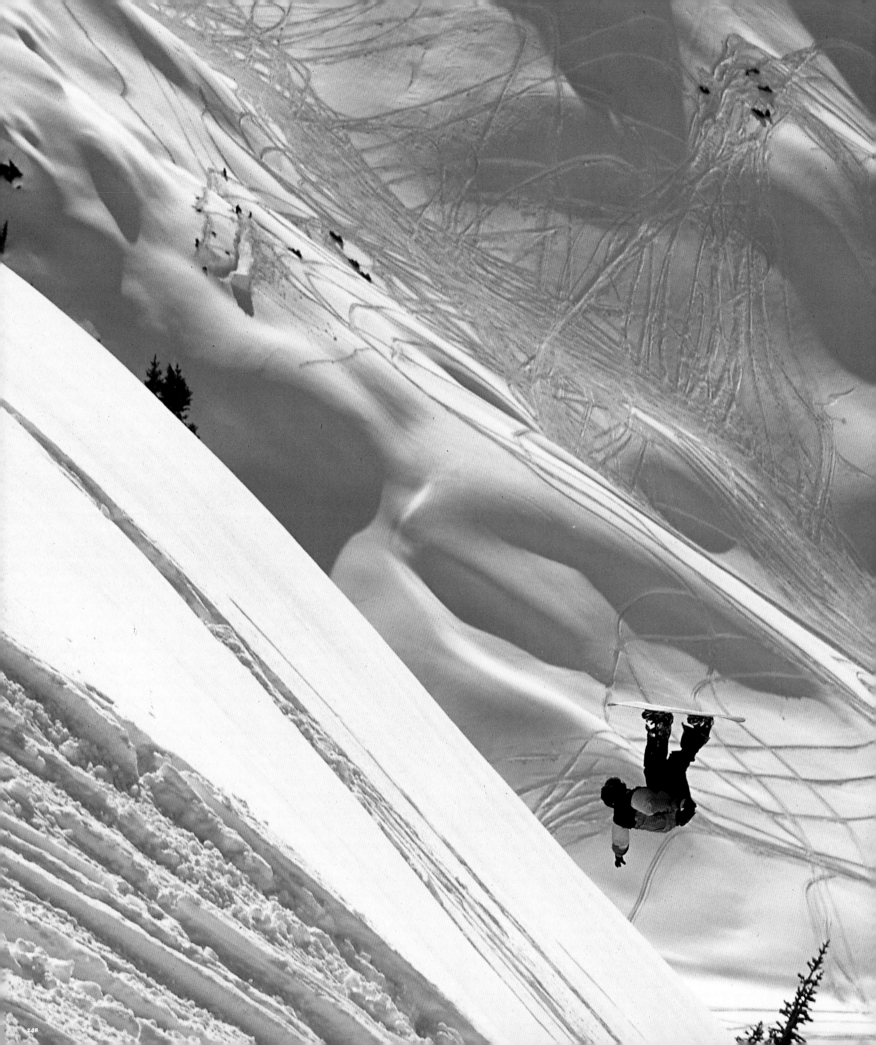

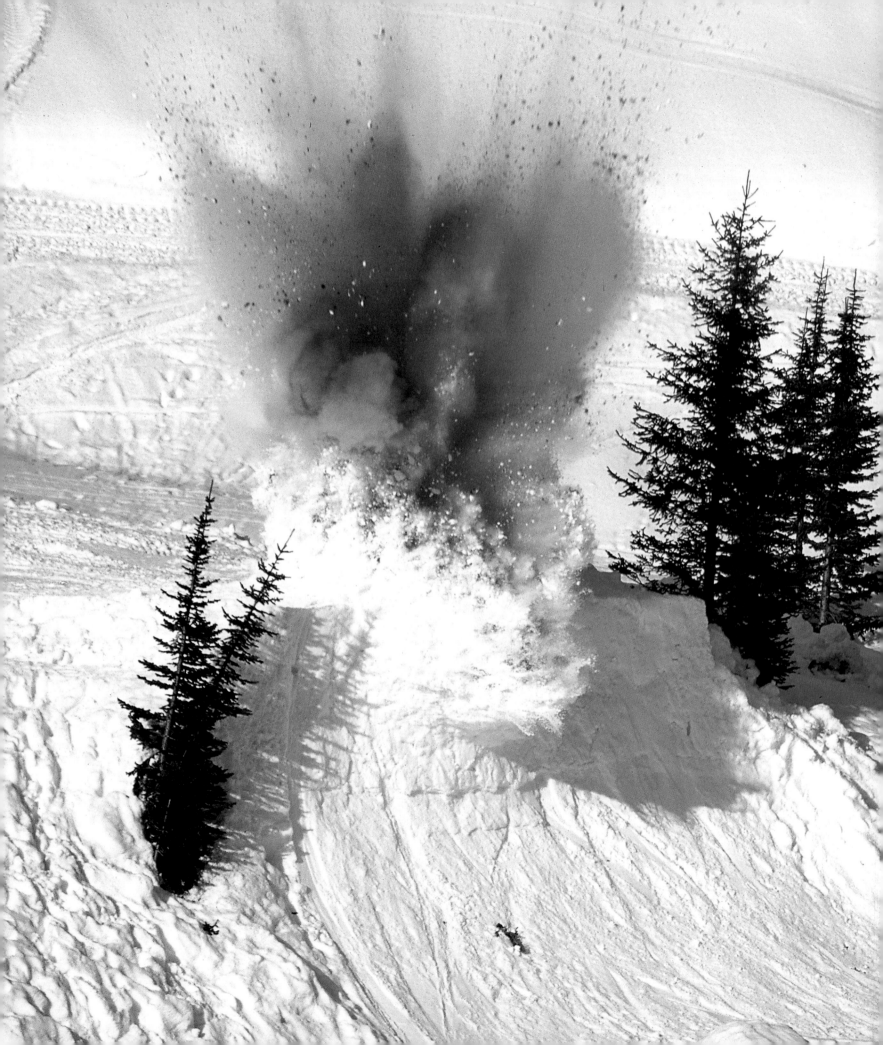

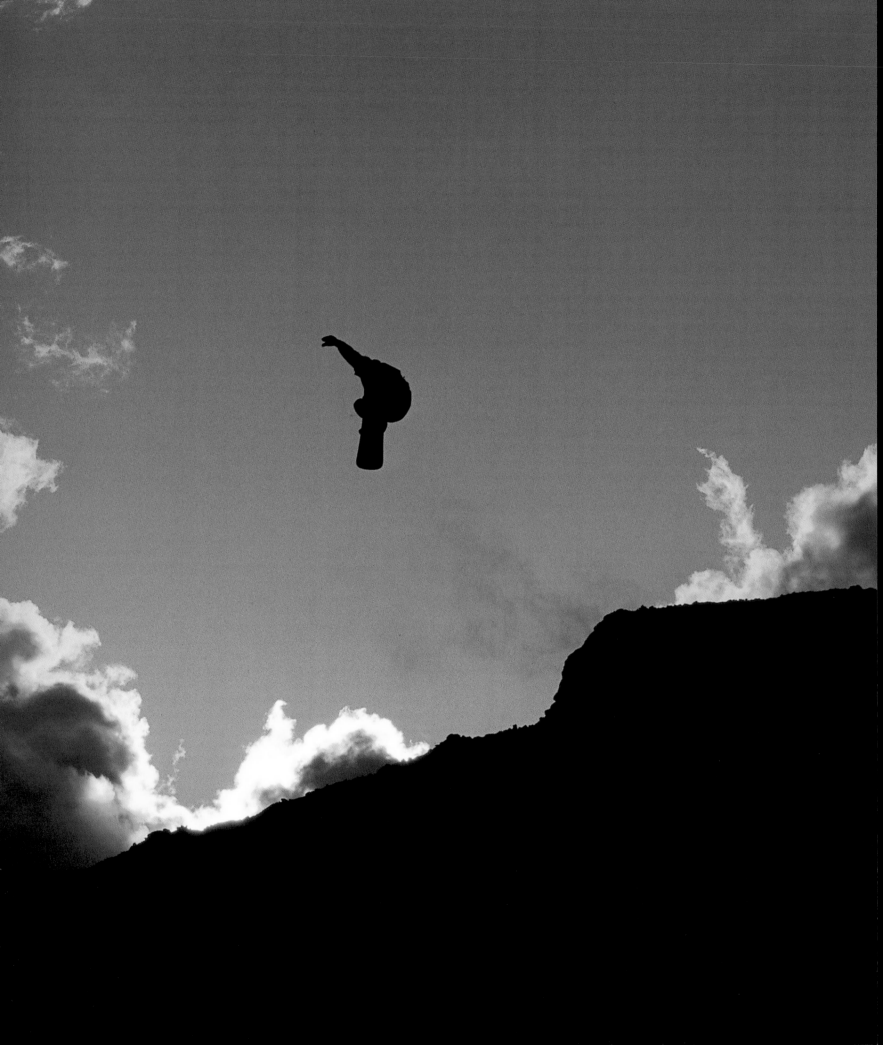

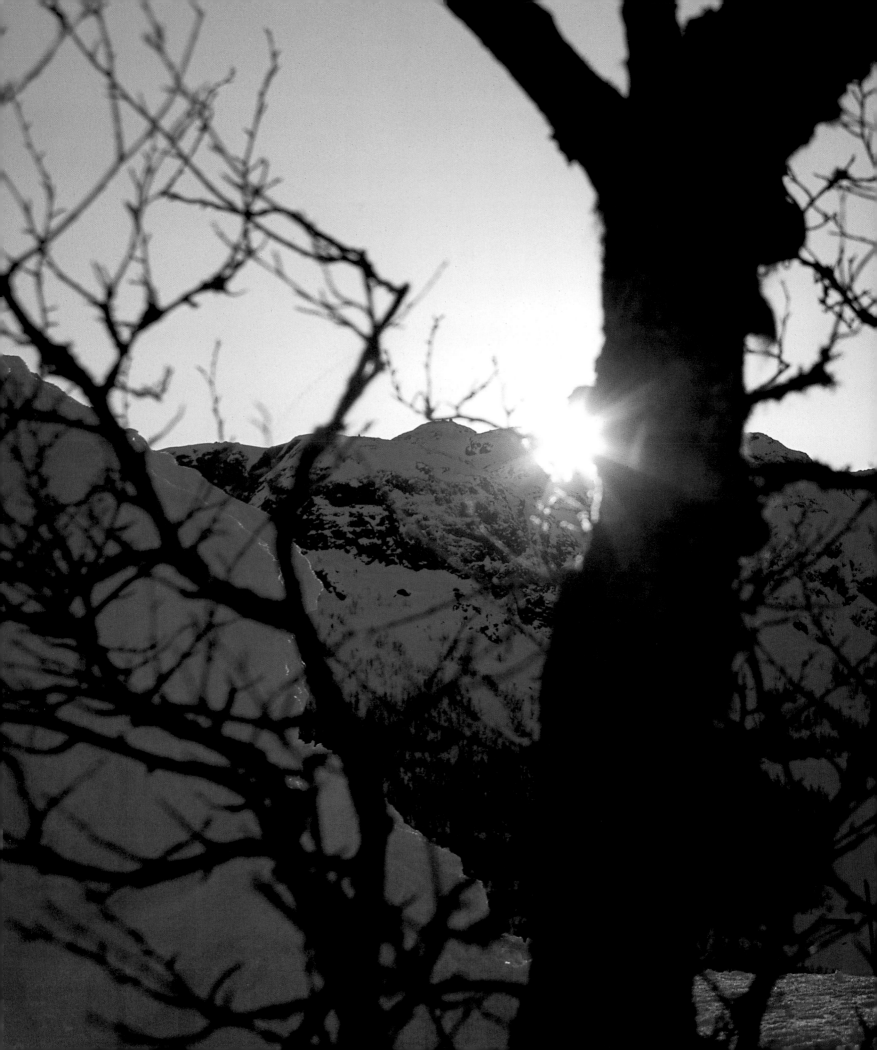

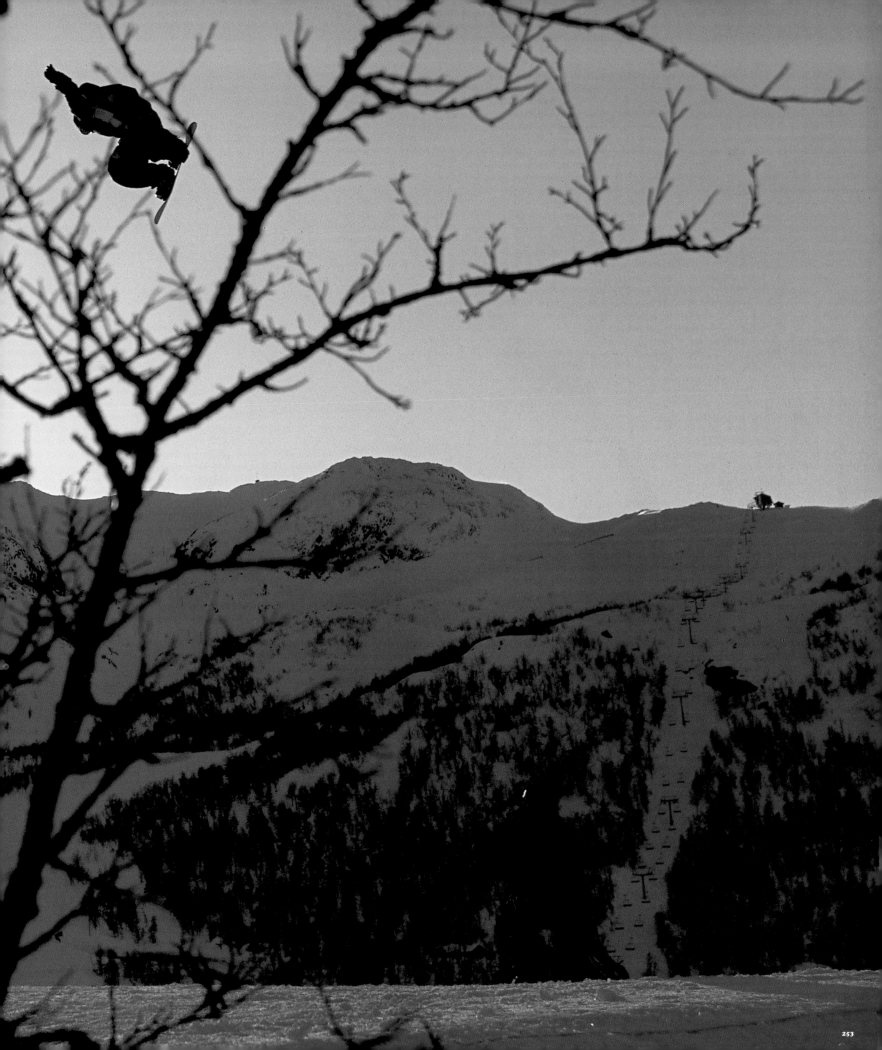

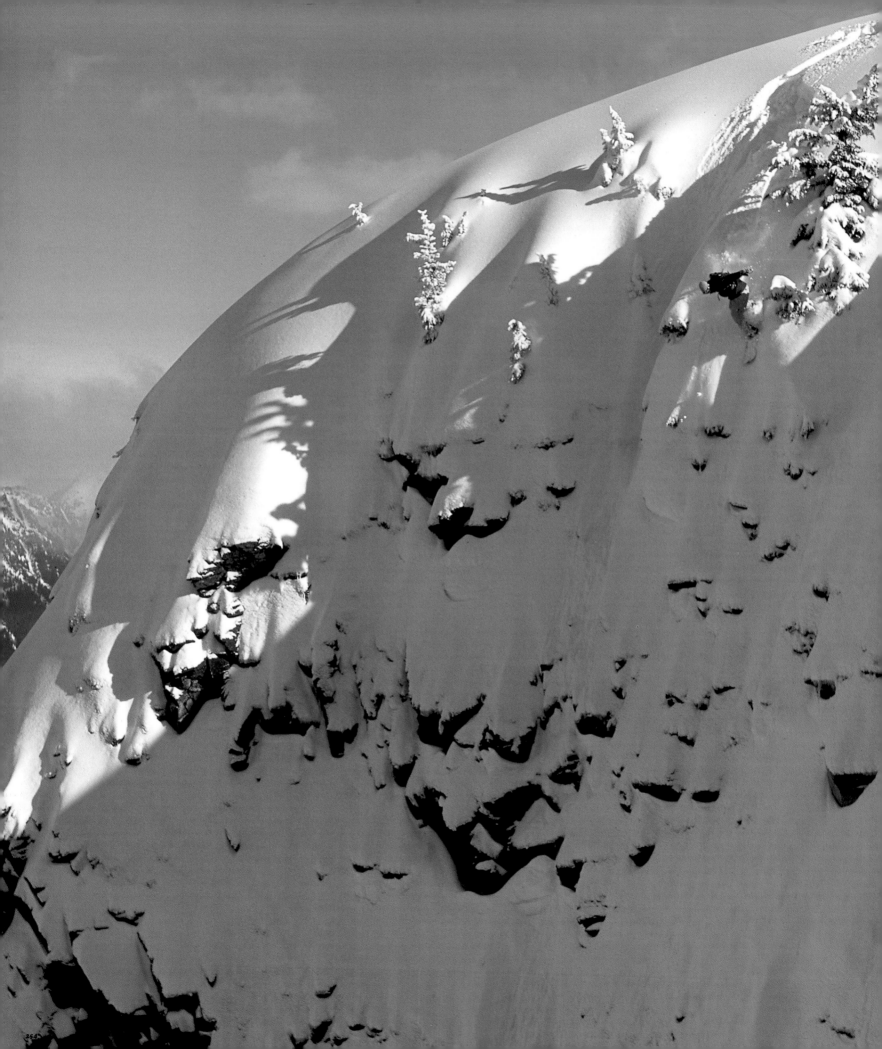

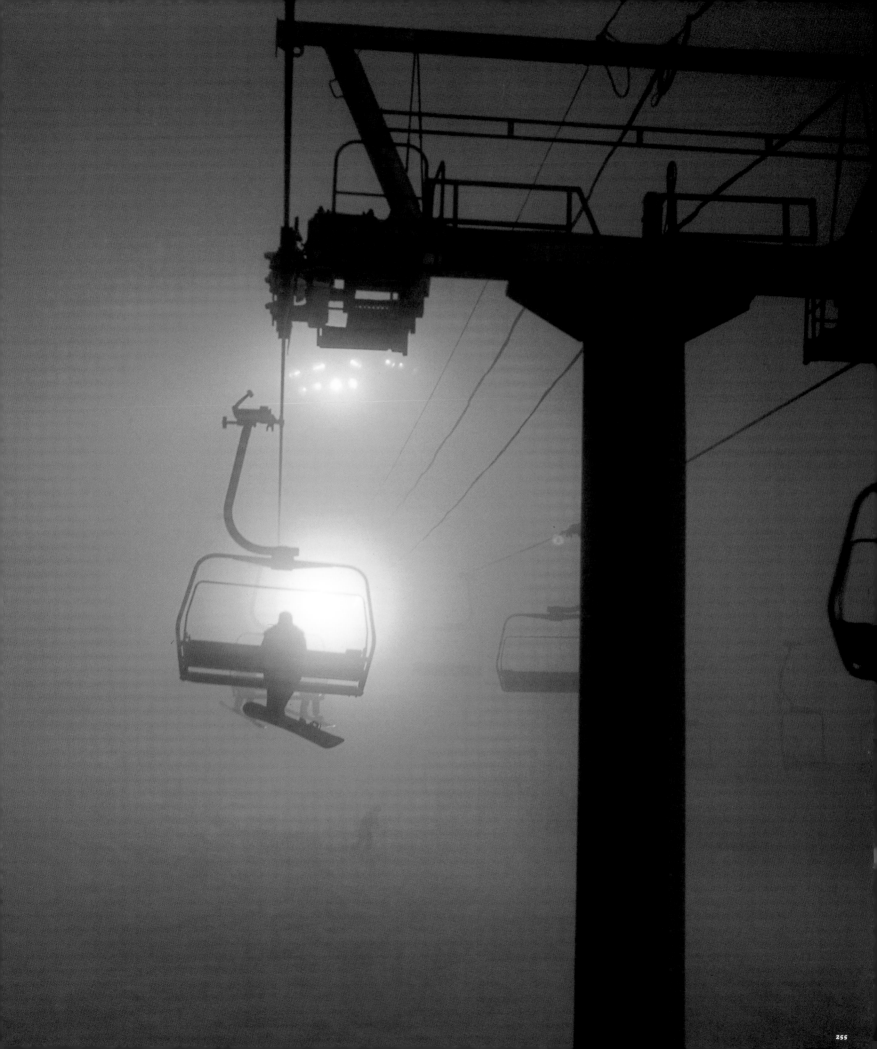

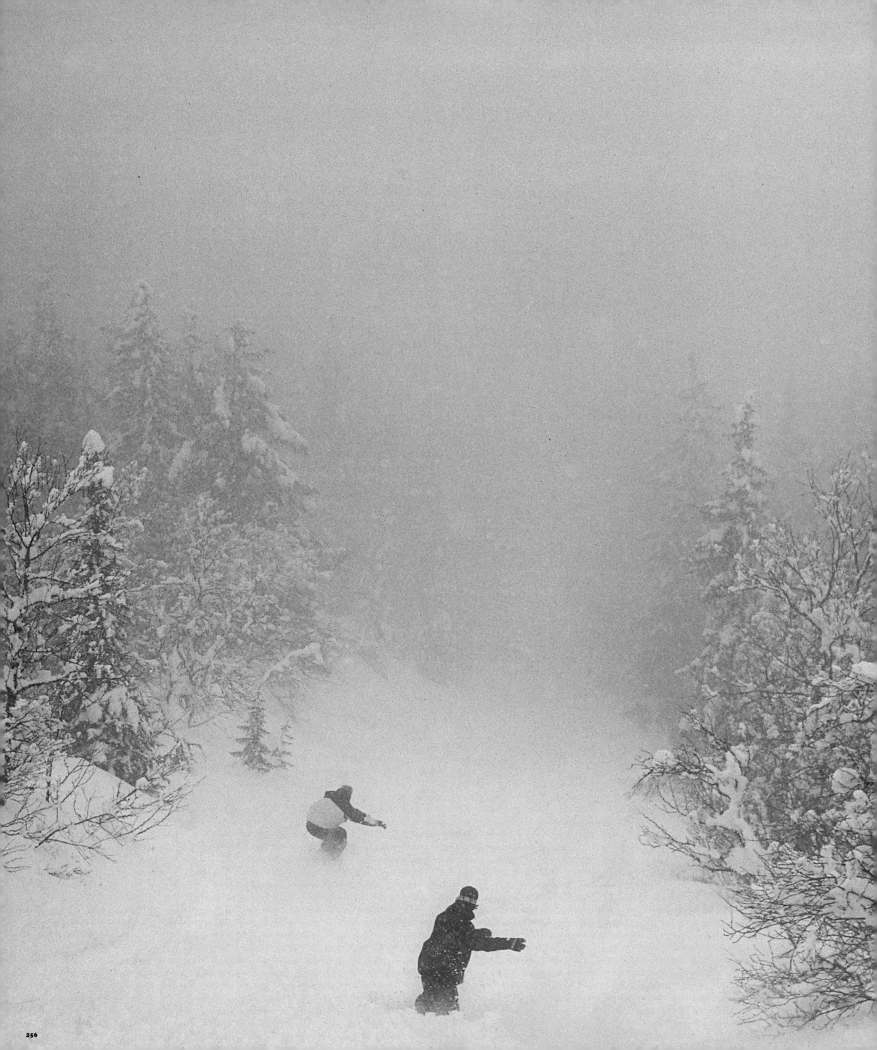

I am a son and a brother, I am thirty-two years old. I am a snowboarder. I can remember my first day like it was yesterday. Joe and I got a Burton Performer in 1984 and took it out to my uncle's backyard in the countryside of Hartford, Wisconsin. I think it took us about three years to be able to stand up straight and actually make it a few hundred feet without slamming. This season, my girlfriend learned to link turns on her first run in Vail. What the? Nevertheless, I wouldn't trade those early days of struggling and experimenting for anything. It felt right, and I knew we were onto something. To this day, each time I ride I progress, finding something new that keeps me coming back.

Somewhere along the line, I got a camera. I think it was a Christmas gift. I am still figuring out how to use the thing. I struggle, I experiment, I carry my manuals to read on the plane, while digging through endless piles of magazines searching for inspiration and ideas. I think I started seriously shooting snowboarding around 1992 in Vail, Colorado. Things happened quickly. My brother Joe was riding for Burton, which gave me instant access to professional riders. My attempt at bussing tables ended after three days with no paycheck in return. I had to be out shooting. My set-up was pretty ghetto. I had all my film processed at the Safeway supermarket. I borrowed gear and stole stuff from my brother's stash of product. I knew nothing about what I was doing but I kept on doing it, and something felt right. By the end of one season, I finally had something to show. I swamped Transworld Snowboarding magazine with shots. A lot of shots. Soon thereafter, Eric Kotch gave me the chance of a lifetime. In 1994 he invited me to a Burton photo shoot. He would pay my way, but that was it. The rest was "an opportunity". I dove in.

Apart from being a lot of other things, Blower is a visual history of the last nine years of my life. I could have never imagined what that first day in the backyard started. Some of my best friends live half a world away. I have sat on planes and circled the world ten times over in search of good snow; after three years I have figured out the Tokyo subways; seen parts of Northern Norway that even Norwegians never visit; and ridden five-thousand-foot vertical runs to the ocean in Alaska. The experiences have been amazing.

I've learned to see and make pictures differently every day. I find inspiration and motivation in Michael Stipe's lyrics, in the early morning light down by the water, in the way Terje straps into his board, and in the photos of my peers published in magazines.

Blower is not an end point, but rather a short glimpse into the window of my snowboarding life. I am not stopping. This project has taught me the power of collaboration, commitment, and friendship. It has allowed me to reminisce with my closest friends over epic powder days and crazy trips around the world. It has allowed us to show photographs that have never been used before, while revisiting some of our favourites. Now, for the first time, I feel an amazing integration between all the things that make up my life; I am taking better photographs, while reaping awareness, pleasure and inspiration from travelling. I have found love and self-fulfilment. I am more stoked on snowboarding and snowboarding photography than ever before. I can hardly wait until next season to kill it.

All of this and I still don't know what I really am. I document our snowboarding lifestyle, but don't consider myself to be a documentary photographer. I love to shoot portraits and lifestyle photographs, but don't aspire to the glitze and politics of fashion photography. I shoot action but am not really a sports photographer. I rarely have a summer and still don't really have a job. I know I'll always be standing "sideways". I know I'll always have a camera somewhere close by. I know I'll always be snowboarding.

– Jeff Curtes

Blower

The solid form of water that crystallizes in the atmosphere and, falling to the Earth, covers, permanently or temporarily about 23 percent of the Earth's surface.

001

©BLOWER INTERNATIONAL. LTD. 2001 420-BROS